LEO FUCHS

SPECIAL PHOTOGRAPHER
FROM THE GOLDEN AGE OF HOLLYWOOD

Words and images by Leo Fuchs
with an introduction by Alexandre Fuchs and an essay by Bruce Weber

pH powerHouse Books
Brooklyn, NY

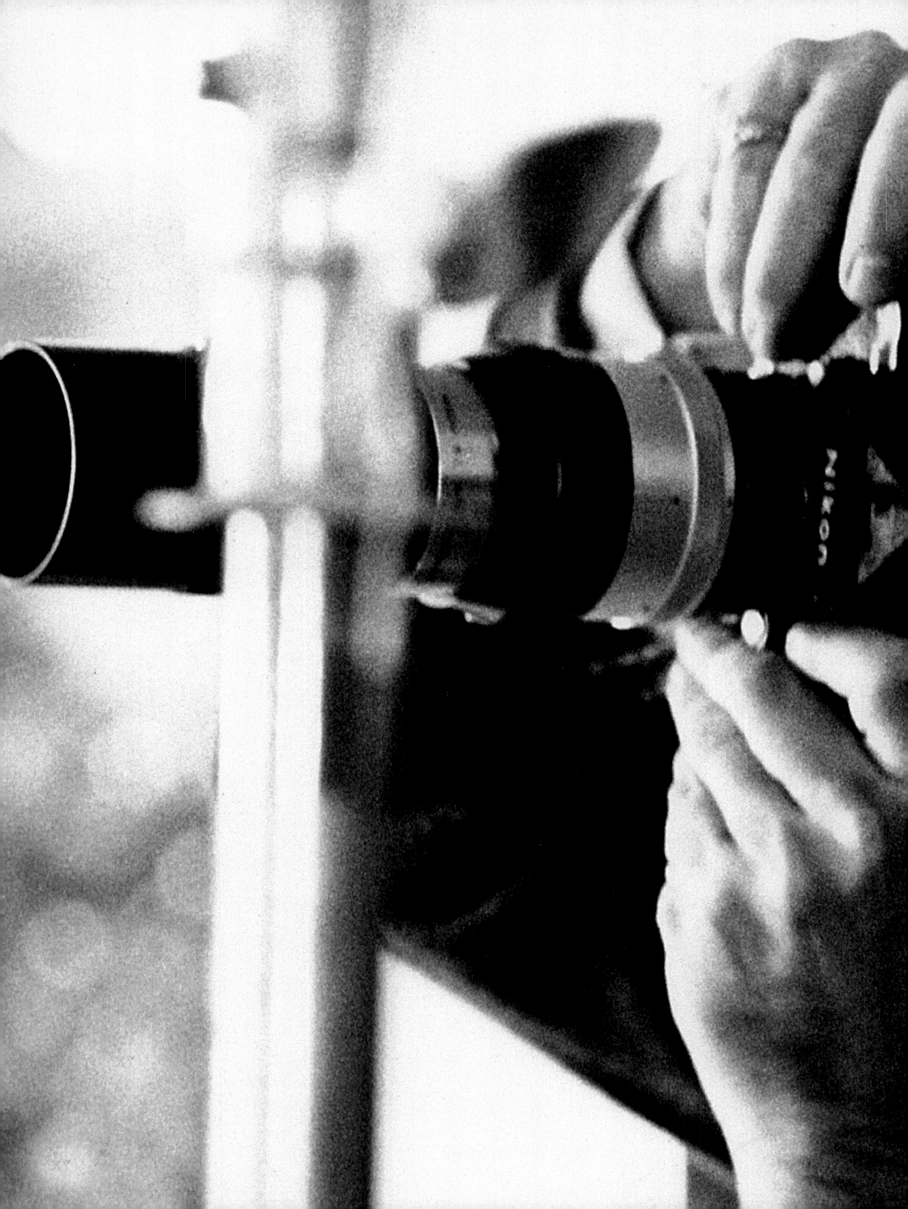

RETRACING INTIMATE FOOTSTEPS

I remember, when I was very young, my mother telling me that my father had made the cover of *LIFE* magazine.

She said it a few times over the years in passing. I had a boy's view of my dad: *he must be great, so much so they put him on the cover of a magazine*, pretty much that simple.

When I was born — in Los Angeles in the mid-60s — my mother insisted the new family move to Europe and pronto. After getting married in 1960 my parents had settled down — trading in his vagabond years for an independent photographer's career in Hollywood. He blossomed there along with the relationships he built in the industry, and more importantly with his subjects. It was an odd decision to leave all that behind.

Now in Paris, my father was a foreigner and a Jew — not exactly the natural recipe for social success in the salon set. Our tale of reverse immigration barely seemed to amuse. Yet, my dad's easy demeanor and ready stories helped him recreate a world for us and to make new friends, many of them artists and entrepreneurs, most quite passionate.

Growing up, I knew little of my parents' old life in America. My mother had wanted for me to grow up in Europe in a more familiar life. She believed that is where my consciousness and identity should take root. Once in a while, a friend, an actor, a director, or my godfather would come by the house in Paris and small elements of their prior life would be revealed.

During my childhood, my father was — and remained until he retired — a film producer. Meaning he was somewhere between a financier and an entrepreneur, but basically people would ask him questions and called him boss. Sometimes it was only his loyal secretary, sometimes it was a small army when he was on a film set somewhere, lost. Sets are a magical place for a kid and I learned much from watching people create in that orchestrated chaos. For all that, during those years, I would not experience him as an artist.

My father and I were extremely close. While I learned an essential cultural identity from my mother, his influence was developmental — he provided me with reasoning, passion, and purpose. Yet his style was never didactic. Rather, he would use storytelling to elicit these lessons. He would give me puzzles to solve or ask me what around us would make an interesting photograph. When — in my early teens — I finally saw my dad's *LIFE* cover, what a disappointment! On it was a picture of some guy...Rock Hudson. I felt cheated, I had fully expected to see my dad's face there.

My father retired in the late 1990s. My mother had passed on by then and he still lived in their apartment in the Saint-Germain-des-Prés neighborhood of Paris, a hundred steps away from where they met, he would tell everyone. As he got sick, we were looking to keep him mentally active and I had his photography archives shipped to Paris. These had been in cold storage at Bekins in Los Angeles for over 30 years and this was meant to be a half-housekeeping, half-nostalgia effort. When the archives, trunks and all, arrived, I was not prepared for what was inside.

First, there were close to 30 trunks filled with contact sheets, negatives, original prints, binders, and hand-written notes. Most of this work was unpublished. Many of the images in this book were found after speleological efforts in a pristine but scrambled mass. But, foremost, what I unearthed were creations of an artist father I never knew I had.

What struck me most was the intimacy of the images. While most were of titans of our collective memory, many images bore witness to individual and often very private moments of vulnerability, passion, or exploit by their iconic subjects. As for me, I was taken by the parallel between the intimacy in these images and the closeness I had experienced with my dad. I could feel his relationships with his subjects and live that momentary closeness exhibited in the photographs. Moreover, they also chronicled my parents' life inside Camelot, at parties, in the studios, and on vacation amongst these icons. I was now able to know the world my parents had left behind and the seeds of my own coming to America.

In making this book, I feel I finally understand that picture of Rock Hudson on the cover of *LIFE* magazine and the complexity of my father's accomplishment. I hope you enjoy retracing these intimate footsteps together.　　　　　*—Alexandre Fuchs, New York, 2010*

Leo's son Alexandre in 1974 in front of the marquee of a theater playing *Le Mouton Enragé*, a film Leo produced.

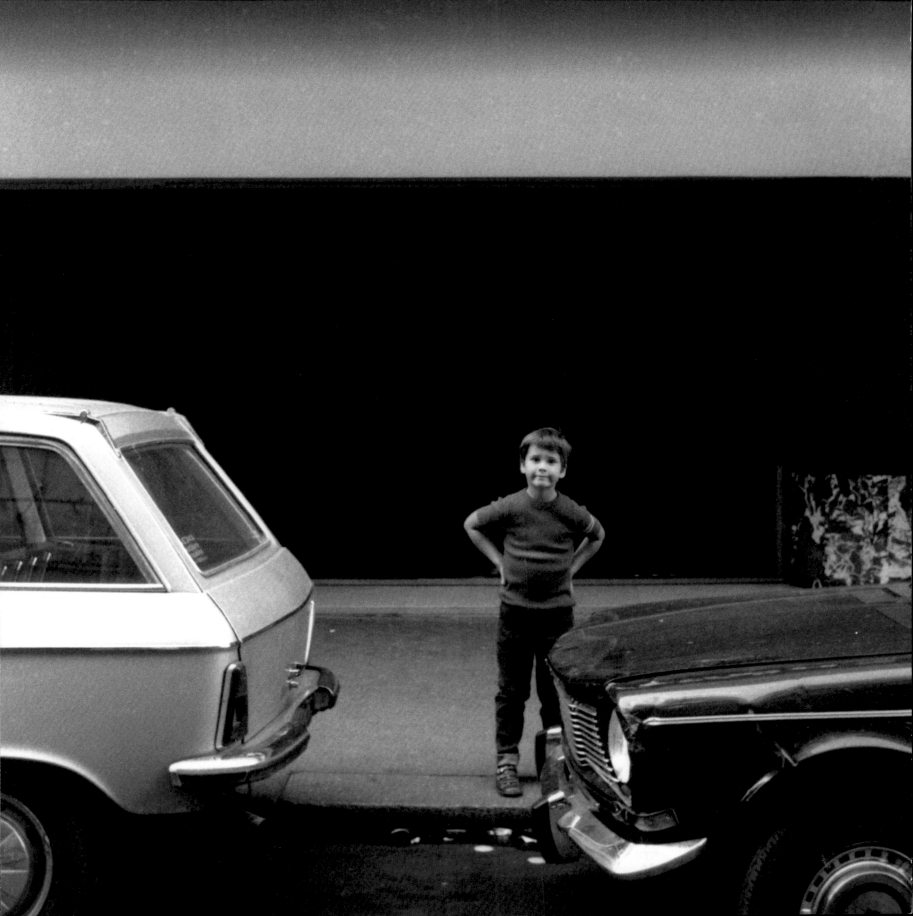

PRODUIT PAR
LEO L. FUCHS

SPECIAL PHOTOGRAPHER

Have you run into a blacksmith or trolley conductor lately? Every era has certain professions that come and go. Some that last only a short time can shape a wonderful life. My profession was "special photographer"; a sort of independent celebrity photographer with access, during a prolific period in the history of Hollywood. It burst onto the scene in the late 1950s and faded away not long thereafter with the arrival of the paparazzi. During that period it allowed my camera and I to travel all over the world, to get close to the rich and famous, and oftentimes those not. That camera opened countless gates and doors, allowing me to capture what others could only imagine.

World War II's fury had subsided; television was still an exclusive luxury; newspapers and magazines ruled. While radio was popular it was only evocative and the visual satisfaction of the image was hungrily sought out by the public, fast becoming the favored commercial medium for advertising and marketing. After a traumatic period of intense political and human struggle, distraction and entertainment were taking over the minds and aspirations of new consumers.

Publicity became a way to gain exposure for one's product. It smelled of newsworthiness. Publicity images, consumed by readers as legitimate news, became a core promotion tool for the film industry. Studio publicity departments maintained a steady and controlled stream of photographs to magazines. These were almost exclusively production stills to start with, taken on the set during the shooting of a movie and given out broadly without exclusivity. The same photos circulated to the desk of editors for *LIFE* or *LOOK*, making the larger publications hunger for closer, exclusive eyes on the subjects of their readers' affection, the movie stars.

Publicists, known then as press agents, did just about anything to get exposure for a client. This was not a profession of integrity. Phony feuds; fist fights; risqué scandals were the norm of press agentry. Anything goes as long as it gets news space and be sure the name is spelled correctly. Some who hired press agents attained celebrity status before ever appearing in a film or stepping onto a stage. A celebrity of the time, millionaire Tommy Manville, married nine times just for the publicity, some unions lasting only a few weeks. Prime outlets for this publicity were widely syndicated columns by Walter Winchell, Ed Sullivan, and Louis Sobol in New York and Hedda Hopper and Louella Parsons in Hollywood. An item "planted" in their texts was the ultimate get. What appeared in these columns in the morning was the stuff of luncheon and dinner conversations, so concentrated were the opinion leaders of the time.

This hyperactive ecosystem of celebrity promotion propelled a golden age of Hollywood as it mass-produced every genre of film—from glitzy musicals and films noir to B pictures, comedies, and dusty Western shoot 'em ups. Magazine editors, aware of their readers' desire to see their favorite stars in print, would decorate their pages with studio-supplied stills. While magazines sent staff photographers to the far reaches of the world, rarely was one sent to Hollywood. Such excursions were considered an unnecessary expense. As a result, most of the images were distant, staged, and two dimensional; more about the film, less about the individual and often it was the individual that the audience was growing to love.

A desire by the pubic to get to know beloved celebrities more intimately fed the editor's need to source away from the studio-produced production stills and find images that brought readers into the lives of movie stars. The photographer would have to go in close, earn the trust of the subject, and bear intimate witness to their lives and humanity. The field opened suddenly for a few independent, freelance photographers to orchestrate this balancing act.

One day a studio publicist approached one of these freelance photographers, whose talent and personality gave him access to stars, and suggested he spend some time hanging around a trailer with a movie star on a movie currently in production. Perhaps he could come up with glimpses—intimate "picture stories" about the movie star's life. When his photographs found their way into print everybody would be a winner.

Thus was born the job of "special photographer."

Leo on location for *The Spiral Road* looking for Rock Hudson and Gena Rowlands, 1961, Paramaribo, Suriname.

KING OF CHEESECAKE

My first exposure to photography was at a dingy art school on East 79th Street in New York. Here, the theory of photography was the main curriculum. Uninspired, I soon switched to a vocational photo school in downtown Manhattan that taught practical photography. It was located in the shadow of the Brooklyn Bridge, which daily gave me much majestic inspiration. I was eager to learn, but I was not good at sitting in a classroom.

When I heard that Eleanor Roosevelt, the politically active wife of our popular president, was to speak near my home, I grabbed my secondhand Speed Graphic and sped to the auditorium where she was to appear. Carrying the ubiquitous tool of the press photographer trade, which my parents had bought for me at considerable financial sacrifice, I gained easy entrance to the theater. Assuring myself of a good vantage point I set off a few one-time number 40 flashbulbs, each the approximate size of today's 60-watt lightbulb.

That night I turned the family bathroom into a darkroom and developed then printed three of the photographs. The next morning on my way to school, I stopped off at the offices of a Yiddish language newspaper my father was fond of reading called *Der Tag* (The Day). The man in charge offered me five dollars for one of the pictures. It ran the next day with my name under it. At the ripe age of 14, I was a professional. My Father's reaction was reminiscent of that old joke: "Yes, but to a photographer are you a photographer?"

The first celebrity who let me take his picture was Larry Fine of the Three Stooges. I took it at a nightclub called the Zanzibar. Among the other Broadway and Hollywood celebrities that would visit the place were commentator Walter Winchell and Damon Runyon, the writer. Runyon showed up with former world heavyweight boxing champion Max Baer, whose shoulders looked broad enough to block out the sun. I would make a few dollars here and there selling these pictures taken after long nights of waiting around for someone of note.

Among the other press agents I had come in contact with was Milton Rubin, a soft-spoken scholarly looking man in his early forties with thinning hair and an enviable roster of clients composed of restaurants and nightclubs, actors and comedians. Each night, Rubin would tour nightclubs and having established relationships with headwaiters and hatcheck girls would pick up tidbits about celebrities that he would immediately pass on to Walter Winchell, the dean of newspaper columnists. Rubin invited me to accompany him on his trek from club to club. This was a big deal for me.

Night's darkness would be nudging the dawn when we ended up in his 22nd-floor office at Rockefeller Center. Often too tired to go home to bed, we grabbed some shuteye propped up in a chair in his office. Sunshine had chased away the night by the time we awoke.

For his efforts on their behalf, three nightclubs paid Rubin $350 weekly to get them in the papers, especially a mention in Walter Winchell's column. It was enough for such mention to be no more than "overheard at the China Doll," one of the nightclubs he promoted. Most often Rubin was the author of such quotes and Winchell gladly used them in his rubric as it amused his readers.

Through my months as Rubin's shadow I gradually gained access to nightclub dressing rooms where I would spend a good deal of my time. There, I photographed showgirls and dancers in their colorful costumes, which became easy sells to cheesecake magazines. To vary the settings, some of the girls went with me to nearby parks or beaches where I could shoot them as undressed as convention would then allow.

At that time the newsstands were stocked with dozens of these cheesecake magazines, essentially publications of soft erotica of the era. These magazines were the major outlet for my work at the time; I had developed a reputation. One newspaper columnist dubbed me the "King of Cheesecake" from the access my time making the rounds at the nightclubs had provided me. I was shooting dancers and showgirls, all pretty girls aspiring to careers in show business who posed for me without being paid. They too hoped for the exposure.

I was by now earning enough to get my own one-bedroom apartment on West 48th Street in the hub of New York's show district. I was always alert to find a new face that would

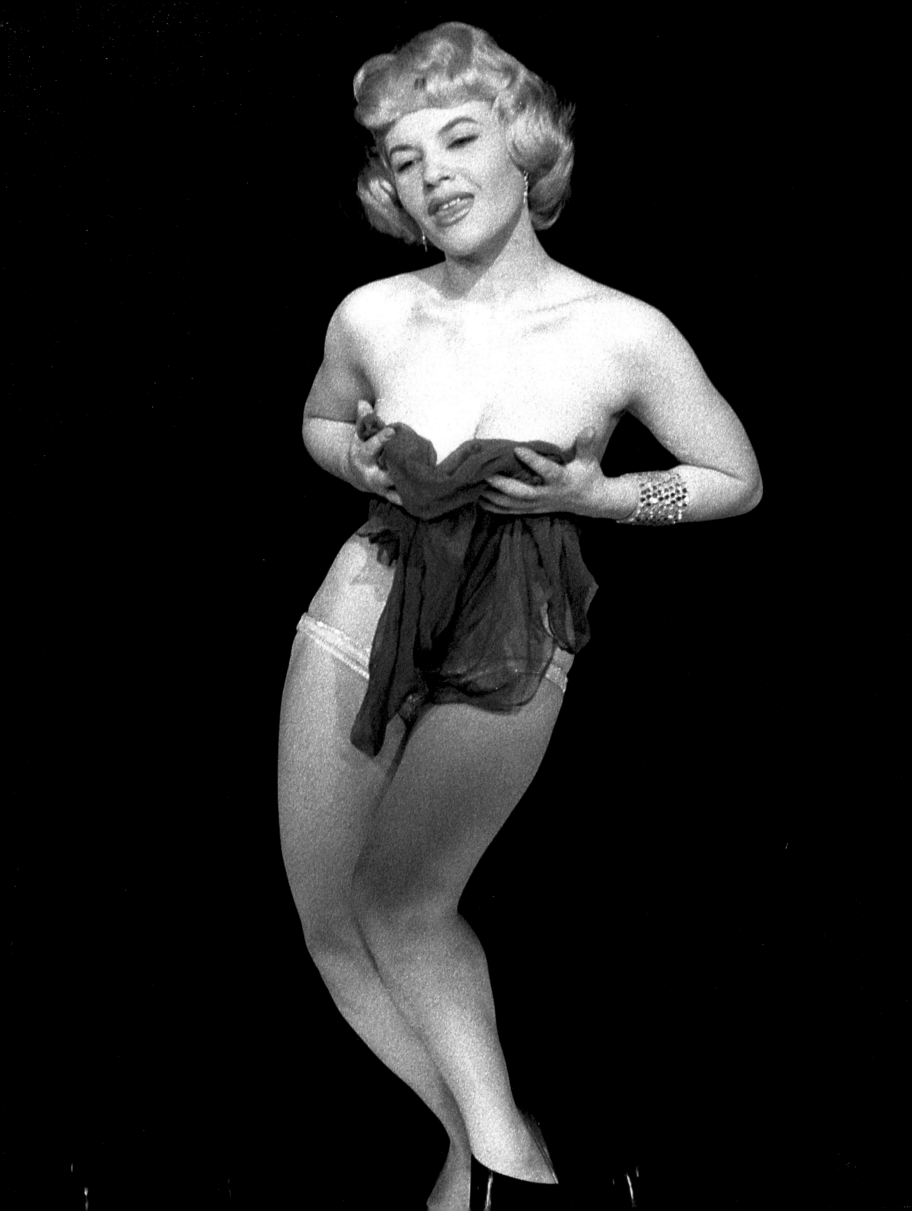

draw a second glance from an editor. Discovering these girls and having their images be published and seen was my source of income.

The club I spent most of my time in was the Latin Quarter on West 48th Street between Seventh Ave. and Broadway, which, along with the Copacabana, was the most successful of the New York clubs. Although there were always rumors about the Copa's mob connections no such talk existed about the Latin Quarter. It was owned and run by Lou Walters —Barbara Walters' father — who produced the shows in his club himself and every now and then would hold auditions for showgirls and dancers. These tall, stately looking beauties walked up and down the stage during the show in revealing and fabulous looking costumes. Whenever he would hold auditions he would sit at a ringside table of the darkened club, the spotlights focused on the stage where the girls paraded before him. Every now and then his voice would ring out, "Honey, get married." This was said not harshly but benignly as if his serious advice.

Getting a date with any of the demoiselles was tough even if they liked you; they had so little time, what with two shows every night. Besides, their interest mainly focused on men with more money than me or who could further an ambitious career. I had my eye on a particularly pretty young woman whom I would often see in the dressing room, reading Dostoyevsky, of all people. Intrigued, I cajoled her into joining me after the second show, although this would be around 2:00 a.m., for a snack or a drink. We had a lively conversation over sandwiches at a nearby drug store about our favorite authors, then I took her to a book shop that was open until all hours, and bought her a couple of books by Stefan Zweig. I then proceeded to spend my very last dollar on a taxicab to take us to where she lived on 70-something Street. As we approached her building I casually said, "So, this is where you live?" Without batting an eye, she shot back at me, "No not at all, this is where my boyfriend lives." The walk back to midtown gave me ample time to reflect upon the complexities of dating showgirls.

One day while cooling my heels waiting to get into an editor's office, I met a picture salesman from Graphic House, a prestigious photo agency in New York with a number of talented photographers on its roster. The agency did not disdain the cheesecake market.

This was not the first time I had run into this salesman; Sandy Harris was Graphic House's star salesman. He was liked by the editors and known for being affable. He was convinced there was a client editor for all of the pictures he carried in his briefcase. With a very pleasant way about him, he was obviously a very talented salesman.

Our paths kept crossing all over town. It seems I was getting to be a thorn in the side of his agency, which was run by Roy Lester, and he wanted to meet with me. I was flattered and of course agreed; Lester's reputation as an aggressive entrepreneur was well deserved.

Of Russian origin, Roy was bald and pudgy. With a violent temper, he spoke with a pronounced European accent that hinted of German more than Russian. During our meeting Roy Lester was on his best behavior.

It didn't take a genius to figure out he valued the page space being taken up by the pictures the various editors bought from me. He felt the best way to get rid of a pesky competitor was to have me join; he made me a very fair offer. By then it was 1947, and I had reached my 18th birthday. My income, although not negligible, was still precarious. Most of my days were spent recruiting new talent in the rehearsal halls, drug stores, and casting halls known as hangouts for the would-be stars waiting to be discovered, which made up the large part of the real estate known as Broadway. Evenings I frequented restaurants and night-clubs that dotted the neon-lit show-business districts. Rarely did I venture beyond the neighborhood's invisible limits. I had a few guy friends, but I think their main interest was a chance to hang around my apartment making eyes and passes at all the pretty girls that passed through daily. I, on the other hand, made use of them as male models whenever I needed to illustrate a picture story, or as assistants to hold the strobe lights or change flash bulbs when needed.

Contact sheet from a session with Melody Bubbles, a showgirl famous for a risqué bathing routine, circa 1946.

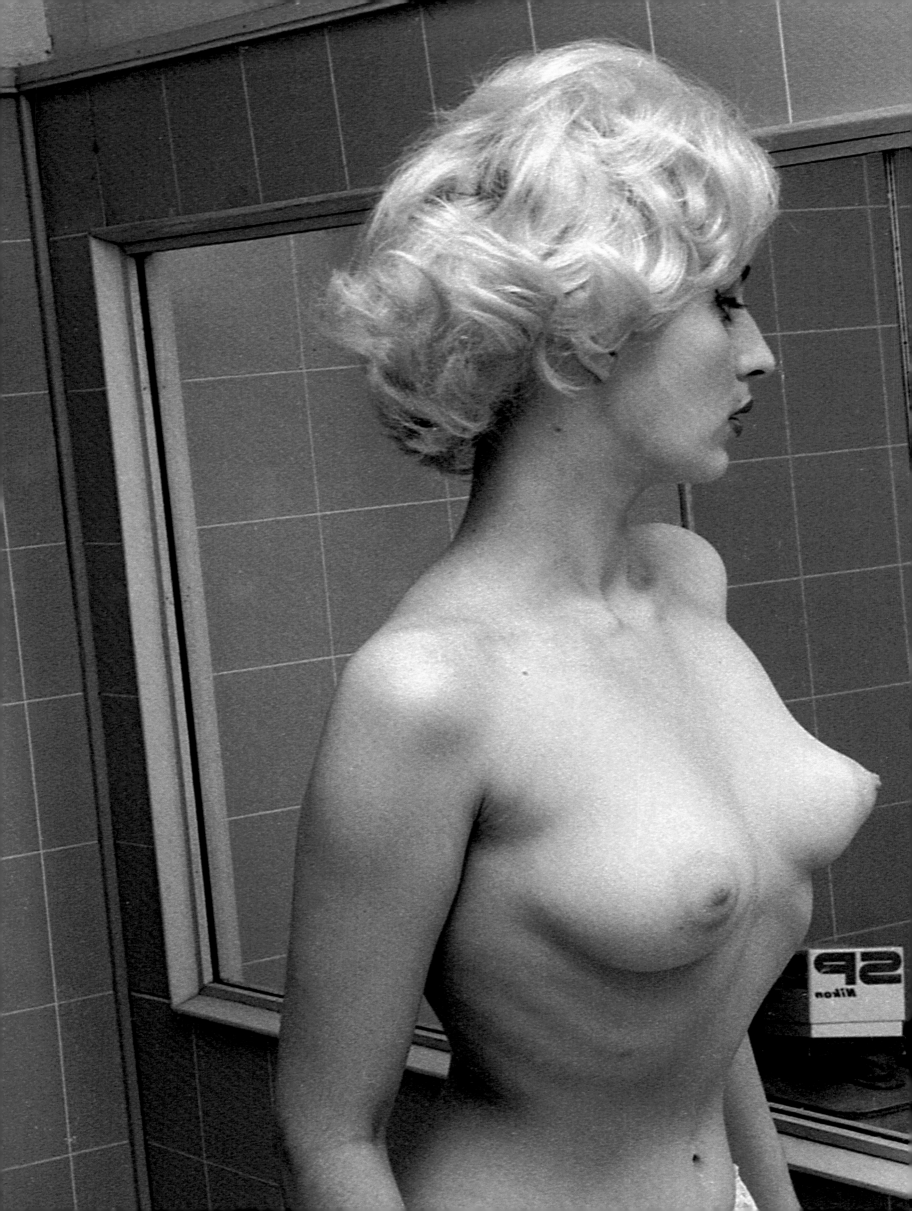

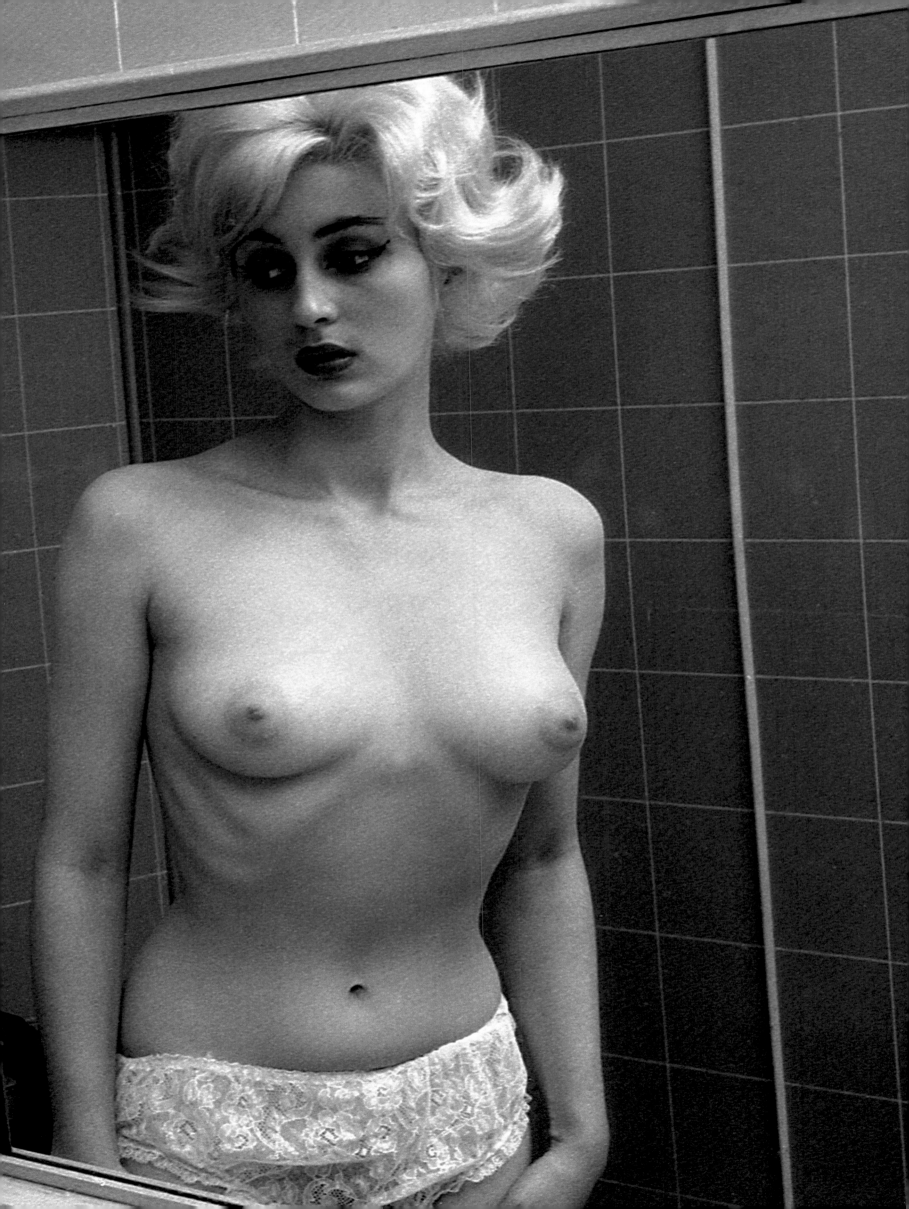

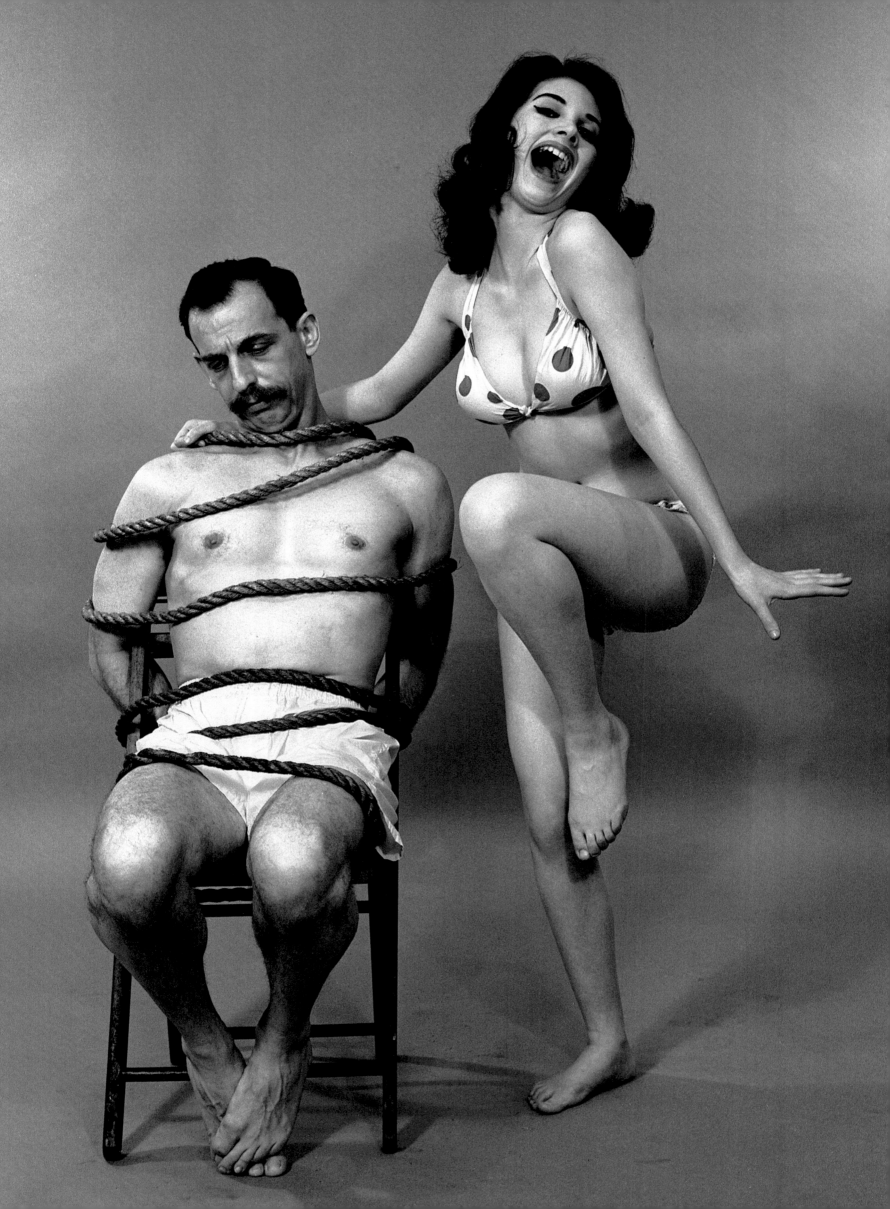

These were colorful characters. One of the friends that used to hang around was a slightly overweight, mature resident of Brooklyn in his mid-30s who worked as head cashier at a fancy 50th Street Chinese restaurant. His name was Leslie. He was soft-spoken, but when he spoke people tended to take his words very seriously. He was a faithful friend, but he was not a man to trifle with. Leslie had a lucrative sideline in a flourishing trade on Broadway known as *loan sharking* or *shylocking*, moneylenders who lent money at six for five. That meant that for every five dollars you borrowed you would have to pay back six at the end of the week. That was the going rate. Loans were mostly quite small, a 10 or 20 dollar bill mostly, but a hundred or two was not unheard of.

Another man I came across was a textile salesman who had drifted north to the Times Square area from the garment district further south. Sid Levy was drawn by the glamorous life of Broadway to which he hoped to find entry. Selling textiles did not satisfy his ambition. Levy, in his early 20s, of medium build, had a round face that he thought to be irresistible to women. He was not the athletic type so he covered his softish body with the latest men's styles. Becoming a ladies man was his sole ambition.

To make himself useful he often held lights and carried cases for me when I had a complicated shoot. He started dating a girl he met on such an occasion. Rosemary Williamson was a stunning, tall, brunette beauty, who appeared every night at the Winter Garden Theatre in *Michael Todd's Peep Show*, one of the more important Broadway musicals. Sid came in one day and approached Leslie with a no-lose deal he had heard about. Someone had told him they knew just when and where expensive furs and clothes were going to fall off delivery trucks. Sid could buy these goods for a song and sell them to legit clients in the garment district.

Leslie's only involvement would be to finance the deal. Never averse to an angle, Leslie agreed and subsequently made somewhere between 20 and 30 thousand dollars available to Sidney. The first two or three operations went off without the slightest hitch. Soon Sid would come around with Rosemary clad in a brand new fur coat and jewels, spending money like it was going out of style. They were now known as the Sid and Rosie who had hit it rich.

Eventually the association came to an end. Leslie was content with the money he had made, but he felt it prudent to retreat. He later explained his philosophy to me, "Always get out when things are going real good, it can only go downward from there. Take your profit and run before they catch on to you." Sid on the other hand got into it more deeply. With his source of financing dried up, Sid had to look elsewhere to sustain his high living. He did not have to look far. His apparent good fortune had come to the attention of two uptown friends. Two dentists wanted in on the good thing that had made Sid so prosperous. With Leslie gone from the scene, Sid eagerly embraced the dentists and took in 10 thousand dollars from each. Unfortunately, however, the police unexpectedly arrested his connections who had been paid in advance. There was no merchandise forthcoming for Sid.

Now, the dentists wanted no explanations, they wanted their money back, and like the bourgeois that they were, they consulted a lawyer, who immediately had them spill the whole deal to the cops. Sid was arrested and the dentists' lawyer went after Rosemary to return the furs and jewels she had gotten from Sid. Rosemary categorically refused, declaring she knew nothing about trucks or deals. Overnight Sid's misdeeds made headlines. When her name was dragged into the headlines she referred to Levy as "that creep" (the first time that the word "creep" had been used in print.) Sid's great dream had turned into dust. The court's decision was that unless Levy was in transit he was not to be seen between 42nd Street and 57th Street and the area between Second and Eighth Avenues for a period of 15 years. Should he be found in violation of this order he was to be arrested and confined to prison. I never saw Sid after that. Rosemary changed her name and married the very charming, handsome headwaiter at the Chinese restaurant where Leslie worked. She ultimately moved to Europe to work in modeling—Paris, I think—where she vanished into the landscape.

WERRY BEAUTIFUL

I continued my association with Graphic House where Roy Lester ruled with an iron fist. One day he summoned me to his office to meet an important new client. Introducing me to new clients was why I had joined his agency. I did not know that this meeting would be the beginning of an emotional roller coaster ride. The man I met in Roy's office was a mid-sized, middle-aged, rather handsome man who also had a pronounced middle-European accent. His name was Mr. Pollini. Pollini was a manufacturer of plastic key chains for which he needed photographs of very pretty girls.

"Beautiful, werry beautiful," he would say. They had to be sexy and relatively undressed. There were only two problems. He insisted on being present when we made the pictures and there was no money for models. The money he had available was just enough to cover the cost of the photography. Roy and Pollini looked to me to solve this dilemma. Considering the amount of time I spent photographing pretty girls I felt confident I could gather a few to come in and pose for free, considering I had managed to get their names into print before. A shoot was scheduled for the next Saturday. For a project of this size I knew I needed the help of the darkroom staff. It was against Roy's nature to grant raises, so in lieu of money, he bestowed titles. The darkroom foreman was dubbed The General. He was assisted by an expert printer named Herbie Fried. A well-read German immigrant, Herbie was about my age and we had become good friends. He volunteered to assist me on the Pollini project. The two of us prepared the studio lighting and were ready to go. It soon became clear that Pollini's presence would be detrimental. He tried to show how he wanted each girl to pose, how arms and legs should be placed. And he kept changing his mind and had no firm idea of what he wanted. It was near eight o'clock in the evening when the last girl disappeared behind the dressing room curtain to get dressed. Herbie collected the 20 rolls of film I had shot with my Rolleiflex. He then headed for the darkroom to develop the film. I bid Pollini goodbye as we both left.

Later that night, anxious as usual about the results of the day's work, I let myself back into Graphic House, headed for the darkroom, and rushed to the wooden heat enclosure where my film rolls had been drying. I almost cried. As I reached for the hanging strips of Kodak film I found totally blank strands of celluloid. Something had not functioned properly. Either my camera shutter or my strobe lights or the synchronizer…in any case not one picture had come out. All blanks!

What now? What to do? What would happen Monday? My promising career at Graphic House seemed to be coming to an ignominious end. The shame was too painful to contemplate. Such mishaps just did not happen to professionals.

Sunday morning I frantically called every one of the girls who had worked with us the day before. Fortunately I had enough goodwill with them that they each agreed to return and spend the day trying to redo the same convoluted gestures we had done the day before.

The next problem was remembering what each girl wore, what skirt with what blouse. And where did you have your hands? How many breasts were showing? Were your legs crossed? Which shoes with which bathing suit? It just seemed an impossible task. Always mindful about how finicky Pollini had been, as the day progressed I became less and less sure I could get away with it.

I will always be grateful to those girls, none of whom I was particularly close with. They were just good kids. Kids, I say! All of them were older than I was at the time. Pollini came in the next morning. As he pored over the still damp proofs, he exclaimed compliments and congratulated us on a complicated job well done.

Outside of the occasional, rather rare advertising job that came to me through Roy's agency, my main task still consisted of coming up with sets of pictures of scantily clad, attractive young women, which, together, would allow an editor to tag on a headline and publish them.

One day I received a call from a press agent ballyhooing a new charter airline between N.Y. and Atlantic City called World Airways. He invited me to join a press flight to verify how comfortable and efficient this new route was going to be. This was a time when fledgling airlines were popping up all over the country. While en route to Atlantic City, I was introduced to the gentleman who owned and ran World Airways. He explained to me that World Airways also flew to Miami and Puerto Rico as well as Los Angeles and San Francisco. He courteously suggested that I call him any time I wanted to fly to any of these places, on the house, on a space available basis of course.

I took him up on his offer promptly. Next, I convinced a friendly press agent for a fancy Miami beach hotel to make accommodations available to me while I looked around trying to find material that would get into print. All that had been setup, now all I needed was a girl to come with me…

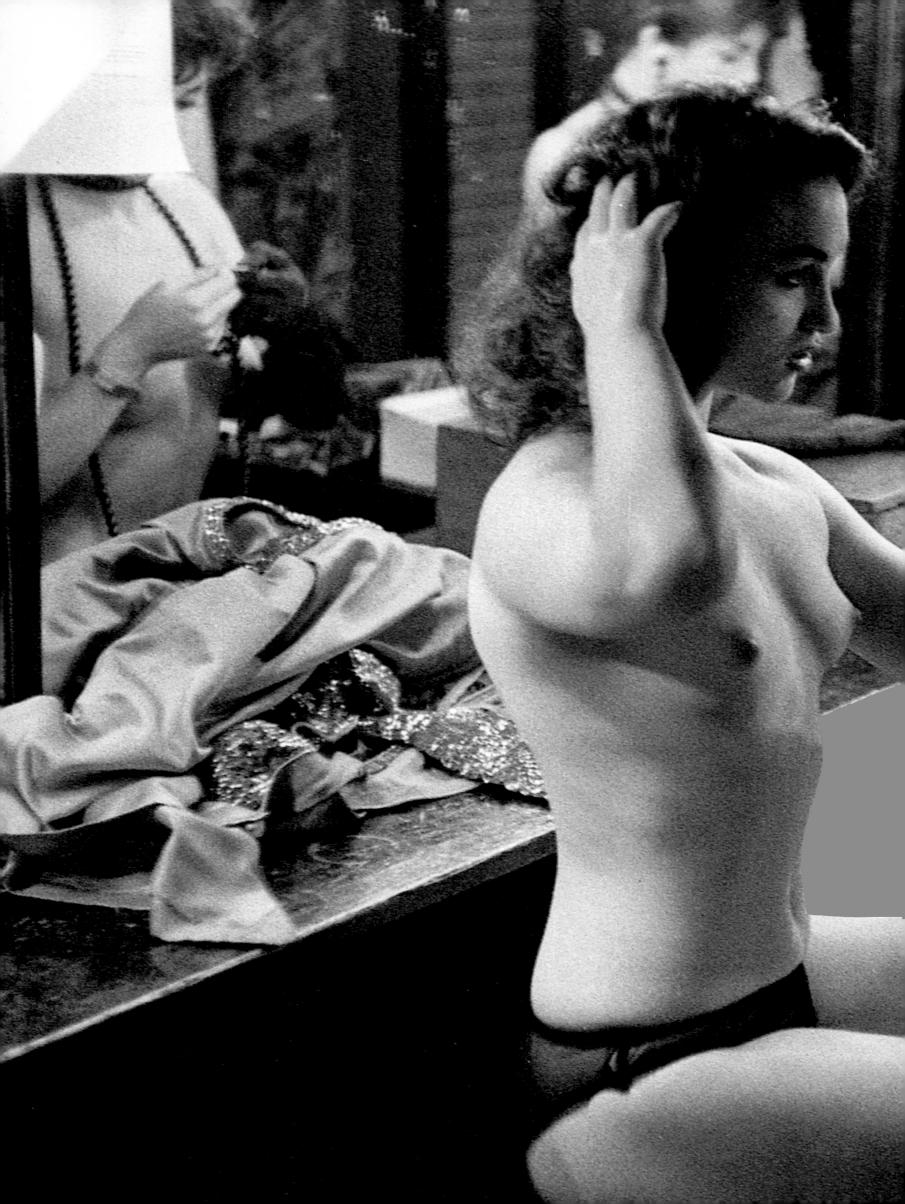

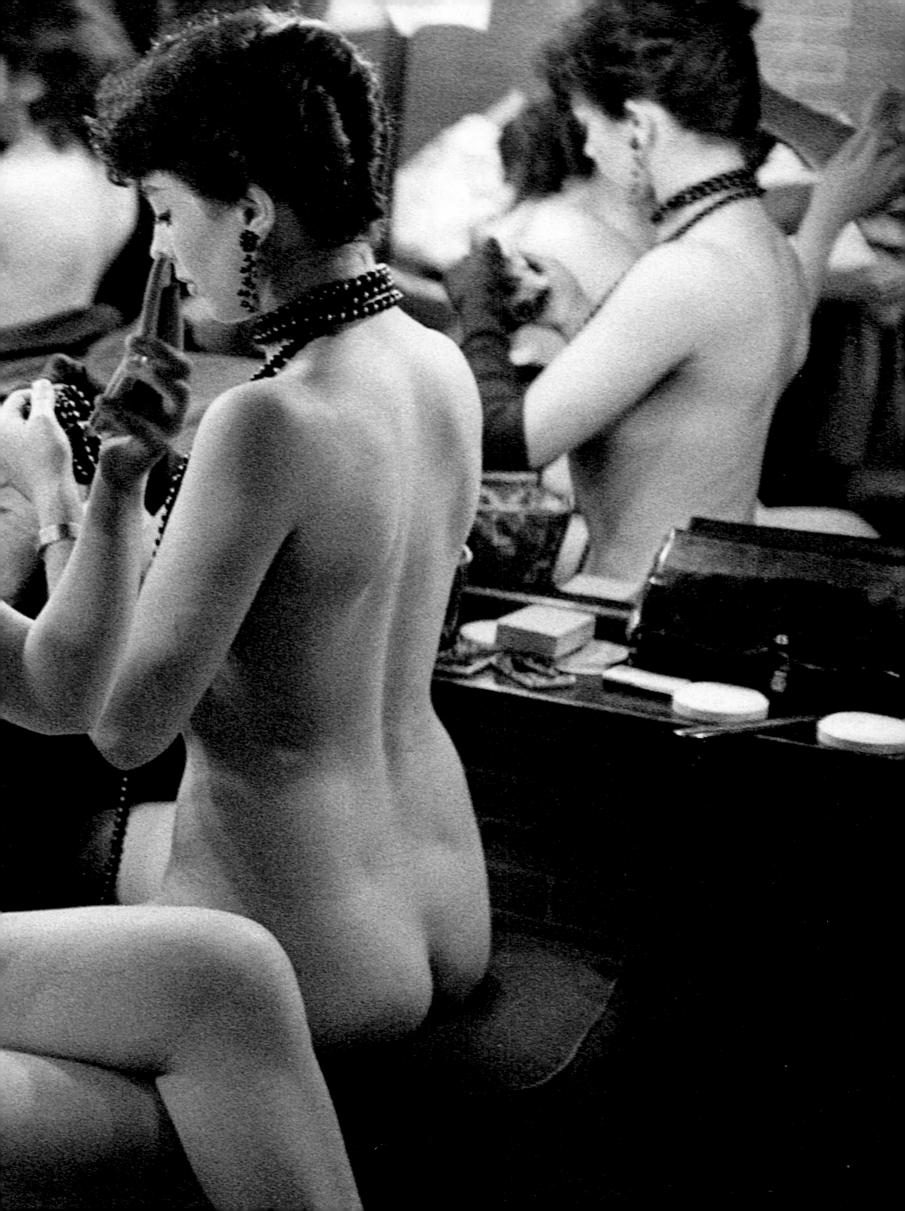

OFF BASE

These glory days were to be short lived. On the other side of the world the Koreas had decided to go to war. Uncle Sam sent me a short message, beginning with the dreaded word: "Greetings." The next two years are worth mentioning only to say that I was probably the worst soldier the U.S. Army has ever had the misfortune to enlist. After three miserable months of basic training in the deep South—Augusta, Georgia, to be exact—I was sent to the U.S. Army Signal Corp Photographic School at Fort Monmouth, New Jersey where, in the army's inimical fashion, they would now teach me how to take pictures.

After finishing school I managed to get stationed at First Army Headquarters at Governors Island in New York Harbor. This allowed me to live "off base," meaning I could room with my ex-assistant at Graphic House, Herbie Fried, in a somewhat dingy West 49th Street apartment where he lived shacked up with a brunette, would-be actress named Marion Ross.

One particularly hot summer in '51, being off-duty, I dressed in civvies and wandered up to Spanish Harlem to see what I could find interesting enough to photograph; just for myself. With my Rolleiflex I caught a bunch of kids playing in the street. They were keeping cool in the hot sun with the water gushing out of a fire hydrant they had managed to open. This shot turned out to be one of my all-time favorite photographs.

Before long, orders came down for me to ship out to Europe. I can recall only two accomplishments during my army stint in Germany. Covering, on land and by helicopter, the widespread floods that devastated Holland in '52 and a series of pictures documenting the rebuilding of Berlin which had been virtually leveled by bombs during the war. While in army uniform, I got to know a Berlin newspaper reporter. Never far from the interests that had propelled my early career, I had my new friend take me around the city's nascent, sexy nightlife, which I duly recorded on film in my spare time. I would mail the pictures to Graphic House in New York for sales to magazines.

These were momentous times in the divided city, rebuilding itself after devastating destruction. The Berliners had rekindled a dormant sense of humor best demonstrated by an old story: an American airman strolling the city's famous thoroughfare asks a news vendor where he can find a historical landmark, the Gedächtniskirche (or Memorial Church). The vendor, without losing a beat, replies, "Interesting, you had no trouble finding it in the middle of the night."

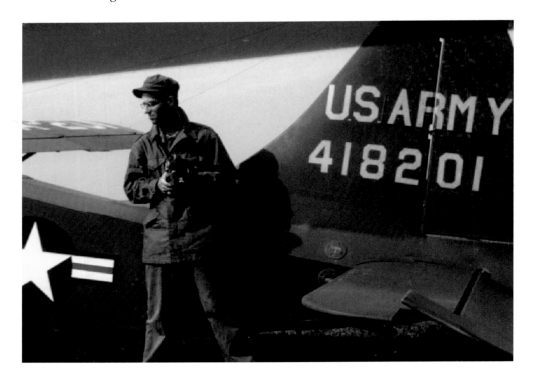

Leo during his time as a Specialist in the U.S. Army Signal Corps before his discharge, Europe, 1952.

SOMETHING FOR YOU

Rebuilding was in progress all over Berlin and the people demonstrated none of the bitterness expected from a conquered population. As in most cultural capitals, a unique cynical humor helped make the tragedies bearable.

When my military obligation ended, I took my discharge in Germany and took up residence in Munich. The language was no handicap as I spoke German fluently, having spent the first 11 years of my life in Vienna, where I had been born. Graphic House agreed to send me $300 a month as an advance on my share of the monies they might receive from the picture stories that I would send them. This put me back on the lookout for new material… pretty girls, night clubs, and general human-interest stories. Some of the pictures I would submit to the German magazines that had sprung up since the war, before sending them off to Graphic House. It helped to pay the bills, but the checks from Graphic House didn't go very far even in those days.

In early November of 1953 the editor of the *Munchner Illustrierte Presse*, a German magazine that bought pictures from me from time to time, phoned to suggest I come by his office. Since it was Christmas time, I bought a bottle of whiskey from the Army PX. Dr. Zentner—all those who have a degree in Germany are called Dr.—greeted me with a big smile. He thanked me for the bottle and then opened a drawer in his desk and uttered the words, "I too have something for you." Then he handed me a letter that was addressed to him and came from the committee organizing the first International Film Festival of São Paulo, Brazil. As soon as I had finished reading, he added, "If you can find a way to get there, I will guarantee to publish five pages of your photographs, at 150 deutsche marks per page, but we cannot afford to pay any expenses."

I went to see *Billed Bladet*, the Swedish magazine, thinking they might be interested in coverage and would help defray the costs. I also contacted Panair do Brasil, the Brazilian airline, and told them I could guarantee the publication of a picture of their aircraft. That publicity should easily be worth a round trip ticket. I gave it a hard sell. Considering that the *Munchner Illustrierte* was one of the four most important periodicals in post-war Germany, the airline director listened with patience. When I had finished my spiel, the executive said, "Give me some time to look into this matter and give me your number. I'll get back to you."

I thought that was the end of that, but lo and behold in January, the phone rang. "Herr

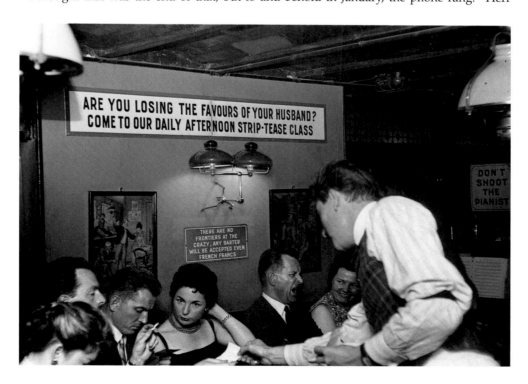

Bar life, New York, Circa 1945. Fuchs found his first sellable material covering the nightlife in the city.

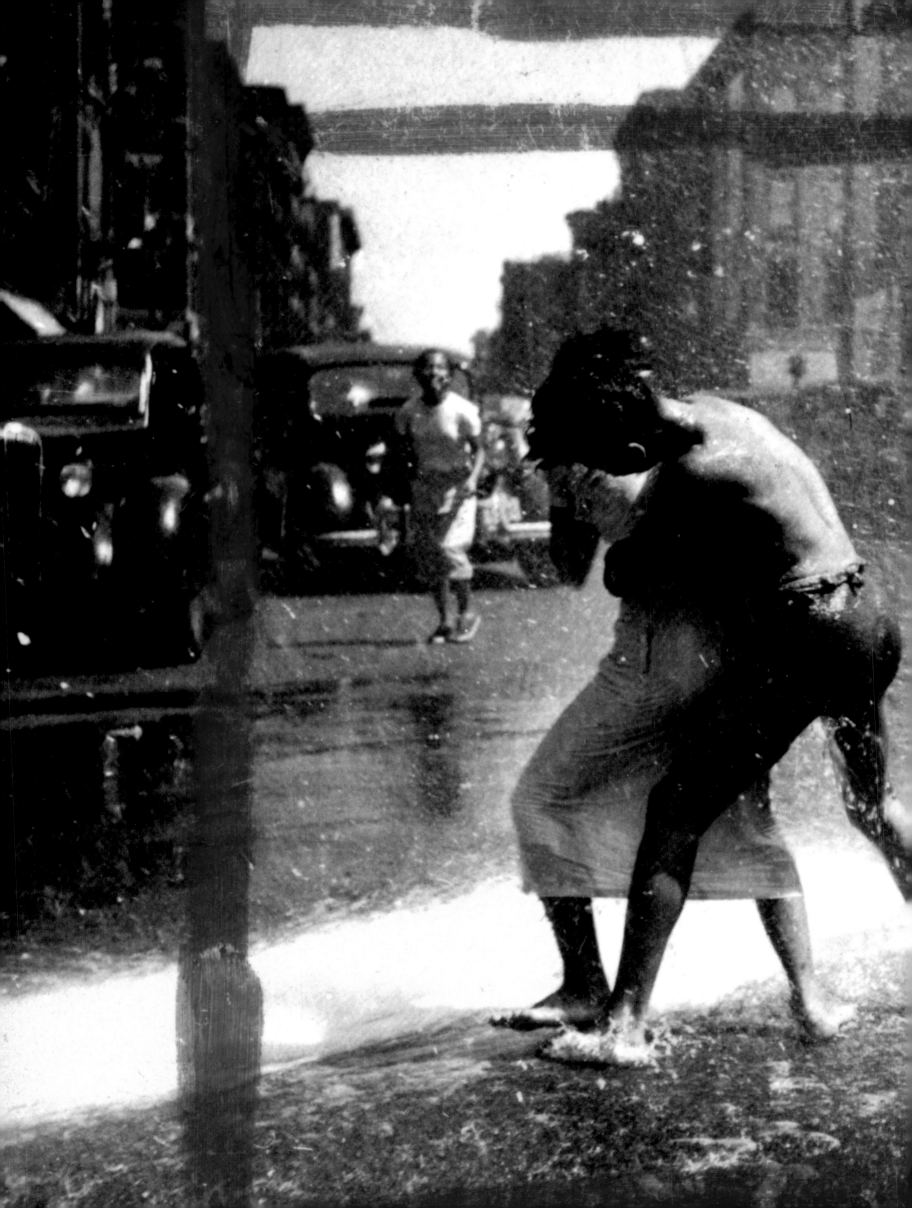

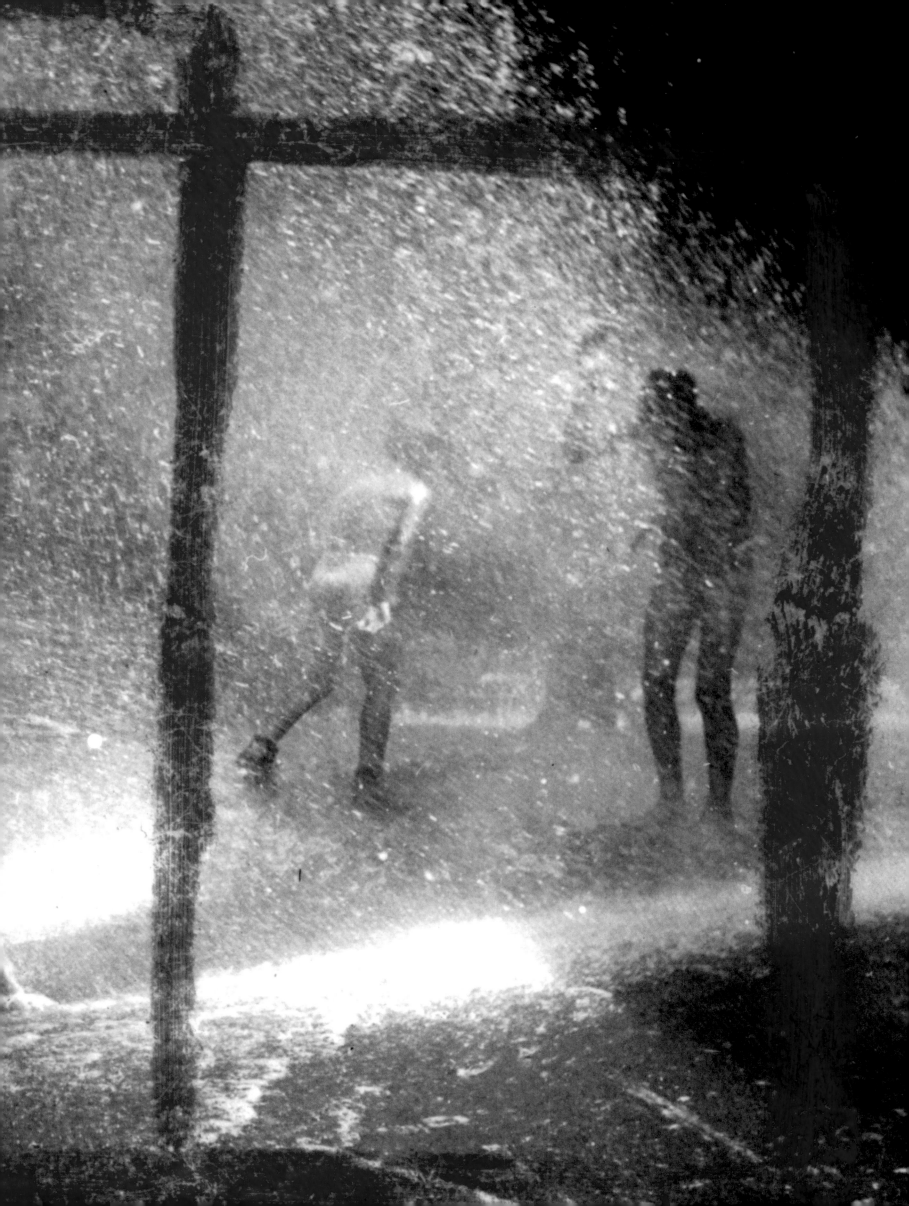

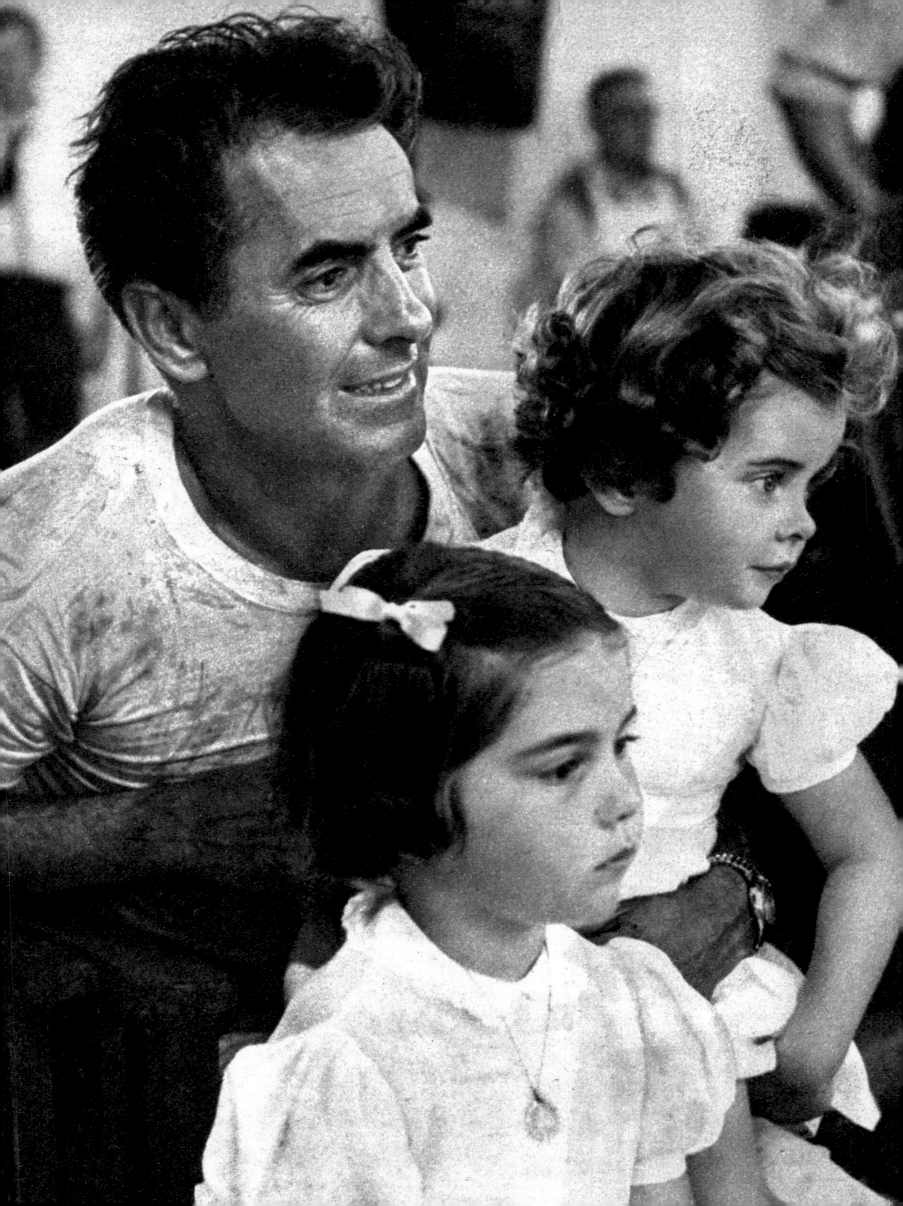

Fuchs? This is Panair do Brasil in Zurich," a very pleasant female voice said to me in English. "If you find yourself at Frankfurt Airport at 11 o'clock, on the morning of the 18th of January, the Panair people there will see to it that you can board an aircraft bound for São Paulo, and assure your return accommodations. Any questions?"

"None, thank you. I'll be there. Thank you very much." I was not particularly flush at this time but the 300 deutsche marks that Zentner finally agreed to advance me enabled me to buy a rail ticket from Munich to Frankfurt. It allowed me to get on the plane to São Paulo with the total sum of a hundred dollars to cover any and all contingencies.

The first stop on the plane after leaving Frankfurt was Paris, where a few people boarded. After that it was on to Rome, then Madrid, then Lisbon. Each time it was the same story. We'd land just long enough for a small group to get on board. Finally it dawned on me that all the people on the plane were the official festival delegates. I later realized that they were all directors, producers, and movie stars. From Lisbon, the flight took us uneventfully to Recife in northern Brazil and then to São Paulo. All in all it took 36 hours.

When we landed in São Paulo a welcoming committee representing the festival came aboard. Festival officials there handed everybody their delegate credentials. When they got to me all they asked was, "Where did you get on?" When I answered Frankfurt, they handed me official German delegation credentials. The individual members of the delegations did not necessarily know each other, so nobody asked too many questions…not even when the biggest German producer and I were assigned to share a vast palatial suite at the Hotel Jaraguá, São Paulo's most prestigious and modern hotel at the time.

The festival of February 1954 in São Paulo had the largest contingent of American stars of any film festival before or since. Forty-one major American stars attended, including such names as Errol Flynn, Robert Wagner, Barbara Rush, Jeffrey Hunter, Anthony Quinn, and Tyrone Power. The morning after my arrival I ran into Patrice Wymore. She was one of the beauties I had done a picture story on in New York before going into the Army. She was now a movie actress living in Hollywood and in the meantime had married Errol Flynn. She introduced me to Flynn and the three of us had some very pleasant times together. There were very few screenings of new films, mostly press conferences and parties. This was the opportunity for movie people of various continents to meet, to play, and to discuss possible deals, my first introduction to what would much later become my life. I had a field day shooting movie personalities which were everywhere, in the hotel, in front of the hotel, in the parks, in every restaurant and café.

Patrice had just had a baby and she and Errol spent evenings rather quietly. When Errol was not occupied by meetings or press conferences, we would all three sightsee around town, taking a lot of pictures. Towards the end of the day Errol had a habit of inviting everybody in sight to join him at dinner—always at a well-known restaurant. There he would hold court from the head of the table, being particularly careful to disappear just before the arrival of the check. It never created a problem, as I think Errol saw to it that there was always some rich member of the party glad to reach for the bill. I took a lot of pictures of Errol but I never really got to know him. He did pay a lot of attention to young girls, especially when Patrice was not around. I don't think he let anyone get close to him. At the end of the festival the official delegates, me included, were cordially invited by the festival committee to spend the next two weeks on the Copacabana beach to enjoy Carnival in Rio de Janeiro. I would search the whole town for more and more film as my camera was exposing roll after roll.

Returning to Munich after the festival and Rio de Janeiro felt a bit dull for a while. The *Munchner Illustrierte Presse* published seven pages about the festival, which allowed me to get just a little bit ahead in my finances. I went back to trying to find material to feed to the agency in New York. Then one day I met a production manager with Republic Pictures, Lee Lukather. He was preparing a Hollywood movie that was going to shoot in Munich.

Previous Spread: Harlem boys enjoying public refreshment in the summer heat, courtesy of the city. Opposite: Tyrone Power and children in Spain during the filming of *Solomon and Sheba* before his death at age 44, in 1958.

FIRST REAL EXPERIENCE

Alan Badel, Rita Gam, Yvonne De Carlo, and Valentina Cortese were being directed by William Dieterle. Part of Lee Lukather's job was putting together the crew to make *Magic Fire*. I was able to convince this veteran of productions in Hollywood studios and on location that I could do an acceptable job as the still photographer on the picture.

Convincing him was helped by the fact that I came cheap. He wouldn't have to bring anyone over from America. This was my first real experience on a movie. Fearing that I had bitten off more than I could chew, I called on my brother Manny, also a photographer, who was traveling through Europe, to come and back me up. He promptly arrived in Munich more than ready to lend a hand.

The three female stars, Yvonne De Carlo, Valentina Cortese, and Rita Gam had been dubbed the Female Ring of *Magic Fire* by the studio. Rita was always available, and never refused any suggestion of a time and place to make some "off the set" shots. Yvonne, a seasoned veteran of numerous swashbuckling pictures, never hesitated to redo a whole scene just for me so that I could get the best scene stills. Valentina, "la Belle Italienne," would always come up with ideas for interesting pictures.

One evening Valentina and I decided to meet for dinner. When I went to the Four Seasons Hotel to pick her up, in the lobby, I ran into Yvonne De Carlo who greeted me with a smile and a friendly, "Hello, I'm so glad I ran into you…want to have dinner?" I stammered for a moment, thinking of Valentina waiting for me upstairs (Valentina was married at this stage and our rendezvous was totally banal). I ran to the telephone and called my brother Manny saying, "Hey, you want to come to dinner with Yvonne De Carlo?" Here I was, scrounging around to find someone available to escort one of the most beautiful and sought-after ladies in the world to dinner. The irony didn't strike me until I realized all eyes were upon the four of us as we walked into the dining room. I realized how thoroughly I enjoyed the experience of working in film and on a movie set. Unfortunately Munich was not New York. Finding magazine material was not easy.

Soon it was going to be 1955, and it was time to move on. By that time Rome had earned the name "Hollywood on the Tiber" because of the many American movies being shot there. The city was full of American actors, technicians, directors, and certainly producers, using Rome and Cinecittà as a hub. Upon moving to the Eternal City, it was back to searching for new material to feed Graphic House. They insisted that there was good cheesecake to be found among the up-and-coming beauties in the Italian movies just becoming known in the United States. One of the more outstanding of these beauties was Rosanna Schiaffino who later played opposite Vince Edwards in Carl Foreman's *The Victors*.

A local agent introduced me to Rosanna and I immediately took her out of Rome to Ostia Antica, a town 19 miles away on the coast. These ancient ruins predated Rome itself and had remained untouched for more than 2000 years. This was one of my favorite settings. I used it often over the years and considered it an ideal outdoor studio. Rosanna and I got along famously. We had a lot of fun together. Most of the time I found someone to come along and interpret directions for the poses I wanted into Italian. This situation did not last long. Soon I was able to defend myself in Italian and I realized that learning languages on the run came easily.

A few weeks later I received a call from Lee Lukather, the production manager from Hollywood who had hired me as stills man on *Magic Fire* in Munich, and with whom I had stayed in contact. I was soon sitting in a hotel in Lisbon preparing to repeat my efforts on a Republic Pictures Film titled *Lisbon* starring Ray Milland, Maureen O'Hara, Claude Rains, and Francis Lederer.

Ray Milland doubled as director on this forgettable tale of espionage and kidnapping. Although a major international star, there was never anything pretentious about him. He

Rosanna Schiaffino, off the set and relaxing on the Italian coast during the filming of *The Victors,* in 1963.

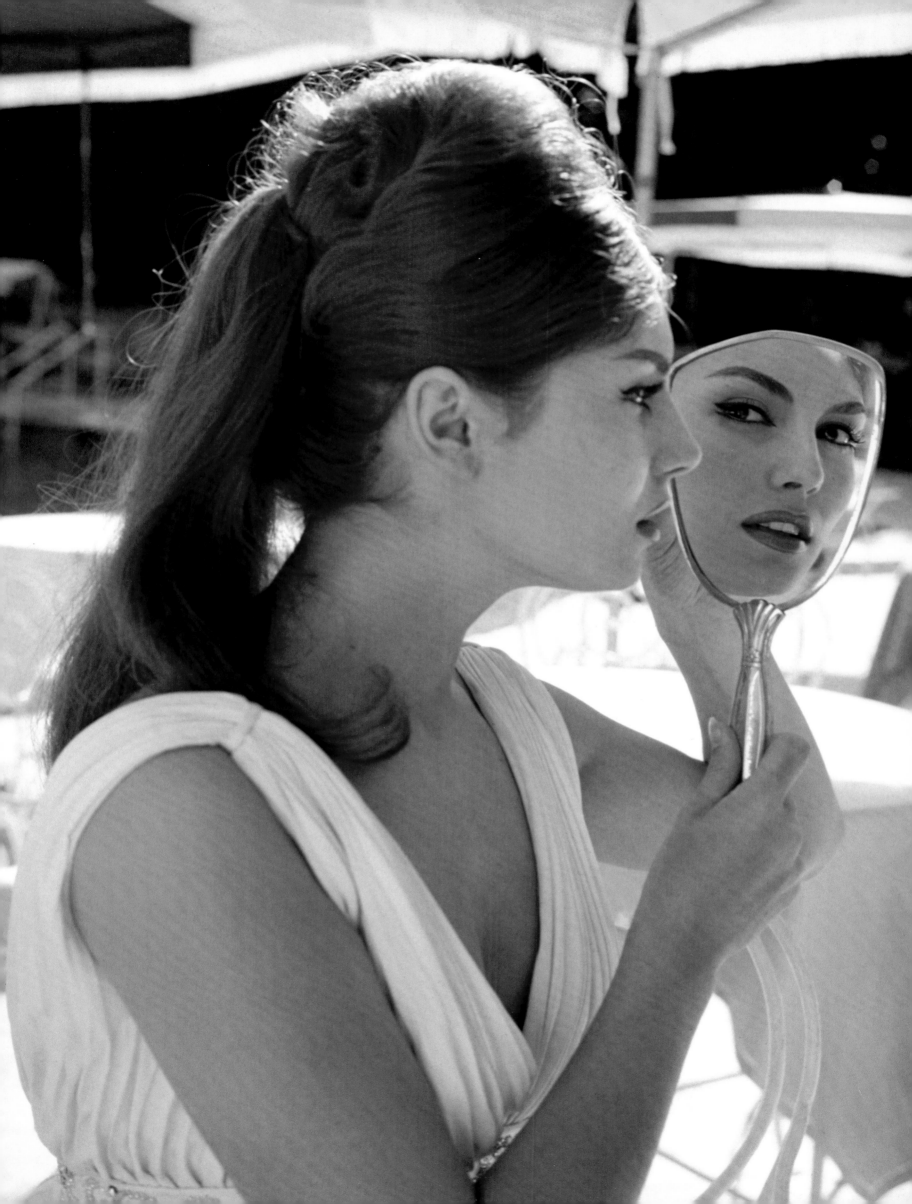

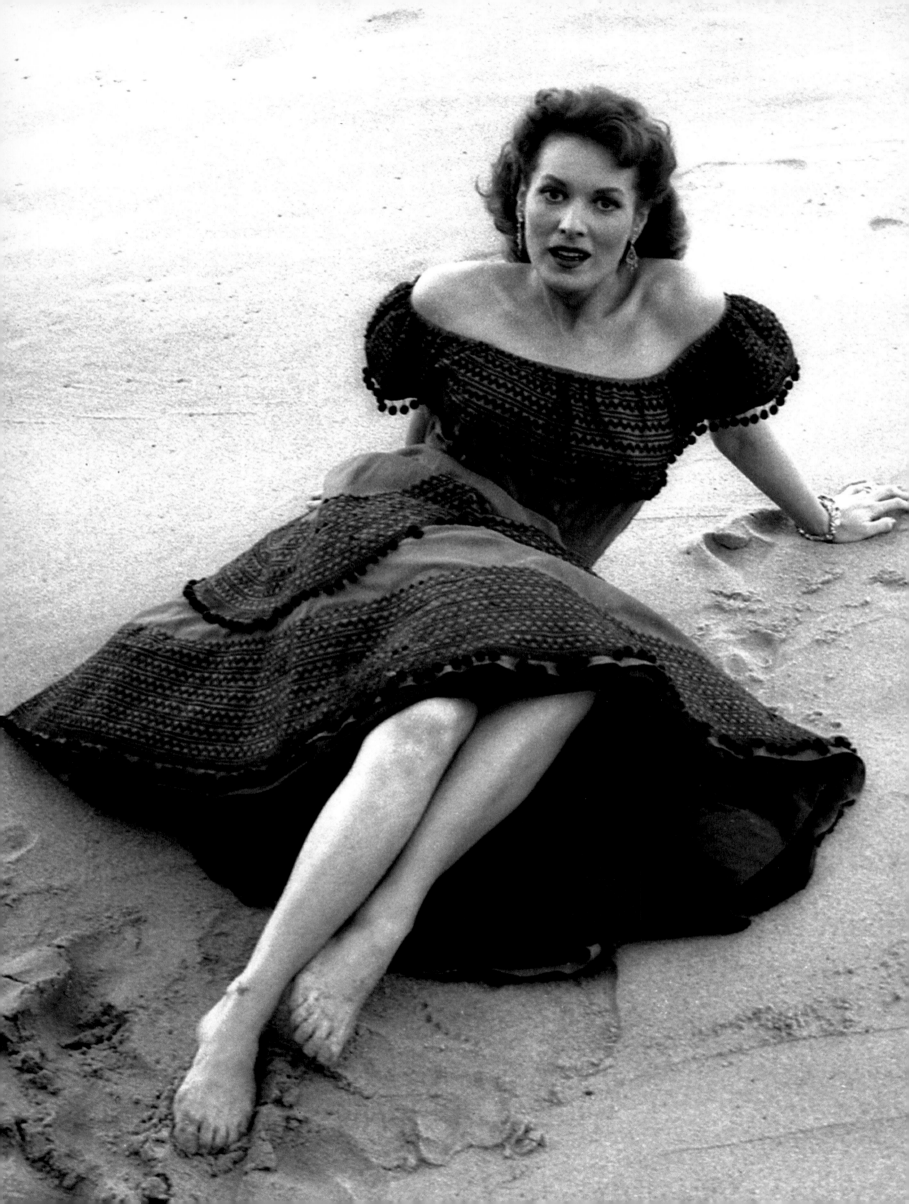

treated me as though we had been working together for years. Milland and Maureen, who were particularly friendly, helped to make life easier. The crew that came to Lisbon was made up of technicians from Republic Studios and was settling in. Maureen was so beautiful it took my breath away. Her natural humanity created a halo of kindness around her. Working with her, one felt the comfort and serenity you feel walking into a church.

It was on the set of this film that I was approached by a young man whom I had not seen before. He started a conversation in English, a language he spoke well, that revealed him to be a serious and intelligent youth of about 16. Polite and somewhat timid, he nonetheless was persistent in asking me about photography. There seemed to be no area in that field that he was not curious about. We discussed cameras, lighting, and exposure and while my knowledge was more instinctual than academic, it was interesting for me to organize what I had learned from experience for someone else.

He wanted to know why I had two Rolleiflexes around my neck. I explained that one was for black and white, the other for color. He asked about the large Speed Graphic I still used on rare occasions and I explained that Lee Lukather suggested that the studio preferred the larger size negative. The young man and I continued talking photography for the rest of the afternoon of his visit. He showed more interest in photography than the filming that was going on before us. By the end of his visit we had become fast friends.

It was not until the next day that I learned he was no ordinary visitor to the set. He was Juan Carlos, heir to the throne of Spain, in Lisbon on vacation. His exiled parents were then making their home at nearby Estoril. Today that young man is, of course, the reigning King of Spain.

A few days later the Spanish consul in Lisbon came to the set. He invited Ray Milland, Maureen O'Hara, and me to dine with Don Juan de Bourbon and his family. I had been asked to join this royal party at the express wishes of the young prince.

The royals had commanded a whole local nightclub be made available for the evening. The dinner was superb. I was seated next to Dōna María. She could not have been more gracious and made small talk with me throughout the meal. By the time we had finished the wine I leaned over to Maureen to remind her of our photo session early the following morning. It was getting quite late as we were on Madrid time. In Madrid dinner rarely begins before 10 o'clock in the evening.

She had agreed to spend the day with me to shoot pictures to take advantage of the city's attractive scenery. But Maureen was enjoying herself. Customarily Maureen was adamant about going to bed early and getting a full measure of her beauty sleep. But on this evening her beauty sleep was bound to be corrupted by the occasion. The doors opened and revealed a group of musicians and flamenco dancers. Evidently we were to be treated to a *juerga* the traditional flamenco party that often lasts until the early hours of the morning. We sat in a semi circle to watch the spectacle. The royal couple, Juan Carlos' sister, three ladies in waiting, their husbands, and our stars watching the gypsies sing, prance, and stomp with ever-increasing excitement and abandon. The exciting music and the staccato beat of the dancers were infectious and great fun.

I vainly tried again to remind Maureen of our photo session set for the early morning. She well knew that she needed to be fresh and clear-eyed, but all she could do was shrug helplessly. After the first few dances I had an impossible time trying to keep my eyes open. After a day on the set I was so drowsy, my eyes kept closing. I kept shaking my head just to keep them open. Finally they just closed. When I realized what had happened, I raised my head and snapped them open.

As I did I found myself looking directly at Dōna María sitting opposite me; she was looking straight at me. She smiled, more to herself than to me, I think, and quickly rose from her chair signifying to all that the party was over. It was time to go. I will always be grateful for her understanding gesture. That was, perhaps, my first understanding of the old phrase, "noblesse oblige."

Maureen O'Hara, a regular subject of Fuchs', in Lisbon, Portugal, in 1955 while on the set of the film *Lisbon*.

OUT WITH A EUROPEAN

Back in Rome, while I was still hunting for material for Graphic House in New York, I managed to get onto the sets of a few of the movies in production such as *War and Peace* with Audrey Hepburn and Henry Fonda, and Fellini's *Il Bidone* with Giulietta Masina and Broderick Crawford. As was often the case, Masina did her dialogue in Italian while Crawford did his in English. *Il Bidone* was an Italian production and all Italian pictures were, and are still, entirely dubbed. The sound recorded during shooting is only used as a guide for the recording of the dialogue that would ultimately be used with the image. Not speaking a word of Italian, my communications with Fellini at this stage were minimal. He allowed me to do my work and it gave me a pretty free position from which to observe his artfully chaotic process. It reminded me of painting, the mind projecting out the elements which make the whole picture.

War and Peace was a giant, much more professional production and given my flimsy credentials as a freelance journalist, my freedom on the set was more limited. I did manage to convince Henry Fonda, a most courteous man, to let me take him around the city of Rome, taking pictures of him enjoying the sights, from La Bocca de la Verità to Michelangelo's Moses. Fonda was a quiet man but never failed to make an appreciative remark whenever one of the numerous pretty Italian girls in their summer dresses crossed our path, always in good taste. Certainly well know, his fame did not make walking down the street an impossible feat.

It was a hot day. We spent all day walking or riding on trolley-cars, buses, and horse-drawn cabs, until I felt I had enough material to call the series of photographs "Henry Fonda Visits Rome." In what felt like déjà vu, I was forced the next day to go to Cinecittà, find Mr. Fonda, and explain to him that all our efforts of the previous day had been wasted. Once again my camera had malfunctioned and all the pictures were blank. I was miserable but he took it very nicely. His only comment was, "Well, don't worry. We'll do it again sometime." This time it was not to be.

Having exhausted the photo opportunities with the greater part of Rome's beautiful young actresses and hopefuls, I sensed it was time to move on. So on to Paris it was. Paris was not lucky for me this time around. Not only did I go broke playing chemin de fer at a Champs-Elysées club, I walked out onto the avenue at three in the morning only to find my Chevrolet convertible, vintage 1950, my prize possession, my means of transportation, my freedom that allowed me to go wherever, whenever I wanted, was gone. I was devastated. I had Roy Lester at Graphic House send me enough money for a third-class ticket on the *Ile de France* ship and I sailed back to New York.

I came back to the city broke. Justin Gilbert, a movie critic at the *Daily Mirror*, and his charming Italian wife Francesca really took me in like a stray cat. One morning, Justin informed me of a call he had received from Columbia Pictures asking if he would be interested in handling the publicity for a film that Dino de Laurentiis was producing for them in Bangkok. It was a four month job and he could choose anyone he wanted to go along with him to do the publicity photography, not quite yet a special photographer, just a sort of combination publicity/special photographer. This meant, shoot what we need and then, if you have time, you can shoot for yourself and sell what you can. I immediately accepted. Unfortunately the paper refused to give Justin the time off, so he had to remain in New York. Nevertheless, a couple of weeks later I was on a plane to L.A. for briefing from the studio publicity department. Justin's replacement turned out to be an old publicity warhorse left over from another era with whom working was anything but pleasant. We, that is, the relic, his wife, and I left for Bangkok, via Hawaii, Wake Island, and Tokyo, then Hong Kong where we changed aircraft before continuing on to Bangkok. If it had been up to Justin's replacement I would still be using cameras that used glass plates like in the days of Daguerre.

He was an impossible man to get along with, and through the Thailand shooting we saw very little of each other. I was too busy with Silvana Mangano, the Italian actress who was

Young girl, Thailand. An extra on the set of *This Angry Age*, 1957, a film by Réne Clément about siblings.

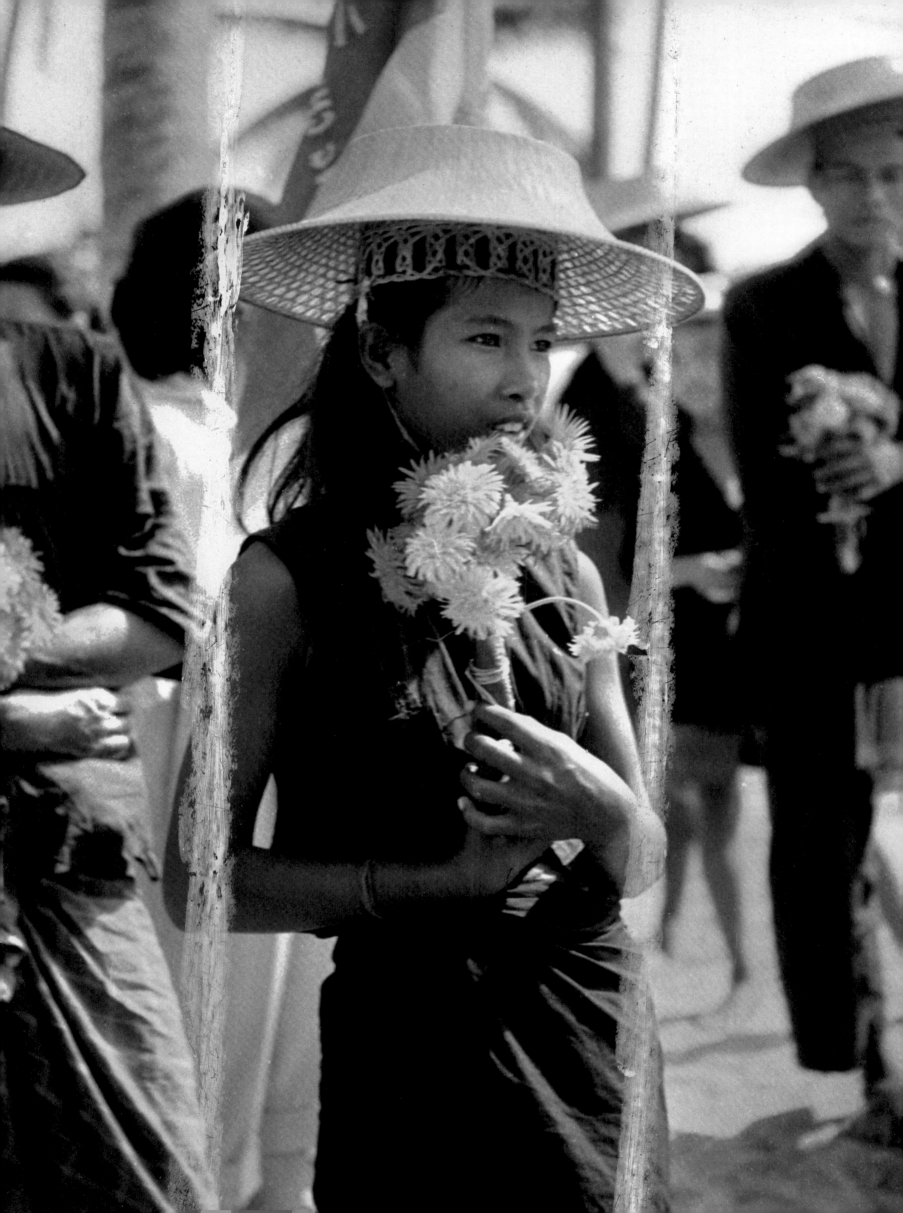

married to Dino de Laurentiis our producer. The movie was directed by Réne Clément and was based on a Marguerite Duras novel. Clément was known for having directed *Jeux Interdits*, a very successful French film a few years earlier. Belle, Clément's wife was always on the set sitting off to the side. Invariably, after every take he would look over to her for approval. Not until she gave him the nod did he turn to his script supervisor and say, "Print."

It was a strange movie, a French director directing in English, an Italian leading lady who spoke broken, very broken English, two male actors who couldn't be more American, Richard Conte and Tony Perkins — not to mention Jo Van Fleet, the consummate actor's studio graduate. There were instances that would have taxed the translation department at the United Nations. This linguistic bouillabaisse occurred on one occasion that perhaps best describes the atmosphere that surrounded the shooting: A Chinese actor was engaged to play an important role but only spoke Mandarin Chinese. To allow the director to instruct him, four interpreters had to be summoned. One to translate French into English, English to Italian, from Italian to Cantonese Chinese and that into Mandarin Chinese for the Chinese actor.

Another episode occurred later, when the production had come back to Italy. It was during a rehearsal for a scene in which Jo Van Fleet, who played Silvana Mangano's mother, was to haul off and slap Mangano flush on the cheek. A method trained actress, Van Fleet let fly with the violent smack that the scene called for. Rumor had it that Mangano did not want to make this film. In fact she wanted to retire from movies and devote herself to her marriage and had only consented to make this film for her husband because her marquee name was needed to raise the production cost from the studio. Now as they were rehearsing this scene Dino quietly walked on to the set just as Jo Van Fleet hauled off, and in true Stanislavsky fashion, planted one on Silvana Mangano. Dino took one quick look, realizing his wife would hold him personally responsible for this, and he turned sharply around on his heels and scurried off to the nearest exit.

I was really much too naïve to even guess. Actually Mangano was always quite gracious although she did have a tendency to be sullen. In those days in polite Italian society indifference was considered chic. She would sit for hours on the beach at the waterline looking wistfully off into the horizon not saying a word unless it was absolutely necessary, Such as "I'm cold" and one of her coterie of makeup, wardrobe, and dialogue people would immediately bring something to wrap around her shoulders. In Bangkok we moved into the very fashionable and modern hotel Erawan which had a fashionable European style restaurant. The hostess was a lovely young Thai lady, the daughter of a prominent Thai family. Educated in Switzerland, she long spoke impeccable English and French. She worked only to keep busy and to get a chance to meet European and American visitors to her country. I was anything but immune to her charm and did not wait very long before inviting her to show me around the town.

She graciously accepted and one evening we went into town for a dinner featuring delicious local fare, then went dancing to Western music in a large night club. At the end of the evening we took a taxi back to the hotel where her chauffeur was waiting to take her home. Before arriving, she turned to me and in a soft voice said "Would you please ask the driver to drop us off two blocks before we arrive at the front door of the hotel?" In answer to my quizzical look, she added, "I wouldn't like for my father's chauffeur to see us together and then tell my father that I had been out with a European. It's not that he is prejudiced, it's just that he wouldn't like it."

Our shooting schedule called for a move to a coastal village 200 miles outside of the capital. I rented a car and then, quickly getting used to driving on the left side of the road, made my way up the coast. It was easy to drive around quasi-aimlessly as the Thai are the gentlest of people, always ready to help. The countryside, as much as the urban areas, were a feast for the eyes.

Soon it was time to go to Rome to shoot the interiors. It wasn't until a few weeks after we moved to Cinecittà in Rome to finish the movie that things came to a head between the publicity man and myself. I could no longer ignore him as I was able to do in Thailand. Reluctantly, but firmly, I decided to quit the film two weeks before the shooting finished.

Close-up of Anthony Perkins, in 1957 during the filming in Thailand of the film *This Angry Age*.

THE GENERAL LAUGHTER

In the spring of 1957 I moved from Rome to Paris at the suggestion of Jerry Juroe, publicity director on a film shooting at Boulogne Studios starring Bob Hope, Fernandel, and Anita Ekberg called *Paris Holiday*. It was at the canteen of this famed studio that Jerry introduced me to Miss Ekberg's stand-in, a young French actress named Sylviane Contis. Sylviane and I went to a movie and dinner in Montparnasse. We saw a Vittorio de Sica masterpiece called *Umberto D*.

As soon as I had finished with *Paris Holiday* I was offered a prolonged period of work on *The Young Lions*, a major Twentieth Century Fox movie. Considering that Marlon Brando and Montgomery Clift had no scenes together but one, the whole shoot was scheduled to alternate between the two stars, one day Marlon, the next Monty, almost day for day. While in Berlin the press was very anxious to interview Marlon. They set up a press conference in one of the big rooms at the Kempinski Hotel. During the conference one of the journalists asked Marlon why he had dyed his hair blond; Marlon wore a blond-dyed crew cut in his portrayal of a German soldier. In answer to the question Marlon looked around and started to say, "Well, you see, I am playing a German soldier…" he got no further because as he looked around he saw that not one of the 40 to 50 German journalists in the room had blond hair. Realizing his faux pas he joined the general laughter that went around the room.

This movie was my first encounter with Marlon Brando, who was not easy to get to know, as he carefully chose the people he got friendly with. The first time I approached him during a break in the shooting was to show him some blow-ups of pictures I had taken of him. One of his minions immediately came to admonish me, "How dare you approach Mr. Brando without first asking permission?"

Consequently I spent most of my time photographing his co-star, Montgomery Clift. Monty Clift was a fascinating human being. He was interested in everything. He had a way of convincing you that whatever you were saying to him was very important to him. Without trying, he made you feel as if you were someone that really existed for him. Unfortunately he drank too much. It was as if the burden of living was just a bit too much to bear. We "sympathized" as they say in France, right from the beginning.

He played a Jewish soldier in the movie and he would frequently ask me for behavioral tips that might help him understand his character better. As for Marlon Brando, it wasn't until a few years later while working as special photographer on *The Ugly American* and *Bedtime Story*, both at Universal Studios, that Marlon became easily approachable and eventually a friend.

One of the highlights of working on *The Young Lions* was the opportunity to observe up close two definitely different approaches to acting. Monty was a total "feeler," sensitive to everyone and everything. Marlon, on the other hand, had, what seemed to me a more intellectual approach to his work. Where Monty seemed to be instinctively guided by what was happening to his character on an emotional level, Marlon seemed to deal with events from an external, methodical approach.

There is a scene in *The Young Lions* when the U.S. troops, Monty Clift in the lead, open the doors to an infamous concentration camp. As he enters, he is confronted with that horrifying sight of emaciated men with haunting eyes, barely alive, which shocks the soul. After the shot of him entering came the reverse shot, from the point of view of the prisoners, featuring Monty's reaction to the horrible sight that confronted him. On this shot, I did the absolute unforgivable thing, I stood with my camera exactly at the spot that Monty was looking at. In cinema jargon that's called the eye line.

As Monty came through the door, looking at what for the audience would be faces of the prisoners, actually he was looking right at me. Monty must have had the picture of what he was supposed to be looking at firmly in his mind; my presence did not seem to phase him. As soon as Edward Dmytryk, the director, hollered, "Cut," Monty shot me an intense

Montgomery Clift portrays a sensitive and intense Jewish soldier in the film *The Young Lions*, Germany, 1957.

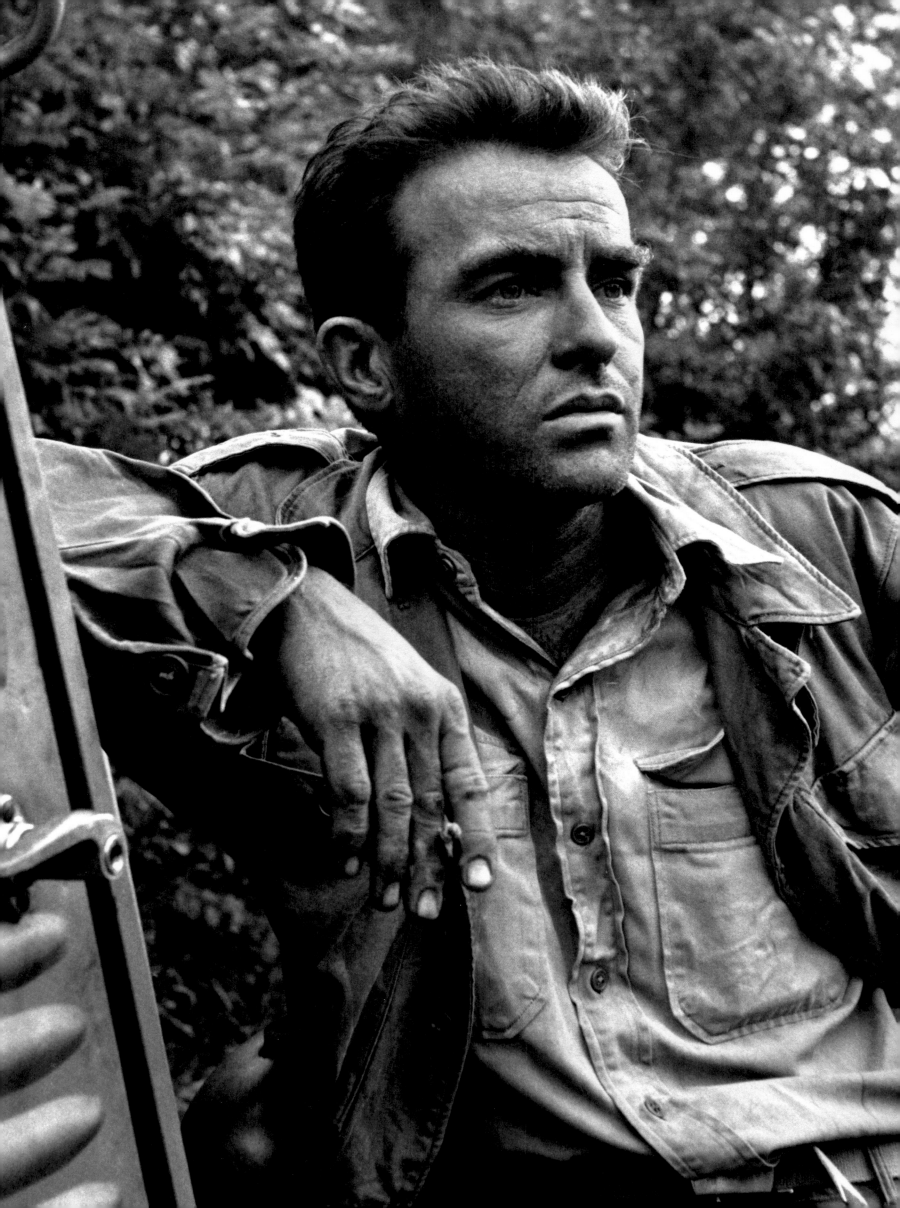

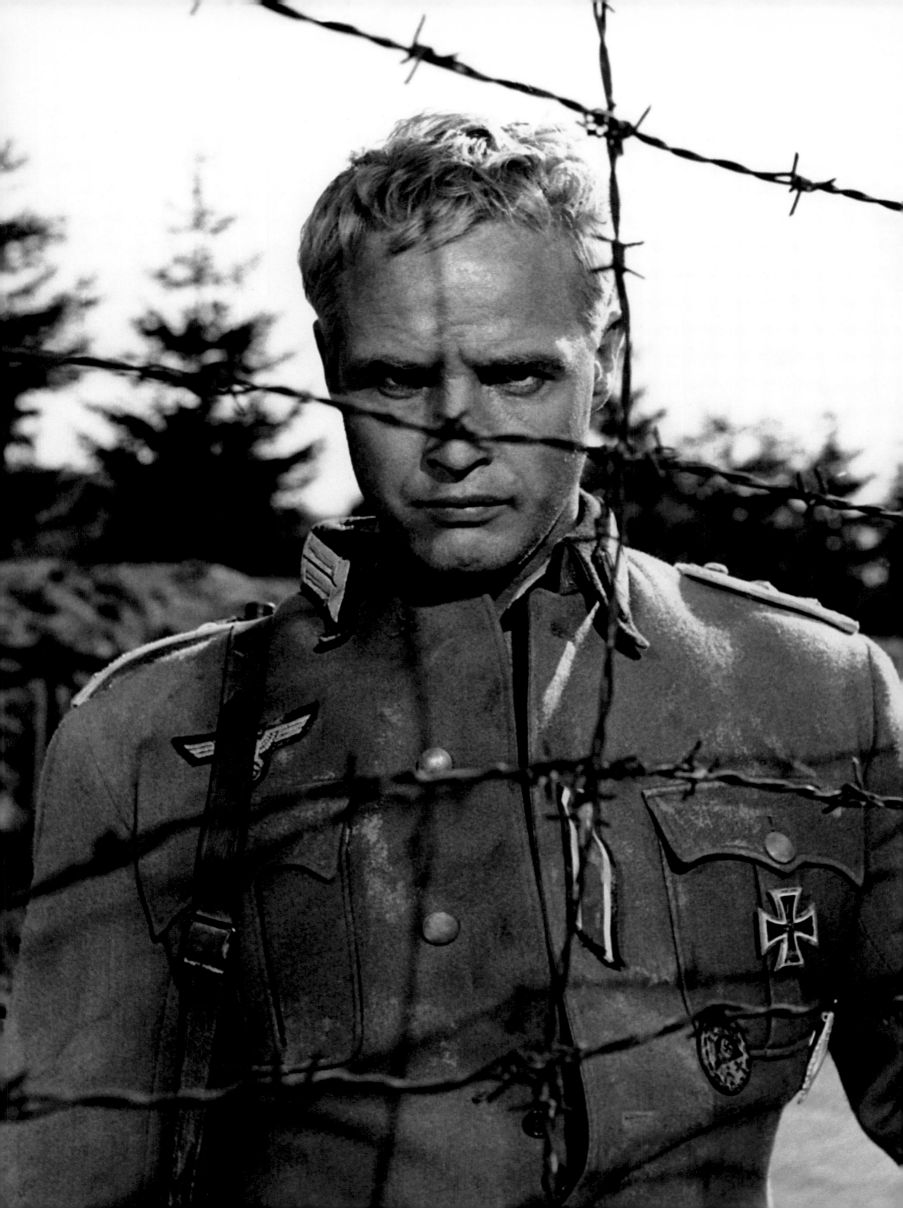

look, but did not scold me. I was certainly glad we had established a rapport by that time, otherwise I would have been drawn and quartered by everyone concerned. But that was where the camera needed to be and what it needed to see. Dmytryk, a warm and erudite gentleman made the only comment: "You're lucky. If it had been me, I'd have wrung your neck right there, I couldn't even put my camera there!" Monty's reaction on that take had been so strong no one thought he could have repeated it.

The Young Lions company moved back to California leaving me behind. Union rules forbade my working in that labor-protected state. Back in Paris, Fox suggested I join a picture called *Fräulein* which was shooting in Germany. Before leaving for Germany I visited the set of *The Hunchback of Notre Dame*, which was shooting at the Boulogne-Billancourt Studios. Gina Lollobrigida, costumed as Esmeralda, was any photographer's delight. I knew that pictures of her would make the salesman at Globe Photos happy, especially those with clients who appreciated sexier images.

Gina is an artist in her own right; she had spent her early years studying and practicing painting and sculpture. She understood the use of lighting and angles and as a result was a magnificent subject. She would often also take pictures herself during our shoots, meandering with one of my cameras. This was the very beginning of a friendship that was to last many years.

Fräulein was my first real stint as a special photographer. The production already had a still man. I was to send all the pictures I shot back to my agency. I was now working with Globe Photos. After having their staff decimated by the war, they had worked their way back to being one of the major picture agencies in the world. Mel Ferrer and I hit it off right away. We were travelling aboard a Rhine riverboat, recounting old jokes on our way to Berlin, shooting scenes for the film as we went along. We enjoyed visiting the small towns at which the boat stopped.

Most of my time was spent both photographing and socializing with a very British lady, his co-star, the beautiful Dana Wynter. One day our conversation centered on languages and word usage. Before I knew it Dana handed me a present, a kind touch from a charming lady. Her gift was a book titled *The Loom of Language* which is a scholarly study of the intertwining of words and expressions, their peregrination and deformation in cultures around the world. I was pleased, as words and their sources have always been a passion of mine. The film wound up shooting in Berlin.

The social barriers on a set were usually impregnable, a reflection of the power structure of the business. Never having worked in Hollywood I paid no attention to such things. Normally the still man is low man on the totem pole, just below the publicity man who is universally considered a nuisance. Besides, as special photographer I assumed the role of an outsider to which such rules just didn't apply. I think it was during these two weeks that I learned that creating a special relationship with movie stars was an absolute necessity to persuade them to spend time and energy in helping you to successfully fulfill your task—creating photos that are truly unique and explore the intimacy of the subject.

I tried to understand the qualities and failings of each of the actors with whom I worked, making sure to avoid taking exaggerated advantage of the possibilities to invade their privacy; to understand the moods and idiosyncrasies that are part of the makeup of extraordinary talents. I think in appreciation of all this, many of the stars were willing to go out of their way to help me accomplish what I wanted with them.

The pictures themselves were changing in intensity, increasingly reflecting the power of the subject, matched with a momentary unfiltered glimpse into their humanity trust had afforded me. The images allowed the viewer to connect emotionally to these icons.

To do this kind of photography one obviously needed the voluntary cooperation of the actors, who needed to contribute their time, concentration, and of course talent. This is just as true of candid photographs taken when the subject was not paying attention, catching an expression or gesture helpful in revealing the inner person.

Marlon Brando plays a blond German army officer with doubts in the film *The Young Lions*, Germany, 1957.

TO MY SURPRISE

The *Fräulein* shoot wrapped to go back to Hollywood. I stayed a few extra days in Berlin at the request of Henry Koster, *Fräulein*'s director, before making my way back to Paris. To my surprise, he requested I shoot some motion picture film of random scenes of Berlin, which he thought he might need to intersperse into his film. He left a movie camera and operator behind to handle the technical end. It was nothing complicated, but it was flattering. Before leaving Berlin, the U.A. publicity department in London were calling, requesting I spend a few weeks with Frank Sinatra and the company of *Kings Go Forth*. The movie had just started its location photography in Paris and was preparing for a change of location to the South of France.

I quickly made my way back to France and caught up with the *Kings* company at Ville-franche-sur-Mer, a fishing village, on the Côte d'Azur. I should mention here that, at this point in time, the feud between Frank Sinatra and the press, especially photographers, was at its height. I was told he refused to allow any photographers to come on the set when he was working. Frank Ross, the producer of *Kings*, a nice guy, took me over to Frank on my first day, and just simply introduced me as part of the company. Frank shook my hand cordially and didn't really say much.

That very same day the scene they were shooting called for Frank to be running as fast as he could down a sloping street leading to the Mediterranean then along the port, to an alley, then up the alley. It was a particularly warm day and the sun was shining down mercilessly. Delmer Daves, the director, called, "Action," and Frank came tear-assing down that street at full speed, made his turn, and disappeared up the alley. No sooner had the director shouted, "Cut," then the camera operator jumped off the dolly with a very dissatisfied expression on his face. He immediately went up to the director and apologetically started gesticulating and explaining that he lost Frank on the turn into the alley. Delmer went to inform Frank of the mishap and advise him they had to go again. To begin with, Frank had an aversion to going more than one take and when he heard the reason for the need to repeat the run, he simply said to Delmer, "Get rid of him, I want to work only with professionals, missing that shot is unforgivable." The next day we had another camera operator. I heard the next day that Frank made sure the first operator was paid his contract in full before leaving. In France, crew members are hired on "run of the picture" or "run of the location" contracts in comparison to the U.S. where people are hired week to week.

Over the next few days, I took whatever pictures I liked without getting in the way or being too present. It is always good for a photographer to know how to blend into the woodwork. I had come to the conclusion that discretion was definitely the better part of valor and stayed as invisible as possible; until the day I ordered blowups of some of the pictures I had made and brought them to the set to show to Frank. He looked at them carefully and as he did so he said to no one in particular, "Hey, these are damn good." He turned to Frank Ross who was standing close by and said, "Frank, get a look at these," Ross stepped over, took a look, and made the appropriate appreciative noises. From that moment I felt I belonged. That night back at the Hôtel Negresco in Nice I ran into Sinatra in the lobby and he suggested we have dinner, which we did. We spent the bulk of the evening talking, mostly about me. Frank's questions showed a sincere interest in the answers, I'll never know what in my background intrigued him, maybe growing up as a refugee in Vienna then Brooklyn, or my youthful wanderings. Anyway from that evening on we became real friendly…. One night we decided to go gambling at Monte Carlo. Gambling was a vice we had in common.

Frank was preoccupied most of the time we were together. I think his mind was still in his ending marriage to Ava Gardner and he had difficulty living with their separation. He never said anything out loud, he was, after all, very closemouthed in general, it was just a few passing remarks and reactions. More than once I caught him desperately trying to get a call through to London. No luck. Ava obviously refused to take the call. We were sitting in

Frank Sinatra as a tough army lieutenant in the film *Kings Go Forth,* shot in the south of France, 1957.

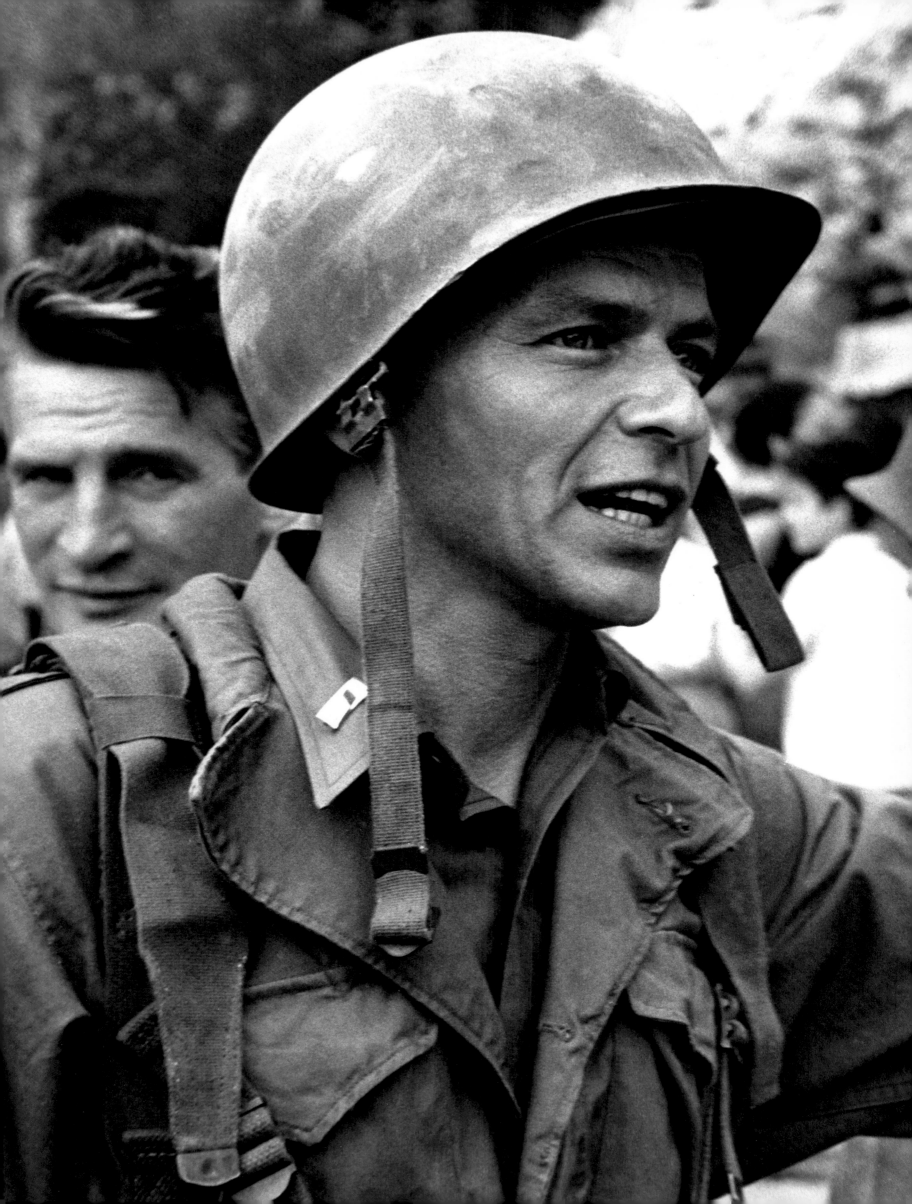

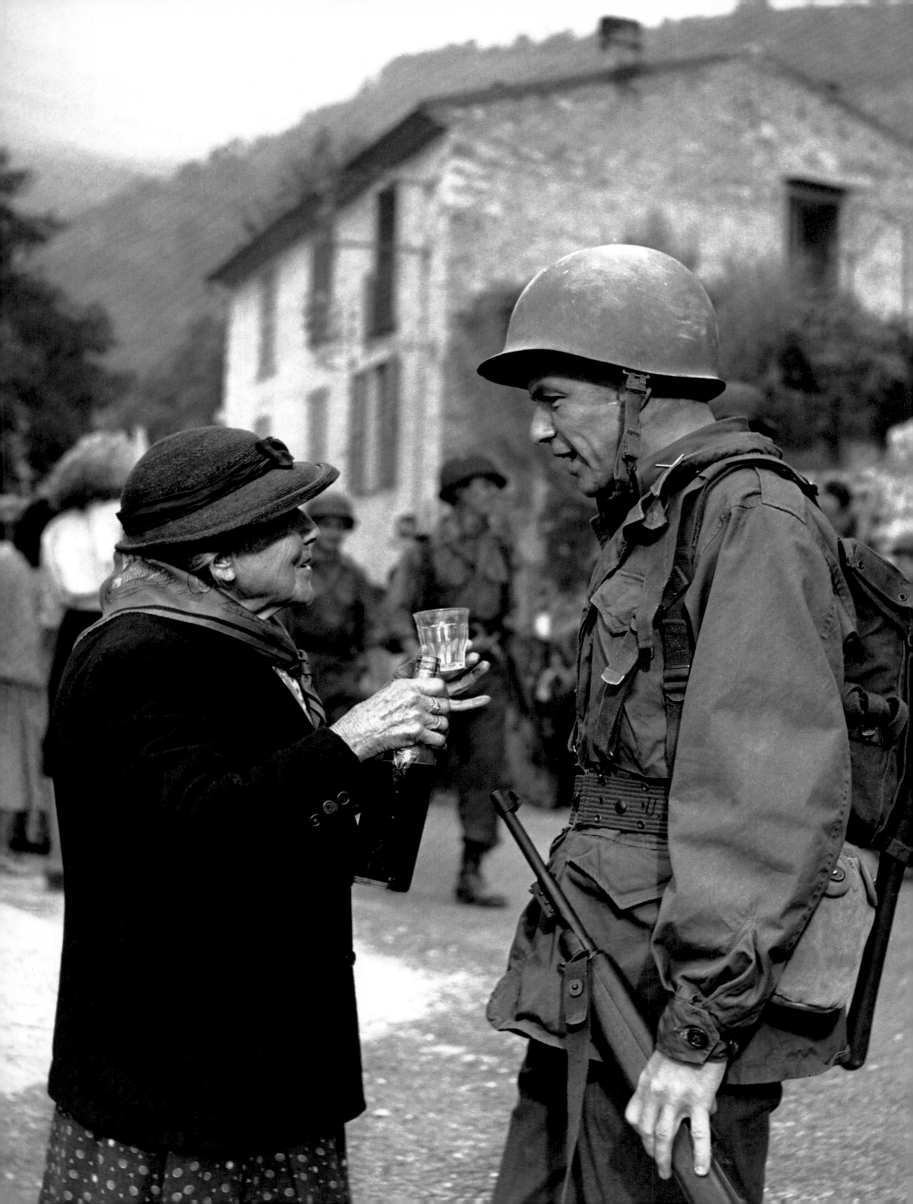

the bar of the private rooms of the casino when we saw Sir Winston Churchill entering the bar escorted by his perennial gentleman bodyguard. Sir Winston was already in his early 80s and his companion was a bit younger, but not by much. As we saw Sir Winston and friend sit down at an empty table, Frank threw a smile at the lovely young woman to his right at the bar, then turned to me on his left and said, "I'm going to do something I've wanted to do since high school, come on." He got off his stool and started toward Churchill's table with me right on his heels. As soon as he reached it he leaned across the table stuck his hand out and said, "My name is Frank Sinatra and I've always wanted to meet you."

The elderly statesman taking Frank's hand looked over at his companion and in that inimitable British voice inquired, "What did he say?" His companion quietly explained. When he had finished and after Sir Winston shook my hand he looked up at Frank smiling, and in a fuller voice said, "Oh, did you win?" Frank laughed and replied, "We did alright." They exchanged a few comments on the vicissitudes of gambling and we all drifted back to the bar. Once settled on his stool, Frank finished the drink he had left behind and without another word said to the lady on his right, while ignoring her escort, "Ready to go, princess?" Without hesitation she turned to her escort, whispered a few words to him then grabbing up her cigarettes descended her stool and proceeded to follow us to the door. I swear he had never said a single word to this woman all evening.

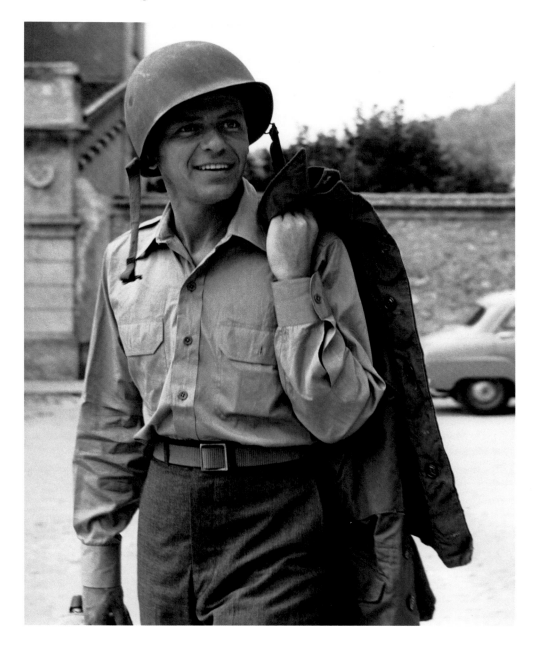

Opposite and above: Frank Sinatra on set in the south of France in 1958, on the film *Kings Go Forth.*

THANK YOU LEO

When the *Kings Go Forth* company started to make the trek back to Hollywood and the sound-stages, Frank called me to his suite and said, "Hey kid, I'm not going to take any of this stuff with me so you might as well have it." There was a record player, a bunch of records, a few other do-dads, and a bottle of Jack Daniel's, which was the only liquor Frank would drink.

After the South of France I made my way back to the American Palace in Rome, a residential apartment hotel on the Via Archimede. It housed a multitude of international personalities including Pierre La Mure, the author of *Moulin Rouge*, a charming, erudite gentleman with whom I spent many Roman dinners and discussions. I heard there was a publicity man from Warner Brothers living in the building. I called him to inquire whether he was in town on a specific project. As a matter of fact, yes he was, "We are preparing to make a picture, which will shoot over six months in Rome and in the Belgian Congo. It will be directed by Fred Zinnemann and star Audrey Hepburn and Peter Finch—the title is *The Nun's Story*." I didn't hesitate a second before asking whether we couldn't meet, "Of course," he replied. After our meeting he told me all he needed was an O.K. from the studio in Hollywood and the job was mine. Same deal: "give us what we need and sell all you can."

Going to the Congo to work with Audrey turned out to be a dream; you couldn't take a bad picture of her if you tried. I adored her for her grace and elegance in everything she did or said. She helped in every way possible to make my job easier. Stanleyville had a Sabena Guest House, which was a set of Spartan bungalows connected by a walkway that led to a restaurant building that served food flown in every day from Brussels. We had 123 consecutive meals in the same restaurant off the very same menu. I had brought with me that record player Frank Sinatra had bequeathed to me and a few records. One of them was Beethoven's Seventh Symphony which I played often when getting back from location. After dinner one evening, Audrey approached me to inquire whether the music came from my bungalow. I admitted so, at which point she asked whether she could come and listen to the Seventh as it was also one of her favorites. The next evening, after the day's shooting and evening meal, still clad in her nun costume, she came to my bungalow and put the Seventh and the Eighth Symphonies on the player for us to listen to. She sat quietly listening to the music. When it was over she rose out of the chair and offered me a simple, "Thank you Leo," then, without uttering another word made her way to her own bungalow which was only a few feet down the path.

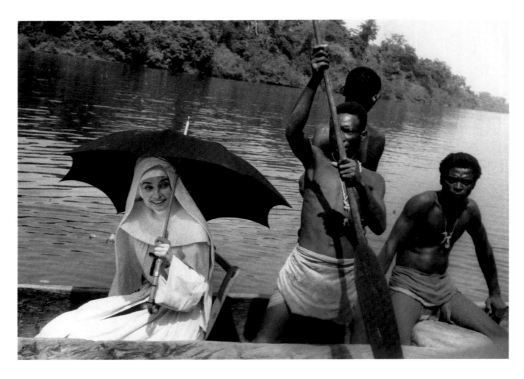

Above and opposite: Audrey Hepburn on and off the set in the Belgian Congo for *The Nun's Story*, 1958.

When she decided to visit a leper colony in the Congo she asked me to come along. No need to say it was a great photo opportunity, but besides that, while there, we met a nun who had been a nurse in the colony for 26 years. When Audrey asked the nurse if she had been back in Holland since coming here, she replied: "No, why? I haven't been sick." An interesting moment for Audrey who was playing a similar role in the film.

After returning to Rome from the Congo, we left for Belgium where the final shooting weeks were to be completed in Bruges, one of the world's most beautiful cities. Fred Zinnemann, one of the world's most talented directors, acted as if his set was to be considered something holy, and working on his film a religious experience. Even when the camera was not rolling everyone was to concentrate. No loud word or noise was allowed. He was a tense man who felt that on the set everything he did or said was not to be taken lightly.

At the end of June 1958 shooting on *The Nun's Story* finished in Ostend. I took a train down to Paris deciding to spend a few vacation days there before going back to Rome. Once in Paris I tried to find Sylviane my companion at the movie *Umberto D.*, the last time I was in town. Her telephone rang and rang, but no answer, so, feeling a little lonely in Paris on a beautiful summer day I went walking, a perfect pastime in the world's most beautiful city. My aimless wandering carried me to Saint-Germain-des-Prés, the favorite hangout for Paris' artist crowd and its cafés Les Deux Magots and Café de Flore. In between these two renowned watering holes there was, and still is, a tiny hotel called Le Montana, which had two tables out in front of the entrance. Sitting at one of these two tables, all alone, was Sylviane, whom I had been trying to reach all afternoon.

She was waiting for a friend who had promised to meet her, but was now more than half an hour late. She invited me to join her. We engaged in idle chatter while her missing friend remained missing. So off we went to dinner and once again to a movie. That night we really discovered each other and by the next day Sylviane decided to join me on the train to Rome. In Rome, we became close and spent the next two weeks enjoying the eternal city. Then reluctantly, to please her mother, who was left alone in Paris, Sylviane flew back to Paris. Soon thereafter United Artists contacted me. They were about to shoot a major international

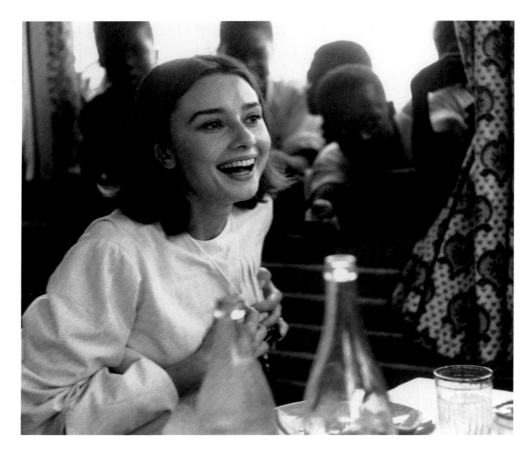

Previous spread and above: Audrey Hepburn off the set, amongst the villagers in the Belgian Congo during filming of *The Nun's Story*, 1958. Opposite: Gina Lollobrigida on set for *Solomon and Sheba* in Madrid, Spain, 1958.

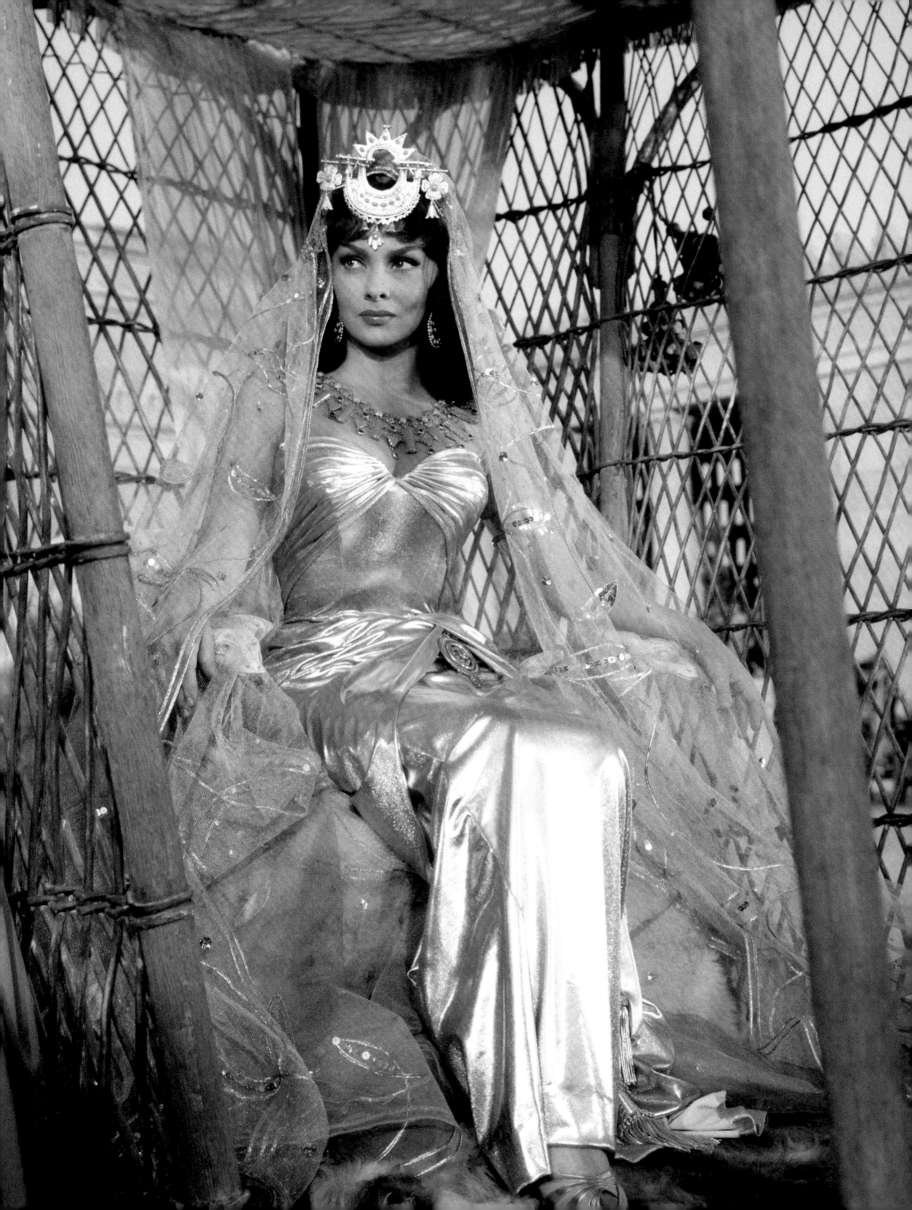

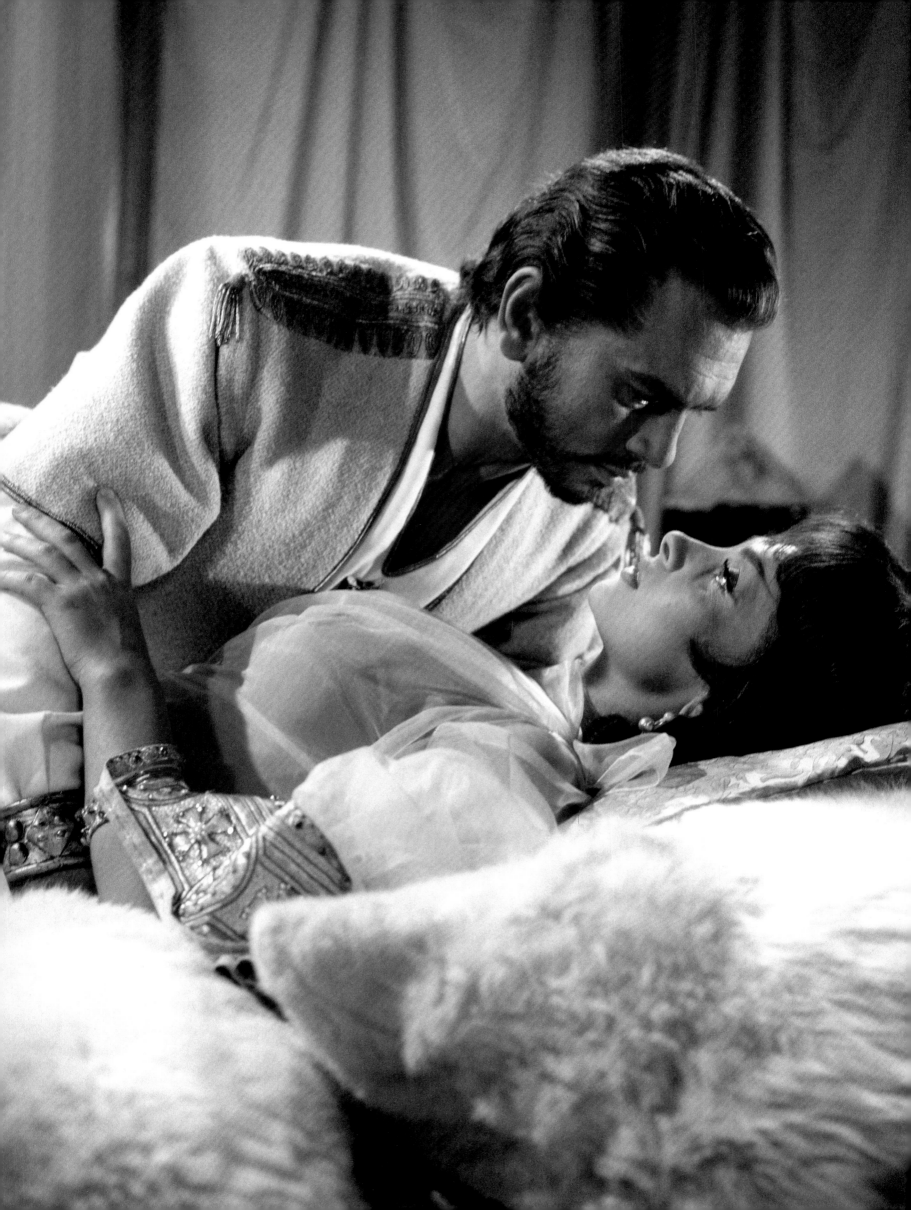

movie called *Solomon and Sheba* in Madrid that fall. It was to star Gina Lollobrigida. She must have mentioned my name to her friends at U.A. The American star was to be Tyrone Power. Waiting for that picture to get underway, I drove to Spain to spend a few weeks on the film *John Paul Jones*, a Sam Bronston production for Warner Brothers shooting on the Mediterranean coast of Spain. The film starred Robert Stack in the title role, while director John Farrow enjoyed himself, playing at being a sea captain. He would steer that boat round and round while the film crew was setting up the shots. The set was a specially built schooner that was later featured in a number of sea epics. My stint on the film concluded very quickly and I was glad to be back on solid Spanish soil; on to Madrid and the biblical epic. Before filming started, Tyrone Power invited me to join him and Debbie, his new wife, and Salvador Dalí at lunch at the Prado Museum restaurant. The minute Dalí saw my camera he started to put on a great show, posing one moment as if he were a fashion model the next a serious scholar—at least five different characters before I had finished my first roll of film. Dalí spoke little English, but expressive gestures and a vast repertoire of facial expressions carried him far. I spent the lunch in silence studying this unique individual. It was not until I got to Madrid that I learned that Gina did specifically request me for the picture.

We were about six weeks into production when catastrophe struck. During the shooting of a strenuous sword fight with George Sanders, Power suddenly stopped fighting, clasped his left arm with his right hand and slowly toppled to the ground. Within minutes he was dead. He was rushed to a local hospital but was beyond medical help. The next day his body was brought back to an empty soundstage at the CEA studios where he lay in state. With Debbie crying and clinging to the coffin, the whole crew passed through to pay their last respects.

Before joining the crew, I was accosted by a representative of *Paris Match*, who offered me 10 thousand dollars, (in 1957 that was a whole lot of money) for a photograph of Debbie with the corpse of her dead husband. I refused without a thought. During the subsequent weeks, I received myriad requests from all over the globe. Requests for the pictures I had taken of Tyrone Power during his last days.

Shooting of the film was suspended while the studio looked for a replacement for Power. Eventually the choice came to Yul Brynner. Brynner arrived in his unmistakable, "I am a big star" fashion. His first day on the set he turned to me and to Bob Landry, an excellent photographer, and said, "Don't take any pictures of me without telling me first." This, of course, was a ridiculous request. If you're going to tell a subject that you're about to take his picture, invariably you end up with something stiff and posed, and devoid of any quality of the candid pictures we were after. Without any conversation between Bob and myself, from that moment on neither of us took a single picture of Mr. Brynner. A short time later he accosted each of us saying, "Don't you fellows want any pictures of me?" That solved that problem. That incident just about summed up Brynner for me. One day he was all smiles and friendly; the next he barely acknowledged your existence.

In contrast, Gina was a delight to be around. Always ready to help in any way she could. Her laughter was spontaneous and genuine. When it came to taking pictures of her, she had as much knowledge on the subject as the photographer did. She had such fabulous artistic talents that she insisted on doing her own makeup on all her films. Stars in Hollywood movies have it written into their contracts that they have the right to approve or disapprove any photograph that was taken of them on the set, with the exception of photographers who were not actually part of the production. In any case, photographing Gina was a lot more fun and productive than shooting Brynner. I learned something important about taking enlargements to Gina for approval. While showing them to her, I would take some back, tear them up immediately saying, "These aren't good enough!" This helped to instill a relationship between us. She was confident that I was as interested in her career as she was and that I would never release an unflattering picture of her. This tactic proved to be extremely useful.

It was during *Solomon* that Gina, Sylviane, (who had come down to Madrid from Paris), and

Yul Brynner replaced Tyrone Power in the starring role of *Solomon and Sheba* after Power's sudden death in 1958.

I became close friends. Gina was a hard worker. Her English was not yet as good as it would become. Our visits to the Corral de la Morería, Madrid's best-known flamenco club, were numerous and always full of fun.

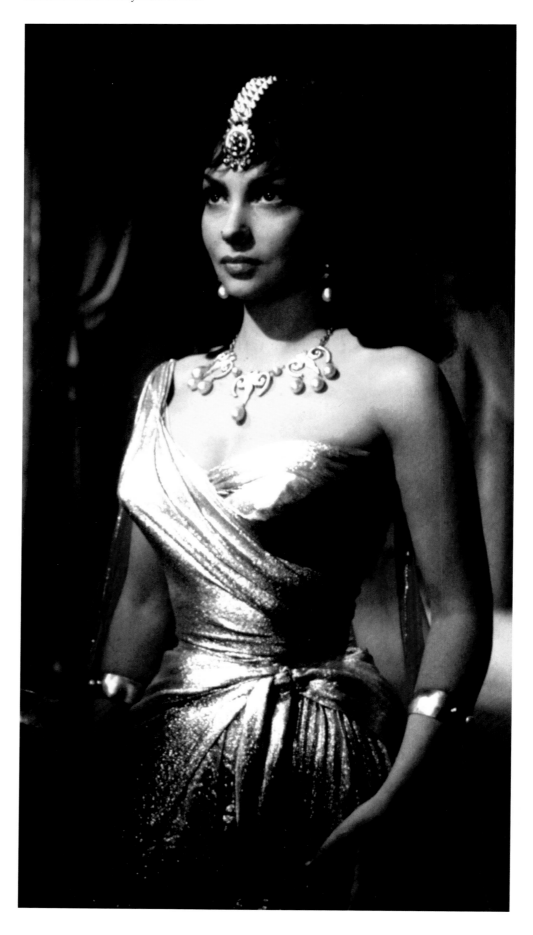

Gina Lollobrigida, striking as the Queen of Sheba in *Solomon and Sheba,* filmed in Madrid, Spain in 1958.

RELAX

When *Solomon and Sheba* was finally finished, Sam Bronston who had delivered *John Paul Jones* to Warner Brothers, approached me. He had an elaborate scheme to produce films independently using financing from DuPont, Burroughs Business Machines, and other companies with blocked funds in Spanish pesetas. This was money they had made selling their products in Spain but could not take out of the country. These monies would not free up for Bronston's use for many months. During that time there were a few who kept faith with Sam and hung in there in Madrid at his insistence.

Eight months later, only a small part of his funds had finally become available to Bronston. The authorities wanted him to match this money dollar for dollar with fresh money from outside of Spain. Rumor had it that by promising to make a picture about the life of Christ, to be called, *Son of Man*, he did manage to persuade the tax ministry of that eminently Catholic country to overlook the peseta law and allow him to proceed. Through the making of the Christ picture, ultimately called *King of Kings*, Bronston eventually built a major international production company in Madrid. Among the movies he made there were *El Cid*, *55 Days at Peking*, *Circus World*, and many others.

Unfortunately or fortunately, depending on how one looks at it, by the time Bronston's money was available, I was gone. I'd received an urgent call from Fran Winikus, publicity chief of United Artists in London, requesting me to join Otto Preminger's production company in Israel where he was preparing *Exodus*, with Paul Newman and Eva Marie Saint. I could not turn this down.

Before leaving for Israel, Sylviane and I decided to get married. This was not exactly an easy task for an American Jew and a French Catholic in Spain, a country that did not recognize civic or secular marriages. You could only get married in the Catholic Church. We got into my car—a delightful, nine-year-old 1950 Mercedes 190SL convertible—and drove to Gibraltar. The British consulate in Madrid had told us that Gibraltar allowed weddings by magistrate without the posting of bans or any other time-consuming obstacles.

We arrived in Gibraltar the morning of March 7, 1960. With the help of two secretaries in the magistrate's office as witnesses we were married. Sylviane rushed immediately to the local French consulate to properly matriculate the marriage, thus insuring that it was legal in her home country. That done, we spent our next few hours visiting the Gibraltar monkeys and

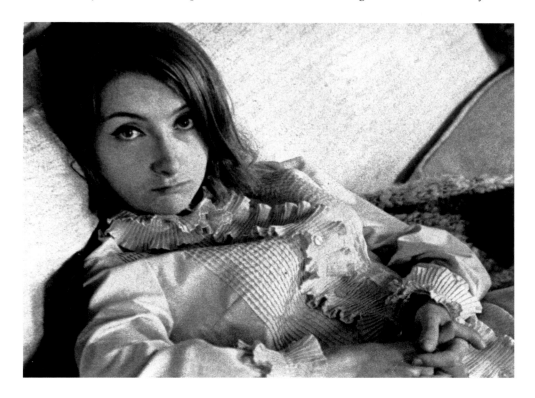

Sylviane Fuchs, *née* Contis. Her social grace helped Leo strike long-lasting relationships in Hollywood.

strolling through town. As we did so, we passed what looked like the only movie theatre on the rock. They were showing *Paris Holiday*, the film on which we had met.

Sylviane decided to visit her mother in Paris for a couple of weeks. I had to get to Israel and Mr. Preminger pronto. We drove to Marseille. From there Sylviane took the train back to Paris and the Mercedes and I embarked on the pride of the Israeli merchant navy: the passenger ship *Theodore Herzl* headed for Haifa. The Mercedes and I arrived in Haifa to the astonishment of the Israelis who off-loaded the vehicle, as there were not many German cars in that country at that time. A few weeks later, Sylviane joined me in Israel, and to feel useful, signed on as stand-in for Eva Marie Saint.

Working with Otto Preminger was a unique experience. He called everyone by their last name as though to ensure all would keep discipline; he ruled his set like a Teutonic dictator. Some said he was the only Jewish Nazi alive. He received an enormous amount of help making *Exodus* from the authorities as well as from the people of Israel. For example, in order to shoot a major sequence he needed 25,000 people to be standing in a very large square in Jerusalem in front of the balcony from which Barak Ben Canaan (Lee J. Cobb) was to announce the decision of the United Nations to partition Palestine, thus creating the state of Israel. To accomplish this without spending the minimum 40 dollars per person that any self respecting extra would have cost for standing around until five o'clock in the morning, the production organized a raffle with two prizes of 10 thousand dollars each. The tickets for this raffle were given gratis to anyone who showed up at six but they had to hang around until shooting was finished that night to find out who had the winning tickets. We didn't finish shooting that night until way after 4:30 in the morning. The people were very good natured and hung around without complaining. They had never seen a movie being shot before. An extra attraction was an unexpected altercation between Preminger and Cobb.

The last shot of the night was a close up of Cobb, who was really the nicest, most soft-spoken and easygoing man. Preminger had been his most overbearing all night. He was fond of bringing his face within centimeters of yours and shouting, at the very top of his voice "Relax!" He would often say, "Don't do what I told you, do what I tell you!" This close up was being shot from a tower built right across from the balcony. It was a sort of very high scaffolding, with a platform just large enough to hold a camera, the director, and the cameraman. High enough

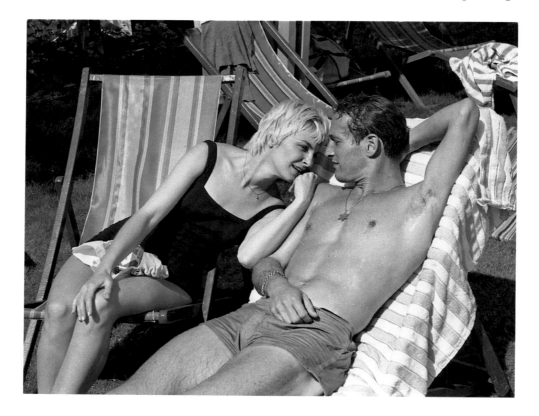

Above and opposite: Joanne Woodward and Paul Newman relaxing in Israel during the filming of *Exodus*, 1959.

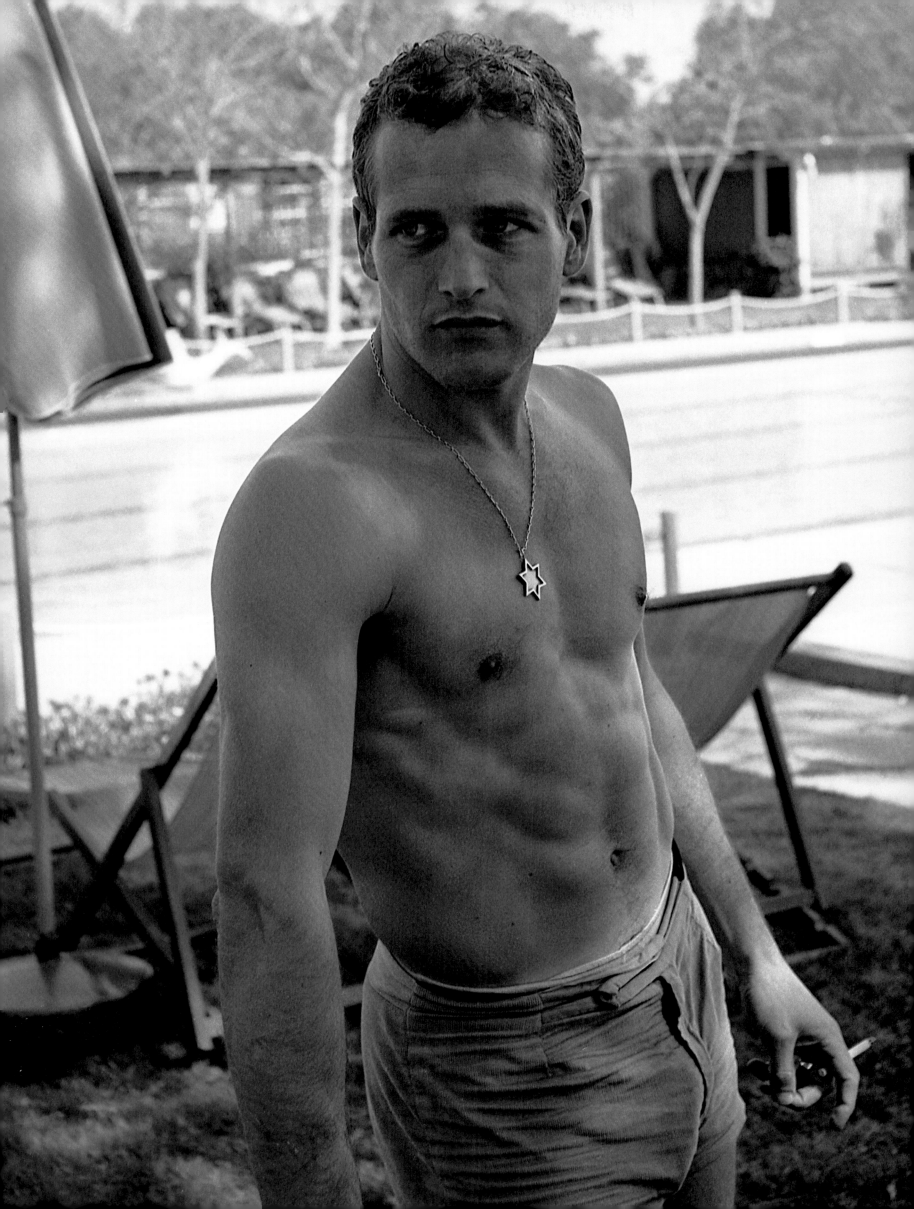

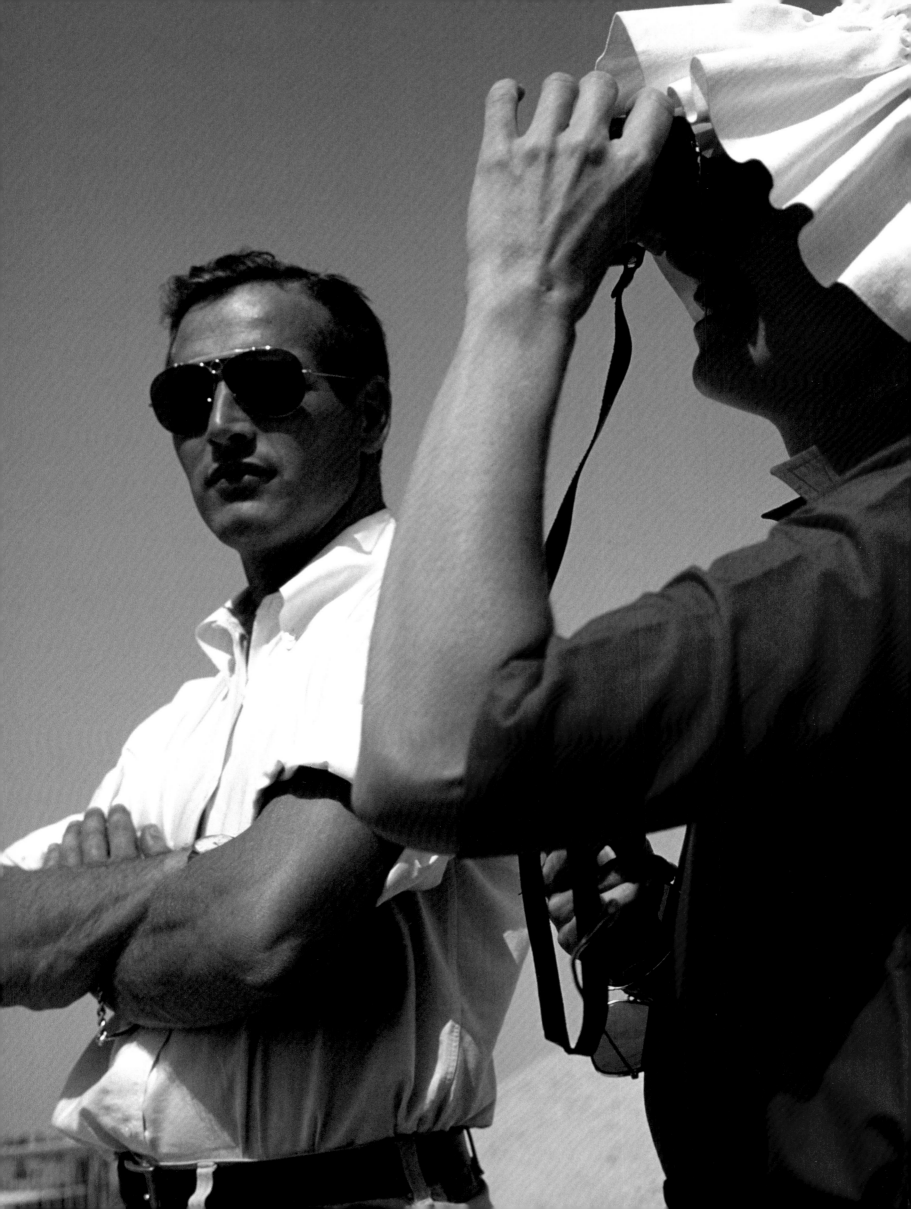

to bring the camera up three stories to about six feet in front of the third floor balcony from which Cobb made his speech. Preminger had been riding everybody all night, cast and crew. On the final shot of the night, at 4:30 in the morning, he found something else to complain about, as he had take after take throughout the night, each time less and less courteously. Cobb just seemed to oblige calmly and would do the scene again and again. Although up to then Preminger had been reasonably controlled with Cobb, this night had been different.

As soon as Preminger announced "cut" and "print," — signifying the end of the nights work — Lee Cobb released all the anger he had pent up over this long night shoot in a screaming tirade at Preminger, telling him in no uncertain terms what he thought of him and his instructions. Preminger remained speechless. Although he looked ready to kill the actor he was unable to even feign physicality. More than a hundred feet above the ground, a measly three-foot distance separated them. The whole crew stood around looking at the spectacle. Finally, Cobb took off back to the hotel. Preminger gave express orders to the production for Cobb, having shot his last scene in the film, to be put on the first flight back home to Los Angeles.

Eva Marie Saint was a very professional, charming, and courteous actress. Unfortunately I really didn't get to know her very well as, to be honest, most of my time was spent with Paul and his wife Joanne Woodward, Oscar winner for *The Three Faces of Eve*, who had accompanied Paul throughout this whole location. Joanne, Paul, Sylviane, and I spent much of our time together. We would go sightseeing around Israel or try different restaurants. Needless to say, Joanne, beside being beautiful and an outstanding actress, is one of the most intelligent and levelheaded women I have met. Paul was very easy to be around, he had an enormous appetite for knowledge, everything interested him, he was indifferent to nothing, he had a fabulous sense of humor yet was very serious about his work, and he never took himself seriously.

One afternoon at dusk, we were shooting at the King David hotel, on the balcony overlooking old Jerusalem, in that period between day and night that lasts only twenty minutes. Preminger managed to shoot only a few feet of film every day for five consecutive days. Having only a very short window of opportunity to shoot created a very tense atmosphere and at one point Paul looked at Preminger saying, "Otto, you're shouting!" which stopped the director in his tracks. It seems Paul had had his agent include a clause in his contract forbidding Preminger to shout at him.

Before leaving Israel, Paul suggested that I contact United Artists about working on his next film, *Paris Blues*. The film was slated for shooting in Paris, in the fall.

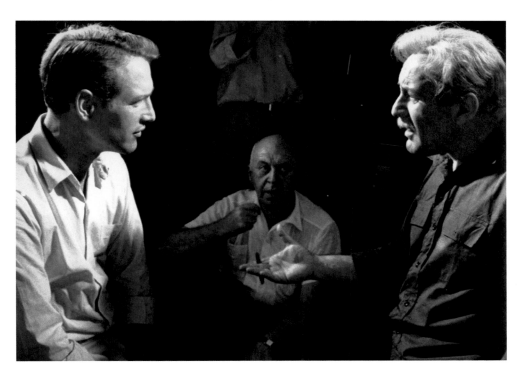

Opposite: Joanne Woodward and Paul Newman vacationing across Israel during the filming of *Exodus*, 1959.
Above: Paul Newman and Lee J. Cobb rehearsing on the set of *Exodus* with director Otto Preminger looking on.

WHEN THE LION GOT LOOSE

From Israel it was back to Madrid where an Italian producer named Paolo Moffa had persuaded United Artists to finance a movie called *Revolt of the Slaves*. It featured Rhonda Fleming, a beautiful redhead that had starred ravishingly in many such costume pictures.

The director of this jock-strap epic was an Italian B-picture director named Nunzio Malasomma. Fleming's co-stars were a Hollywood hunk she had recently married named Lang Jeffries as well as a short, wiry, intellectual-looking French singer-songwriter destined to become very famous in France, Serge Gainsbourg. He played a lion tamer—for those who know of him, adventures in casting indeed! The executive in charge of U.A. in Spain was Bud Ornstein, a heavyset and pleasant man who, a few years later, would finance the first Beatles picture. This movie did not exactly offer many opportunities for interesting material aside from the voluptuous Rhonda Fleming. One summer afternoon as the clock approached "las cinco en punto de la tarde" (5:00 p.m.) as García Lorca would write, I made my way to the local bull ring to enjoy the day's corrida.

After the day's six bulls had been dispatched, when I was heading home I bumped into Bob Rooney, a former correspondent for U.P.I. who handled the publicity for the film. He later became a lifelong friend. "Where were you when the lion got loose?" he asked in a way of greeting. It appeared one of the lions escaped his handlers and roamed freely around the studio grounds all afternoon. The unscheduled escapade brought Ornstein to the set to learn what had occurred. As he crossed the courtyard, he looked at me, a reproach on the tip of his tongue, but before he was able to say a word, I beat him to the punch shouting, "Listen Bud, the next time you let a lion loose you could at least let me know beforehand so I can take a few pictures."

And with that, he just laughed and I was off the hook. It is always good to have a bit of good-will stored up in reserve. Before leaving Madrid I received a call from Universal's Publicity department requesting that I go to Santa Margherita on the Ligurian coast of Italy where production was starting on a comedy entitled *Come September*. The film starred Gina Lollobrigida and Rock Hudson. Sylviane and I got back into our trusty old car and made our way to Italy.

As we arrived in front of the hotel in Santa Margherita we found Gina standing there along with Marta de Cars her dialogue coach. The first words out of Gina, without even a hello, were, "Married yet?" We hadn't seen Gina in more than a year and she had never really approved of our being together without being married during *Solomon*.

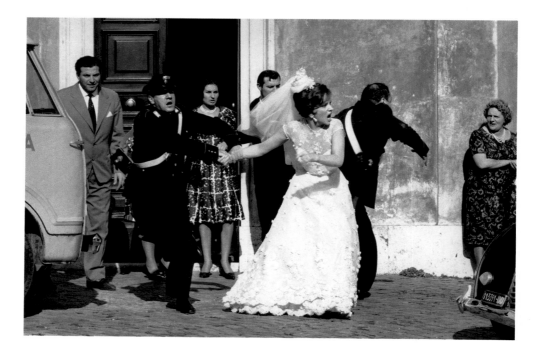

Above: A moment of mayhem for Gina Lollobrigida's character in *Come September*, Italy, 1960. Opposite: Rock Hudson and Gina Lollobrigida zipping through the crowded streets of Rome, Italy on a moped, 1960.

Gina and Rock had already been on location for a while when we got there. They had built a very comfortable friendship and both invited Sylviane and me to share. *Come September* was probably the happiest location I have ever been on, certainly up to that time. The director Bob Mulligan was a man with a great sense of humor, and Rock being a man that rarely chose to take anything very seriously, the whole location was a lot of fun.

It was also particularly productive for me, outside of Rock and Gina, two stars that elicited an interest from many magazines; this picture also showcased the meeting of two teenage idols that actually fell in love during the filming: Sandra Dee and Bobby Darin. Sandra was a Universal-groomed hot property, and the studio had sent a very charming veteran press agent named Betty Mitchel to look after her. Bobby was something of a bad boy and Betty with Sandra's mother, Mary Douvan, did not look approvingly upon the developing romance between the two.

Nevertheless, soon after the picture was finished Sandra and Bobby got married. All this was lucky for me as all the fan magazines back in the states were clamoring for pictures of the teenagers' two new darlings. Gina and Rock were of course available for anything I asked of them. By the time the company moved to Rome, Gina, Rock, Sylviane, and Bob Mulligan who enjoyed a practical joke almost as much as Rock, all felt as if we had known each for years.

Towards the end of the Rome shoot, Rock took me aside and said, "I'm scheduled to start a picture with Doris Day in January"—about two months away—"Why don't you come and work on it?" I shot back at him, "Because nobody asked me." He came back with, "I'm asking you." "In that case I'll be there," I said, grinning from ear to ear. Two days later I received a telegram from Jack Diamond, the head of publicity for Universal studios. He asked me to come to Los Angeles at their expense to do special photography on *Lover Come Back* a sort of sequel to the Rock Hudson-Doris Day megahit *Pillow Talk*.

Before going to California there was still *Paris Blues* with Paul Newman, Joanne Woodward, Sidney Poitier, and Diahann Carroll to work on in Paris. Marty Ritt was directing; he and Paul were old friends. *Paris Blues* was about jazz musicians living and working in Paris after the war. At one point, to the joy of everyone concerned, three great musicians showed up to play in the film: Duke Ellington, Count Basie, and Louis "Satchmo" Armstrong. They really didn't do very much in the film, I think they were mostly window dressing, but they certainly made things interesting for me. It isn't every day you get these three together in a perfect, prepared setting. They posed individually, they posed all together, and then they agreed to walk through the streets of Paris. These three legendary musicians were a different kind of celebrity, and Parisians everywhere showed them adulation even if they could hardly understand them speak. That whole location was over very quickly and soon

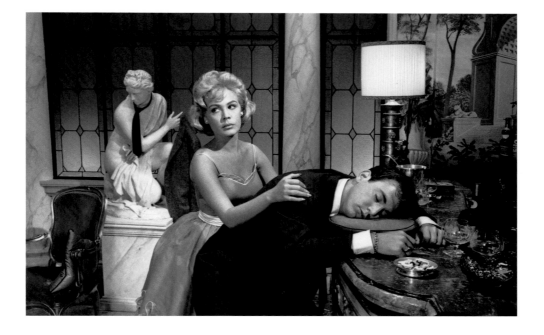

Opposite: Gina Lollobrigida for *Come September*. Above: Bobby Darin and Sandra Dee, *Come September*, Italy, 1960.

61

Sylviane and I were on the *Queen Elizabeth* on our way to the States.

We disembarked in New York with a new car we had acquired in Paris before leaving, a 1955 Mercedes sedan, a classic car which took us from New York to Los Angeles in six days and a whole lot of gasoline. As we crossed America we looked like royalty gone broke, but it offered both of us a chance to see the country together. Arriving in Los Angeles we were greeted by the whole publicity department of Universal Studios, led by its director Jack Diamond who did everything possible to make us feel welcome. Once settled into a poolside, furnished apartment on Ventura Boulevard, I sold the Mercedes and bought a Thunderbird, which would take me down Ventura to Universal Studios every day.

The first day, Rock took me to Doris Day's trailer and introduced me with, "Meet Leo, who takes pictures that make you look like you wish you did." Doris smiled, took my hand, and looking me in the eye, simply said, "Hi. I've heard about you." She was in good spirits and she and Rock would laugh together spontaneously—both of them liked to clown around. It was obvious these two both respected and liked each other.

Lover Come Back was an introduction to a Hollywood I quickly learned to love—made up of professionals who respected each other's work, and who had a financially secure lifestyle, which helped to give everybody a good disposition. No more hand to mouth. Everyone was so helpful to both Sylviane and me, including Rock, who did everything to make us feel comfortable. He'd invite us up to his house for dinner two to three times a week or down to Newport for the weekend on his boat. Whenever he or Doris threw a party, we'd get a chance to meet more interesting people. It was like a new family. I was never really comfortable at glitzy Hollywood parties but it was good to meet talented and interesting people. Sylviane, whose French charm captured everyone, was soon the toast of the town.

Rock and Doris made my professional life easier as well. One day on the set, between changes, I suggested we could have some fun doing layout by going hunting around in the studio's massive costume wardrobe and set inventory. My idea was to have the then hottest movie couple spoof earlier movie duos like Marie Dressler and Wallace Beery, Jeanette MacDonald and Nelson Eddy, as well as Laurel and Hardy, Tarzan and Jane, and the Keystone Cops. They both jumped at the idea and soon we were on an empty soundstage surrounded by costume and makeup people all clowning around shooting the layout.

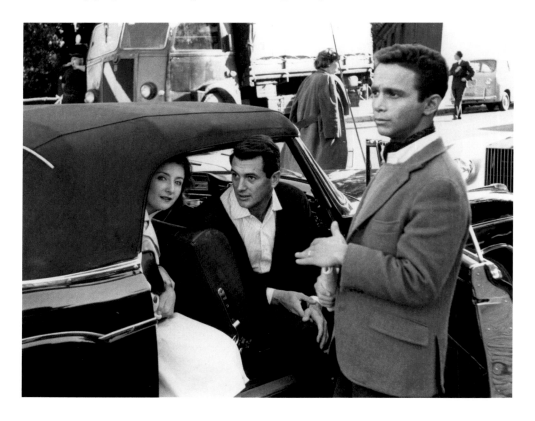

Above: Rock Hudson, Sylviane Fuchs, and Joel Grey on the Universal Studios lot during *Lover Come Back*, 1960.
Opposite: Rock Hudson and Doris Day had a successful box office run as the playboy and the ingenue.

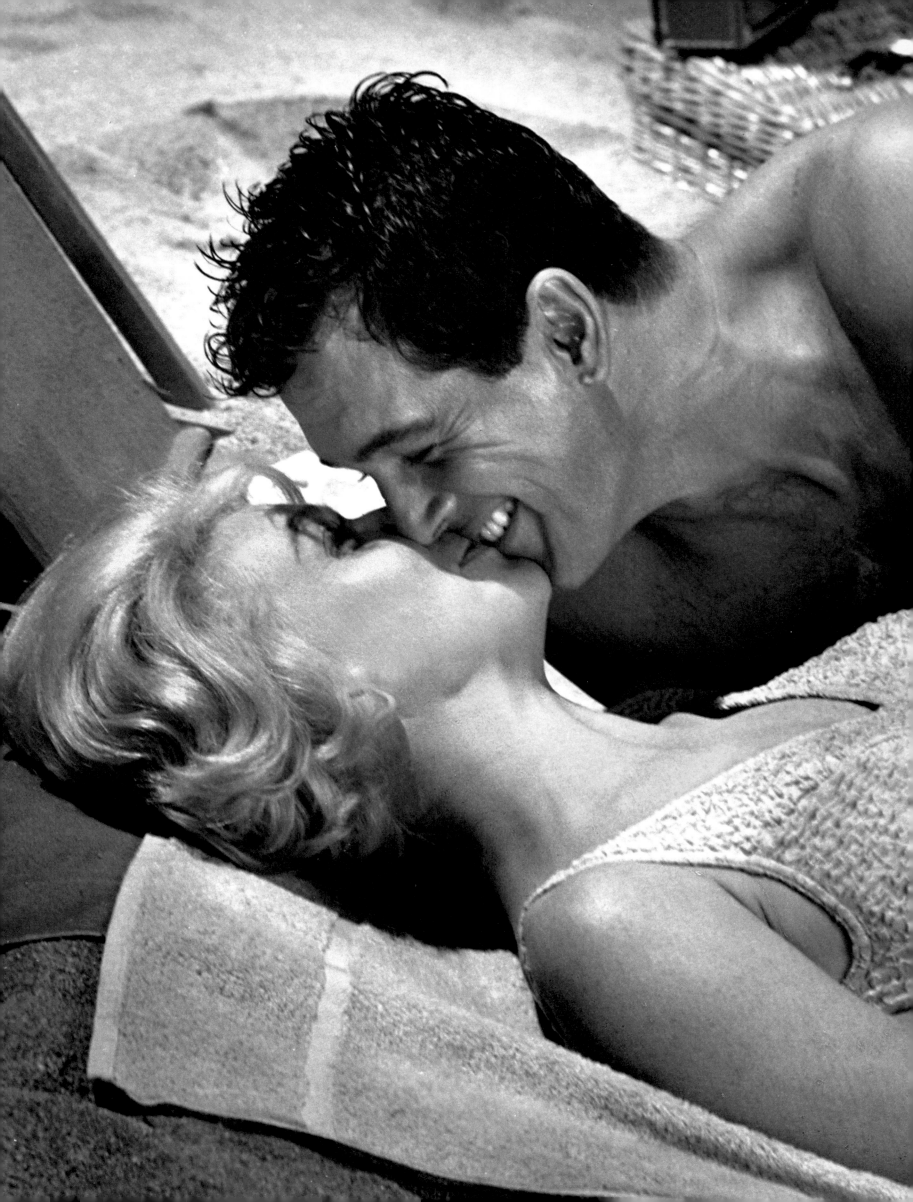

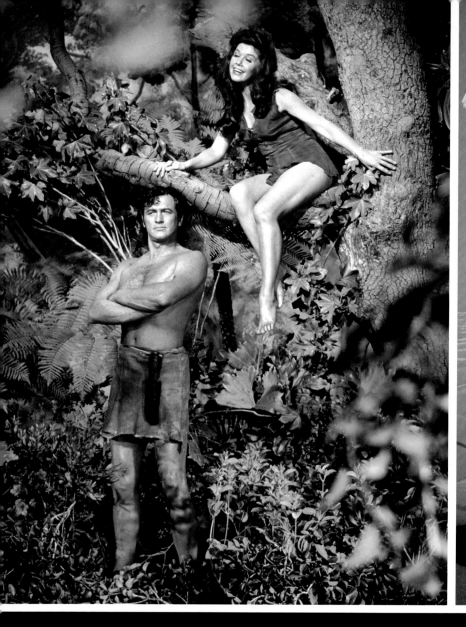

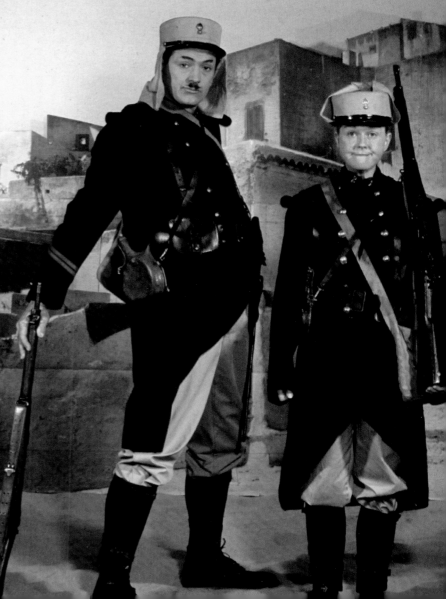

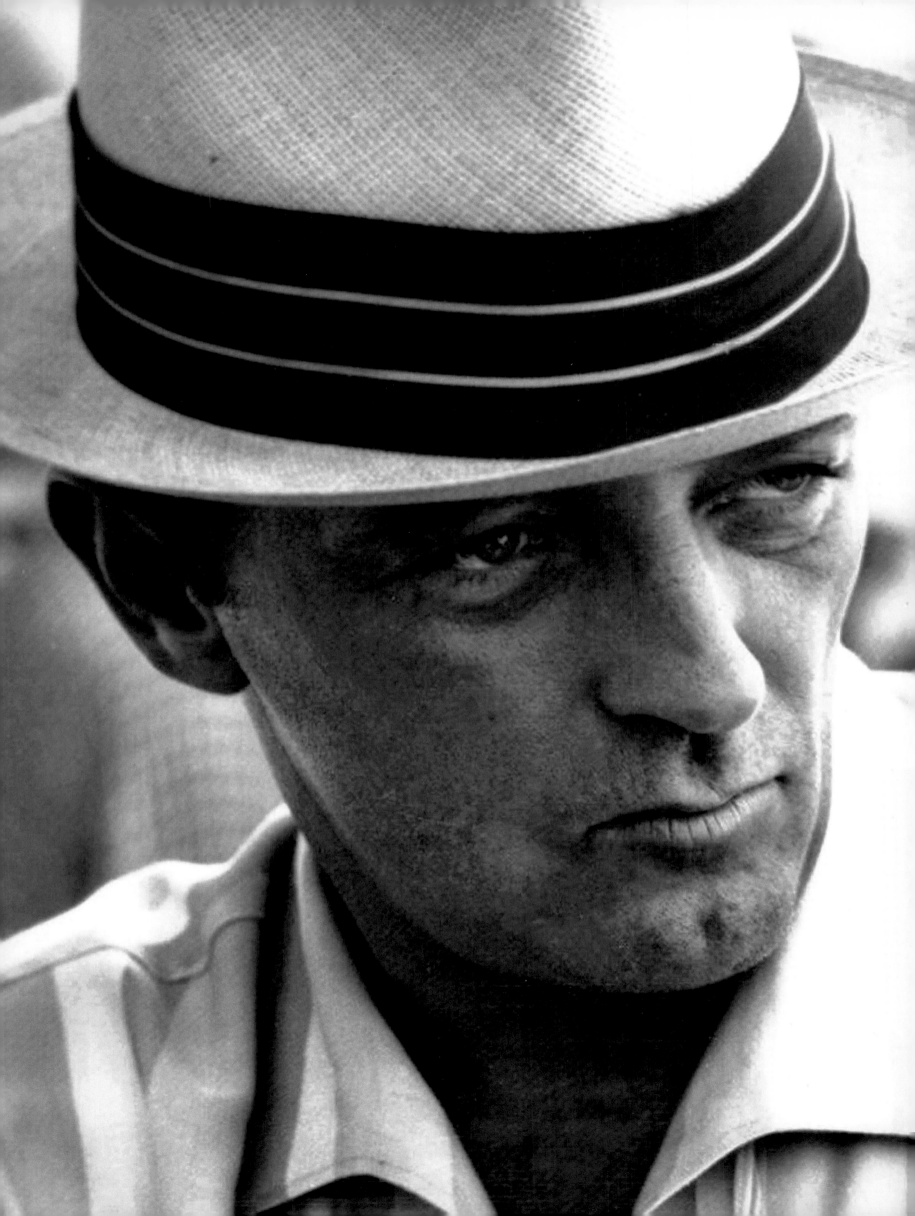

UP YOUR ASS

Soon after *Lover Come Back*, Universal, where I was spontaneously sprouting roots, was preparing to shoot a film in Savannah, Georgia starring Gregory Peck and Robert Mitchum with J. Lee Thompson directing. Sylviane and I decided to once again drive across the United States, this time going east, along the southern route to Savannah. We arrived in a beautiful city full of southern charm. When we got to the hotel, one of the crew told us about something which had just happened to Mitchum that afternoon at the hotel. It seems members of the bourgeois ladies' club of Savannah had cornered him, one of whom asked the actor if he had ever been in Savannah before. "A few years ago I spent a bit of time here on a chain gang," he replied. The ladies looked at each other in disbelief and hastened an embarrassed retreat.

I had never met Greg Peck but I had worked with Bob Mitchum in Ireland two years earlier when U.A. asked me to go spend a week on a picture about the "troubles in Ireland." On that picture, Richard Harris co-starred with Mitchum, the two actors making instantly inseparable drinking buddies. Mitchum was already an enigma to me in Ireland.

Mitchum was extremely well read, with deep knowledge in the humanities; a few minutes of conversation proved that he had a brain like a steel trap. A truly superior intelligence hiding behind a truculent exterior, most often inebriated. He was never disagreeable or difficult when working with people who he did not feel annoyed him uselessly. Mostly, he was nonchalant and easygoing.

As for photographers, he was ambivalent and tolerated them. One afternoon the third assistant knocked on his hotel room door to deliver the call sheet for the following day. When Mitchum shouted "come in," the young man pushed open the door only to be confronted with a lovely, but totally nude, local female. From behind her, without missing a beat, Mitchum bellowed, "Just drop it on the dresser. Thank you." The assistant obliged, then quietly eased himself out the door. In the hallway, still dazed, he ran into me walking down the hall and unable to contain himself he blurted, "If you're headed for Mitchum's room be prepared for a surprise." With that he disappeared around the corner.

A few nights later, a few from the crew were in a local bar drinking after a reasonably long day. Mitchum was in a corner enjoying his drink and the company of another Savannah native when a middle-aged, rather large female came up to his table, pushed a piece of paper in front of him, and said, "How about an autograph?"

No "excuse me," no "please," just, "how about an autograph." Mitchum without looking up replied, "Not now please." But the woman refused to let go. She insisted and would not take a hint. Finally having had enough of this, Mitchum grabbed the paper and scribbled something on it. She took it back, read it, then duly shocked did an about face and scurried off in a huff. Later on I passed by the table and sneaked a look at the paper. It said in big bold letters, UP YOUR ASS…. No signature.

Polly Bergen also starred in this film and was married at the time to Freddie Fields, one of Hollywood's most successful agents. Polly, Sylviane, Freddie, and I dined a few times on this location. As it turned out I was unknowingly doing a bit of networking, as years later Freddie Fields became head of production at MGM when I became a producer.

The most memorable thing to come out of the stay in Savannah on *Cape Fear* was Sylviane meeting Veronique, Greg Peck's wife. Both were Parisian and both had similar backgrounds. Sylviane and Veronique found a million things in common and liked each other right off the bat. From then on and for several years, until we moved to Paris, Greg, Veronique, Sylviane, and I spent much time together at dinners or on weekends near La Jolla where the Pecks had a house, with Cecilia and Anthony their young children. Greg and I would often play chess at their house. A few of my favorite portraits of Greg were taken during such times, taking a moment's break to walk through the garden of their beautiful house and then returning to the chess play.

Previous spread: Rock Hudson and Doris Day delve into the Universal Studios prop and wardrobe departments.
Opposite: Robert Mitchum during the filming of *Cape Fear* in Savannah, Georgia, 1961.

HOT DOGS AT A DODGER GAME

Once back in Hollywood I got a call from the Columbia publicity people asking me to come and spend a few days on a picture called *The Interns*, which starred Suzy Parker. I welcomed an opportunity to work with who was then America's most famous and beautiful model. *The Interns* didn't really lend itself to a lot of publishable pictures so I knew I needed to come up with an angle, an idea which gave me an opportunity to make pictures with Suzy that had more than a passing chance to get published. I pitched the following idea to her: why don't we do a series of pictures showing how different people see you. Like your boyfriend, your mother, your lawyer, etc…. We shot a series with Suzy as a little girl, as a femme fatale, and so on. This series sold very well, like hot dogs at a Dodger game.

Above: Suzy Parker on the set of *The Interns*. Opposite: "Facets" series of Suzy Parker, Hollywood, 1961.

GOO-OOD EVENING

"Suriname? Where the hell is Suriname?" I asked. "South America," Rock answered. "The picture is *The Spiral Road*. A wonderful book by Jan de Hartog," he explained. "We shoot in Suriname for two months then come back here to finish."

We were up in Rock's new house, which Universal had just recently built for him on Lindacrest Drive, on top of a hill behind the Beverly Hills Hotel. Sylviane and I, joined by Don Morgan and Betty Mitchell from the publicity department, came up for dinner and a game of bridge, a game that Rock and I were just learning. Sylviane didn't play, or want to; the others were veteran bridge players. Don was the assigned publicist for the South American location.

The studio booked us, Rock, Don, and Marc Rydell, Rock's makeup man, on a multistop island-hopping flight that took us to Barbados, Antigua, Trinidad, and what felt like every other Caribbean island before landing in Curaçao, the Dutch colony known for its beaches and its tax-exempt economy. Rock suggested that we spend this free weekend before shooting started on the beaches of Curaçao. Everyone agreed of course. That evening at dinner we all had a little too much to drink, and after dessert Rock put on a set of plastic vampire teeth, and sauntered out into the lobby. He went straight for the front desk where a polite young man was waiting in line to get checked in. Rock tapped him on the shoulder and in an exaggerated gravel voice uttered, "GOO-OOD EVENING." The young man turned around, managed a very startled and confused look, then burst into laughter. Rock and all of us immediately joined in along with the other tourists checking in.

The young man turned out to be Yuri Gagarin, the Russian cosmonaut who a few weeks earlier had become the first man to orbit the earth in a spacecraft. He was on a world public relations tour. We sat around the lobby, drinks in hand, swapping stories for the rest of the evening. Yuri, despite his halting English, was most friendly and charming, although I am convinced he was totally unaware of Rock's celebrity and he thought he was talking to a crazy, if jovial, American. Rock on the other hand was in awe of his new friend. The next day Yuri was gone and we went back to playing bridge, with Don Morgan giving the lessons.

Paramaribo, the capital of Suriname, was a multiracial, multicultural society: Dutch, English, African, and Indian, all mixed together. The heat was barely bearable. For a while we shot

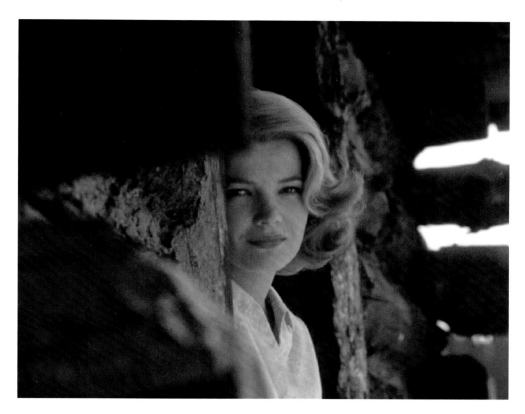

Opposite: Rock Hudson in *The Spiral Road*. Above: Gena Rowlands in *The Spiral Road*, Paramaribo, Suriname, 1961.

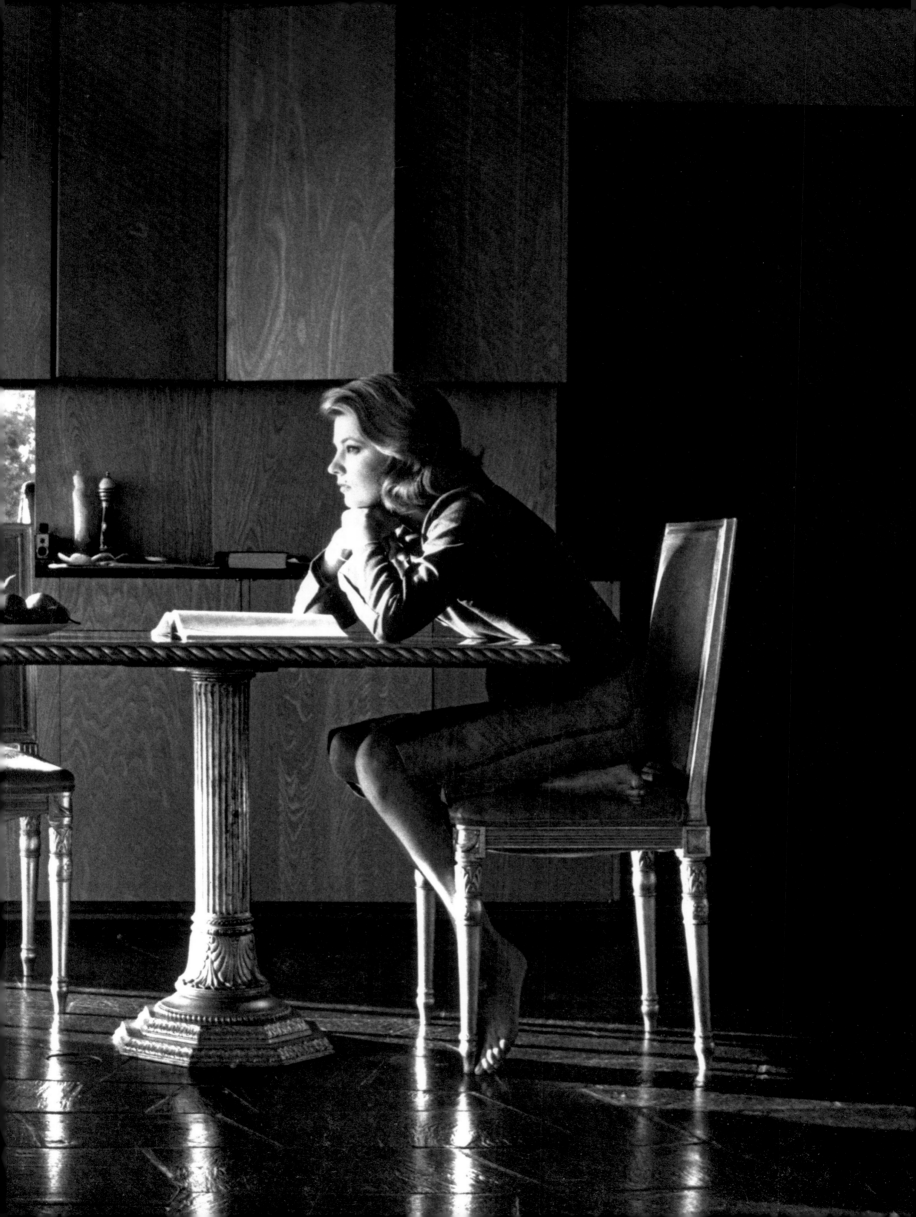

on a boat, the sun beating down on us. I tried to cool off by hanging my feet off the end of the boat into the water, until one of the crew advised me the river was full of piranhas, which, being flesh eaters, would not "hesitate to bite your toes off." My feet came out of that water like a shot.

Before long, Gena Rowlands joined us. She was Rock's co-star in this epic of doctors in the tropics. Gena was as smart as she was beautiful and her acting talent had long been proved. She was reserved but caring, a real trouper who never complained despite the heat and discomfort.

The food was so foreign to us all that Bob Arthur, the producer who had remained in California, shipped us 80 T-bone steaks by air, which we got to barbecue for dinner. That meal was one of the highlights of the location. One day I received a phone call from my agent Sandy Harris telling me *LIFE* magazine wanted me to make a photograph of Rock that would be suitable for the cover of the magazine. There was no more coveted prize for a photographer in movies than a *LIFE* cover.

That afternoon Rock and I went off by ourselves to see whether we could come up with a worthy shot. The most difficult aspect of photographing an actor is capturing the real person; that is, getting him to relax enough to let who he is come through. It is relatively easy to capture the character he is playing, that, after all, is his stock in trade—being someone else, someone he created, but nevertheless someone else. After about an hour of walking around, I propped Rock up against a ladder and said, "Hey, why don't you tell me all about the location you were on last year in Mexico, I understand it was quite a hassle." At this point Rock started rambling on, completely lost in his memories, not at all posing, just finally being himself. Within a few minutes I was convinced I had what was needed, I must have shown it as Rock turned to me saying, "I think we have it." Then with a glance at a young man standing a short distance away, he added, "I think I might also get lucky."

When we got back to the studio I was determined to come up with an idea for Gena Rowlands, an extremely intelligent and cultured woman. I looked at her concentrating, suddenly taken by her beauty I wondered what the result would have been if Rembrandt had a chance to paint her, or Leonardo, or Goya, or even Picasso; I suggested to Gena we find out. She agreed immediately. From there on it was just a question of a bit of research, costumes, and makeup, and a lot of imagination on everybody's part, and the results were soon on the cover of *This Week* magazine.

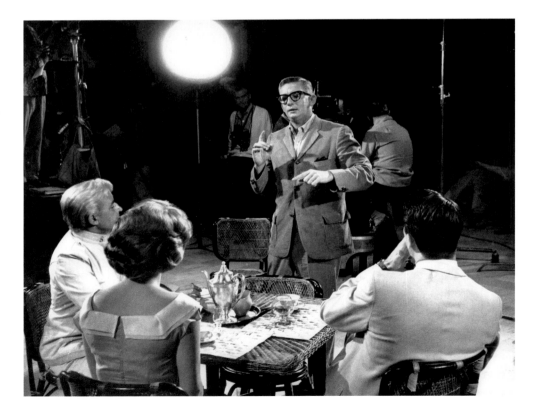

Previous spread: Gena Rowlands at home reading a script for *The Spiral Road* before heading to Suriname, 1961. Above: Rock Hudson, director Robert Mulligan, and Gena Rowlands. Opposite: Gena Rowlands thoughtful on set.

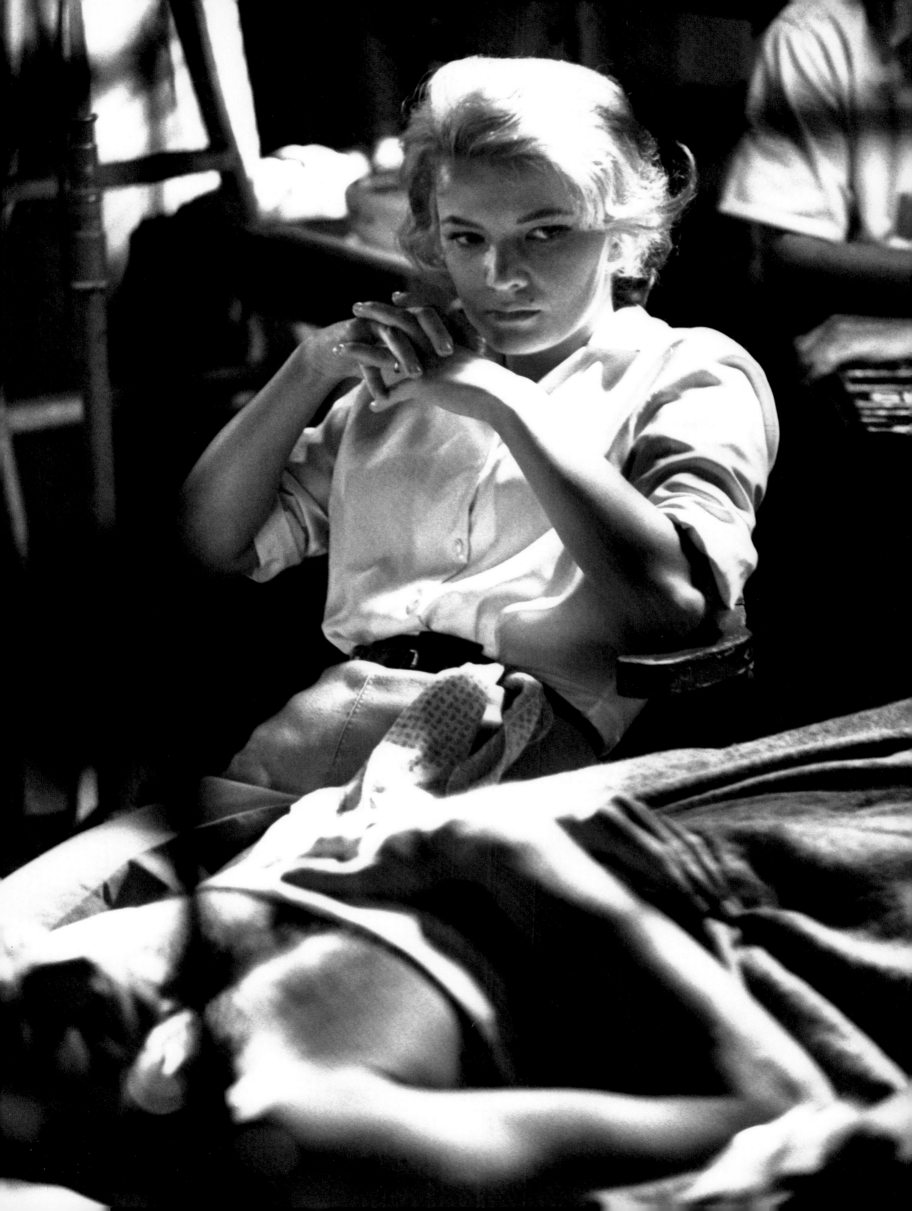

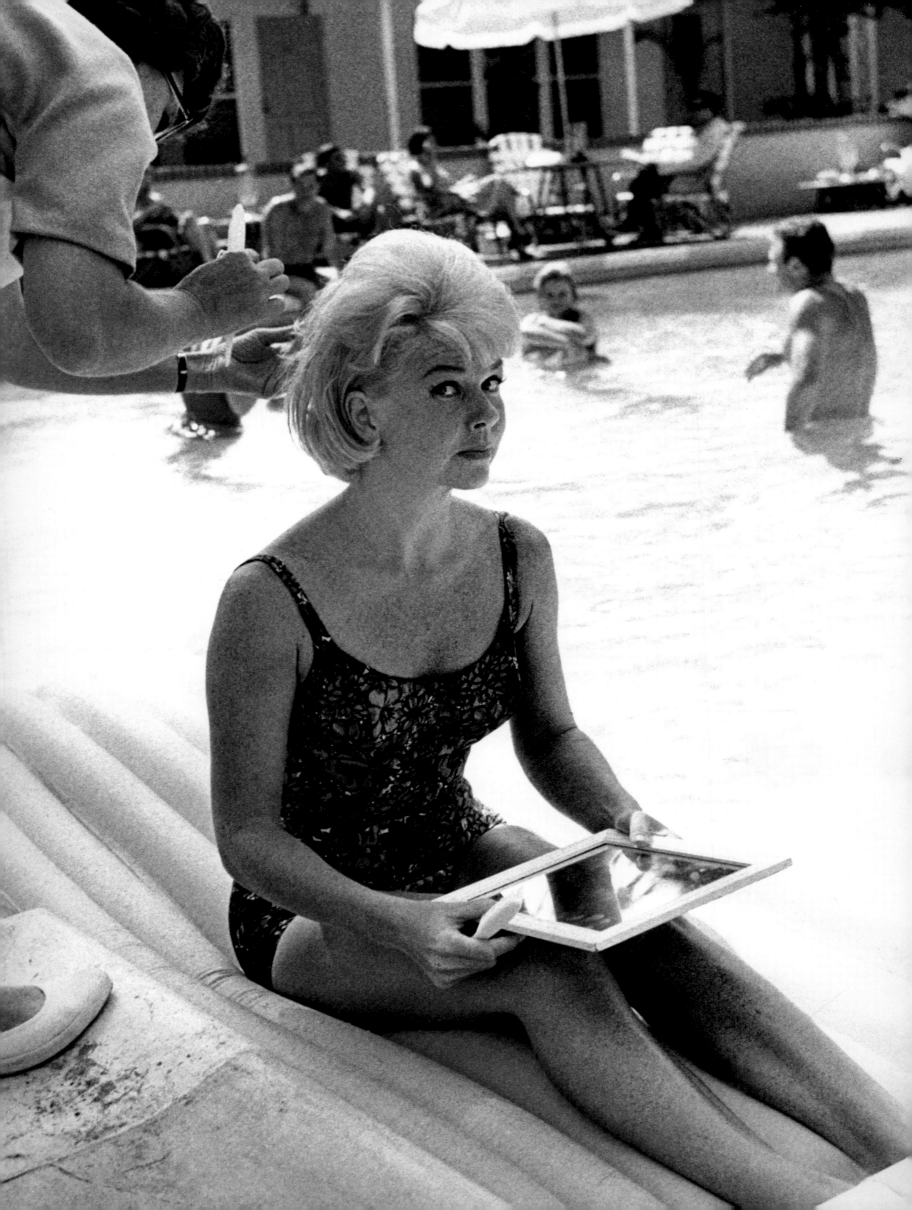

I'LL TAKE CARE OF IT SIR

After *The Spiral Road*, Jack Diamond asked me if I was interested in doing special photography on a whole slate of upcoming movies. This was particularly complimentary as by union rules, for every day I set foot on a sound stage or on the back lot of the studio they had to pay me a full day's pay as a "stand-by," even if I had no need to show up. The first of the pictures under the new deal was another Doris Day comedy, this time with Cary Grant.

Cary was most elegant and courteous at all times. It was just impossible not to be drawn to this handsome and cultured man. He had a ready smile and always a kind word. It was, however, rumored that he still had the first nickel he had ever earned. At that moment one of the highest paid actors in Hollywood, it was said that by contract the negative, and thus the rights to his movies, reverted to him after nine years.

Bob Arthur, the film's producer, would tell the following story: He and Cary were on their way to Europe. They stayed at the Plaza in New York, a hotel in which Cary supposedly had part ownership. In the morning they called room service for breakfast and Bob, knowing that Cary liked English muffins, ordered them with coffee from room service.

When they came Cary looked at them and asked the waiter, "What happened to the other half? Two muffins make four halves, there are only three here." The embarrassed waiter at a loss for an answer said, "I'll take care of it, sir." He returned a few minutes later with a muffin cut in half, that is to say two more halves. Normal—he was not going to bring one measly muffin half. Two weeks later they returned from Europe and again stayed at the Plaza. This time when they ordered breakfast someone in the kitchen with a good memory proceeded to put five muffin halves on the tray.

Another anecdote concerning Cary and his infatuation with the almighty dollar was told to me by a beautiful young lady, an ex-model and the widow of a well-known producer, who had lived with Cary for few months. It was a short affair, way before Cary and Dyan Cannon become a steady couple. Anyway, it seems my friend mentioned to Cary that the toaster in his kitchen was broken; it only toasted one of the usual two pieces of bread. Cary suggested that the next time she went down to Beverly Hills, she pick up a brochure on various toasters to research buying one. The next day she appeared at breakfast with a bunch of brochures, each sporting the latest innovations in toasters. Cary examined each very carefully, then finally putting them down he decided. "No need to buy anything, I can only eat one piece of toast."

That Touch of Mink was another fun movie. Cary and Doris respected and admired each

Opposite and above: Doris Day, carefully preparing before takes for *That Touch of Mink* in Bermuda, 1961.

other. The only one who had a problem was Delbert Mann, the director, as both Cary and Doris favored their right profile, which was appropriate as they both photographed much better when shot from the right. Therefore, in every scene they both had to be looking in the same direction. This made for slightly nonsensical love scenes. Del Mann was particularly adroit at handling this delicate situation.

Incidentally, it was during this picture that Doris showed how much of a baseball fan she really was. She would often go out to Dodger Stadium to watch the Dodgers play, especially Maury Wills their extraordinary shortstop. So when the script called for a scene with baseball idols Mickey Mantle, Roger Maris, and Yogi Berra in one of the dugout boxes at Yankee Stadium, Doris was like a kid in a candy store. She couldn't have been happier, surrounded by three men destined to become baseball legends. All three were generous and delighted all of us with old baseball stories.

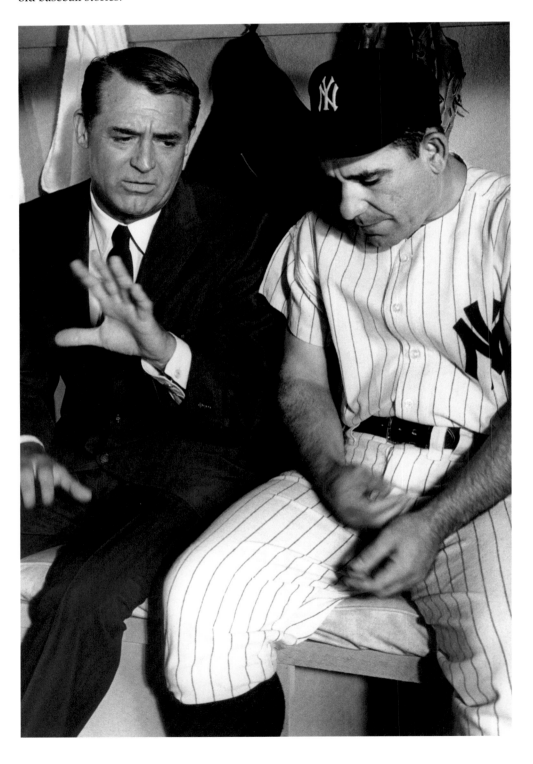

Above: Cary Grant, filming *That Touch of Mink*, discussing sports with Yogi Berra after a game in New York, 1961. Opposite: Doris Day and Cary Grant blow off some steam on the set of *That Touch of Mink*, Bermuda, 1961.

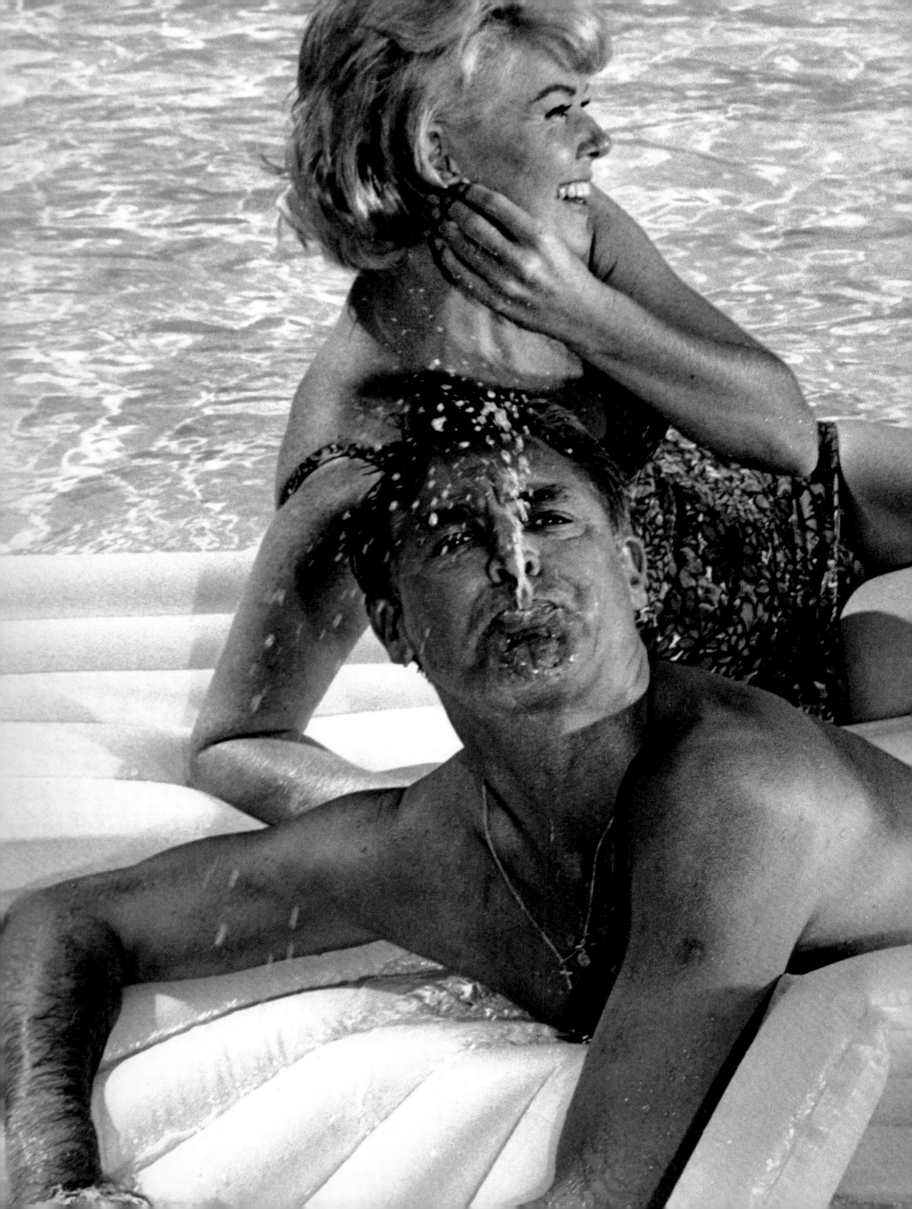

NOBODY TREATS ME LIKE THAT

Next up was a Tony Curtis comedy, *40 Pounds of Trouble*, which co-starred Suzanne Pleshette and was directed by Norman Jewison, shot primarily on location at Disneyland with a few days in Tahoe.

At the Disneyland hotel, relations between Tony and the Fuchs had reached a point that Tony suggested he take one bedroom of a suite, while we take the other. We shared the big salon; this made for some hectic, three-handed gin rummy games.

When this movie was finished, Tony started a hot and heavy romance with a very young German actress named Christine Kaufmann who was an absolutely stunning 17 year old; it was a sort of clandestine affair that her mother could not find out about. Tony invited Sylviane and me to join them for a long weekend in Newport. The new lovers, Sylviane, and I enjoyed a few days rest. The following year Christine and Tony were married.

Sylviane, and I were walking from the publicity building to our car parked in a little lot situated between the stars' bungalows and the publicity department. As I got into my car I saw Cary Grant about 40 feet away speaking to someone inside an automobile. Cary caught my eye, waved, then proceeded to walk over to us; we chatted a few minutes, with me at one door of our car and Sylviane at the other. As we talked, I saw the car Cary had been talking to take off and that the person driving was Tony Curtis. I waved to him as he passed; Cary said goodbye and proceeded back to his car.

The next day as I walked onto the sound stage, Tony called me over and greeted me with, "Nobody treats me like that. Why would your wife talk to Cary Grant and not even say hello to me?" I couldn't believe my ears. "I guess she didn't see you," was all I could offer. "Oh, she saw me. It was an insult." When I told Sylviane she thought he'd gone bonkers. Nevertheless I could never change him from his viewpoint. That was in 1962 and neither one of us have spoken one word to each other since. Who was it that said, "All actors are children"? This is one instance where I would have to agree.

A few days later, the issue of *LIFE* magazine with my photo of Rock Hudson on the cover appeared on the newsstands. That day I walked into the commissary to congratulatory smiles from all, including Cary Grant who waved me over to his table. A little while later, Jack Diamond came by and in the course of the conversation suggested that the major magazines

Opposite: Gregory Peck pensive on the set of *To Kill a Mockingbird*, Monroeville, Alabama. Above: Mary Badham's Scout and rarely-photographed author Harper Lee during a visit to the set of *To Kill a Mockingbird*, 1961.

would probably be very interested in coverage of *To Kill a Mockingbird*, the best-selling Harper Lee novel that Bob Mulligan was going to turn into a movie starring Gregory Peck.

Jack Diamond, Universal's director of publicity, suggested I fly to Birmingham, Alabama to make some pictures of Mary Badham, the 10-year-old girl who was going to play a leading role in *To Kill A Mockingbird* opposite Gregory Peck.

I went to this southern city in the middle of winter and found a very bright and cooperative little girl surrounded by a supportive family. I made all the pictures I needed in a few hours, but unfortunately that day Birmingham was snowed in and no aircraft could get off the ground. The Badham family took pity on me and insisted I spend the night on their living room couch. The snow finally let up and I was on my way back to Hollywood.

Gregory Peck gave an Oscar-winning performance in *Mockingbird*. The role of Atticus Finch the country lawyer was perfect for Greg. During the preparation period for this movie, Sylviane and I spent a lot of time with the Pecks and while I was taking pictures on the set, Sylviane would often be shopping with Veronique. In the evenings we'd often get together for a pleasant game of four-handed gin rummy, at other times we would weekend near La Jolla where the Pecks had a house, with Cecilia and Anthony their young children.

Greg was not difficult to photograph; he was, after all, one of the most handsome and interesting men in all Hollywood. The trick though was to capture on film that warmth and humanity that emanated from his distinguished and distinguishable voice and that was very much the essence of Gregory Peck.

We spent much of our time discussing politics, world affairs, or the human condition in general when we were not playing gin rummy, which all four of us enjoyed immensely. Veronique had set aside a cookie jar where we deposited losses and/or picked up wins at the end of the week. Five years later when Sylviane gave birth to Alexandre, Greg took on the responsibility of being Godfather to our only son.

Previous spread: Mary Badham during rehearsal and wardrobe technicals in Birmingham, Alabama. Above and opposite: Gregory Peck in private, off-the-set moments during the filming of *To Kill a Mockingbird*, 1961.

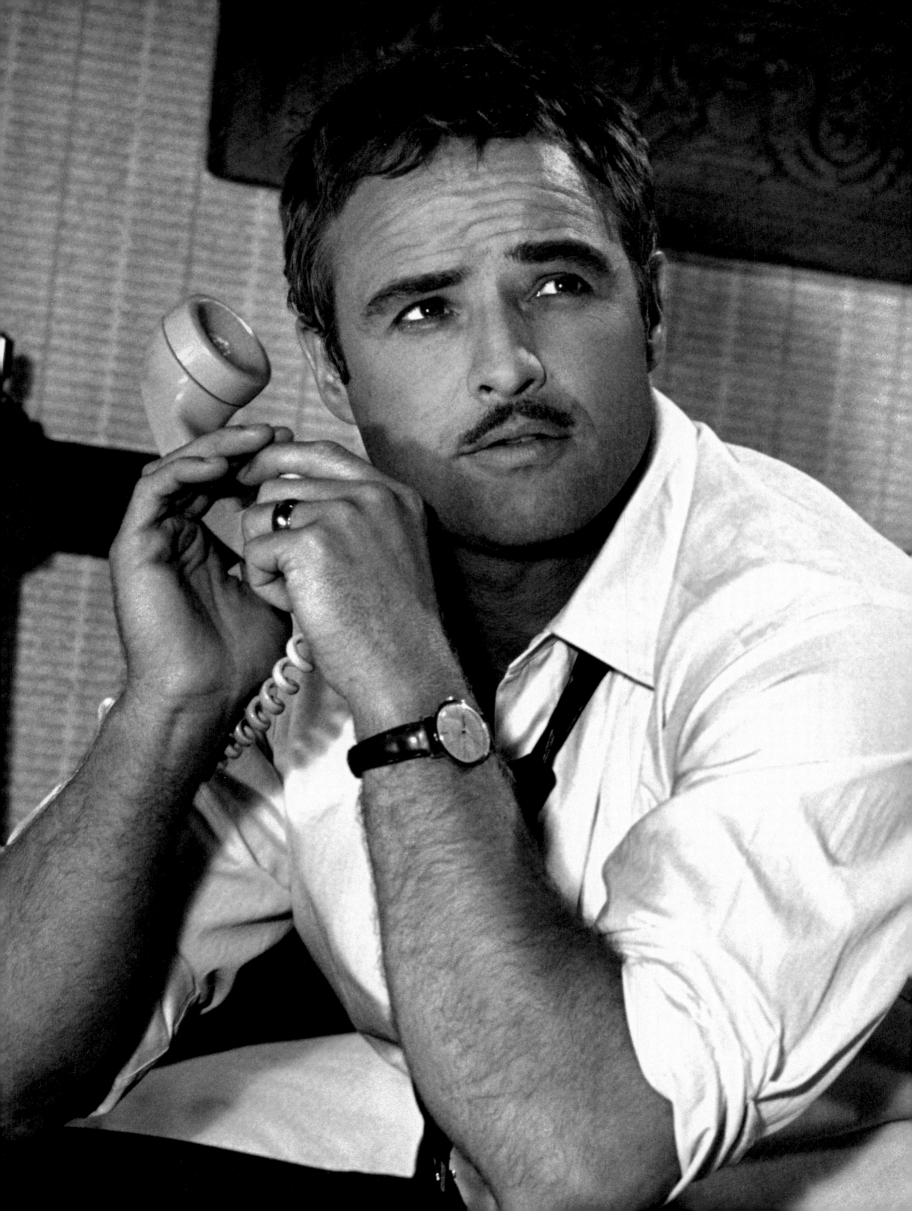

INTO THE NIGHT

My next assignment gave me another opportunity to work with Marlon Brando. This time it was Universal's version of the trials and tribulations of an American ambassador in Southeast Asia in the Burdick and Lederer saga *The Ugly American,* a prophetic tale of what was to come in that stormy part of the world.

Despite the fact that all the action was set in Asia, George Englund the director, Marlon, and the studio heads decided to shoot the whole picture on soundstages and on the back lot. Marlon had mellowed quite a bit since Paris and *Young Lions.* He was both courteous and cooperative, my camera never seemed to annoy him. The fact that Marlon would wear a moustache on some days, then choose not to on other days, must have driven the script girl and film editor crazy.

One night at the end of shooting, as Sylviane helped me to put my cameras away, Marlon came over to look at a couple of pictures and invited us to a nearby restaurant for a bite to eat. After dinner we took off for a local bistro in the San Fernando Valley and talked into the night. Later, Sylviane subtly hinted at a desire to visit her mother in France. She persuaded me we should spend the summer in Europe.

Opposite and above: Marlon Brando during the filming of *The Ugly American* at Universal Studios, 1962.

NO COMMENT, NO QUESTIONS

This was also an opportunity to work in Europe again. The Mirisch Company whose publicity department was headed by my friend Jeff Livingstone, had two major projects going in Europe that year: *Irma La Douce*, directed by Billy Wilder and starring Shirley MacLaine and Jack Lemmon in Paris and in Munich, and *The Great Escape* directed by John Sturges with Steve McQueen and James Garner among many others. United Artists had *Woman of Straw* a London-based film, with Gina Lollobrigida, Sean Connery, and Sir Ralph Richardson going on in Majorca.

I left Sylviane with her mother in Paris and made my way to Majorca and the *Woman of Straw* company. Gina gave me a warm welcome then scolded me for not bringing Sylviane. Sean Connery turned out to be friendly and amiable and therefore easy to work with. The interesting personality on this film was Ralph Richardson, a veteran British star whom I had already photographed during his very short stint on *Exodus*.

He was a fascinating actor to watch. He could do a scene seven times over, repeat what he had done previously down to a miniscule hand or eye movement. If he spoke a specific word in a sentence while performing a specific action he would do it at exactly the same moment during the exact same spoken word as in all the previous takes. He could be seen rehearsing with this precision before each take. An absolute dream for the script girl, and subsequently the film editor, who are responsible for the edited sequence to flow with exact continuity. After finishing with this epic I rejoined Sylviane in Paris and we took off together for Germany.

I took me a few days to show the city of Munich to Sylviane who had never been there, before joining the *Escape* company. When we finally did, we were welcomed by Steve McQueen and his wife, Neile Adams, on the set at the Geiselgasteig Studios, which were not unfamiliar to me. Neile and Steve were particularly gracious professionally, always ready to do whatever I asked in the search for interesting pictures, and socially, always available for excursions to Bavarian rathskeller restaurants in search of local color. They enjoyed each other's company very much and it was easy to enjoy theirs. Neile showed herself to be a very caring wife and Steve was the epitome of cool; nothing seemed to bother him. If I were to ask him to do a handstand on his motorcycle because I thought it would make good picture, or even without any specific reason, just because — he would think about it for about a second and a half, then just do it. No comment,

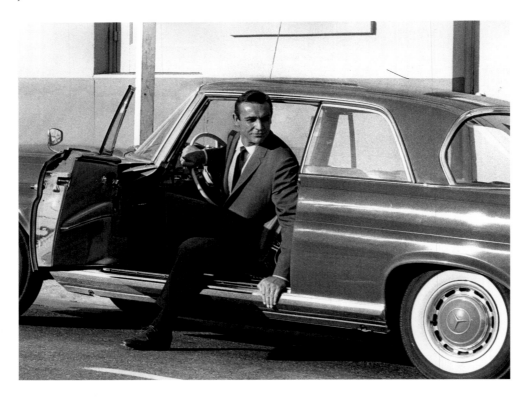

Above and opposite: Off the set with Sean Connery in Majorca, Spain during *Woman of Straw*, 1963.

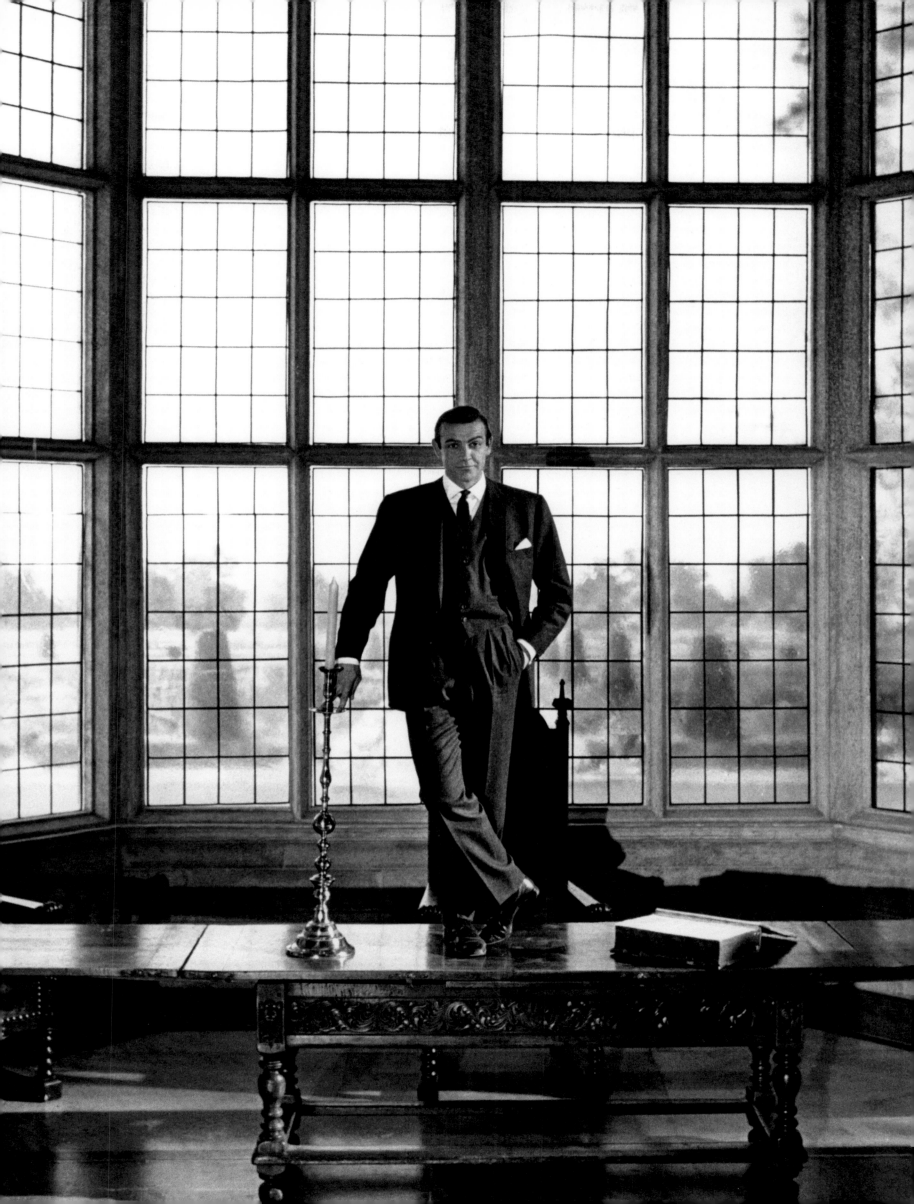

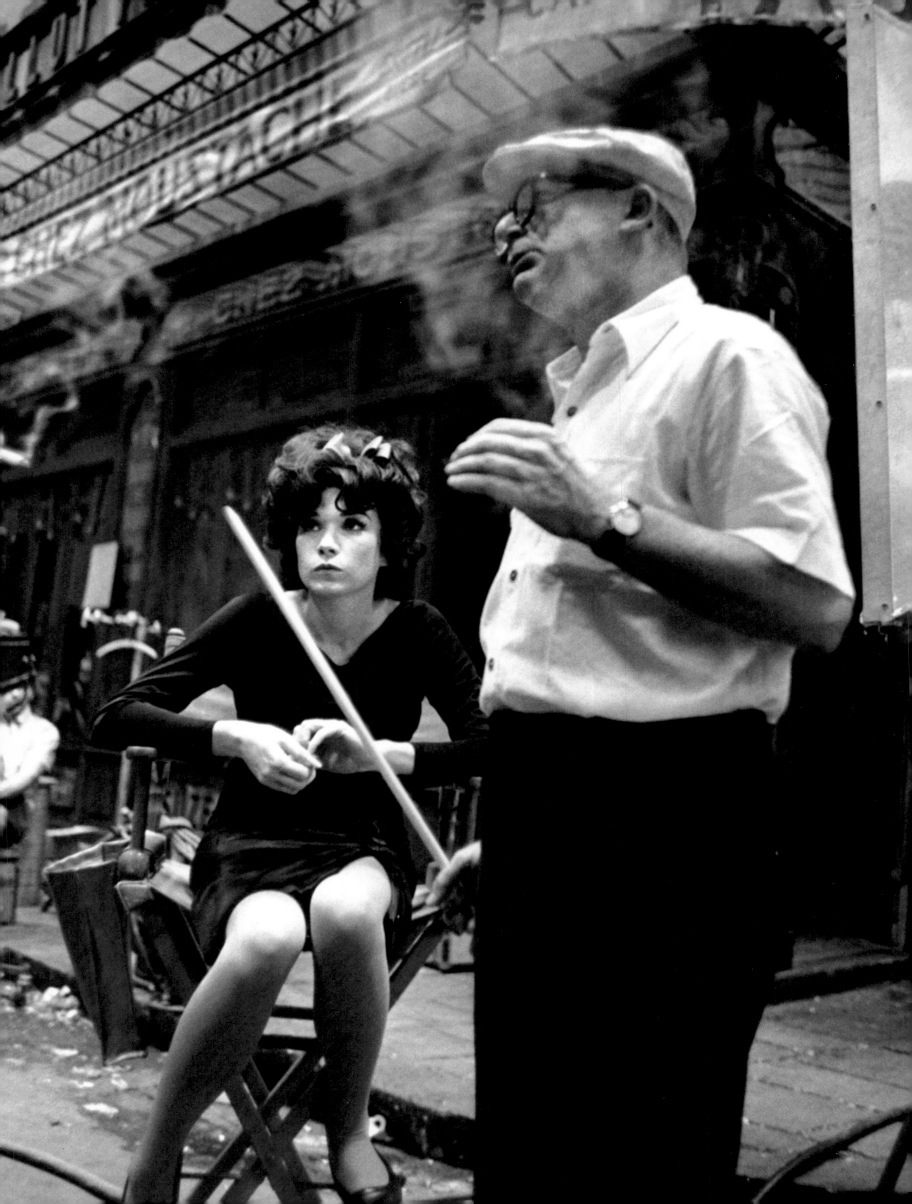

no questions, confident that I wouldn't do anything that would make him look silly.

James Garner was also a member of that small clan of unpretentious, easygoing, approachable film stars that make my profession a continuing pleasure. Nothing was ever too difficult, or came at an inopportune moment — in simple words, he was someone I could count on. There were numerous occasions for still pictures of Steve and all the rest of the cast in the dramatic scenes of prison camp, but only few available to capture them in the local countryside's eating and drinking establishments.

Next it was time to get to Paris. The *Irma* company was gathering around Billy Wilder. Shirley and Jack had arrived and preparations were under way. The shooting locations had been chosen, wardrobe selected, and Shirley wanted to do some research on the ladies of the evening that plied their trade out on the streets of the city.

To get an inside look at this age-old profession, Christian Ferry, the French assistant production manager reached out to some local acquaintances to find a candidate who would be willing to let Shirley witness the ABC's of her profession. Shirley did not hesitate to recount to us some of the less-lurid tales of her adventures with Nanou, one of the belles of Les Halles.

Taking pictures of Shirley MacLaine is a unique experience. You never know just what you're going to get. She's so full of life and so unpredictable. You just look into the viewfinder and prepare to push the button as soon as you see something, an expression or a movement, you like. Since you're bound to miss it, you have to press anticipating something you may like. When you put the camera down you have probably captured gestures and expressions that would make Marcel Marceau jealous.

Shirley has a tremendous sense of humor and enjoys telling or listening to a good joke. The more risqué the better — when it comes to telling stories Shirley likes to be one of the boys. The stories

Opposite: Shirley MacLaine and Billy Wilder on the set of *Irma La Douce* in Boulogne, France, 1962. Above: Shirley MacLaine and Jack Lemmon rehearsing during the filming of *Irma La Douce*, France, 1962.

she told of her nights with Nanou could have put a pornographer to shame. Billy Wilder, despite his reputation as a cynic, was a very funny man who created an atmosphere on his sets that made the workday seem more like a play day. He gathered top-notch professionals around him, most of whom had worked with him before and knew what he wanted before he would finish his sentence. The result seemed to work for everyone. His sense of humor was legendary: there is the story that went around in which Billy was seen talking to Otto Preminger, the poor man's version of a Prussian nobleman. When a friend of Billy's admonished him with, "How can you stand to be seen talking to that man?" Billy replied, "What can I do, I still have relatives in Germany."

Most directors are indifferent to the efforts of a still photographer and most of them consider them necessary nuisances at best. Not Billy Wilder; he was supportive of everyone working on his set. When making a shot that is an excerpt of the film itself, he would hang around to help get it just right, and if necessary cajole the actors into giving it their all. If he sensed that he was in the shot when I was shooting candidly, he would help make it interesting.

Jack Lemmon had come to Paris with his then fiancée Felicia Farr and they decided to get married in Paris. The mayor of the posh 8th arrondissement was chosen to officiate, the production manager having prevailed on him to overlook the customary six weeks posting and other nonsense the law required. They were married in the fin de siècle décor of the Mairie of the 8th in Paris, with half of the working press corps attending in what looked like an over the top movie set.

Jack was very funny on screen and very serious off screen. He jumped from one to the other quicker than you can say Jack Lemmon. He could have be standing off to the side of the scene, just out of sight of the camera waiting for his cue and whispering about yesterday's ball game and as soon as he heard his cue and the director's, "Action!" he would utter two words to himself, "magic time," and immediately, like lightning, metamorphose into character and own the dialogue of the scene. He could be kidding around, or doing anything, "magic time" would always serve as the key to the instant transition.

The *Irma* company folded its Parisian tent and returned to find Alex Trauner's outstanding sets on the Mirisch brothers studio lot on Santa Monica Boulevard in L.A. We went back with them. Back in Tinseltown, I got a call from *LIFE* magazine, this time they wanted a layout on Jack Lemmon and his bride. In doing this layout, Jack suggested we pay a visit to the mansion of Harold Lloyd, world-renowned silent star, comic, and a friend of Lemmon's. When we got to his house we found Lloyd—whose signature was the horn-rimmed glasses he was never without in his films—missing his glasses. I immediately offered him my own, which solved that problem, but made my focusing approximate at best.

Previous spread: Shirley MacLaine and Jack Lemmon take in the sights, Place Vendôme, Paris. Above: Shirley MacLaine and Billy Wilder, Paris, France, 1962. Opposite: Shirley MacLaine pensive on set, 1962.

USE LONG LENSES

Doris Day must have mentioned my name to someone at Twentieth Century because they called me to come and spend some time on a picture called *Move Over, Darling*. This was a movie Marilyn Monroe started, and it remained unfinished when she took her own life. Now it had been rewritten for Doris and was about to go into production. Needless to say I was delighted. It seemed like a fun script with some unusual sequences.

By the time of *Move Over, Darling*, I had already established a very pleasant working relationship with Doris. Every time I would bring her pictures for approval, a contractual obligation, she was very happy with what she saw. She would rarely kill any picture except for those that I had already earmarked for the trash bin, which made for an enviable atmosphere of confidence. I had often been to her house with Sylviane, who then sometimes doubled as my assistant. Doris had a real-life soda fountain in her home and the ice cream sodas were delicious.

Doris had barely finished at Fox and she was back at Universal, this time with James Garner who was now a full-fledged star. The picture was *The Thrill of It All* another light comedy from that the brilliant director Norman Jewison. Individually everyone got along with Doris or James; together they were a joy. I couldn't come up with any bright ideas of special layouts for them, therefore my coverage was confined to what I could get from the film scenes and that which surrounded them.

My relationship with Doris was such that I received a call one day on the set. It was Marty Melcher, Doris' husband, agent, and manager. The conversation went something like this: "Leo, you know Doris just completed an album for Decca Records. Well, they just called me asking for photographs of Doris to go on the album cover. I don't want to ask her to sit still for a photo session, I know she'll turn me down." He hesitated for a moment, then, "So, would you ask her? I know she won't refuse you."

I agreed of course, and that very afternoon, without mentioning Marty's call, I took her off to the side and using the incidental light which spilled over from the set we were shooting on, made a long series of head shots. The soft indirect light was exceptionally flattering. I expedited

Opposite: Doris Day during the filming of *Send Me No Flowers* at Universal Studios, Universal City, California, 1963. Above: Director Norman Jewison and Doris Day during a meal on set for *The Thrill of It All*, 1962.

the pictures to Sandy Harris my agent in New York. He took them to Decca Records who gladly paid the price Sandy asked for.

With *Send Me No Flowers*, Universal decided to bring Rock and Doris together for a third time, once again with Tony Randall, the perennial rich and funny sidekick. All three romped through this script with the ease of the cast of a well-oiled Broadway show.

Rock and Doris' reign as top box-office couple was waning though, and the successful routine of the virgin and the playboy was beginning to wear thin. Nevertheless *Flowers* had an honorable run at the box office.

By then Doris was viewed by the public as a beacon of fashion. With that in mind she and I headed to a Beverly Hills hat maker to do a series of shots trying on hats. Doris was sitting and making funny faces to go with each of the eccentric bonnets she was trying on and I was photographing. We didn't realize the mirror Doris was using was just behind the immense store window of the boutique, and before we knew it a rather large and amused crowd had gathered at the window to enjoy the free spectacle. Usually Beverly Hills crowds are a blasé bunch, but this crowd kept on growing and just wouldn't go away. When we became aware of what was going on outside she simply smiled, and, going along with the gag, accentuated her grimaces to the enjoyment of the ever-growing group of onlookers outside.

At the time, there seemed to be a fair amount of balance between commercial interests and the stars' human sides. In what was already a company town, the lives of the movie people — famous, infamous, and journeymen — were intertwined with the life of the city. It seemed perhaps more open and innocent then because everything was less rehearsed and security concerns were not yet the norm. This was a good time to find subject matter for my camera in what were the first days of the celebrity identity.

One day called for shooting at the Riviera Country Club, which at the time was still a restricted club — no Jews allowed. The assistant director, who typed the call sheet for that day, had the sense of humor to write on it, "PLEASE NOTE: THOSE THAT CANNOT GAIN ENTRANCE, PLEASE GO TO HILLCREST COUNTRY CLUB AND USE LONG LENSES."

After *Flowers* there was a lull for a while, then along came *Man's Favorite Sport*. Rock was happy to be scheduled to work on *Man's Favorite Sport* with Howard Hawks, a veteran director and discoverer of beautiful young actresses of which Lauren Bacall was not the least well known. For this film he had a new discovery named Maria Perschy, a beautiful blond actress imported from Vienna. In usual Hawks style, the movie started shooting with a very loose script. He liked to make things up as he went along.

Above: Rock Hudson and Maria Perschy during a scene in *Man's Favorite Sport* filmed at Universal Studios, 1963.
Opposite: Maria Perschy between takes during the filming *Man's Favorite Sport*, 1963.

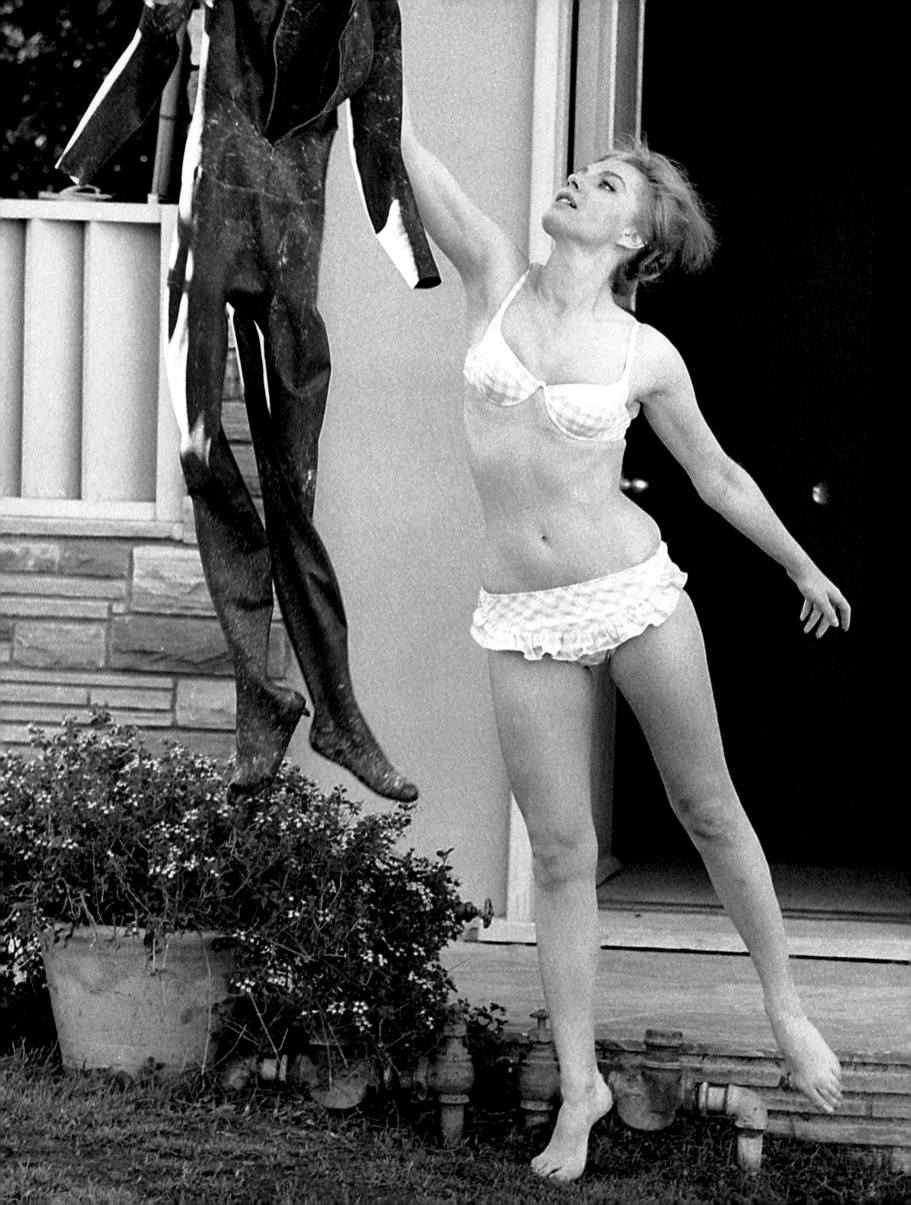

A LITTLE BRIGHTER

Doris Day, who in the early 60s was America's top box office attraction and its most popular movie star, was not above making fun of herself. Doris was perfectly comfortable putting on a clown outfit for a photo shoot; she gesticulated as if she had worn it all her life. Without Rock around, Doris didn't really clown around much off camera. She had a pretty serious attitude toward her work, and life in general, but that did not keep her from having a very pleasant disposition and always making others around her feel good. She was always gracious no matter what the situation. There are such people whose very presence seems to make life a little brighter.

Opposite: Doris Day. Above: Rock Hudson and Doris Day dressed as clowns at Universal Studios, 1960.

I AGREED TO TRY

Gail Gifford, another veteran of the Universal publicity department who had gone out of her way to help us settle into Hollywood, was assigned to work with Alfred Hitchcock on *Marnie*. This was the latest in a series of pictures that Hitchcock made for Universal. She persuaded me to see what I could come up with that would get into print and I agreed to try. After all, that's what I was there for. We started off by going to the L.A. airport to pick up Sean Connery who was coming in to co-star with Tippi Hedren.

Right from the airport we decided to give Sean a bit of a taste of California by taking him to Olvera Street, the oldest street in Los Angeles and an urban landmark full of Mexican color. We had a lunch of Mexican delicacies; I made some shots of Sean soaking up the local color. Sean talked to us about looking forward to working with Hitchcock. He has since made a reputation of being cooperative about publicity but nevertheless a private person with an immense amount of talent and charm, all which came out in the photographs.

Alfred Hitchcock was a benign autocrat who knew exactly what he wanted and how he wanted it. He usually shot only one take and always knew exactly how it would cut together with the rest. It would be said that Hitchcock did not direct his actors, he directed the audience. He seemed interested in what was happening in front of the camera only to the extent of the effect it would ultimately have on the audience. In that way, he was a master manipulator.

Above: Tippi Hedren during rehearsals on the film *Marnie*, Pennsylvania, 1963. Opposite: Alfred Hitchcock in his production office. Following spread: Tippi Hedren, Virginia, 1963.

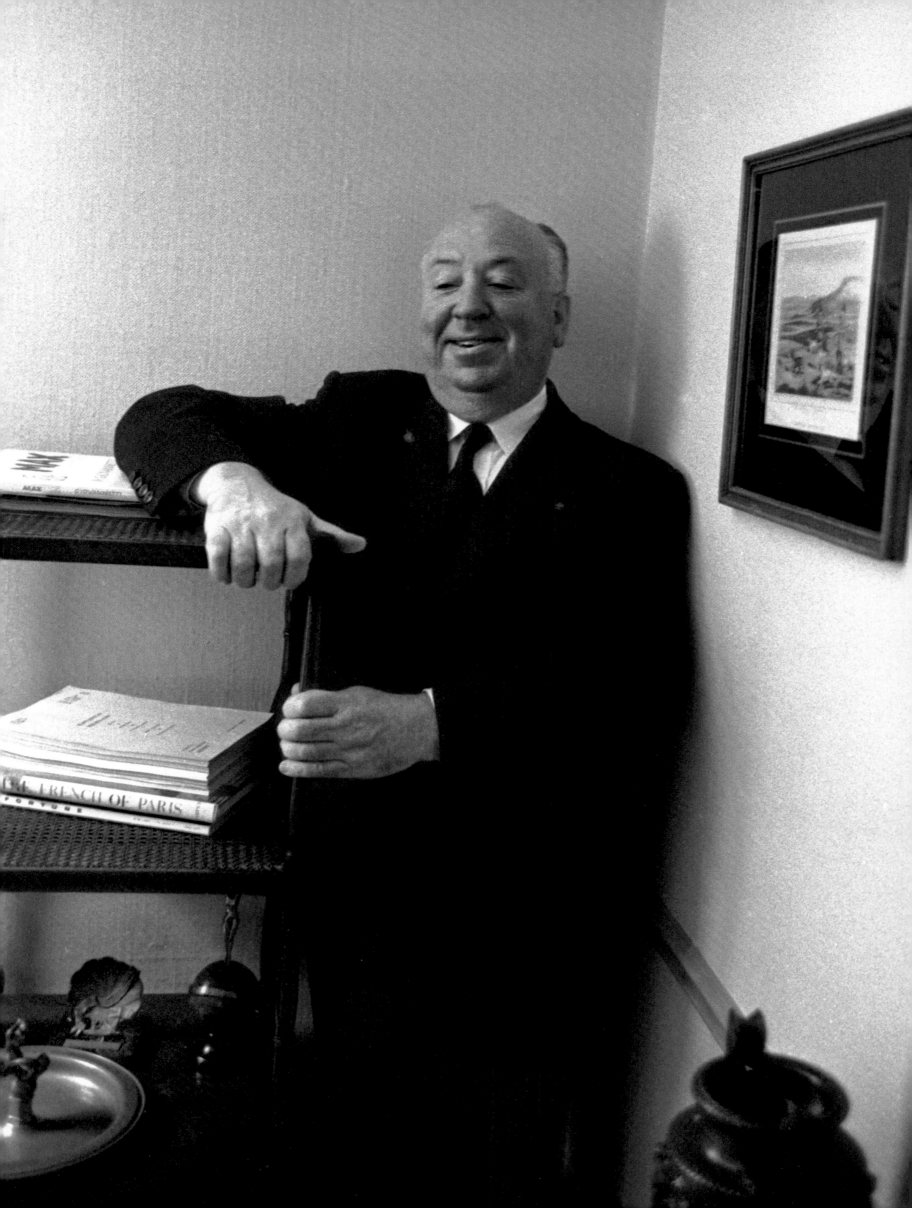

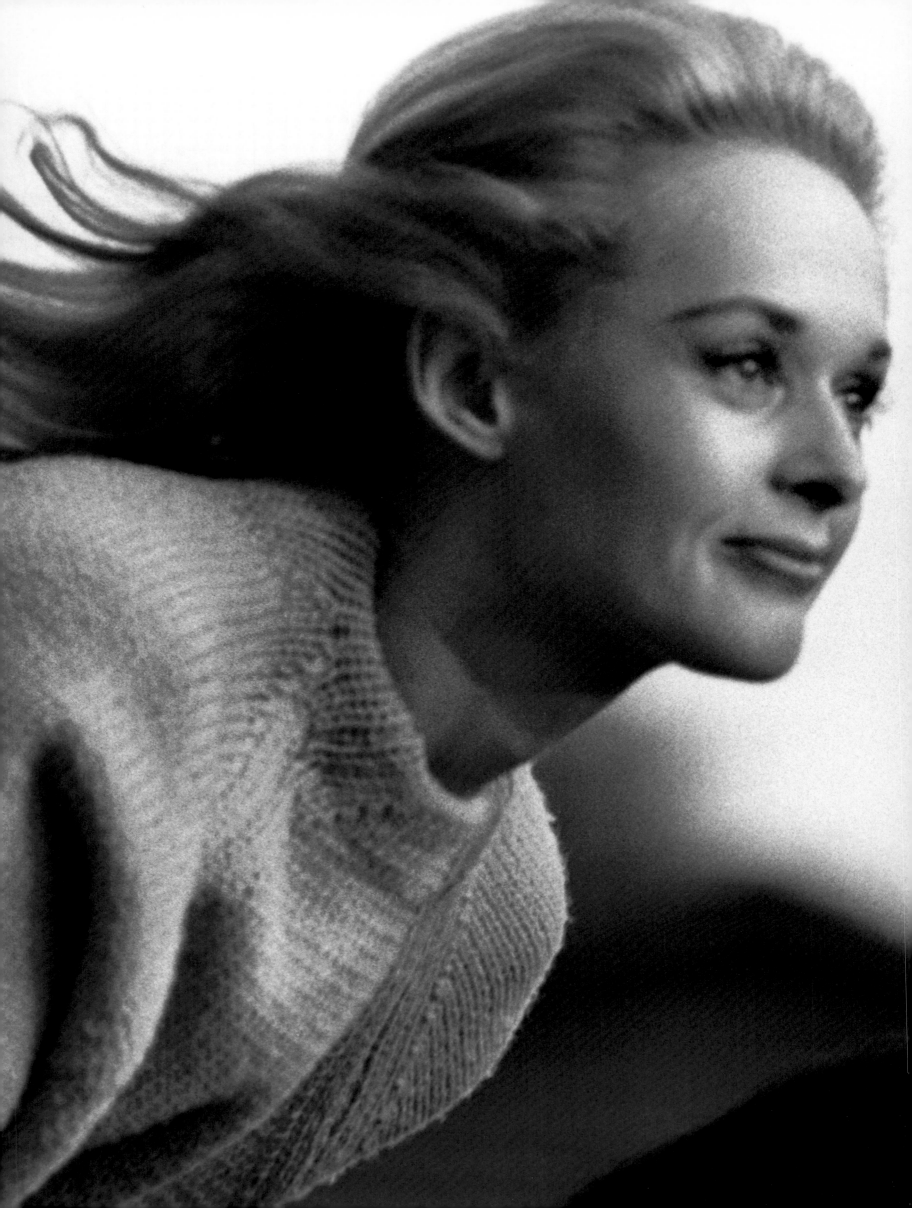

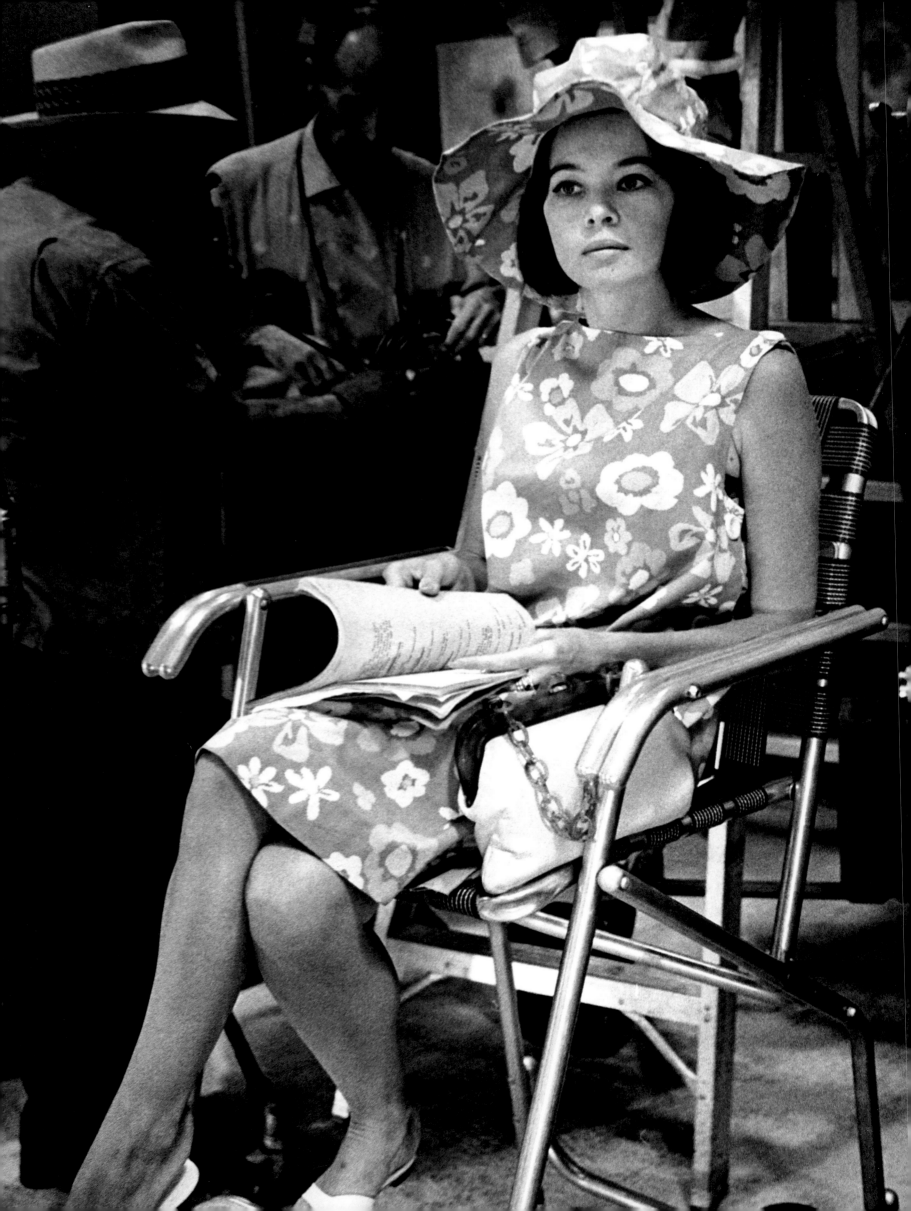

THE PERFECT SOLUTION

Ocho Ríos, Jamaica was the location where *Father Goose* was to be shot. Cary Grant joined Robert Arthur in producing the film co-starring the beautiful French actress Leslie Caron. We all stayed at a first class hotel in Ocho Ríos. Cary played a scruffy, Australian plane spotter during the war. He ends up burdened with maintaining the safety of a troupe of pre-teen children and their nurse/teacher whom he has to protect from the Japanese. Peter Stone's Oscar winning comedy script describes them as, "goody two shoes and the filthy beast."

As producer, Cary was unusually involved in checking and rechecking the dialogue with Peter Stone, making sure that it was funny enough. At one point I saw Peter tearing his hair out because, as he explained to me, Cary had just asked him to rewrite one particular line of dialogue for the sixth time. Peter finally had enough. He confided in me that he would submit the very first and original version of the line to Cary, betting that the star would not remember how the line read originally or what it was that he objected to. Five minutes later Peter winked at me with a smile while Cary complimented him on finding the perfect solution. This

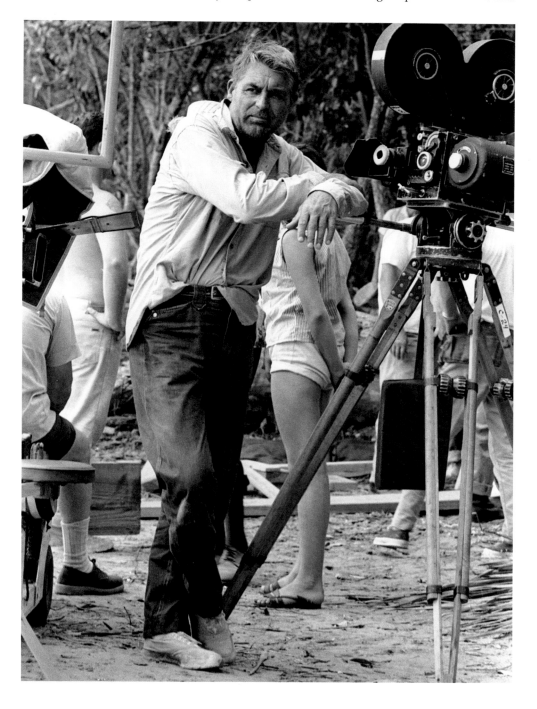

Opposite: Leslie Caron running lines with her script during a break in the filming of *Father Goose* in Jamaica, 1963.
Above: Cary Grant, contemplative, on the set of *Father Goose* in Jamaica, 1963.

incident was more telling of the pressures of producing, as Cary had an exemplary talent for suggesting valid changes.

He was also very pliable and easily took the trouble to satisfy my needs for a good photograph. One day we were having a buffet lunch arranged by the caterer on tables set up in the forest. Toward the end of the meal I saw Cary count the plates that were left on the buffet table, and I asked one of the production assistants what that was all about. He told me that the production paid the caterer on the basis of the number of plates used. He would put out a stack of so many clean plates and by counting the amount of clean plates left he would know just how many meals he had provided. One day I captured a glimpse of his new role and the weight of his responsibilities as he sat alone in a corner, contemplative.

The two French women on the location, Leslie Caron and Sylviane, my patient wife who had come on this location with me to act as my assistant, became quick confidantes and accomplices. Leslie, a dancer, was beautiful and quite graceful, moving like a cat. She was also as unpredictable and strong-willed as any feline. She always knew exactly what she wanted and how to get it. And she was an absolute dream to photograph, no directions needed. Even between Jamaica's tropical vegetation and trees she knew exactly which position to take to give me a pleasant rush of excitement as I looked through the viewfinder.

All in all, Jamaica was a long vacation. A beautiful island. Lots of lazing around on the clear, white-sand beaches and private coves. We all had a big laugh when Cary was refused entry to a restaurant for not wearing a tie. Such things did happen even to the man considered to be the world's most elegant.

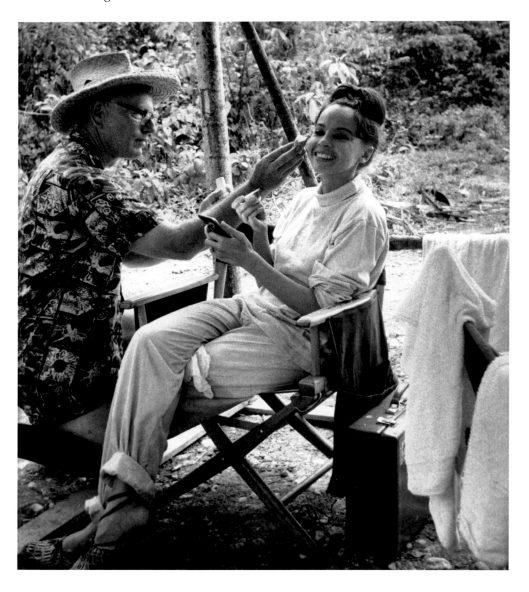

Above: Leslie Caron between takes on the set of *Father Goose*, Jamaica, 1963. Opposite: Cary Grant, thoughtful, away from the set of *Father Goose*. Grant was a first time producer and dealt with more than acting on the film, 1963.

TO Leo —
THOUGHTFULLY
and with
appreciation
Clay

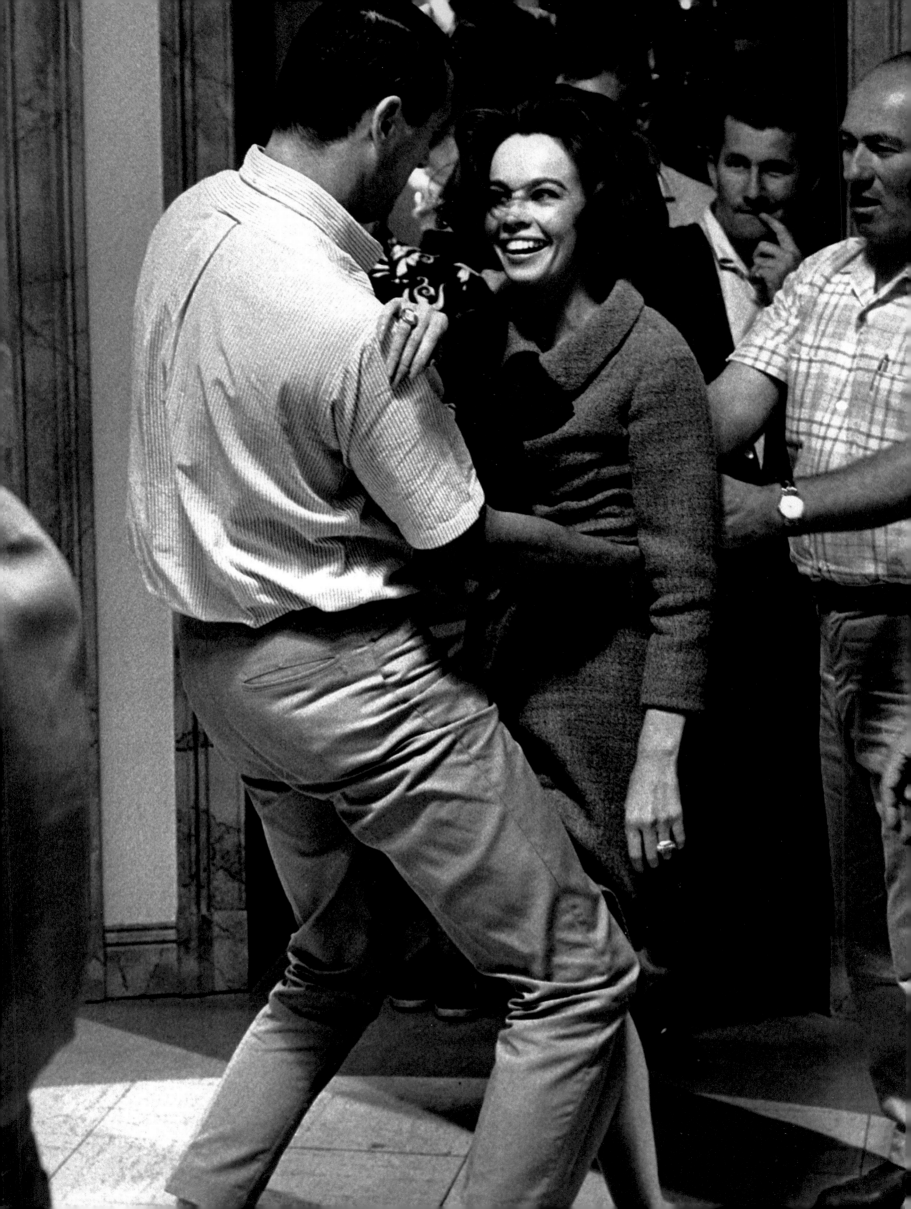

AT HOME

Upon returning to Hollywood, we went right into another film with Leslie Caron, this time under the direction of Mike Gordon and co-starring Rock Hudson and Charles Boyer. When Sylviane was around, the dressing rooms sounded more like a Parisian boudoir than an L.A. set. Leslie and Rock got along famously, Boyer the serious, veteran professional stayed aloof toward the practical jokes Leslie and Rock played on each other. We spent a few Sunday afternoons at Leslie's house for some "at home" shots with Warren Beatty, Leslie's paramour at the time. Photographing Leslie was just as much a kick in Brentwood as it had been in Jamaica.

Opposite and above: Rock Hudson and Leslie Caron in *A Very Special Favor*, Universal Studios, 1964.

THE EFFORT SHOWS

Stanley Shapiro was a prolific screenwriter who had supplied the scripts for such pictures as *Pillow Talk*, *Lover Come Back*, *That Touch of Mink*, and a few others. He had given birth to a very funny comedy script called *Bedtime Story*, this time for Marlon Brando and David Niven.

Unfortunately Marlon's genius did not carry over to comedy. It became sadly evident as the days passed that you can take comedy just too seriously. "Funny" is not something you labor to be, and when the effort shows, so goes the comedy.

Marlon tried too hard and it showed, Niven on the other hand was an old hand, always pleasant, as are most stars when you point a camera in their direction. It's when you call on their personal time and effort, extracurricular, that you must be careful not to be imposing. This is when you need to count on the friendship and goodwill built with these professionals.

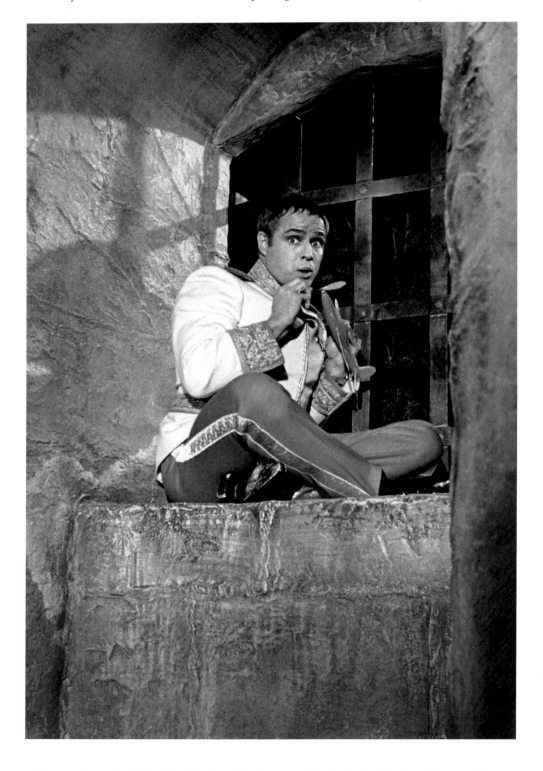

Above and opposite: Marlon Brando tries his hand at comedy in the film *Bedtime Story*, Hollywood, 1963.

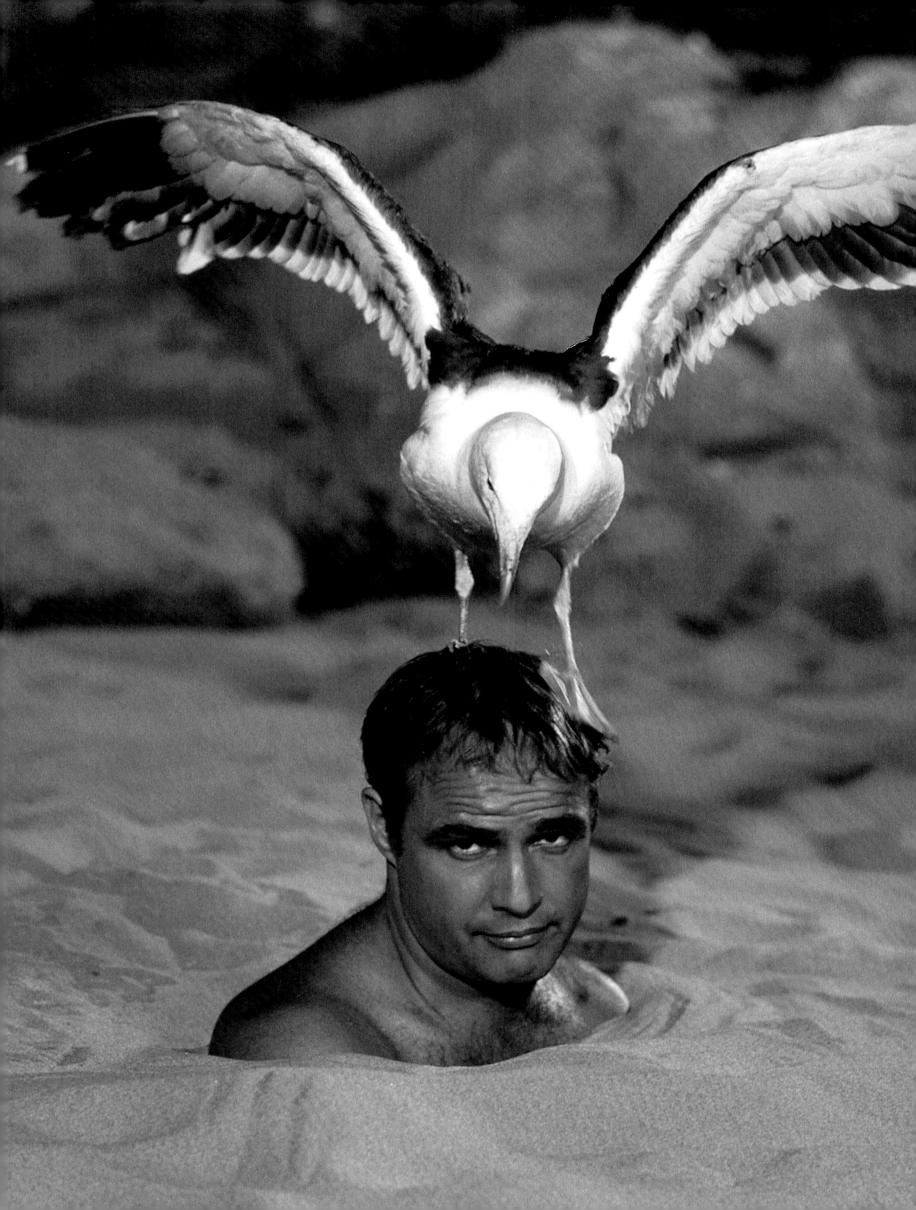

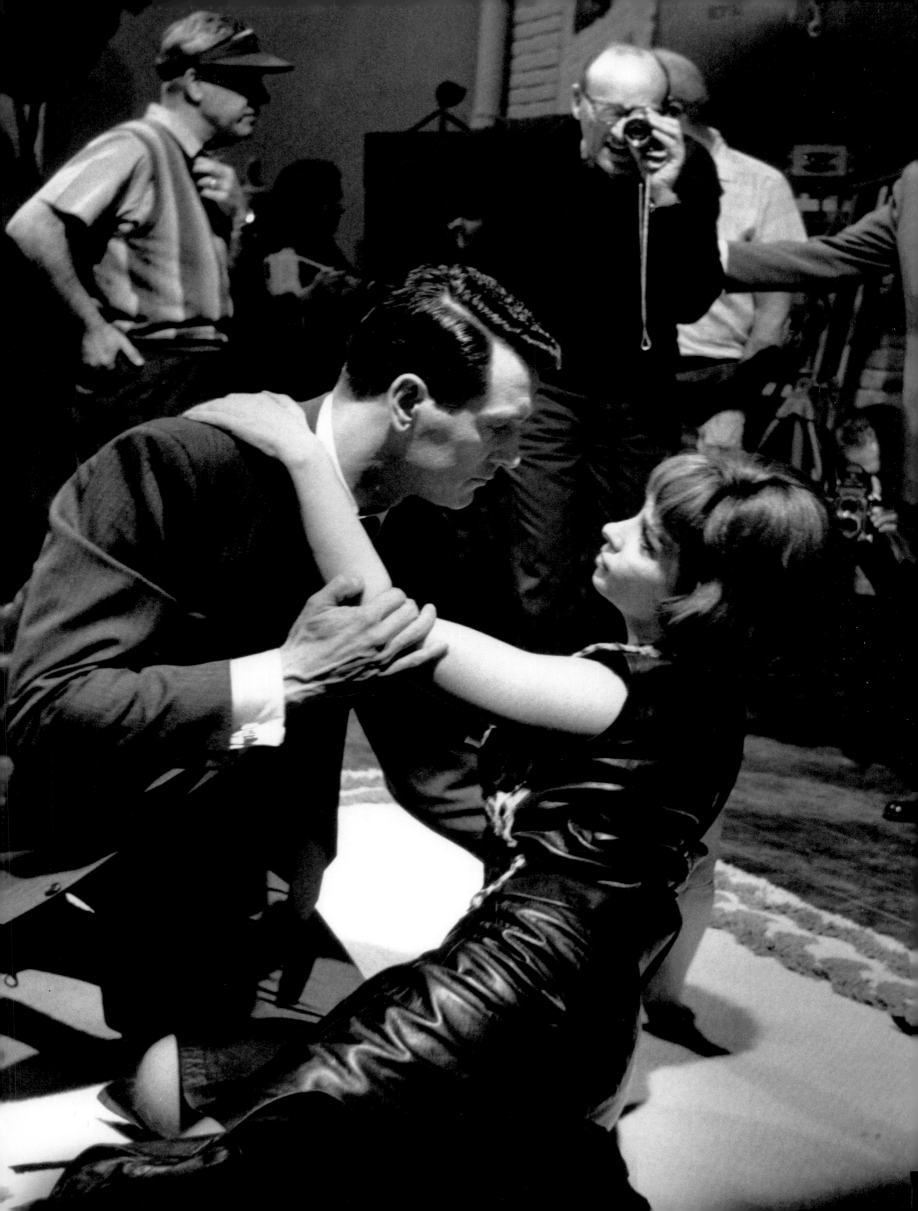

I FELL INTO STEP

In 1964, Gina Lollobrigida rented a house in Beverly Hills and prepared to spend a few months in Hollywood. By this time Gina's English had improved markedly and she had come to star with Rock Hudson in another comedy, *Strange Bedfellows*.

Now, a few years after Italy and *Come September*, Gina and Rock rediscovered the fun-loving atmosphere from their earlier collaboration. In the interval between the two pictures, Gina had developed her own skills as a photographer. She spent a lot of her time taking pictures. She and Rock had to learn a dance routine for this picture, so they spent a lot of time rehearsing. Gina couldn't get Rock to stop clowning around.

From observing these two, it seemed Gina — who was married and quite alien to promiscuity — felt especially safe with Rock. This was very different from her experience with Yul Brynner, who had come on to her very hard the first day. Both Rock and Gina periodically threw parties at their respective homes. I was, and still am, an uncomfortable partygoer, maladapted to large social settings (without a camera), yet felt I should not avoid the social whirl that these parties represented. It so happened that Ed Muhl, the head of Universal Studios, was a similarly reluctant partygoer. As a result we would often find each other in an out-of-the-way corner drink in hand. We would sit and solve all the problems of the movie industry as well as all the problems of the world at large. These were open-ended conversations that would continue from party to party.

A few days after *Bedfellows* finished shooting, Gina asked Sylviane and me up to the house in Beverly Hills. When lunch was over she handed me three scripts, all bearing the same title and told me the following story. MGM had asked her to star with Tony Curtis in a film to be made of Romain Gary's novel *Lady L.* to be directed by George Cukor. They had given her a script by Robert Anderson, which she agreed to do. Tony Curtis had also agreed. Unfortunately, George Cukor disagreed and now refused Anderson's script. Despite the fact that shooting was scheduled to start within a few weeks, Cukor had persuaded MGM to hire two other writers to write screenplays for this movie, both very distinguished. None of the three scripts satisfied the three people involved, Cukor, Gina, or Tony.

The reason that Gina told me all of this was that she wanted me to help her put together one script made up of all the "good scenes" from each of the scripts. An impossible job, as each writer had a different style and sequencing…but when a friend asks a favor, and such an ego-stroking one at that, you don't argue, you do your best. It was a new exercise for me and I was glad when I delivered what felt like a professional, if inelegant, draft. Once it went to Ed Henry, Gina's agent (one of Hollywood's most powerful), I decided that discretion was the better part of valor and disappeared. The experience of crafting the story stayed with me.

Despite the fact that MGM had already spent millions on sets and costumes, when George Cukor had himself admitted to a hospital, the picture was shelved. A couple of years later it was finally made with a brand new script, a different director, and Sophia Loren and Paul Newman. All that remained was the title, *Lady L.*

A couple of days later I was walking through the lot on my way back to the *Bedfellows* soundstage when I ran into Ed Muhl who happened to be heading for the same place. He was on his way to the set to talk to Rock. We continued on together, and when we arrived he went into Rock's trailer and I went to the closet that the Property Department put at my disposal, and locked up my cameras for the night.

On leaving the stage, I found Ed Muhl who had finished his meeting with Rock, on his way back to his office. I fell into step with him again and we finished the conversation we had started on the way to the stage. I mentioned that I was thinking of moving back to Europe. Actually Sylviane had been bugging me for a while on this subject. Ed inquired why I would want to do that, and wasn't I happy in Hollywood. I explained that I could do the same thing that I was doing here, in Europe, make just as much money, and life would be more interesting.

Rock Hudson and Gina Lollobrigida embrace in *Strange Bedfellows*, Universal Studios, California, 1964.

He came back with "What do you want to do?"

I said, "I thought, being that I was in the middle the world's film capital, that maybe I could somehow get involved in actual filmmaking."

"Have you ever thought of producing?" He asked.

"I've thought about it," I admitted, "But that's all."

He said, "Come and have lunch with me tomorrow."

I said, "Not tomorrow, its Yom Kippur, how about Thursday, the day after."

"Fine," he said, "I'll see you then."

That day I joined Ed Muhl at his table in the corner of the commissary while everyone from publicity who was there gaped open-mouthed at this unusual pair having lunch. No sooner was I seated then the friendly studio head opened the conversation by inquiring, "How much do you make a year taking pictures?"

"I average somewhere around $25,000," I answered.

"Okay," he said, "we'll start you at $25,000. I'll have the legal department draw up a contract. Check with them and look around and see if you can find yourself an empty office."

And so my career as a special photographer came to an end and a fresh, new Hollywood producer was born. All my stills, prints, cameras, contact sheets, logs, and other equipment went into boxes and what became long term storage until we opened them up a few years ago after 30 years.

Within a year I finished my first movie as a producer, *Gambit* starring the biggest female star of the moment, Shirley MacLaine, with Michael Caine…

But that's another story.

FILMS PRODUCED BY LEO FUCHS

GAMBIT (1966)

THE SECRET WAR OF HARRY FRIGG (1968)

RUBA AL PROSSIMO TUO (1969)

JO (1971)

LA MANDARINE (1972)

LA FEMME EN BLEU (1973)

L'IMPORTANT C'EST D'AIMER (1975)

CATHERINE ET CIE (1975)

LES PASSAGERS (1977)

PLEIN LES POCHES POUR PAS UN ROND… (1978)

SUNDAY LOVERS (1980)

LE GUÉPIOT (1981)

JUST THE WAY YOU ARE (1984)

MALONE (1987)

Opposite: Michael Caine starred in the first film Leo produced, *Gambit*, 1966. Following spread: Leo Fuchs and Gina Lollobrigida during a photography session. Lollobrigida is an accomplished photographer and sculptor.

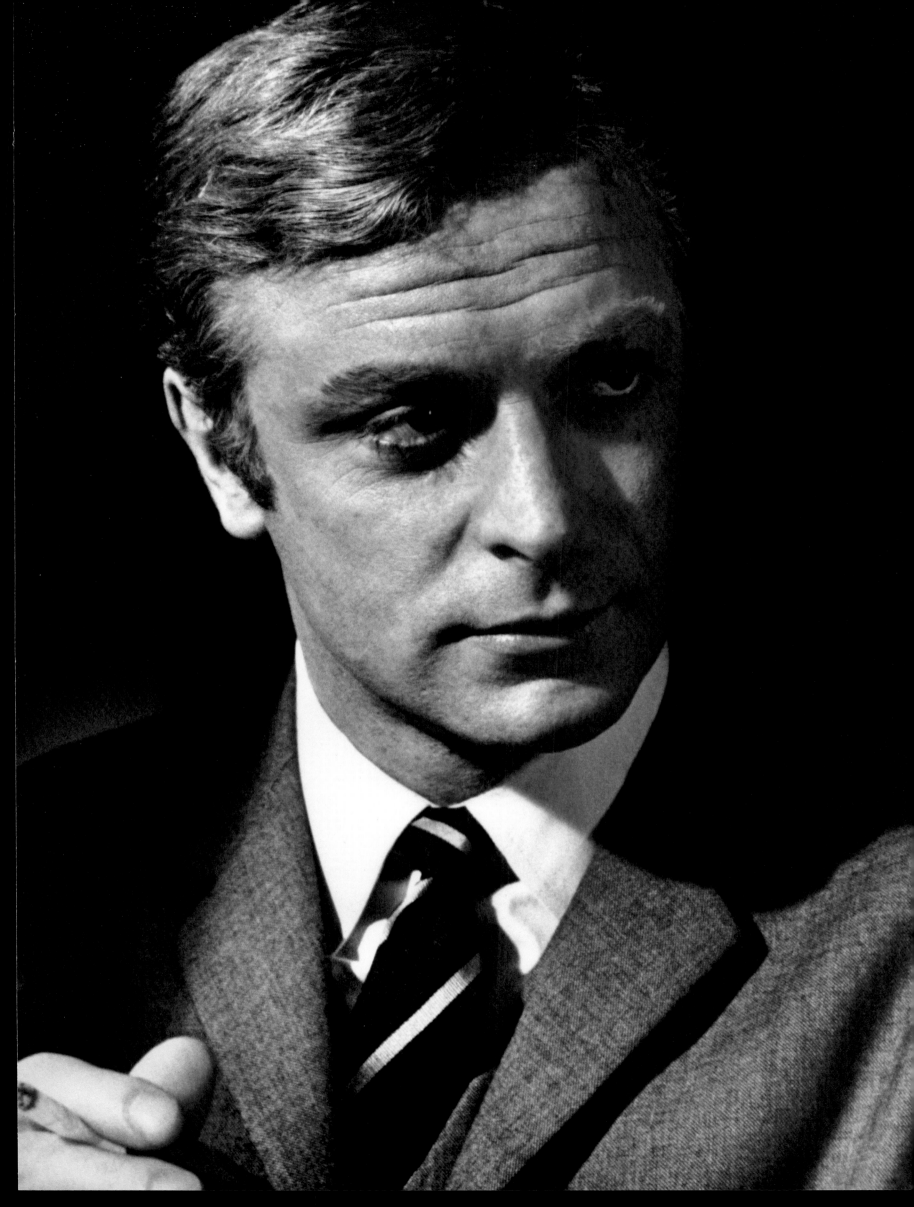

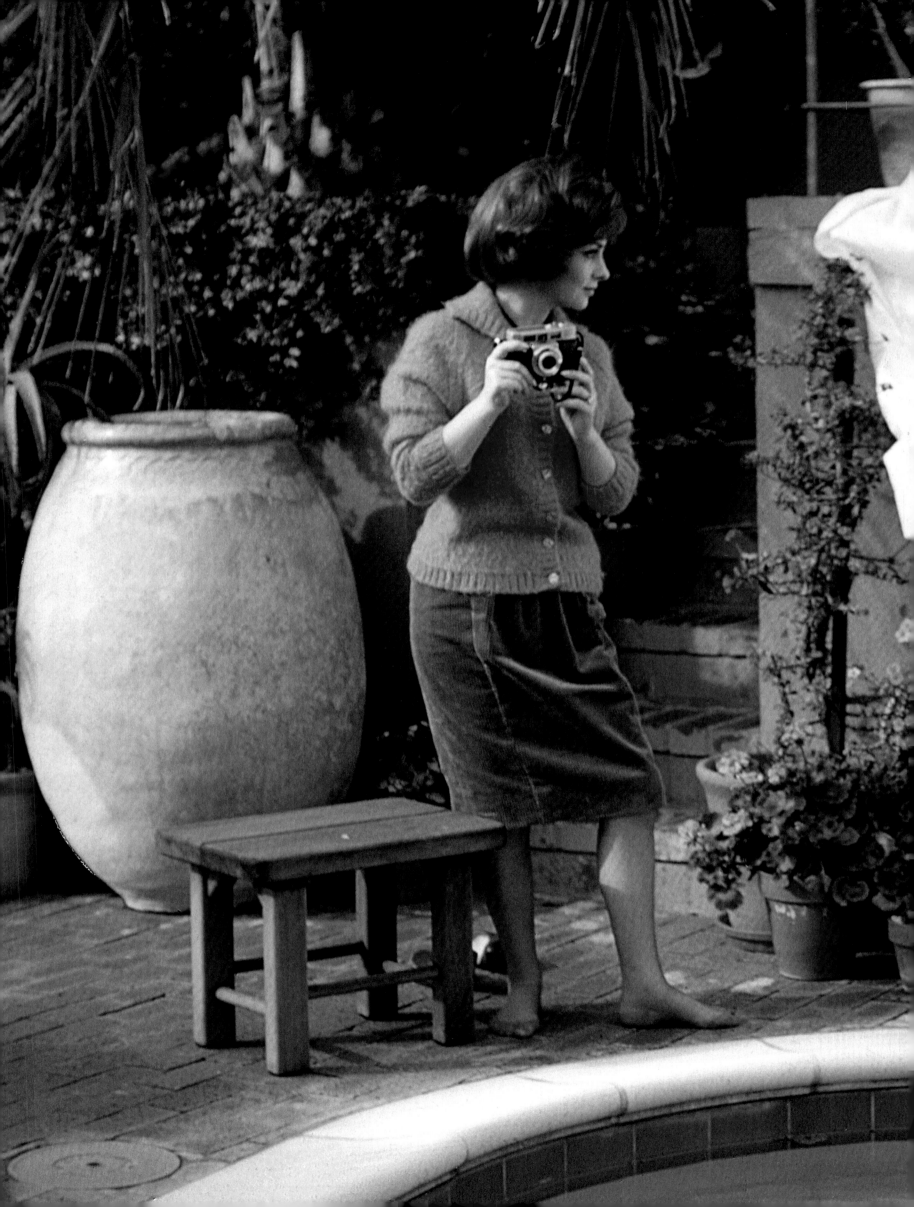

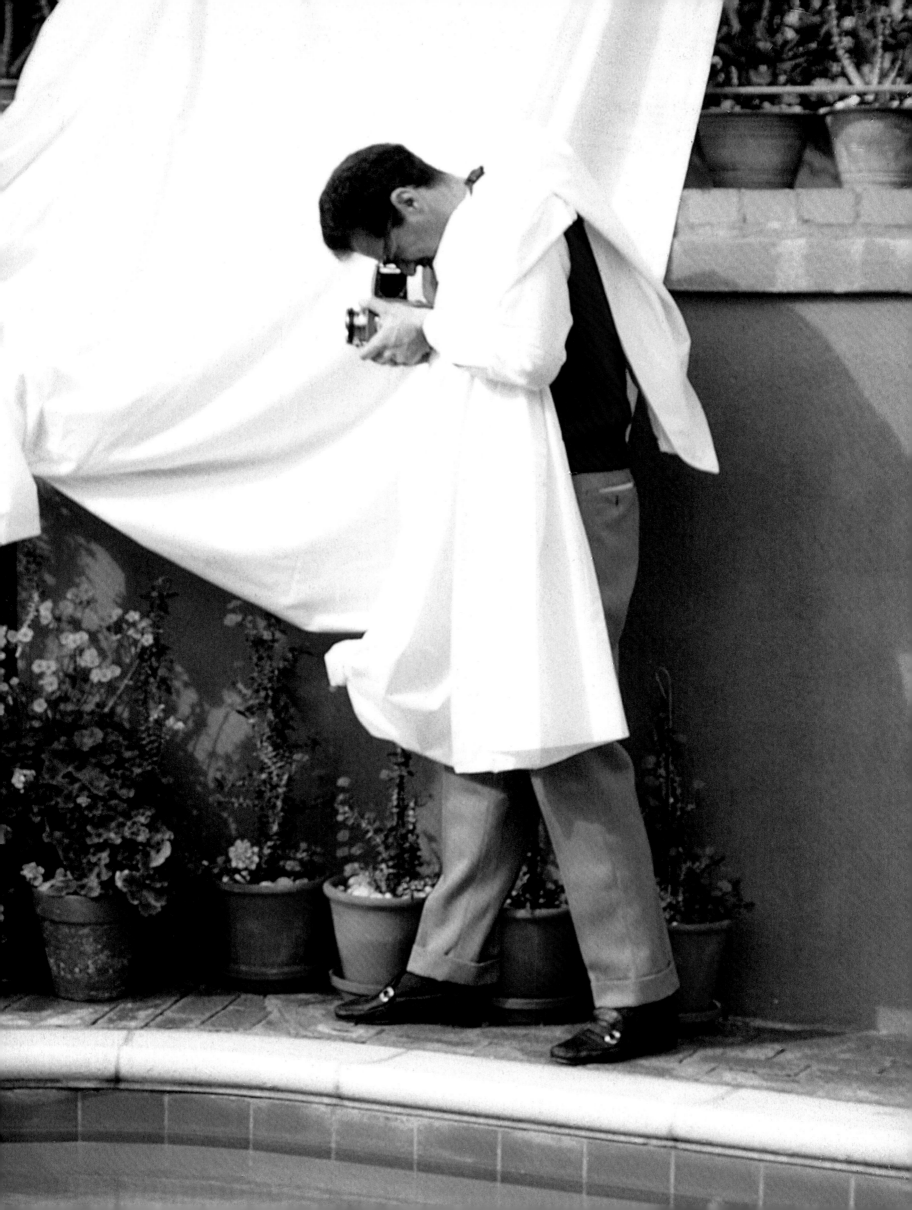

A LONG JOURNEY HOME

Just today a young actor arrived, quite unexpectedly, at my house by the sea in Golden Beach to say goodbye and give me a book by Hunter S. Thompson, titled *Gonzo*. He wanted to say thank you for all the photographs and films we did together this past winter before driving up to New York City with only a one-night stopover.

"Do you have any good music with you?" I asked.

"Yes, I've downloaded a lot of new things, but after eight hours the music can get a little stale, so I have something by Dostoyevsky on CD."

I responded, "Well, let me show you some photographs by Leo Fuchs for a few minutes. They are in a book about his work as a photographer and a producer, as seen from behind the scenes of the film world. You might recognize some of these actors and directors. Even though you only have some 24 years on you, I know you still watch older films on DVD or Turner Classic Movies." We looked together at a draft of Leo's book *Special Photographer* and lingered over the photos of Paul Newman. The young actor visiting me looked a lot like him. I told him how I had once photographed Paul Newman years ago at the Palm Beach International Raceway in Florida. My dad had been ill, so I had stopped working. But I accepted this one assignment from *Esquire* to photograph Mr. Newman for the cover. My mom always said to my dad when he was gardening with his shirt off, "Al, you look just like Paul Newman." Looking at these older photographs of Leo's, I can't help but think he was doing all this at a time when actors weren't afraid to show the pathos and complexity that went along with their art of making films.

"It was a wild ride through these pages," I told him, since I always believed this book wasn't just about the film world—but also about a son's journey to try and understand his father's life through the images taken when Alexandre was still a young man. I smiled as I saw the innocent look in the young actor's eyes. He responded to the photographs as I always did, looking at them over and over again. We shared that feeling between a smile and a tear, remembering things forgotten and one's own beginnings. This young actor's family were refugees from Poland, and he lost his mother at a very young age. He was looking at Leo's photographs of the actors his mom and dad grew up watching, hoping their new life in America would live up to the dream they saw in the movies being made here. For me, these photographs represented my first date at the movies without my grandparents as chaperones and the beginnings of why I wanted to take photographs and make films. With this book, Leo joins the ranks of John Hamilton (John Ford's favorite on-set photographer), Sid Avery (George Stevens' photographer of choice on films like *Giant*), and Phil Stern (The Rat Pack's pal). The naturalness of their photographs can only be compared to Imogen Cunningham's informal portraits of Spencer Tracy, or Cecil Beaton's portraits of the young Marlon Brando, with his unruly hair and all wrapped up in an overcoat like a blanket. "One could say," I told this actor, "that these photographs of Leo's were the 'raw deal,' or as they like to say in Hollywood, 'the real deal.'" Like his counterparts, Leo was an artist of persuasion. We are not talking about a group of guys at P.J. Clark's drinking Wild Turkey bourbon and betting on the next race at Belmont—we are talking about men, working alone with only their cameras and the whim of a chance meeting. Leo was in a class by himself, and he locked these remembrances on Agfa paper away in a trunk when he moved with his family back to Paris. At last they have been rescued by his son Alexandre, like lost treasures buried deep at sea.

As I looked up from these photographs, the actor sitting next to me in baggy shorts and a tank top seemed lost in Leo's world. You could hear his heart beating louder, showing his own excitement to be on his way to New York City and the chance to sow his wild oats in the world Leo made so magical in his photographs. It's like when you first open your eyes in the morning and see a loved one, or the sea, or a garden filled with flowers and children's broken toys. I said, "It's funny what photographs can do. They can make you an imaginary promise, and they can seduce you as much as any tearjerker or comedy. His photographs reach outward and give you the pleasure of sharing someone's life, leaving you still hungry for every answer to every question of how and why." — *Bruce Weber, Golden Beach, Florida, 2010*

Leo Fuchs on the set of *Gambit*, the first film he made after leaving photography to be a producer in 1966.

THE NUN'S STORY

DIRECTED BY FRED ZINNEMANN, STARRING AUDREY HEPBURN,
ITALY, BELGIUM, AND THE BELGIAN CONGO, 1958

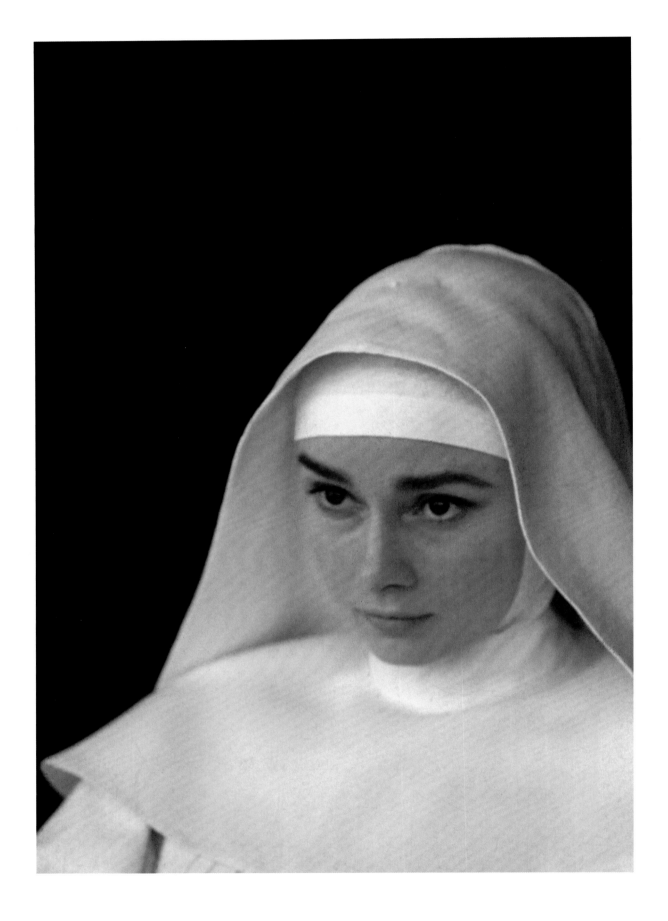

Above and opposite: Audrey Hepburn in costume during the filming of *The Nun's Story* in the Belgian Congo in 1958.

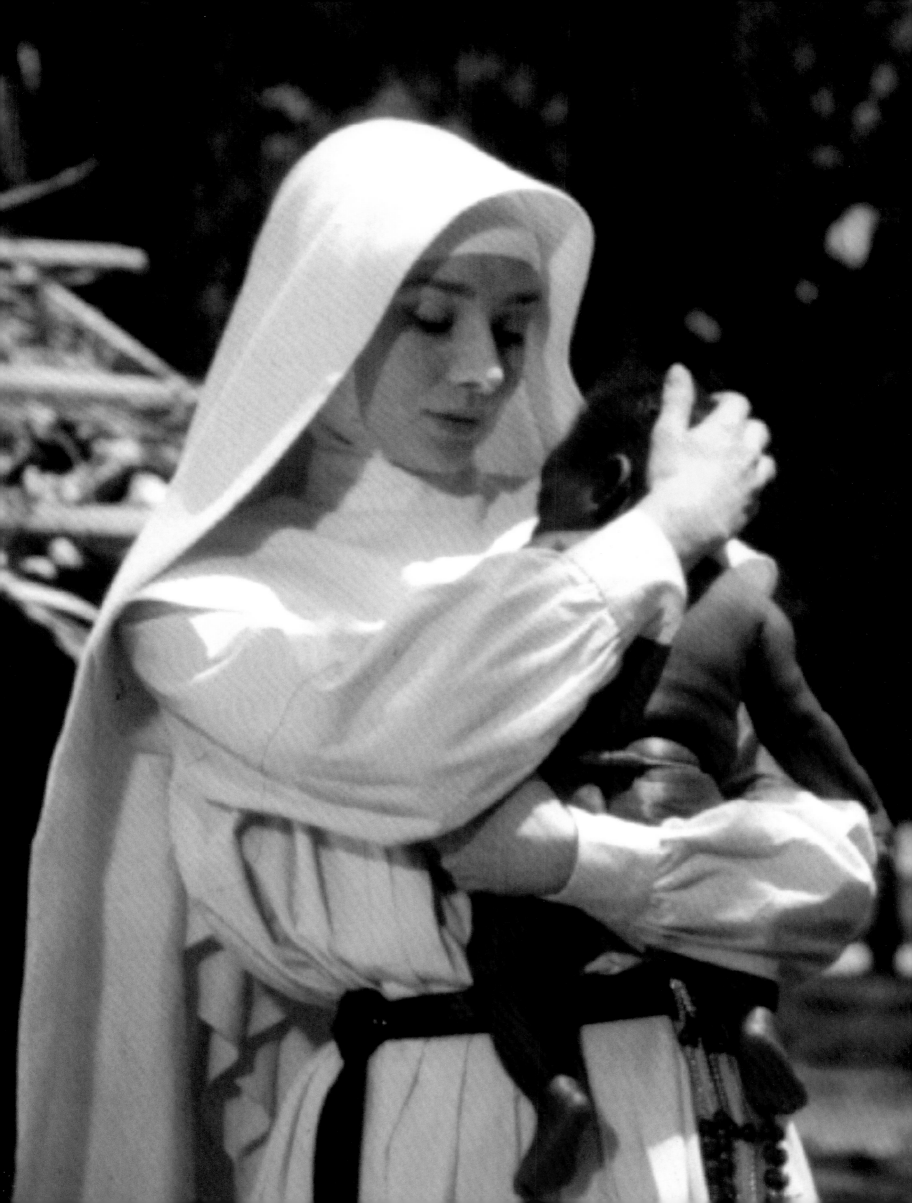

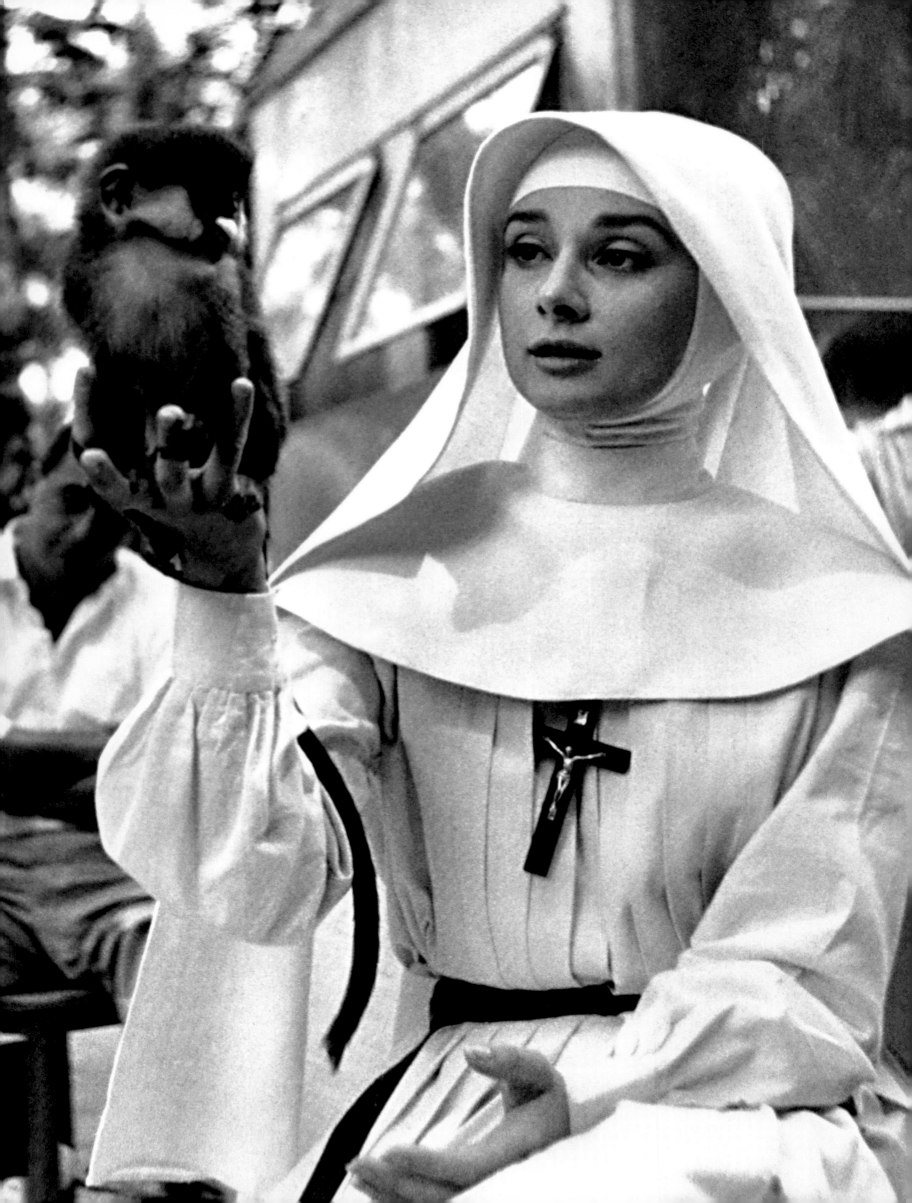

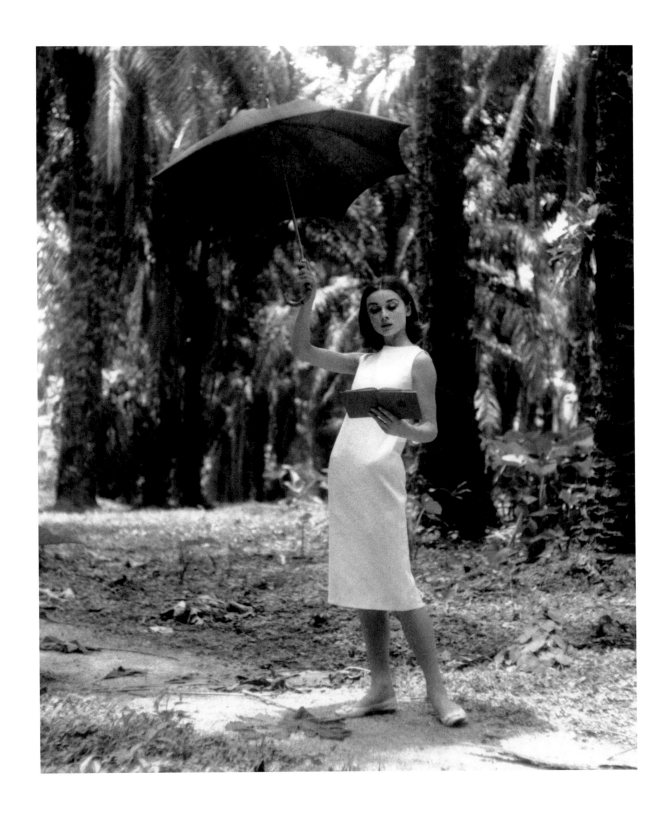

Opposite, above, and following spread: Audrey Hepburn off the set in the Congo in 1958 during the filming of *The Nun's Story*.

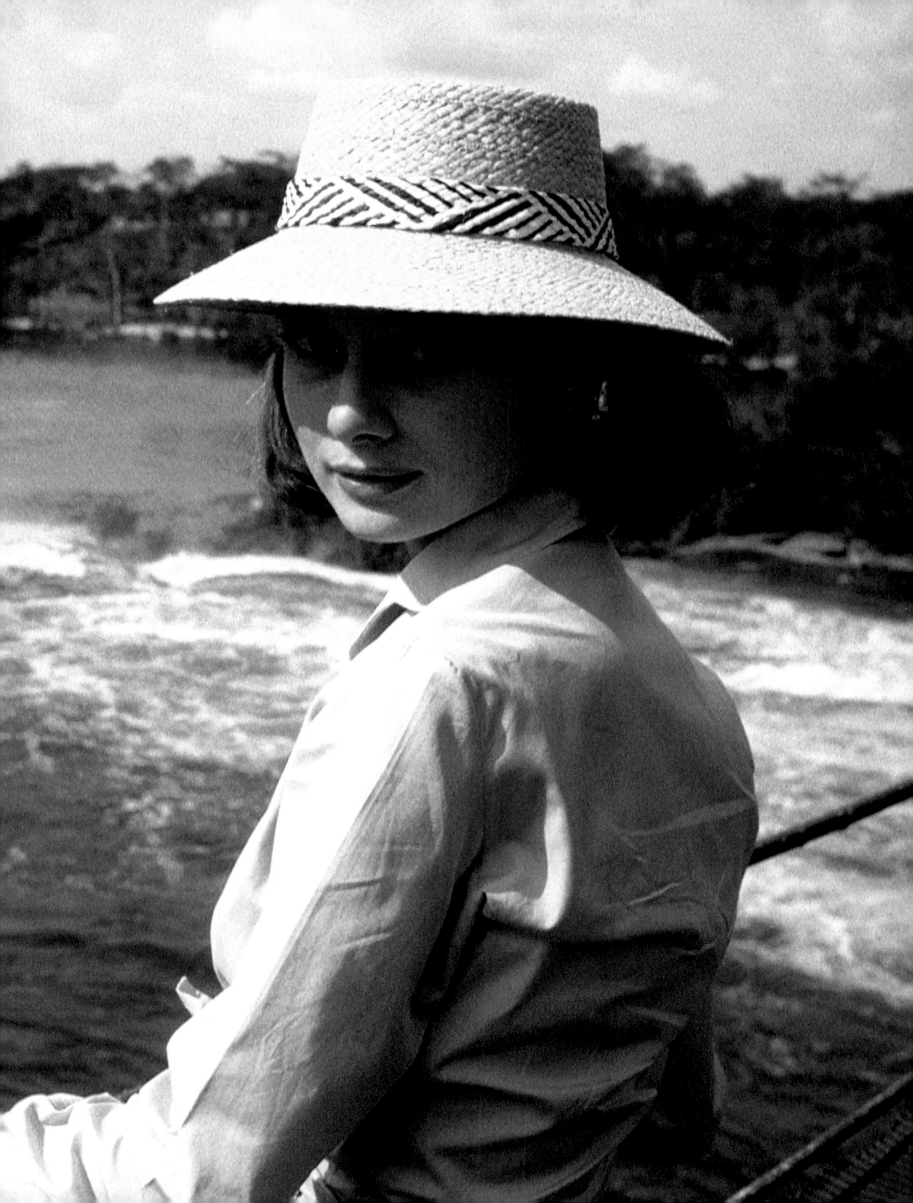

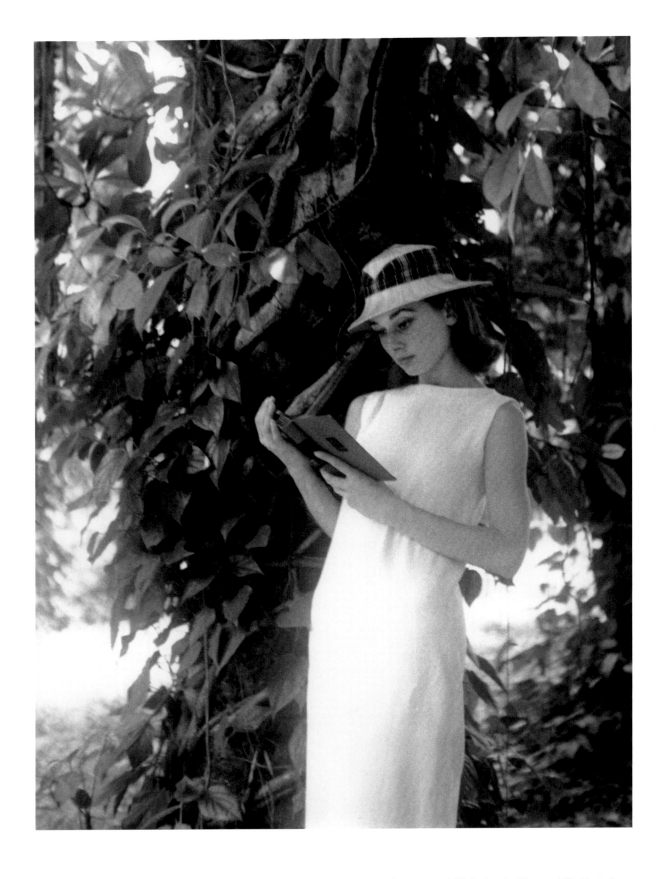

Above and opposite: A photogenic Audrey Hepburn enjoys some leisure time in the Congo in 1958 during the filming of *The Nun's Story*.

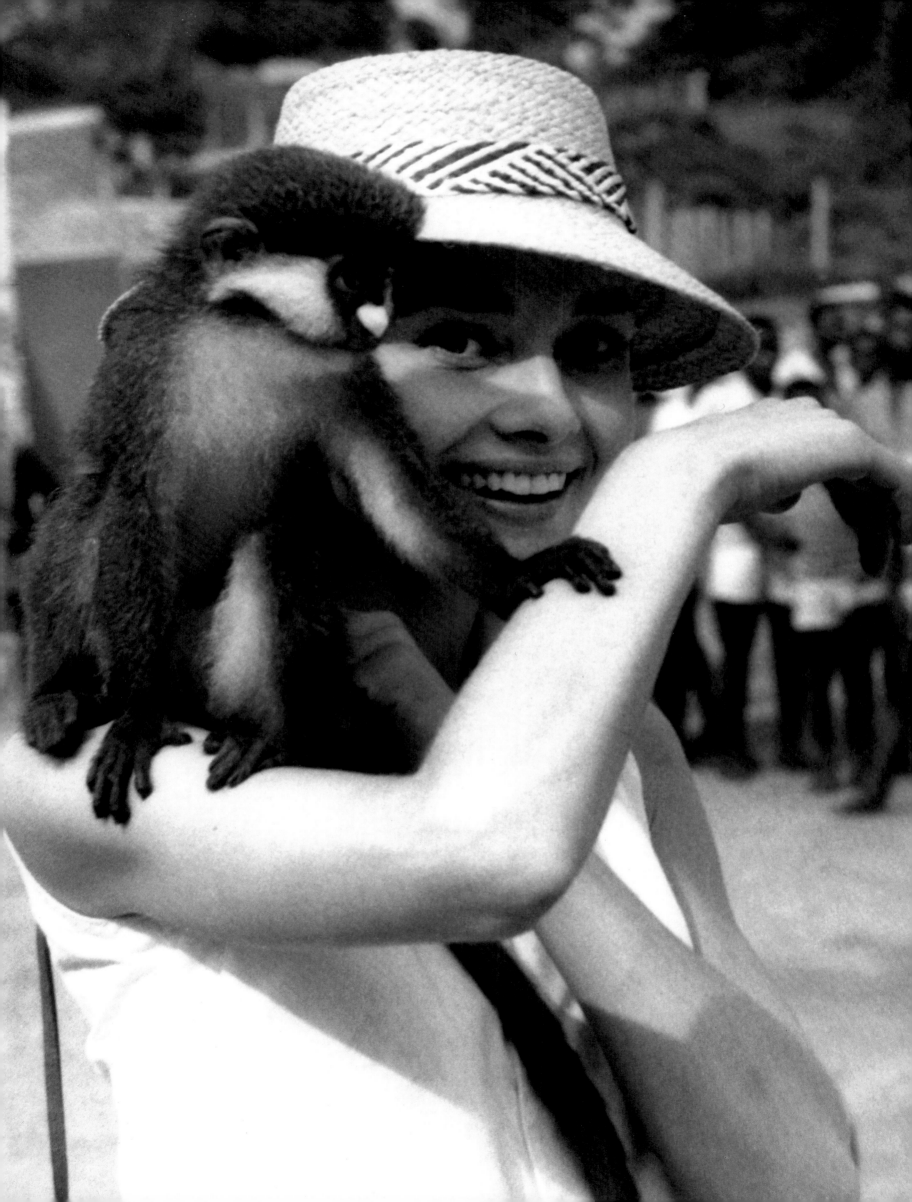

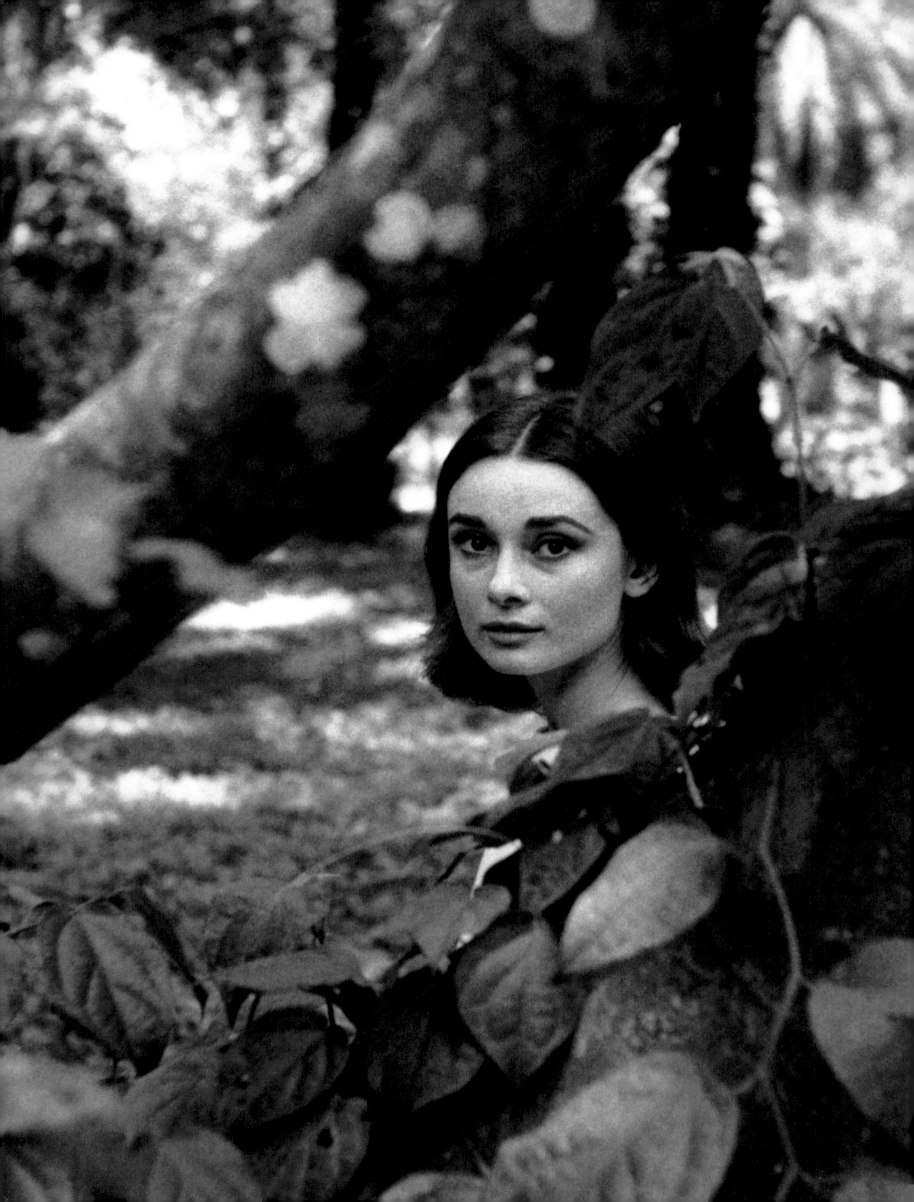

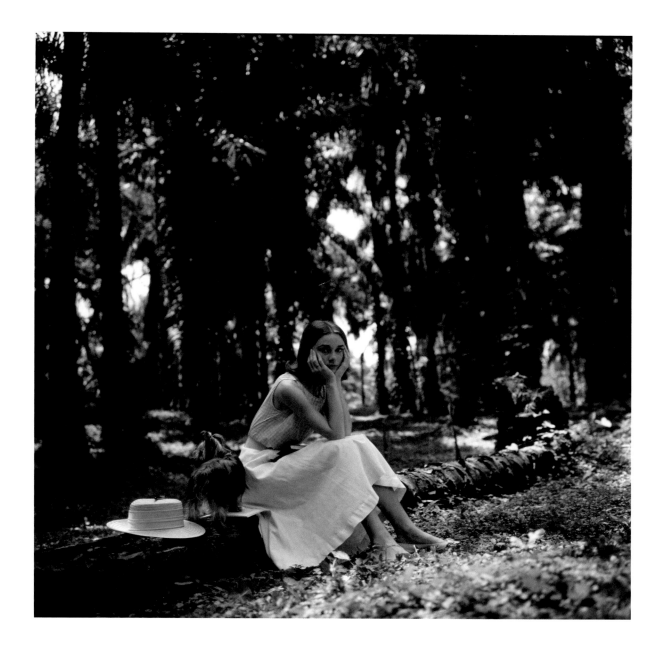

Above and opposite: Audrey Hepburn poses in the lush rainforest of the Congo in 1958 during the filming of *The Nun's Story*.

EXODUS

DIRECTED BY OTTO PREMINGER, STARRING PAUL NEWMAN, SAL MINEO, EVA MARIE SAINT, AND LEE J. COBB, ISRAEL AND CYPRUS, 1959

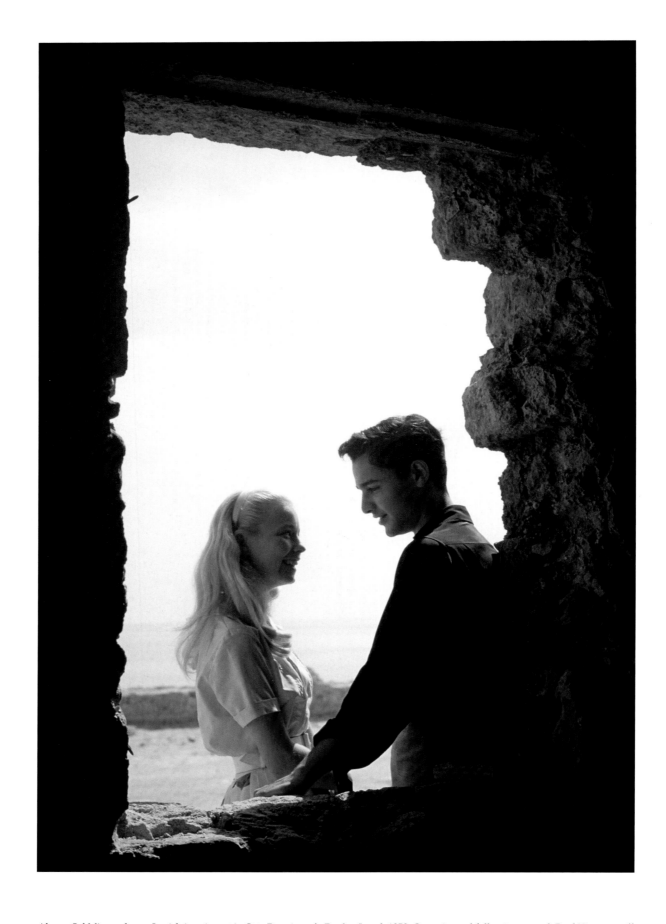

Above: Sal Mineo plays a Jewish immigrant in Otto Preminger's *Exodus*, Israel, 1959. Opposite and following spread: Paul Newman off the set while visiting the Israeli countryside and the ruins of Masada National Park, Israel, 1959.

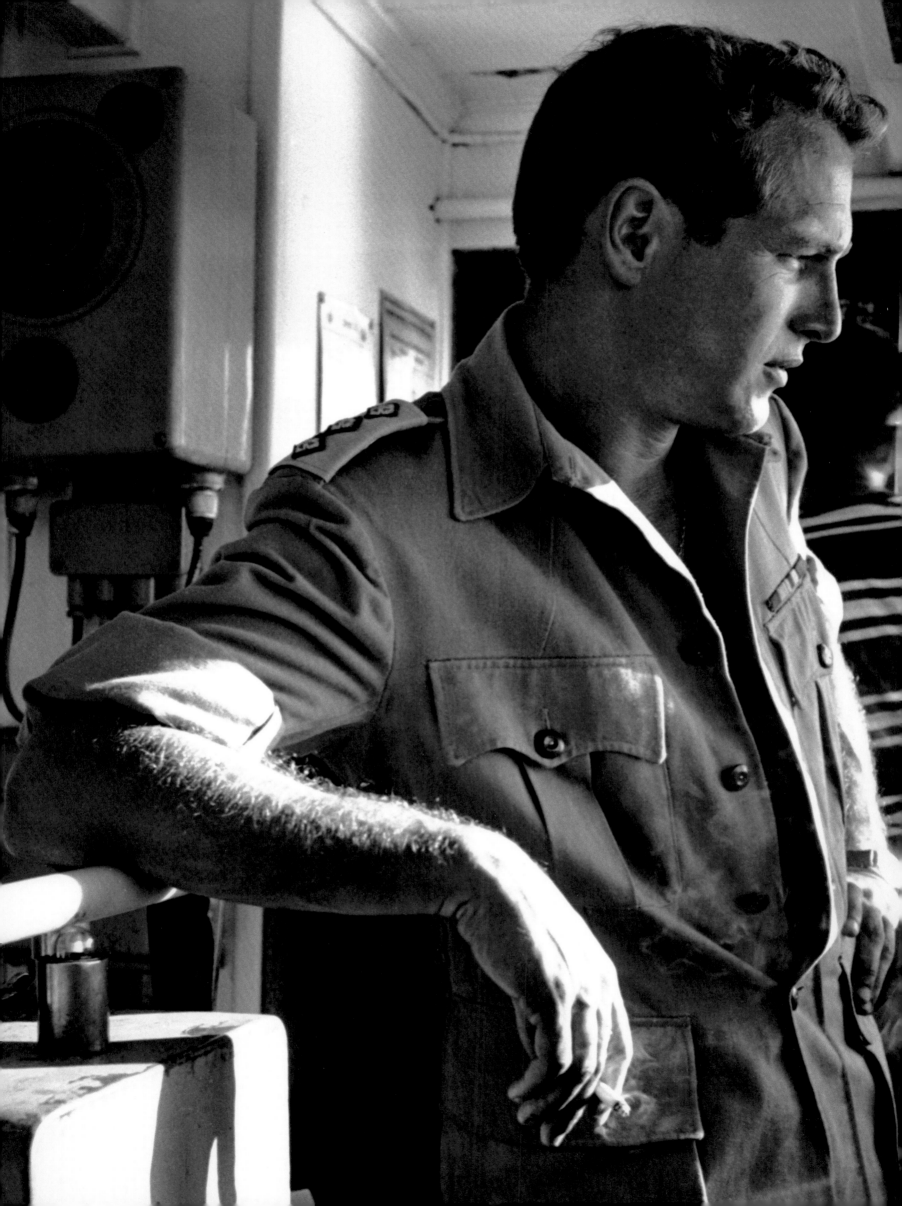

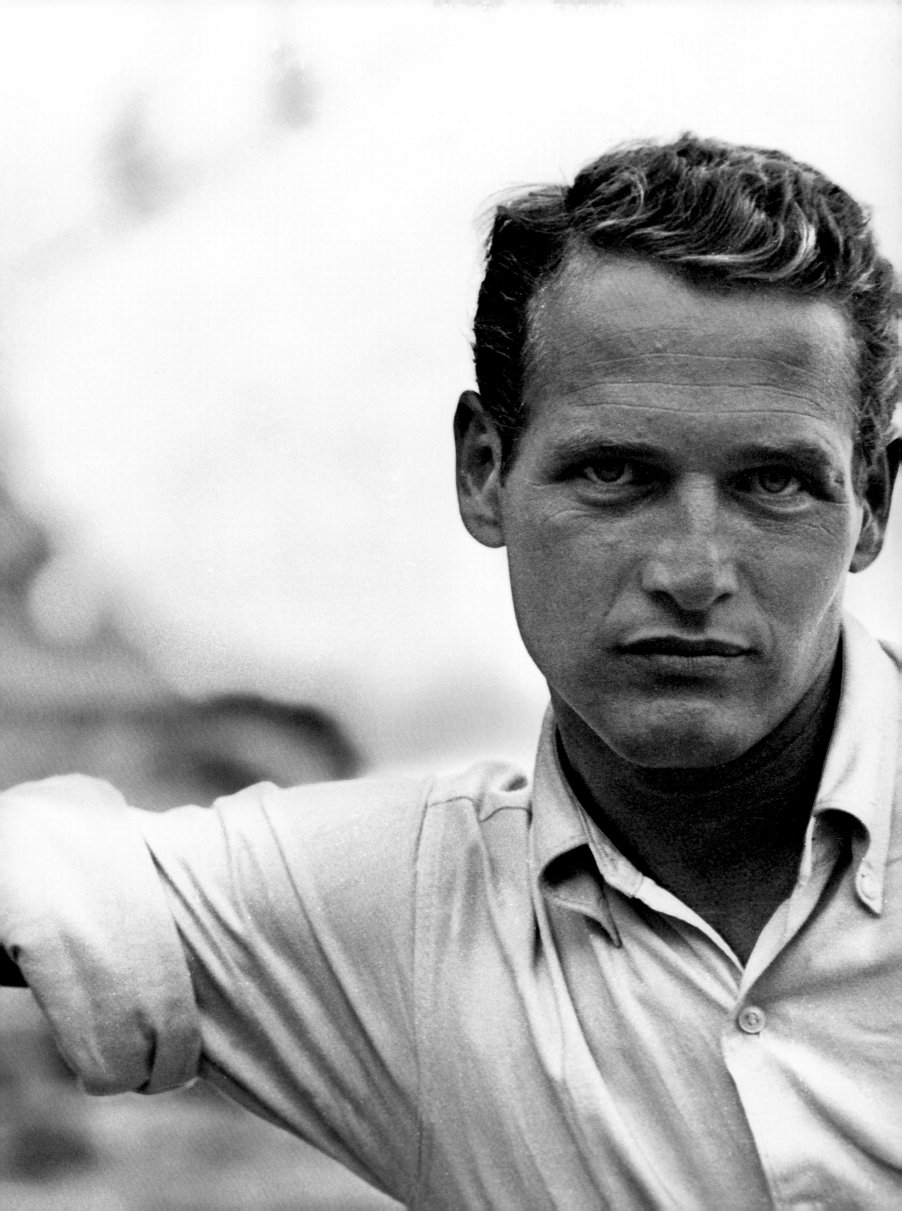

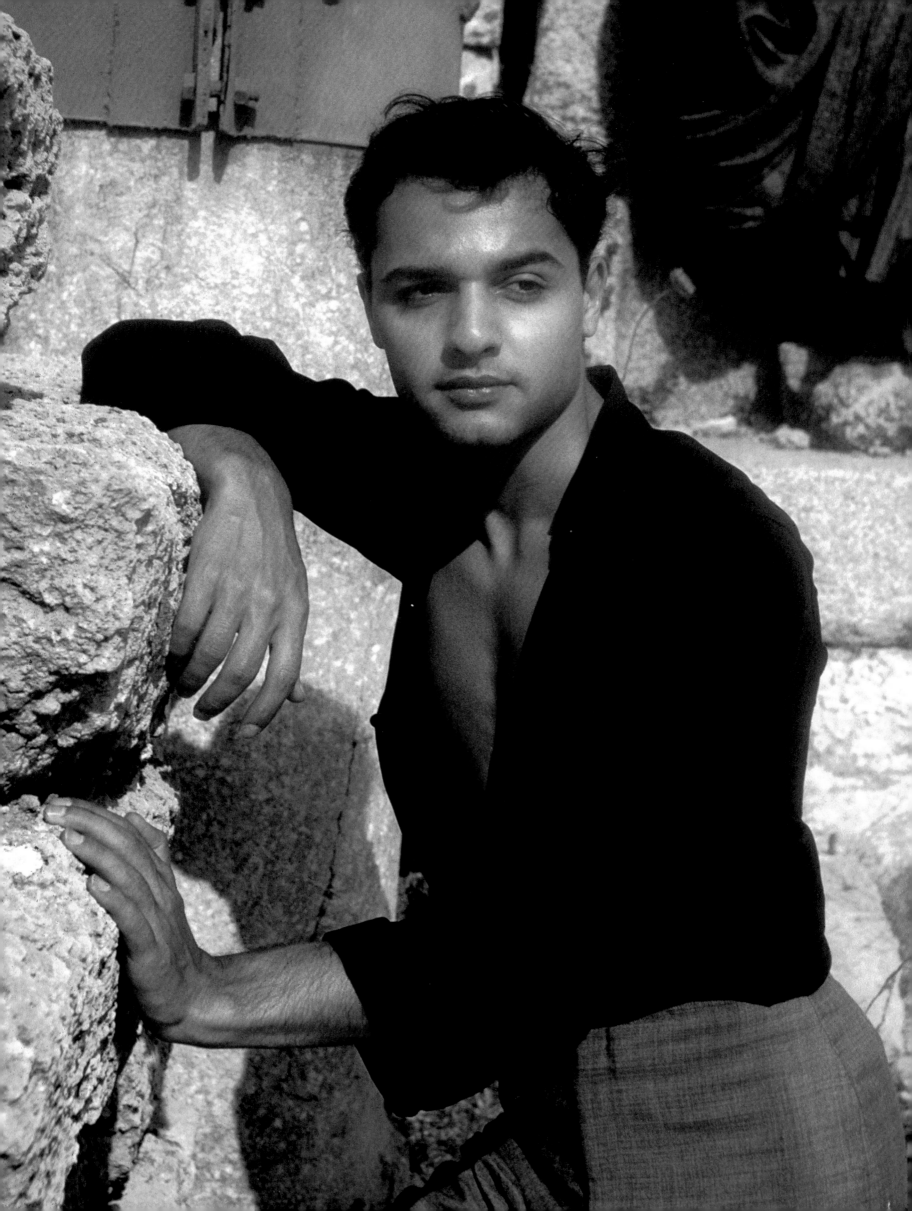

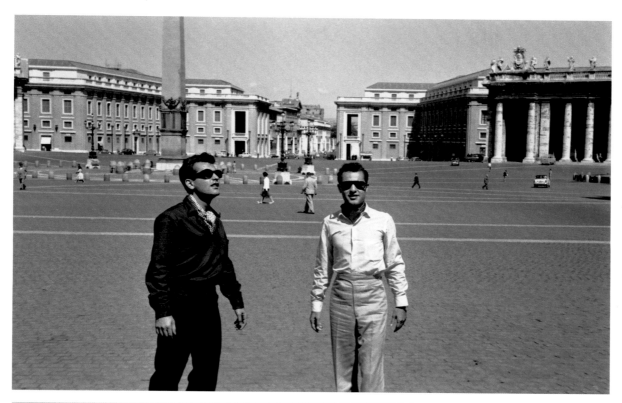

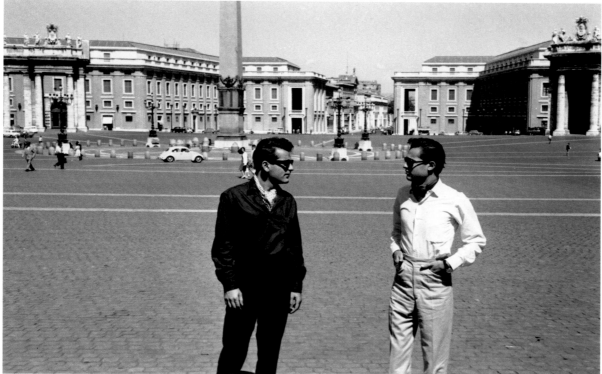

Opposite: Sal Mineo on the set of Otto Preminger's *Exodus*, Israel, 1959. Above: Sal Mineo and boyfriend visiting the Vatican, 1959.
Following spread: Paul Newman at a cafe in rural Israel during the filming of *Exodus*, 1959.

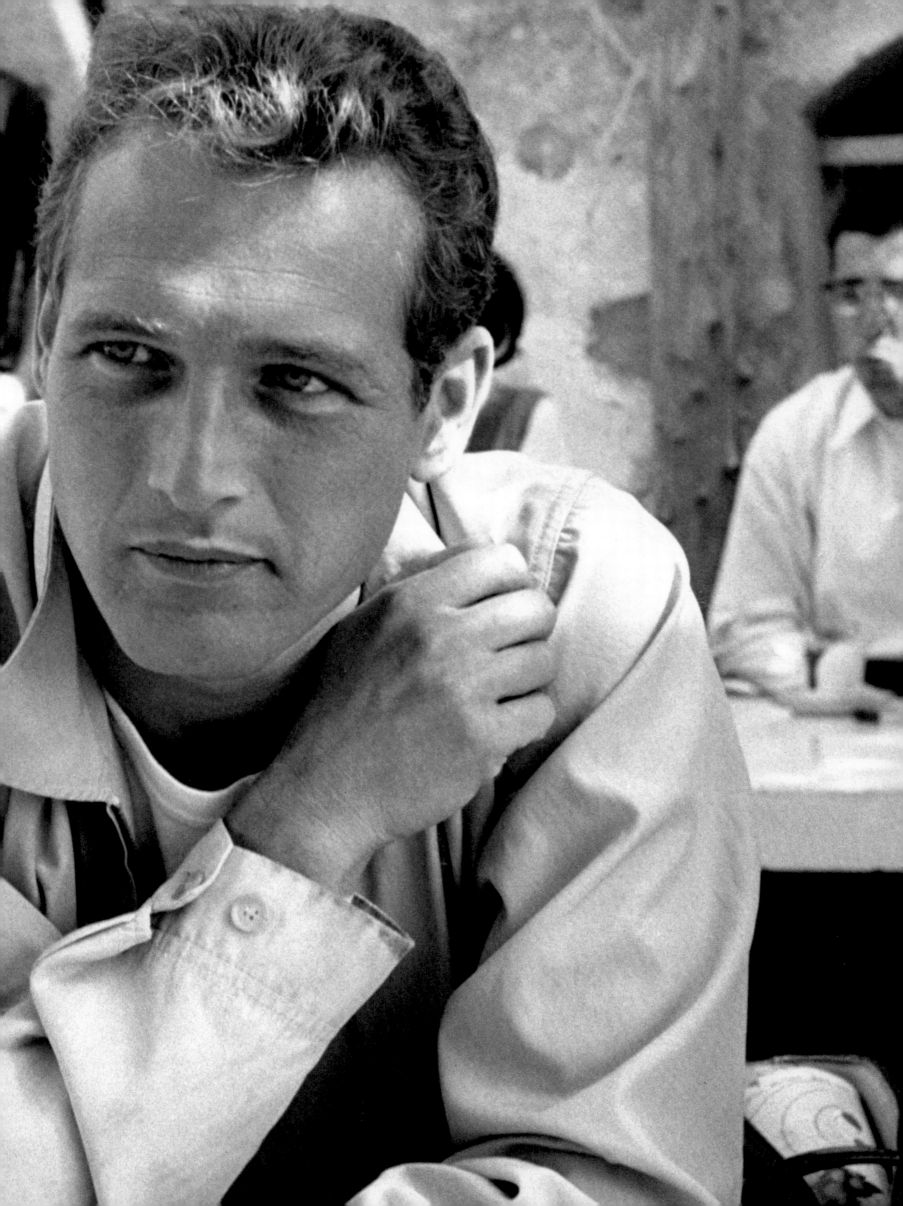

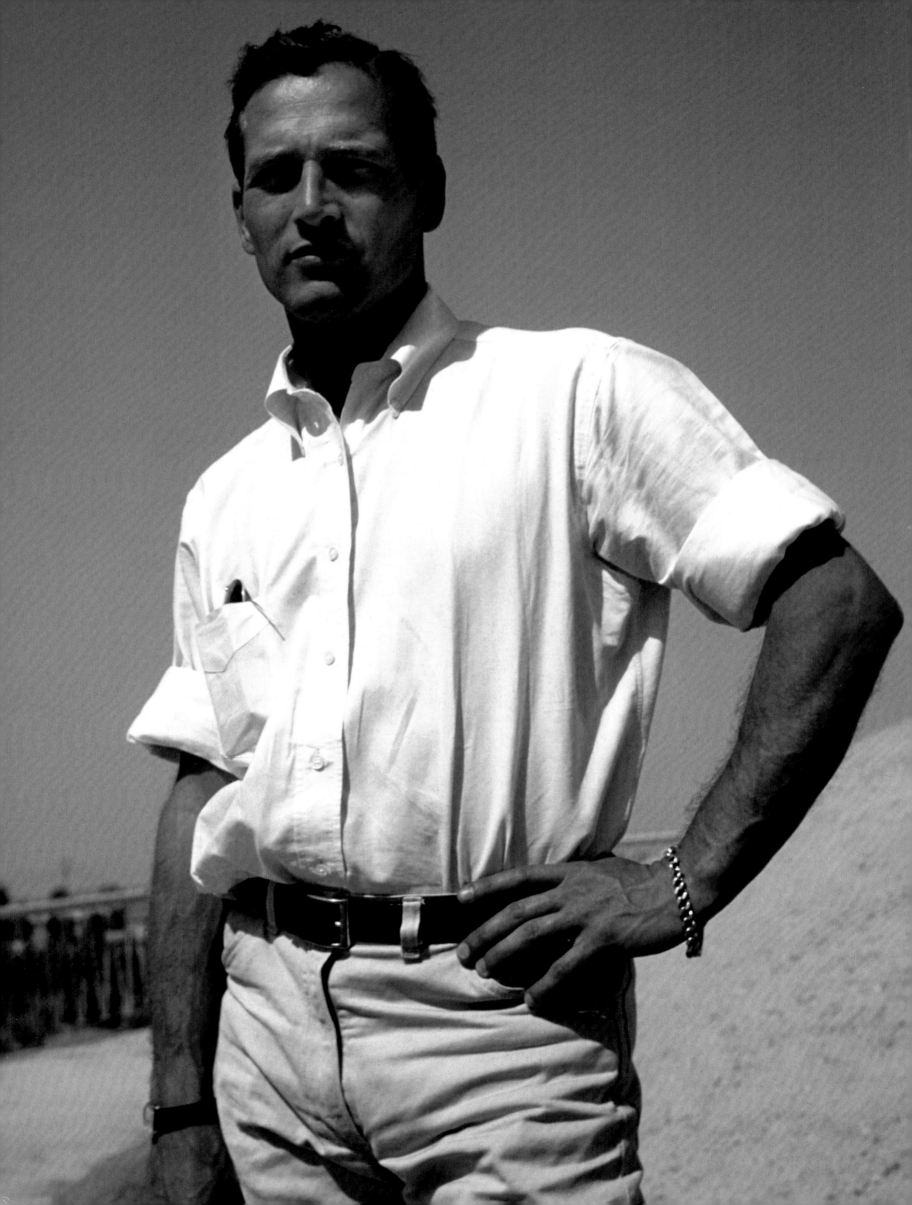

Opposite: Paul Newman as a tourist taking in the sights in Israel in 1959. Above: Paul Newman in daily life in Paris, France, 1959.

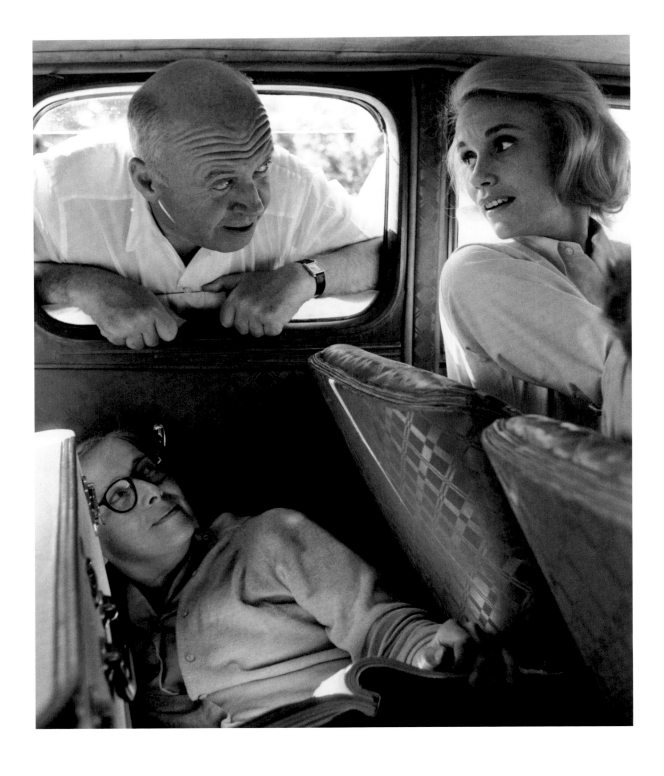

Above: Otto Preminger, Eva Marie Saint, and the continuity person during an intricate car shot while filming *Exodus* in Israel, 1959.
Opposite and following spread: Paul Newman and Joanne Woodward visit the countryside and take in the sights in Israel, 1959.

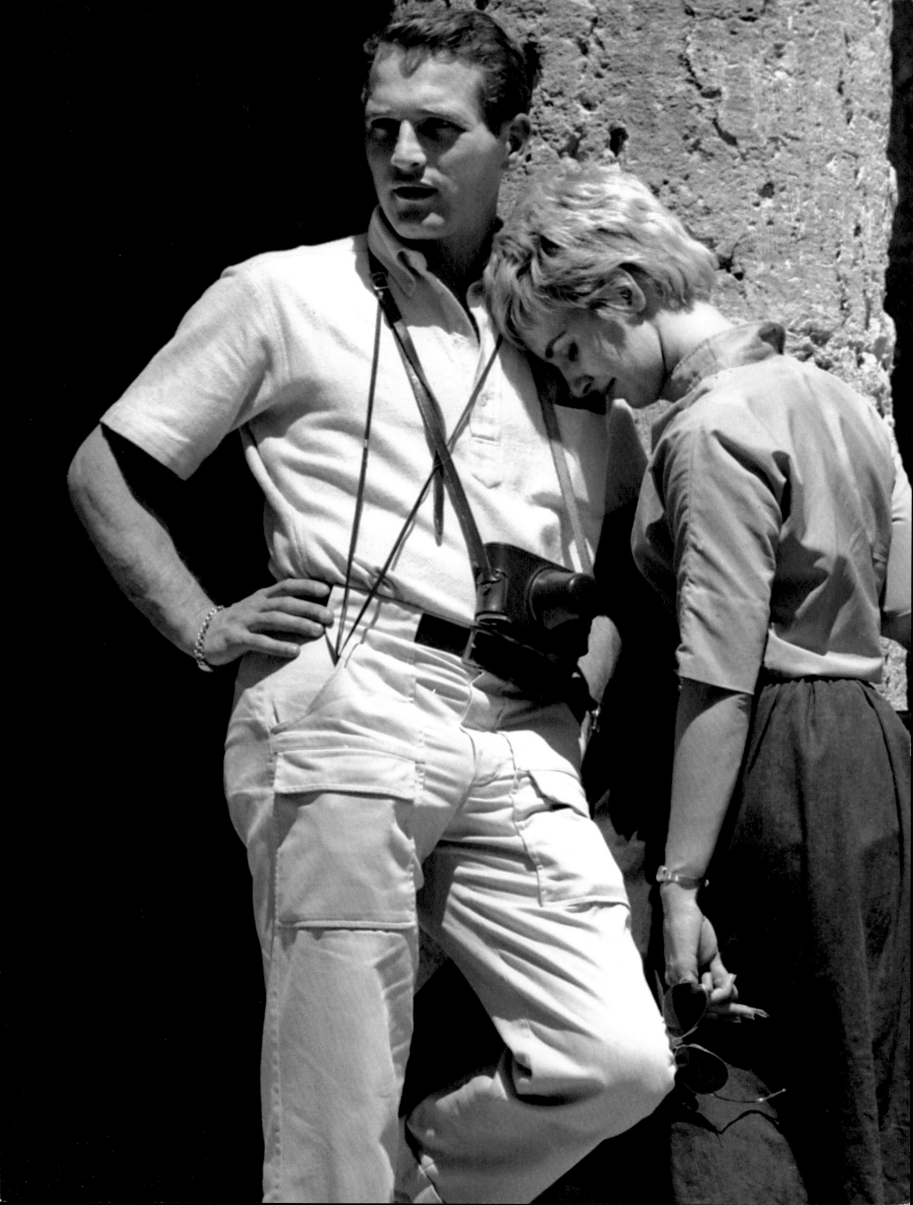

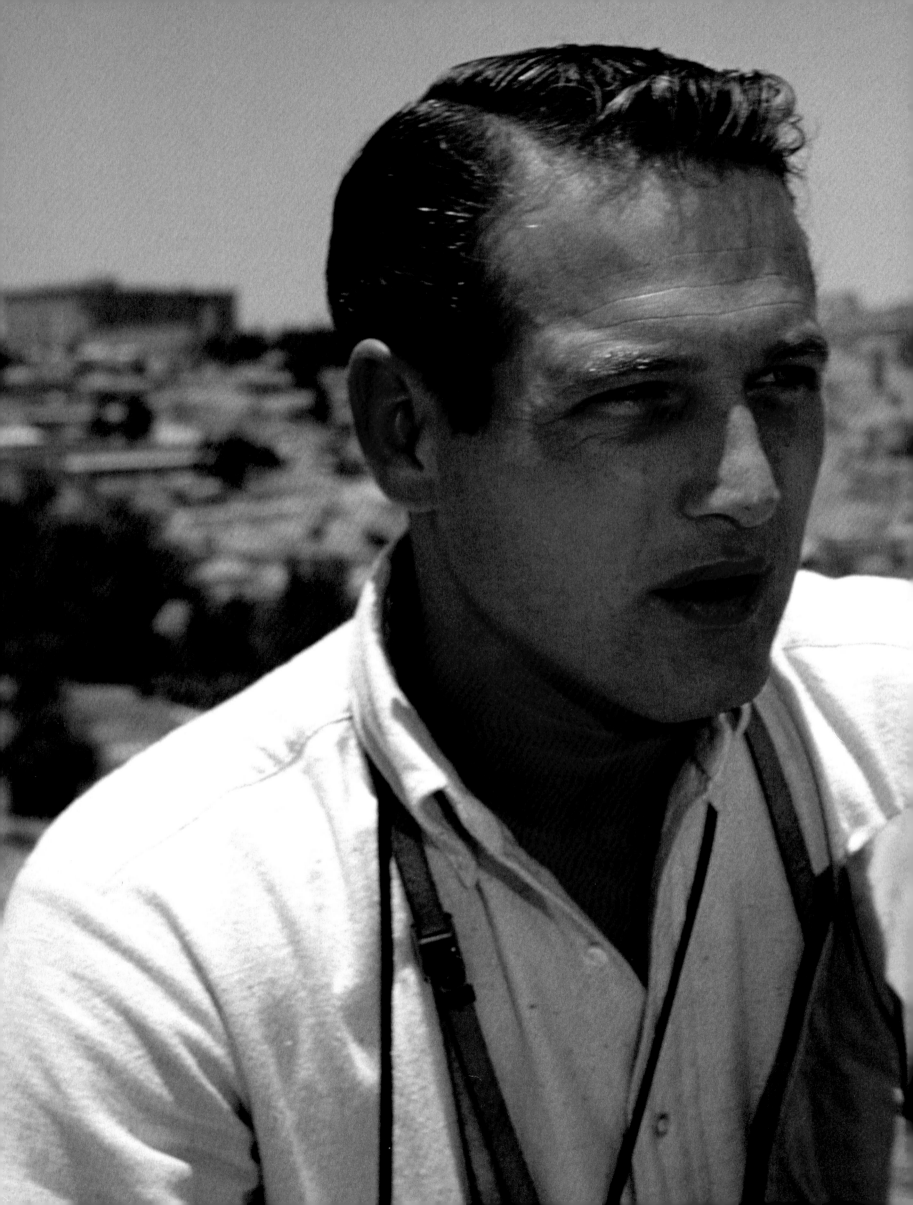

COME SEPTEMBER

**DIRECTED BY ROBERT MULLIGAN, STARRING ROCK HUDSON, GINA LOLLOBRIGIDA,
BOBBY DARIN, AND SANDRA DEE, ITALY, 1960**

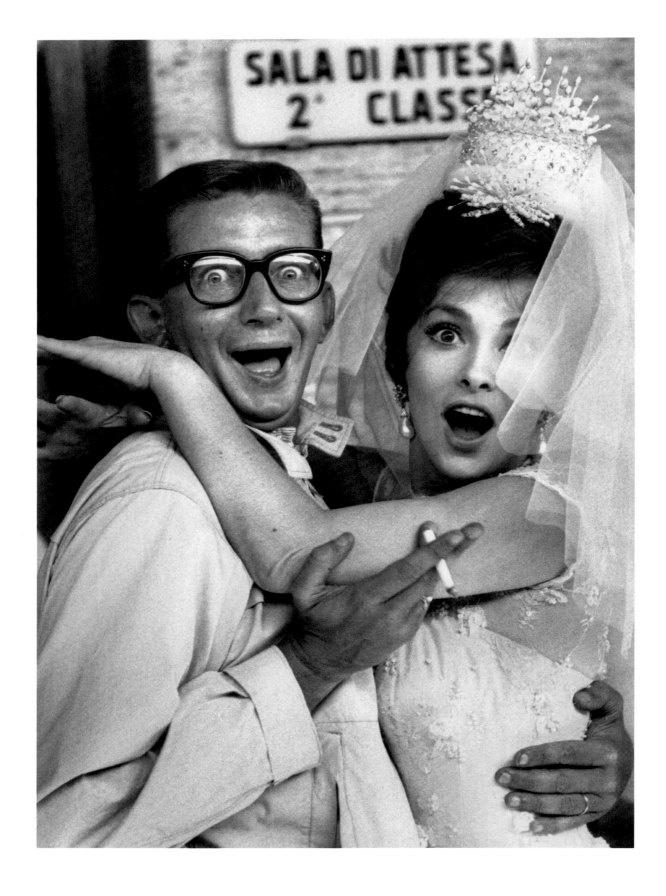

Above: Robert Mulligan and Gina Lollobrigida in Italy for *Come September*. Opposite: Gina Lollobrigida taking time off, on the set.

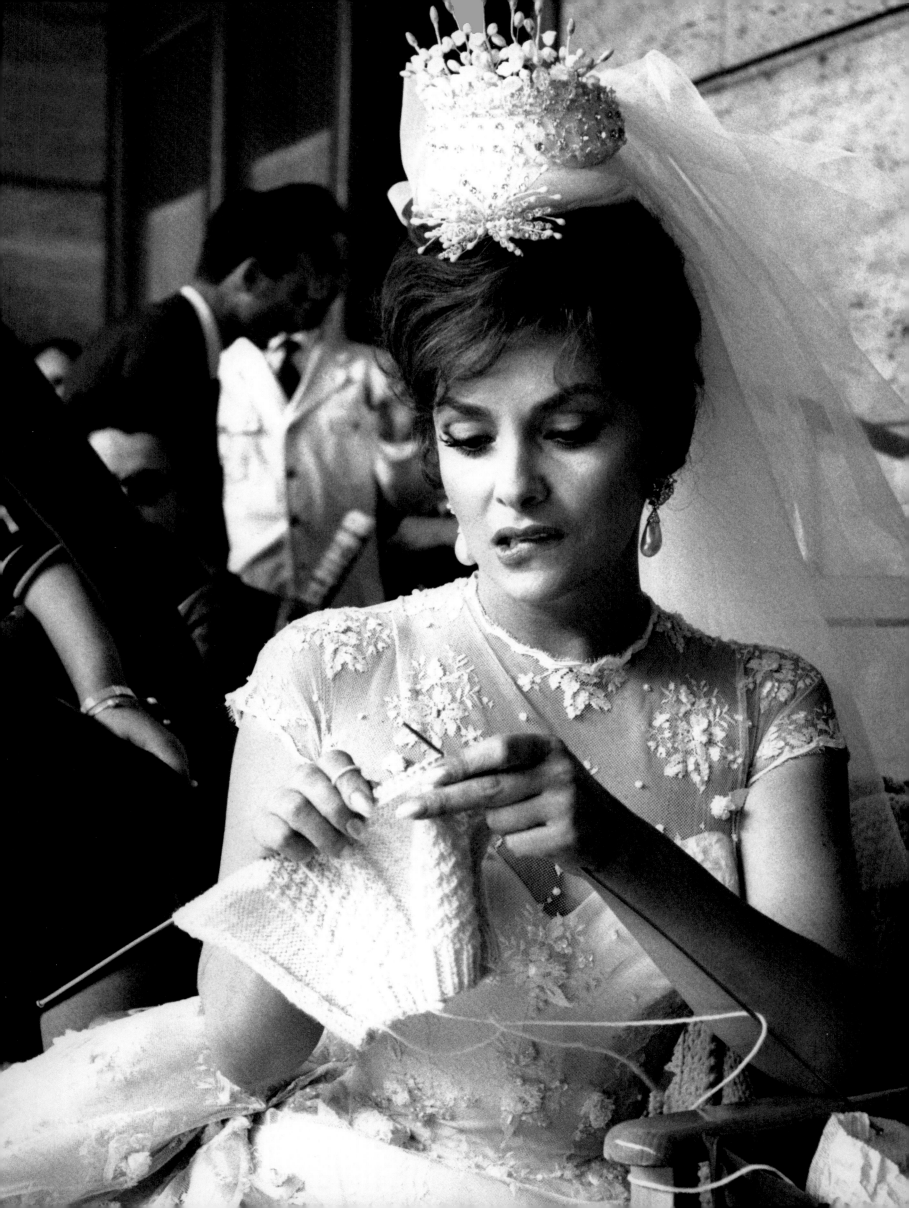

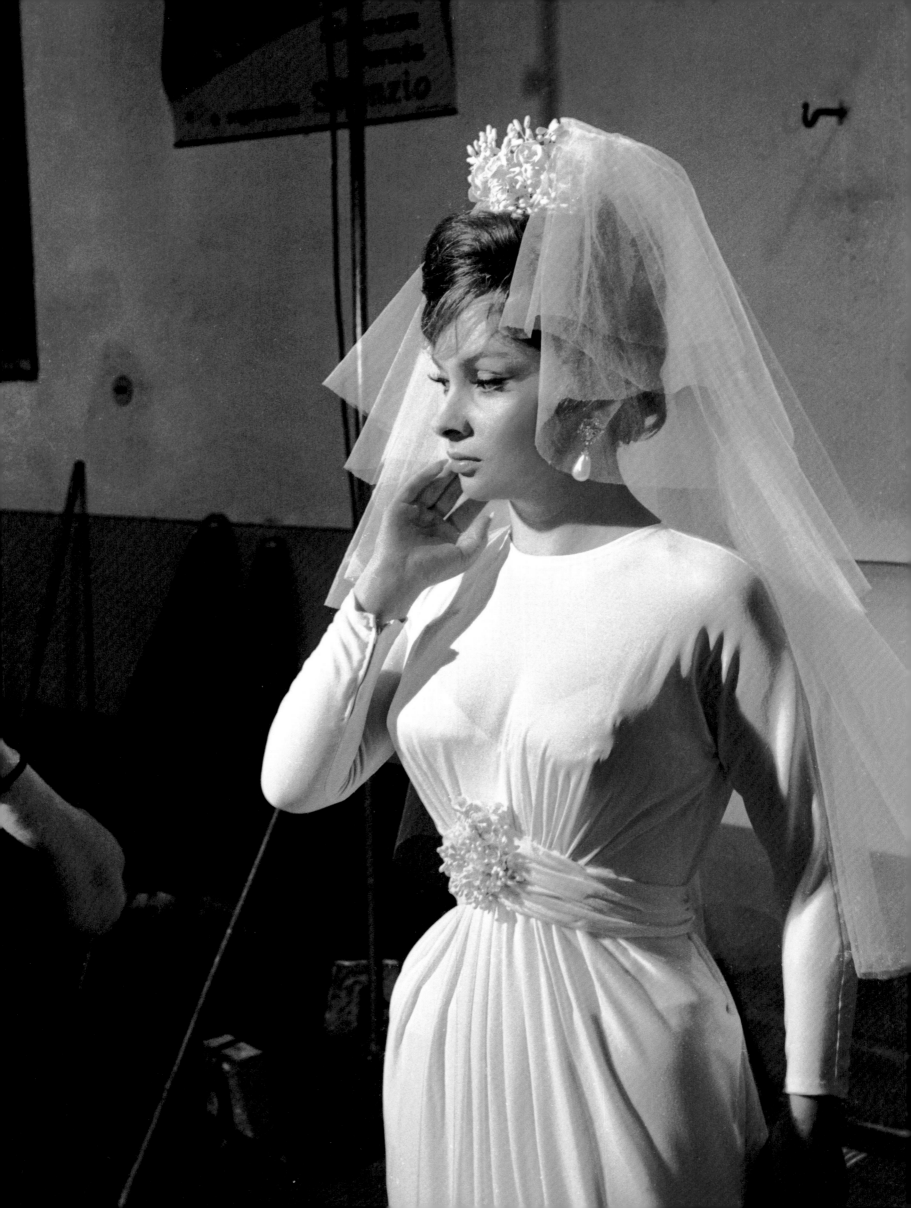

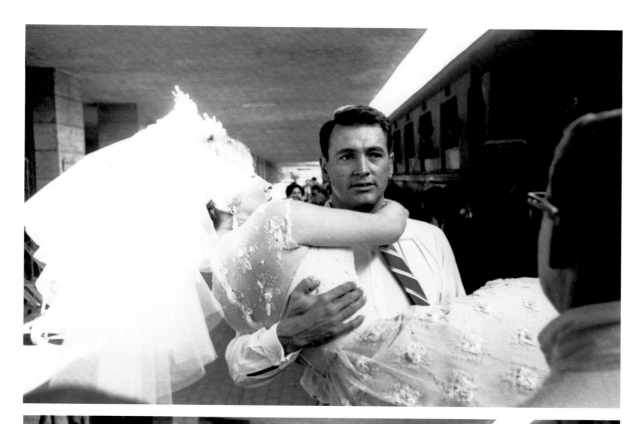

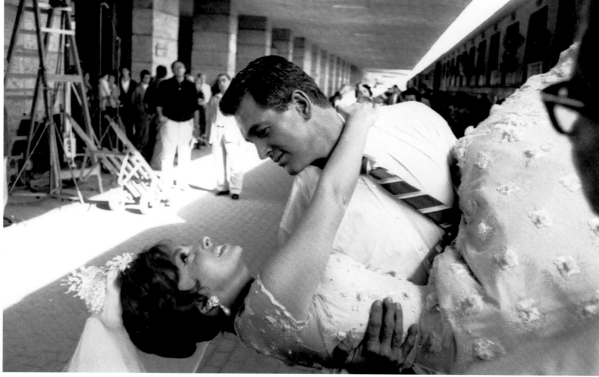

Opposite: Gina Lollobrigida, Italy, 1960. Above: Rock Hudson and Gina Lollobrigida, Italy, 1960. Following spread: Sandra Dee and Bobby Darin first met in Italy in 1960 during the filming of *Come September*.

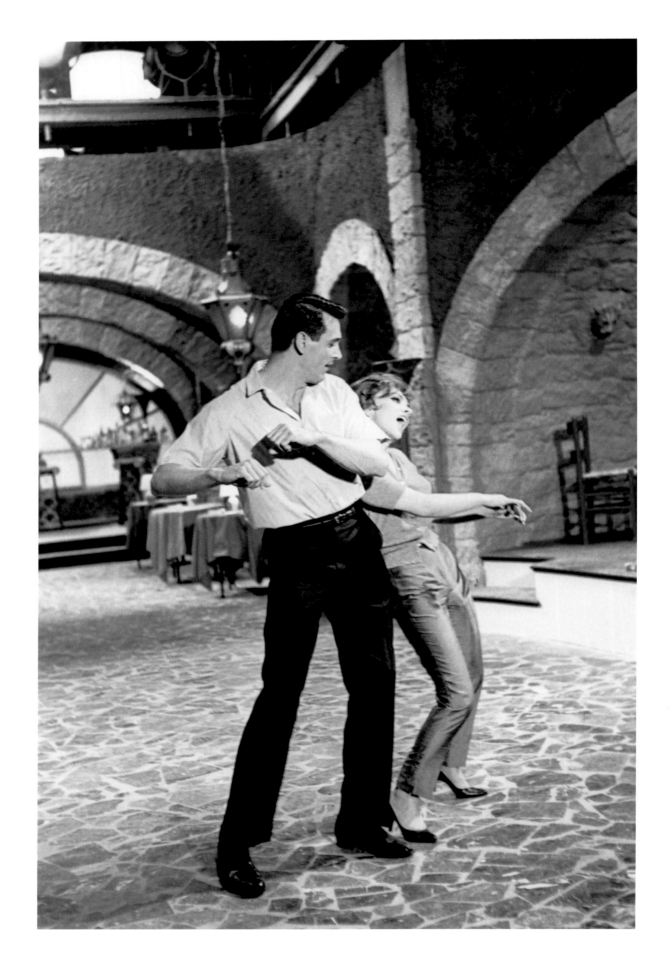

Above and opposite: Rock Hudson and Gina Lollobrigida, Italy, 1960. Following spread: Sandra Dee and Bobby Darin, Italy, 1960.

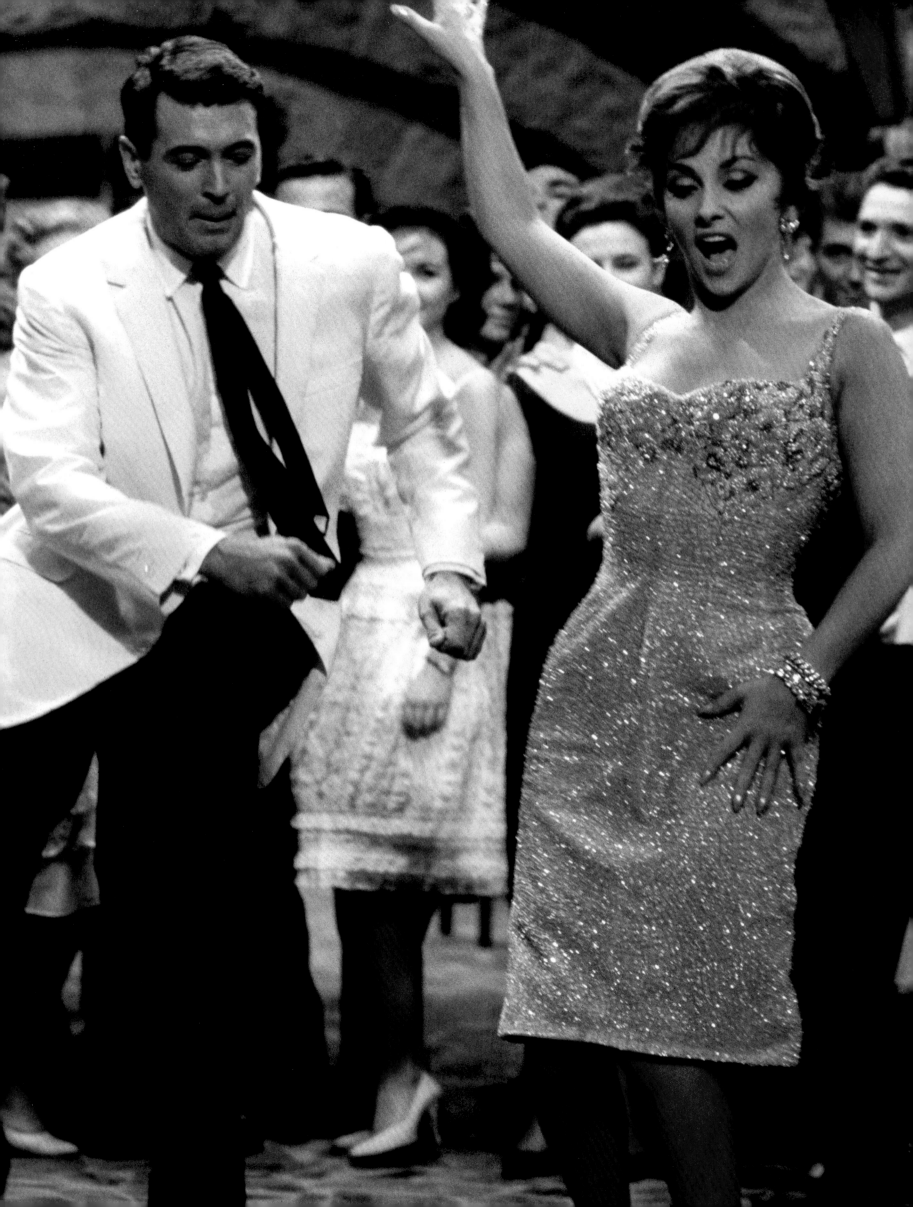

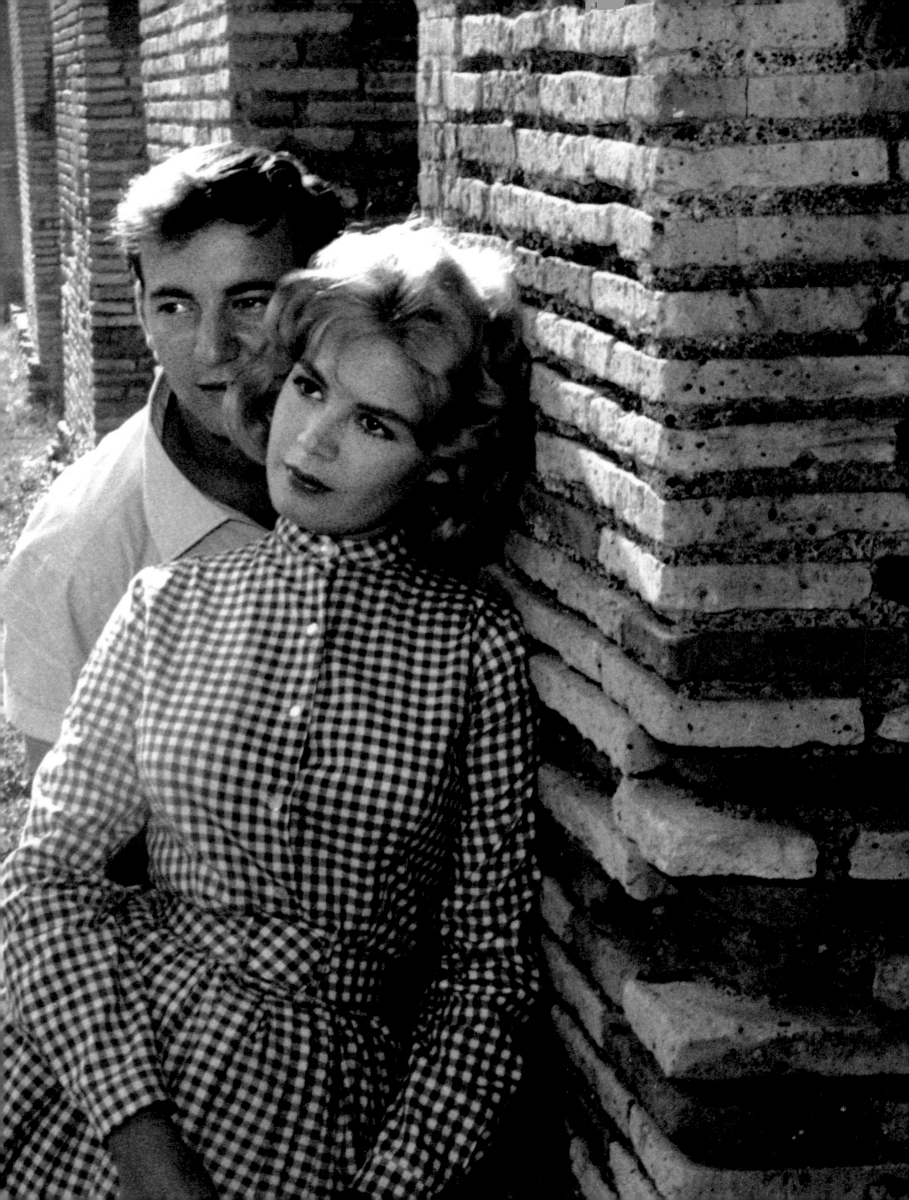

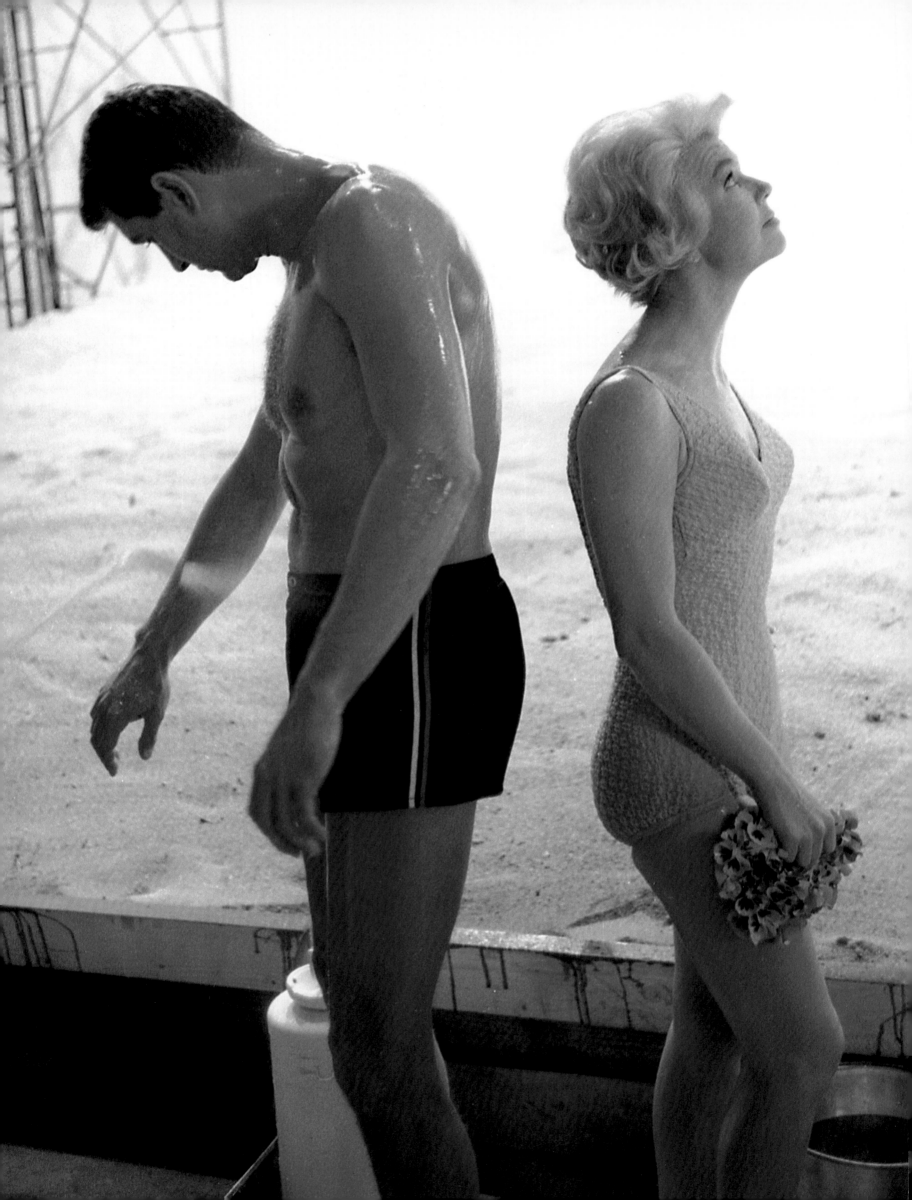

LOVER COME BACK

DIRECTED BY DELBERT MANN, STARRING ROCK HUDSON, DORIS DAY, AND TONY RANDALL, HOLLYWOOD, 1960

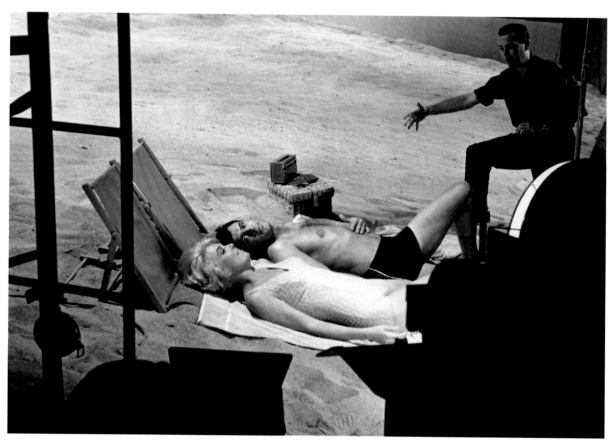

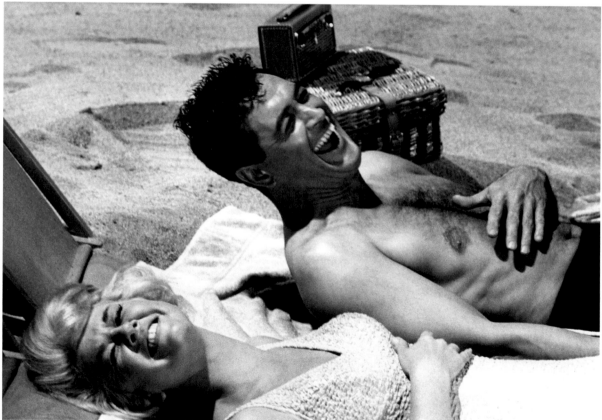

Opposite, above, and following spread: Rock Hudson and Doris Day had engaging and compatible personalities that made each of the sets they shared a pleasant and fun one on which to work, Universal Studios, California, 1960.

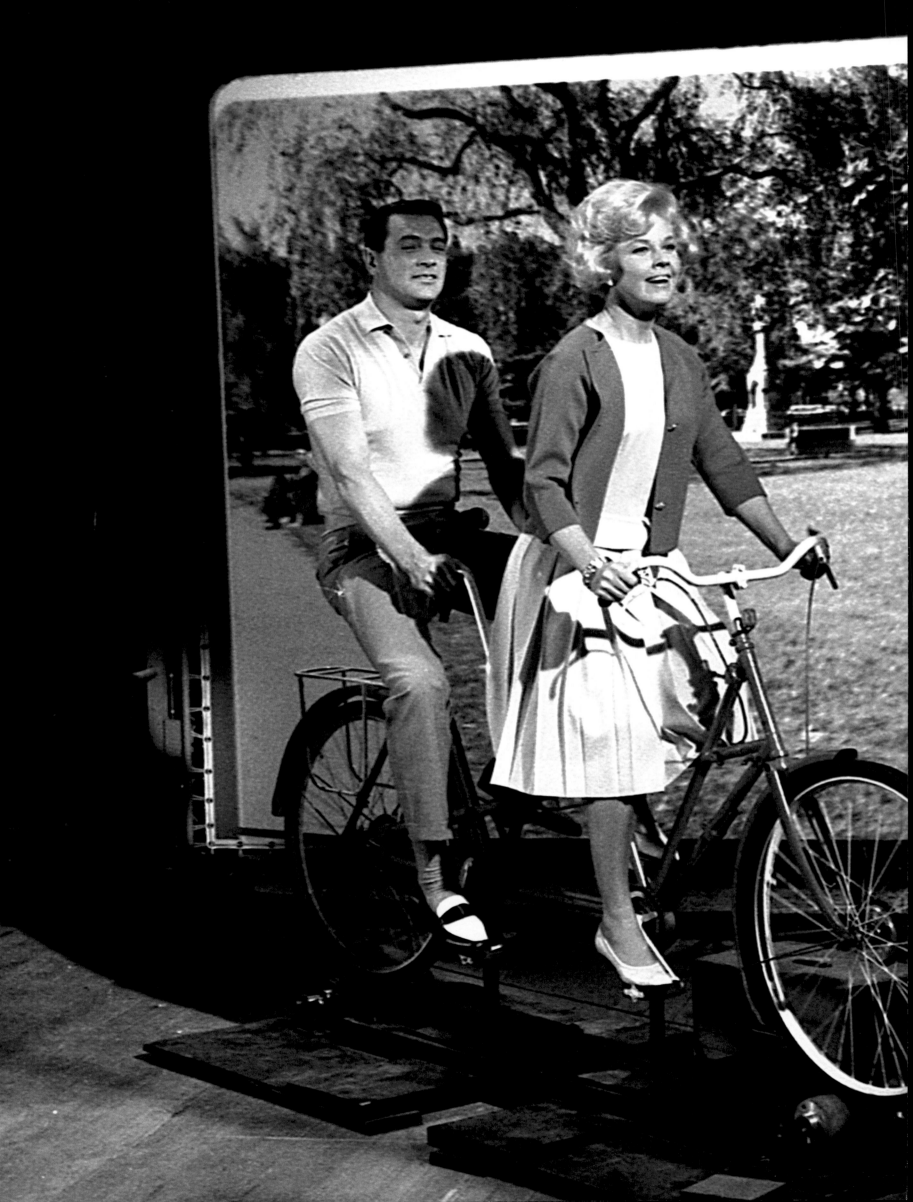

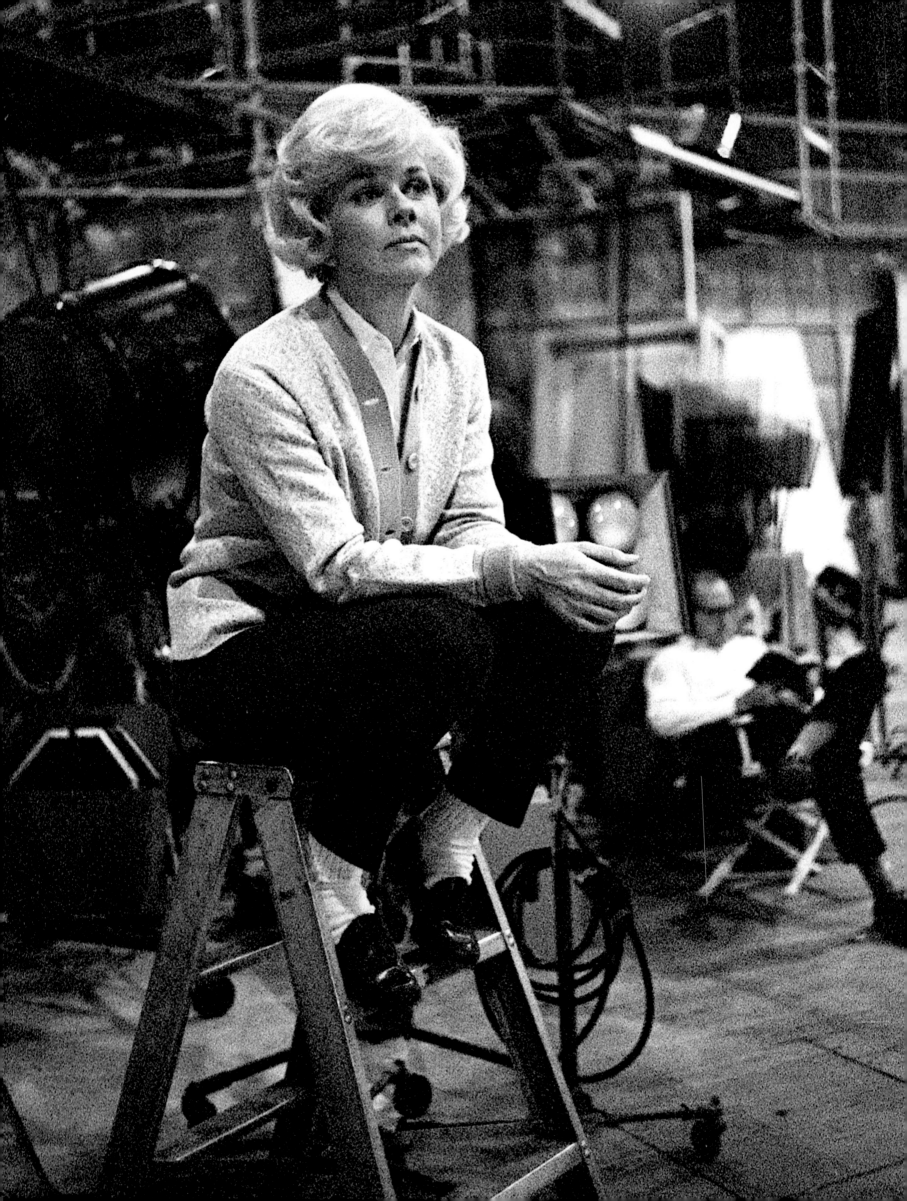

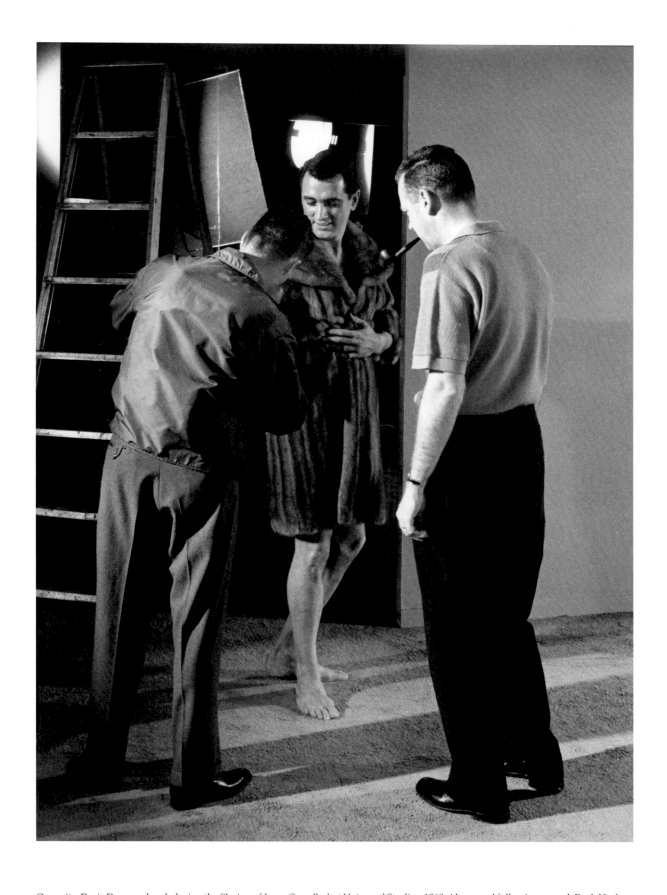

Opposite: Doris Day on a break during the filming of *Lover Come Back* at Universal Studios, 1960. Above and following spread: Rock Hudson parades around the set during rehearsals, Universal Studios, California, 1960.

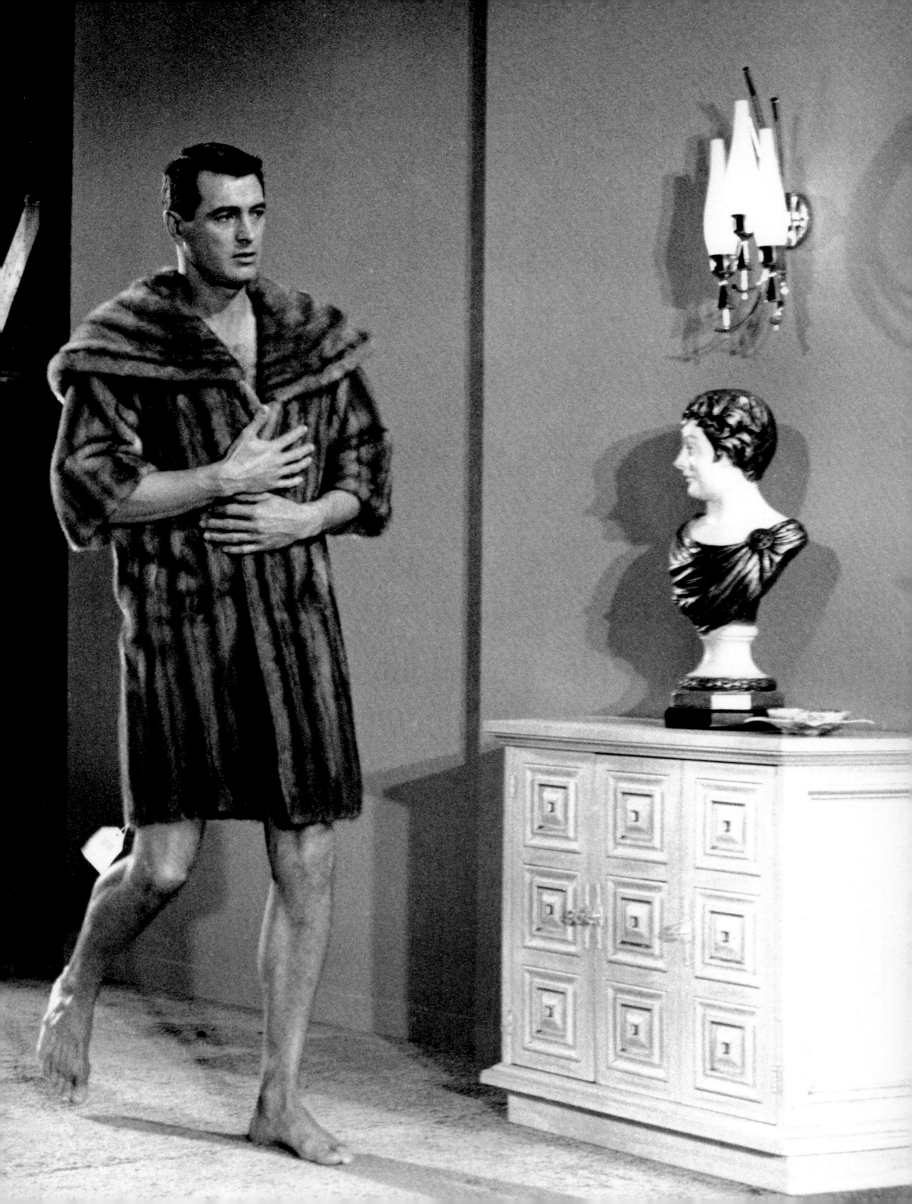

THE POWER AND THE GLORY

DIRECTED BY MARC DANIELS, STARRING LAURENCE OLIVIER, HOLLYWOOD, 1960

Above, opposite, and following spread: Laurence Olivier, in 1960, in the film adaptation of Graham Greene's *The Power and the Glory*.

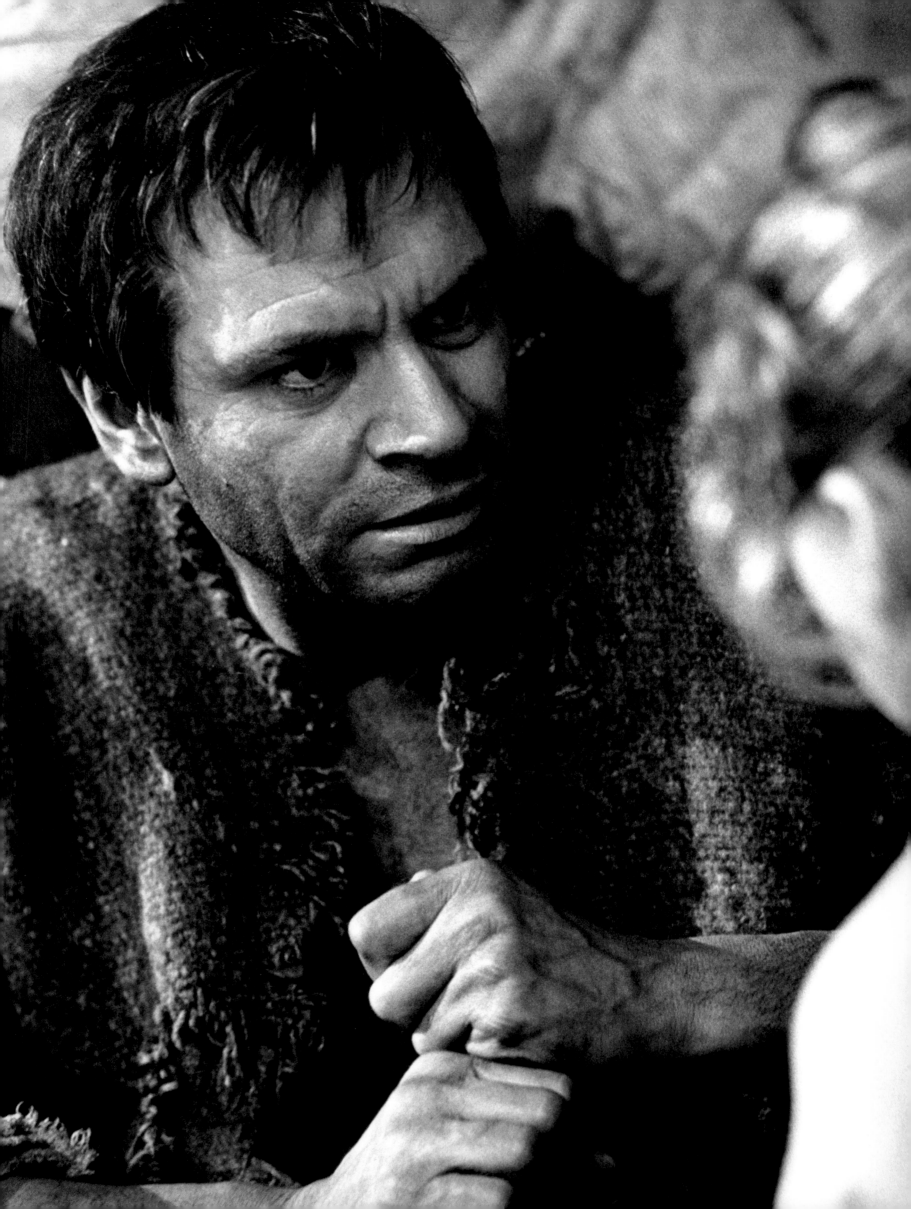

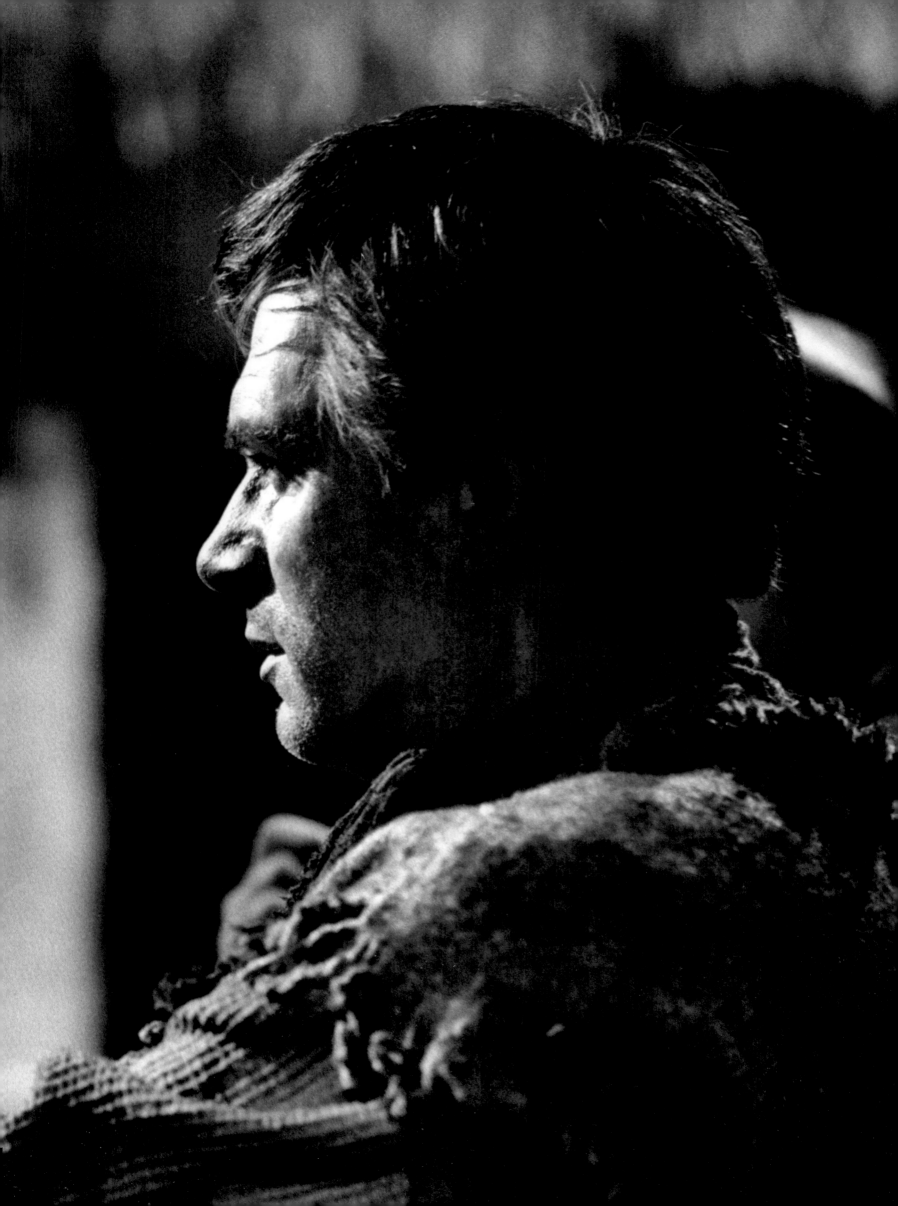

40 POUNDS OF TROUBLE

DIRECTED BY NORMAN JEWISON, STARRING TONY CURTIS, SUZANNE PLESHETTE, AND STUBBY KAYE, DISNEYLAND AND LAKE TAHOE, 1961

CURTIS ENTERPRISES PRODS., INC. 1921
DIR. - JEWISON "A"
CAM. - MacDONALD NC 151
EXT. DAY
DATE 5-2-62
269A 1

Above: Tony Curtis poses with a slate bearing the name of his production company at Disneyland Park in 1961. Opposite: Suzanne Pleshette at Disneyland in California in 1961, during the filming of *40 Pounds of Trouble*. Following Spread: Tony Curtis driving during a take at Disneyland in 1961. Second following spread: Stubby Kaye at the Cal Neva Lodge, Reno, Nevada, 1961.

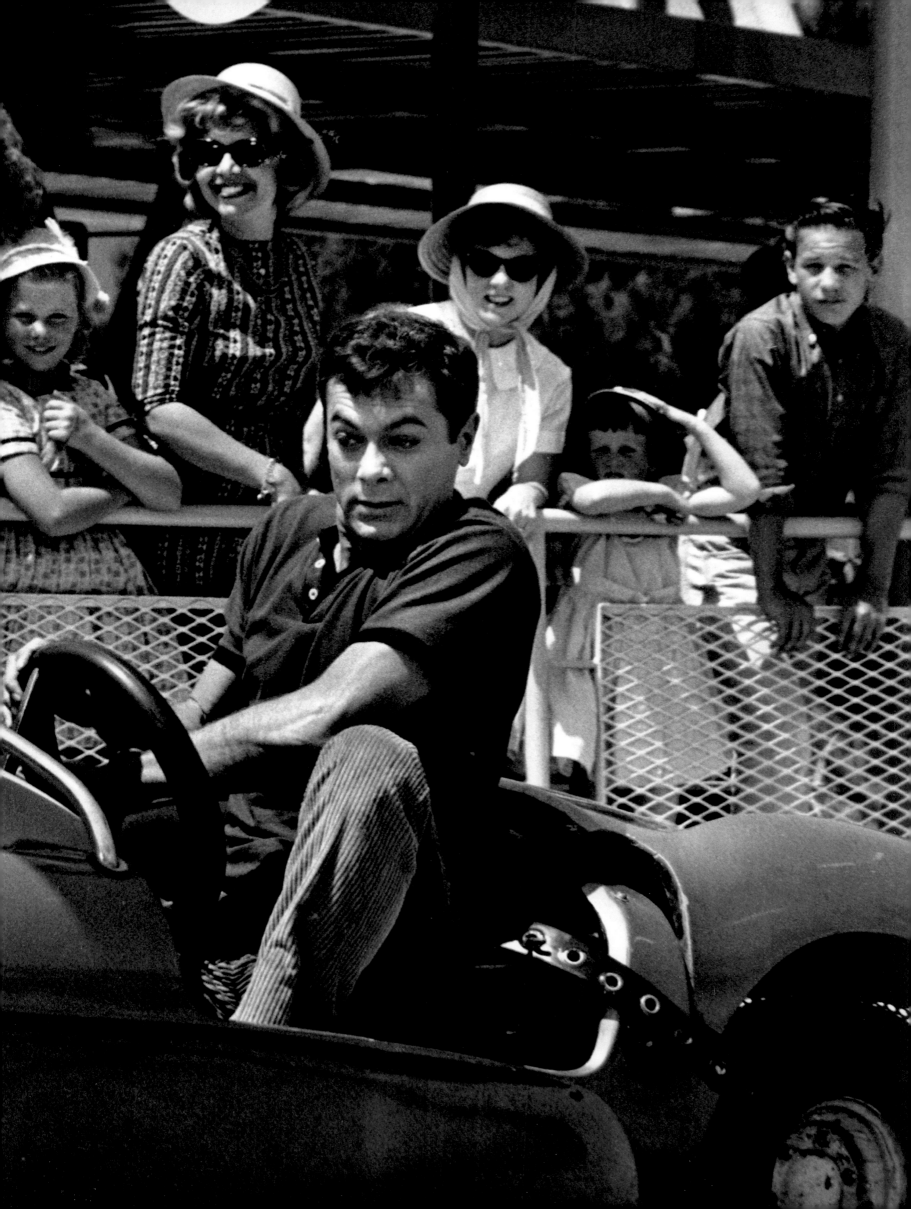

CAPE FEAR

DIRECTED BY J. LEE THOMPSON, STARRING GERGORY PECK AND ROBERT MITCHUM, GEORGIA AND HOLLYWOOD, 1961

Above and opposite: Gregory Peck plays a calm man whose family is stalked in *Cape Fear,* filmed near Savannah, Georgia in 1961.

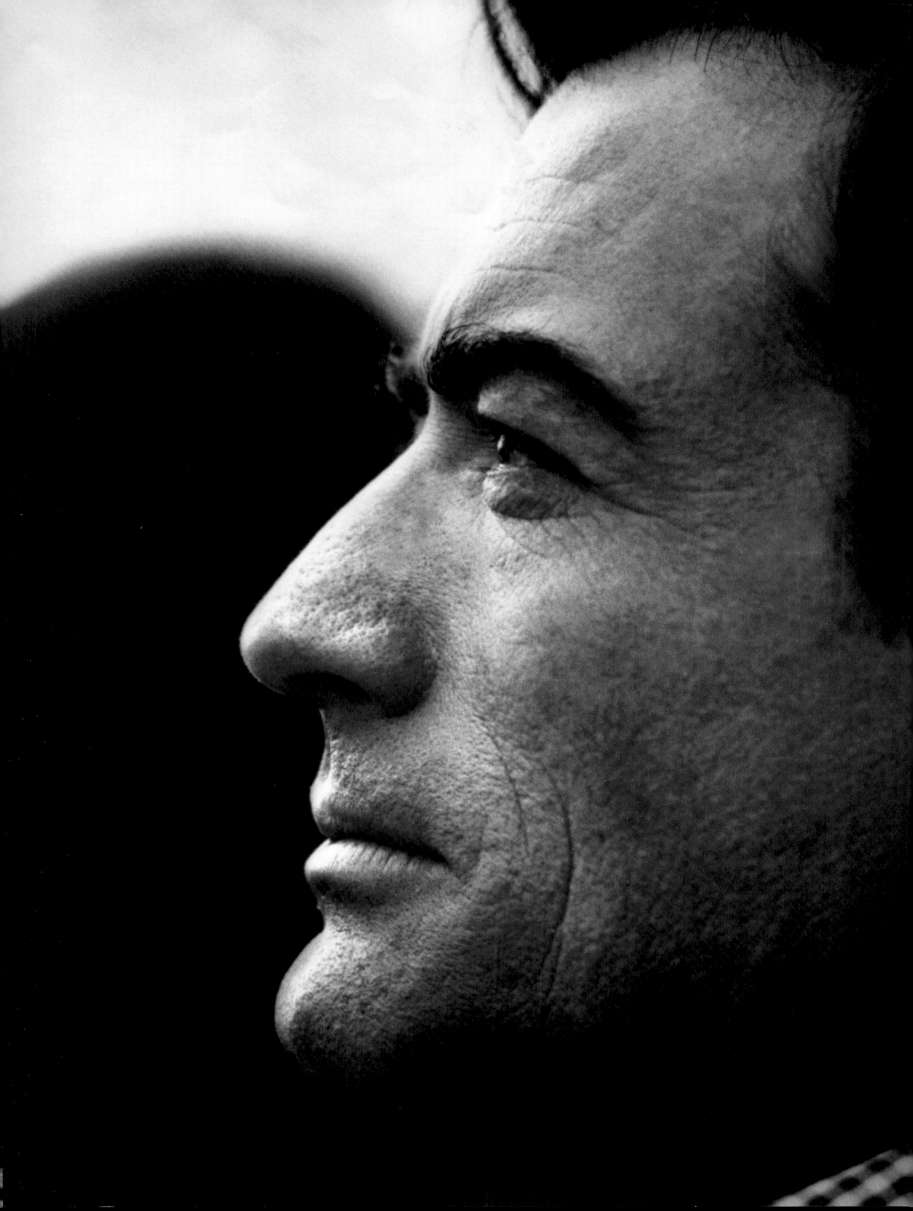

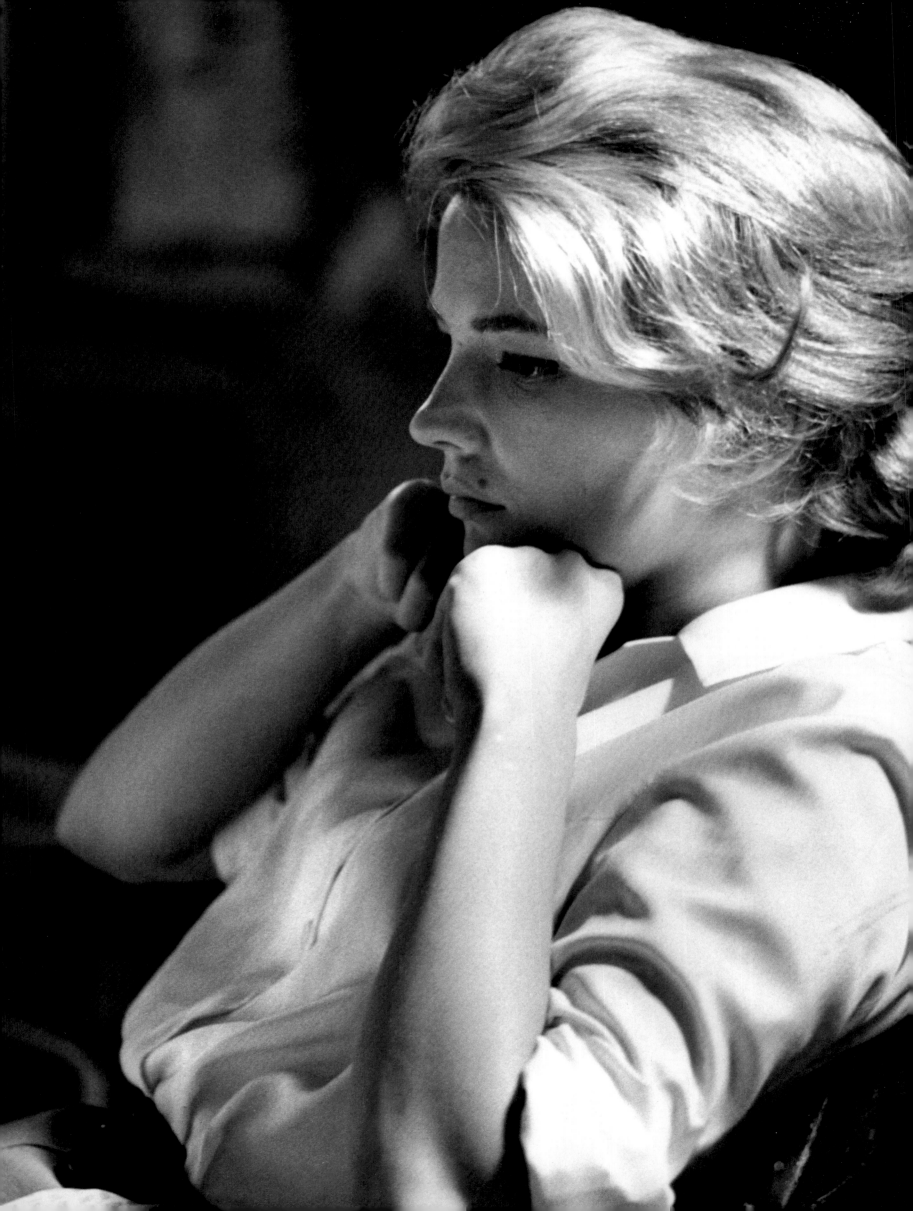

THE SPIRAL ROAD

DIRECTED BY ROBERT MULLIGAN, STARRING ROCK HUDSON, GENA ROWLANDS, AND BURL IVES, SURINAME, 1961

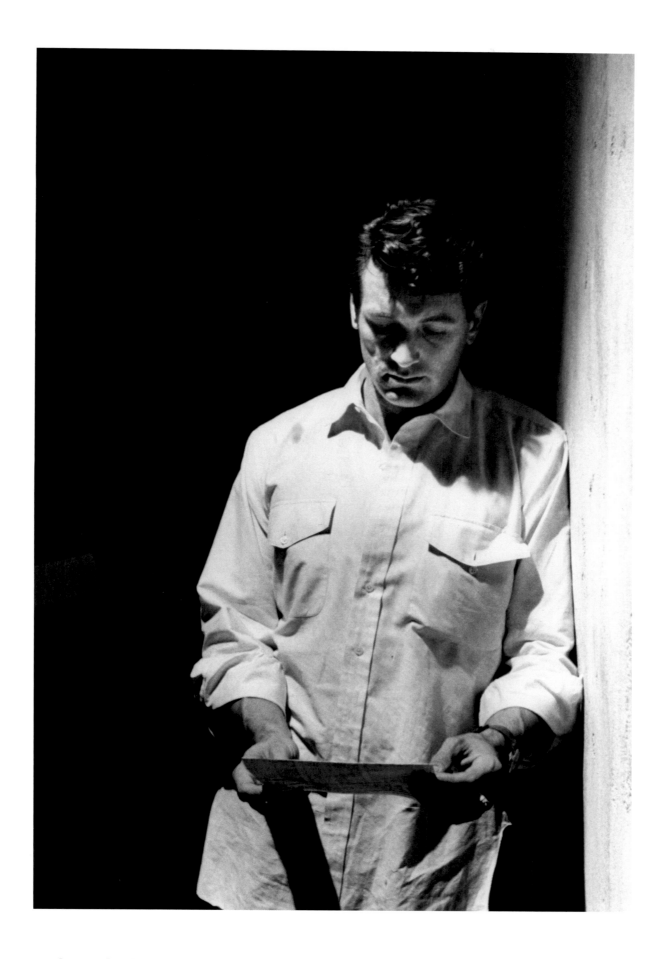

Opposite: Gena Rowlands on the set of *The Spiral Road* in Paramaribo, Suriname in 1961. Above: Rock Hudson off the set.
Following spread: Gena Rowlands, Rock Hudson, and Robert Mulligan during rehearsals on the set in Suriname, 1961

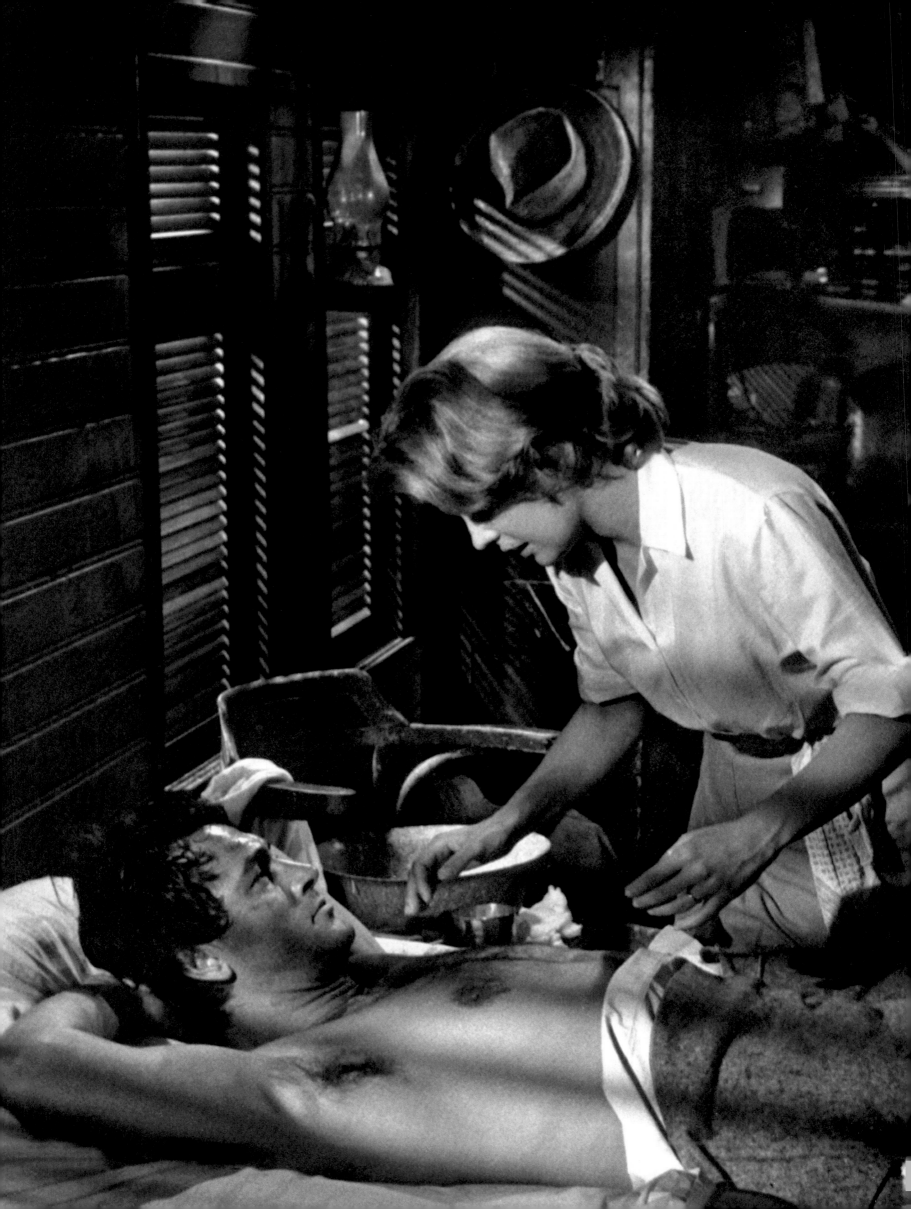

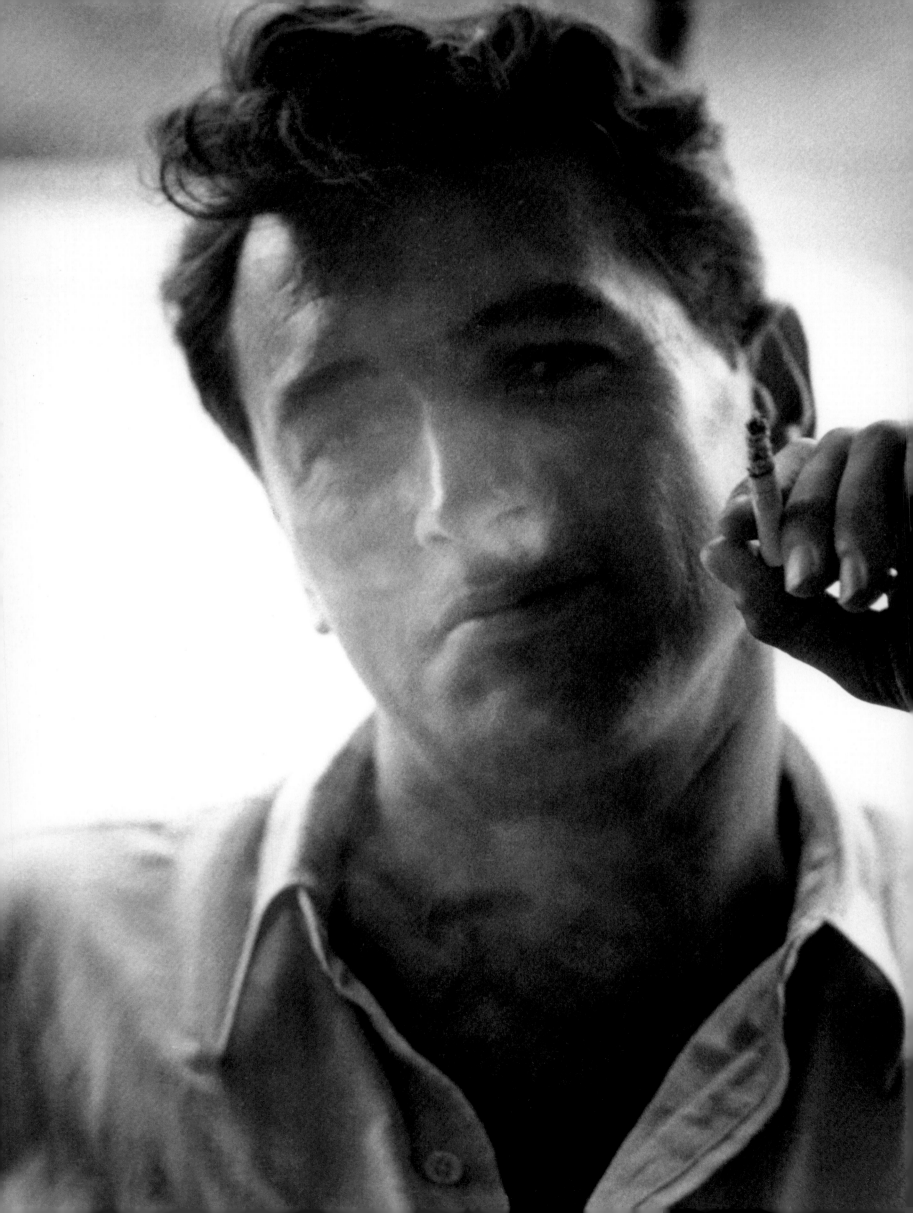

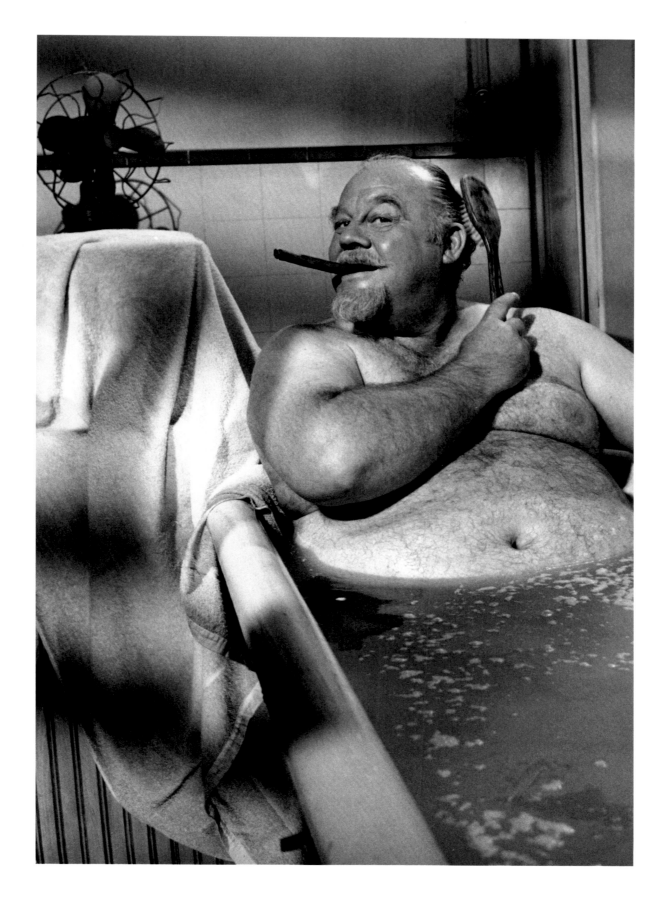

Opposite and following spread: Rock Hudson during private times, off the set of *The Spiral Road* in Suriname. Above: Burl Ives poses.

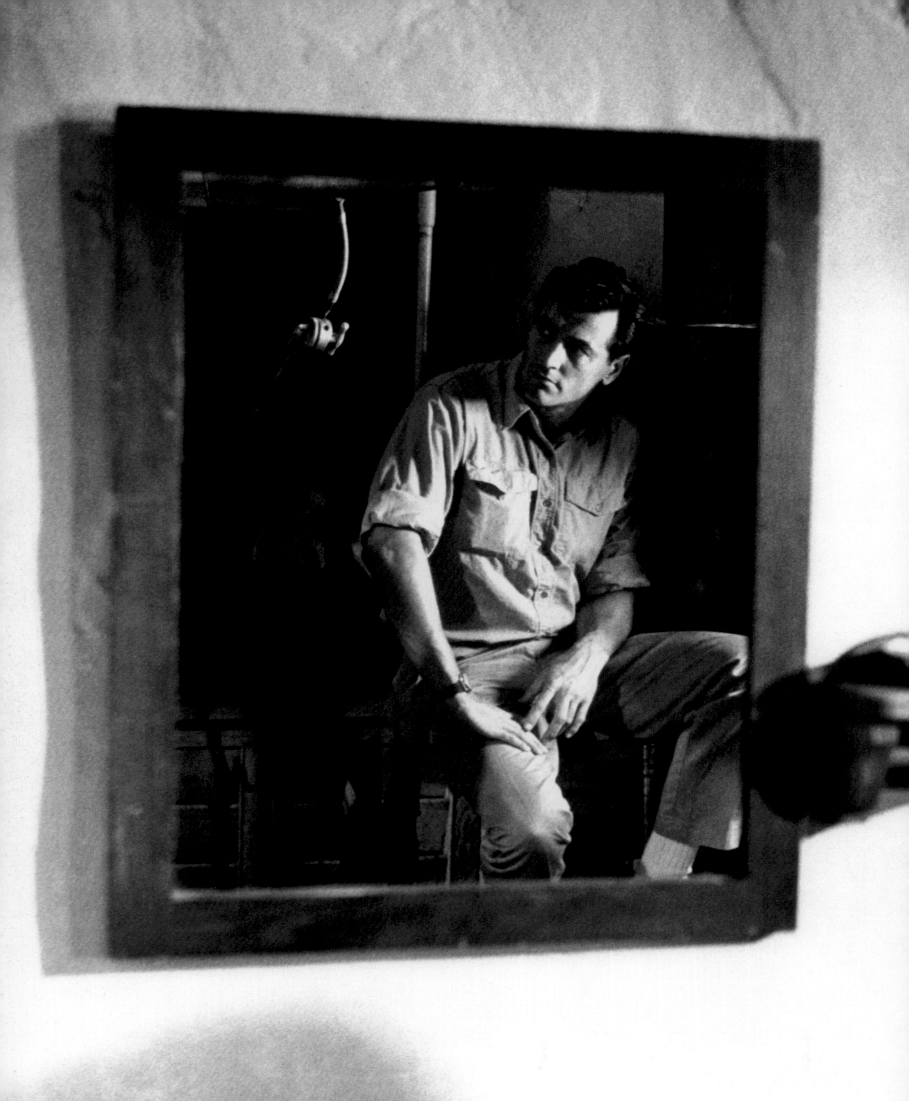

TO KILL A MOCKINGBIRD

DIRECTED BY ROBERT MULLIGAN, STARRING GREGORY PECK, MARY BADHAM, AND PHILLIP ALFORD, ALABAMA AND HOLLYWOOD, 1961

Above and opposite: Gregory Peck and Mary Badham during the filming of *To Kill a Mockingbird* in Monroeville, Alabama, 1961. Following spread: Mary Badham and the author Harper Lee together in town during the filming of *To Kill a Mockingbird*, 1961.

Above and opposite: Mary Badham, Monroeville, Alabama, 1961. Following spread: Gregory Peck and Robert Mulligan
sitting by the camera during takes on the set of *To Kill a Mockingbird*, Monroeville, Alabama, 1961.

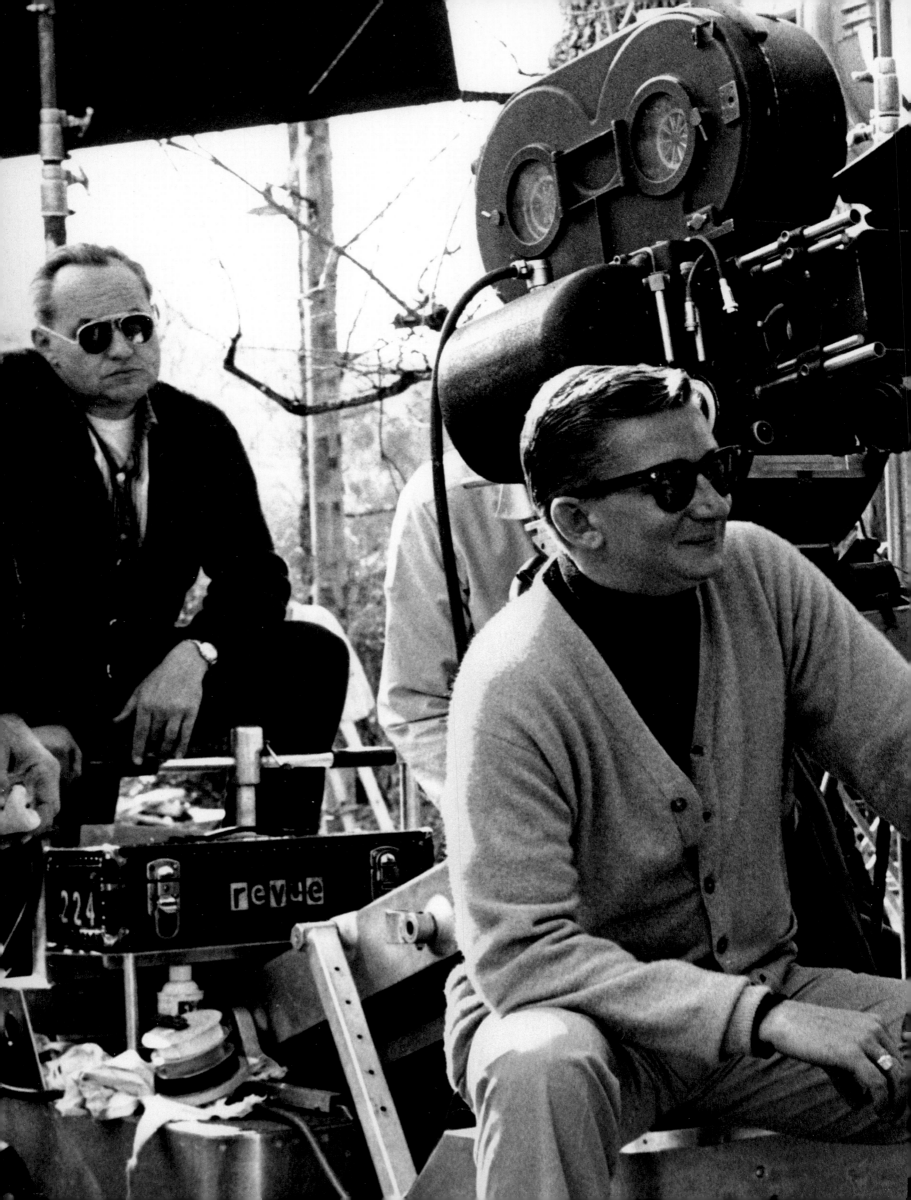

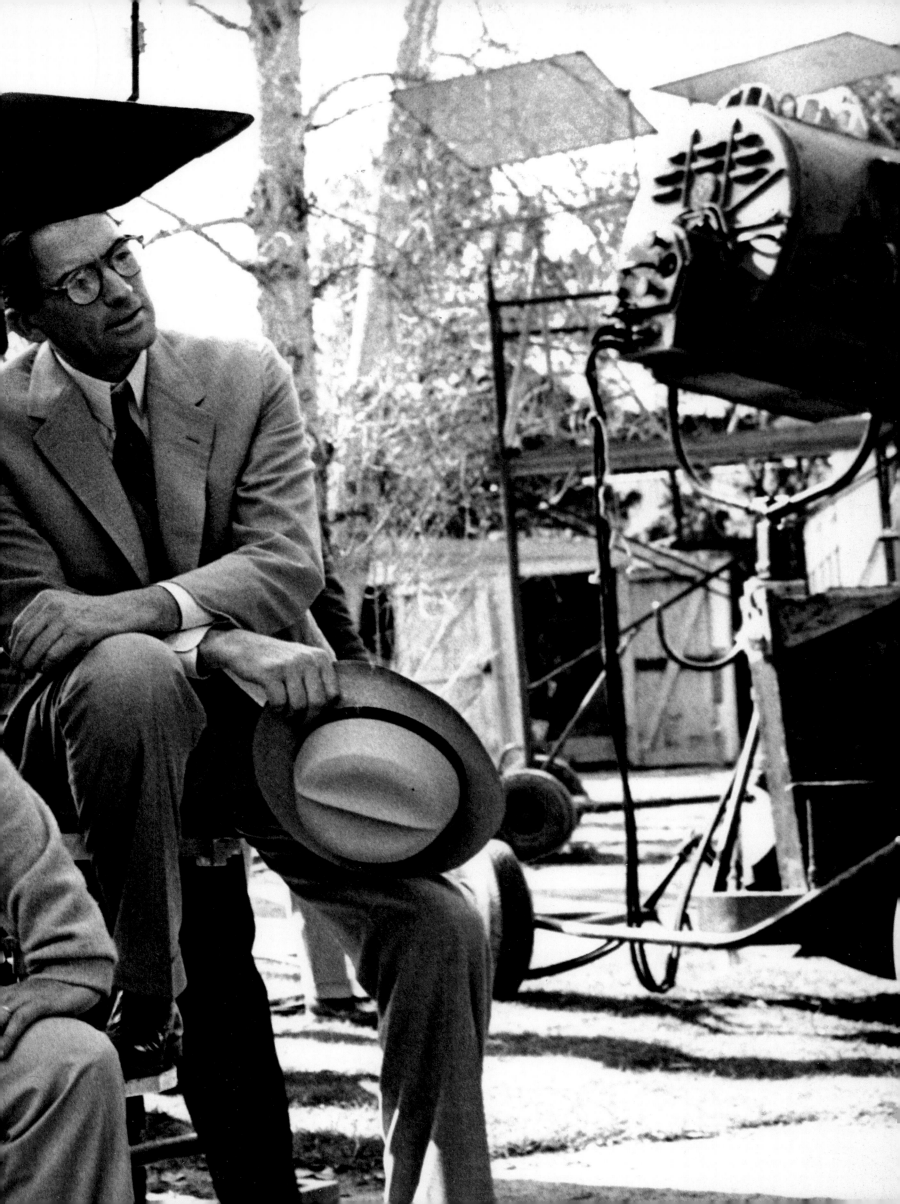

Above: Author Harper Lee with Mary Badham on a porch in Monroeville, Alabama, 1961. Opposite: Phillip Alford on scaffolding between takes. Following spread: Mary Badham is rolled in a tire, Monroeville, Alabama.

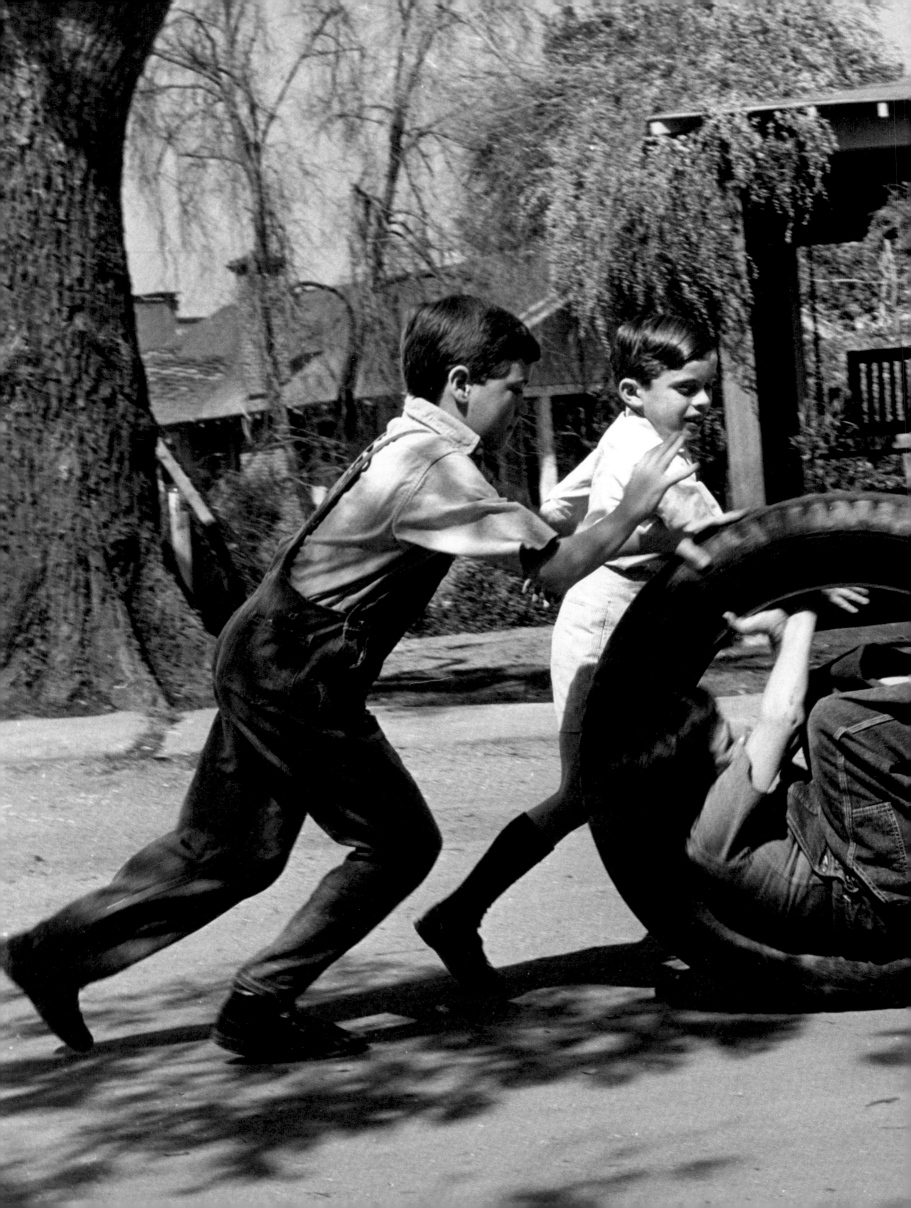

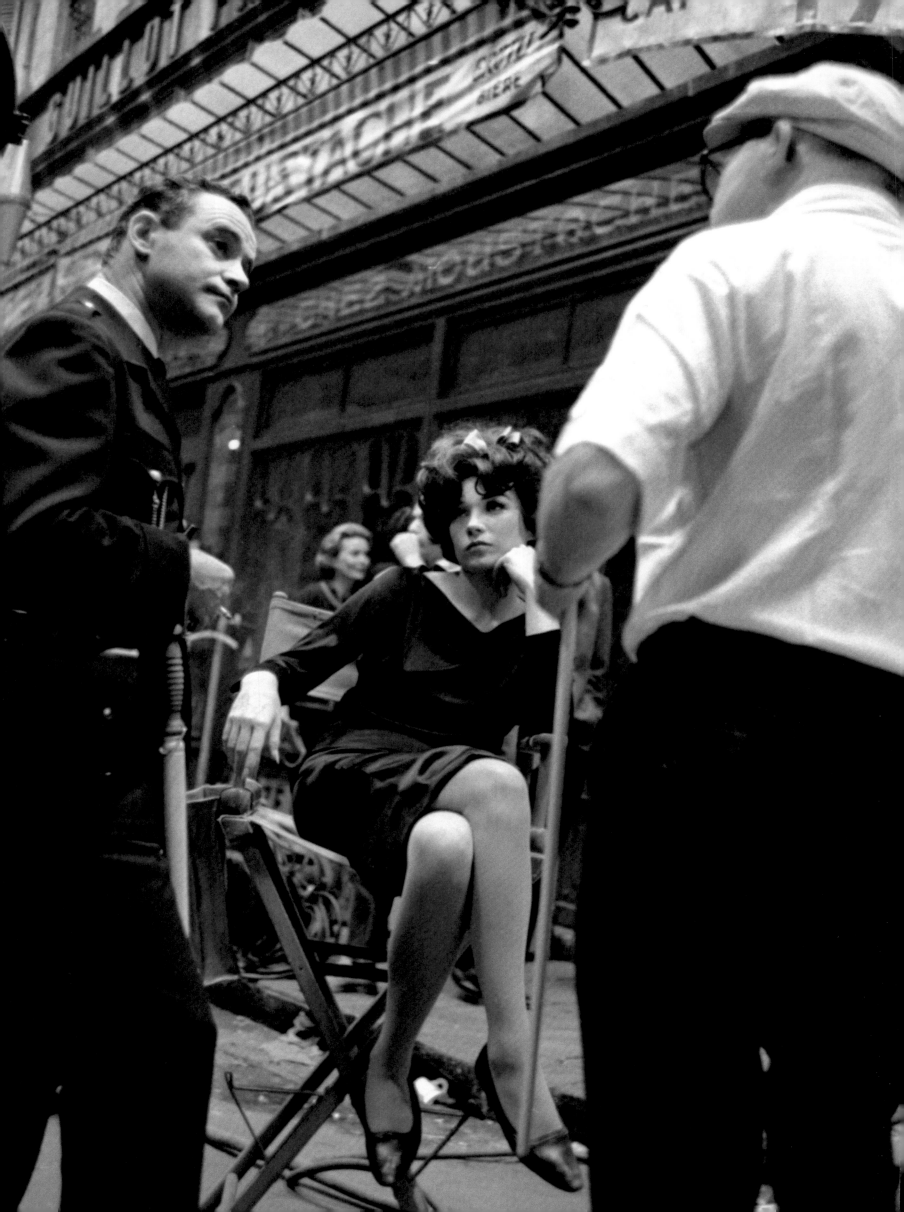

IRMA LA DOUCE

**DIRECTED BY BILLY WILDER, STARRING JACK LEMMON AND SHIRLEY MACLAINE,
HOLLYWOOD, 1962**

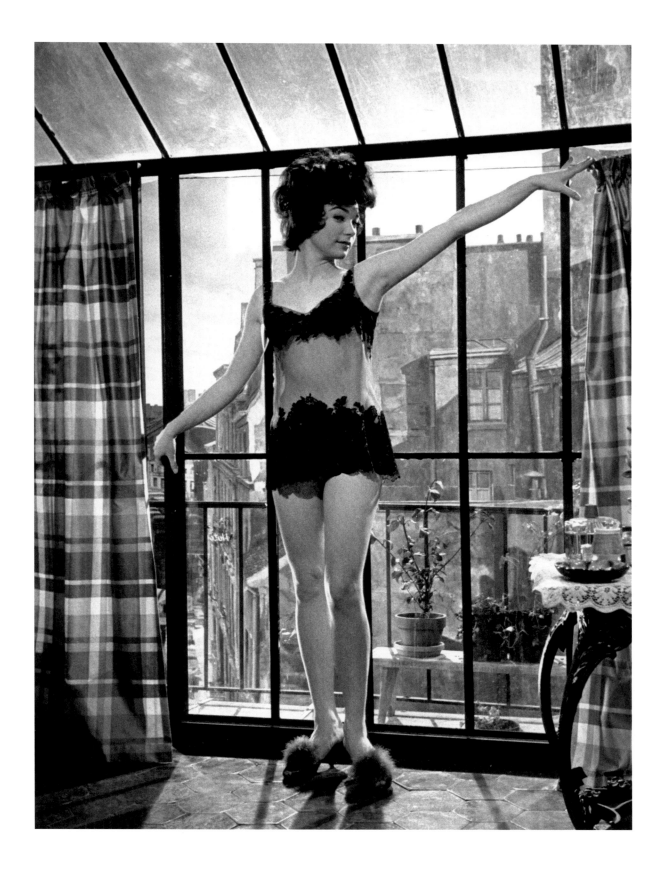

Opposite: Jack Lemmon, Shirley MacLaine, and director Billy Wilder in discussion during the filming of *Irma la Douce*, Paris, France, 1962.
Above: Shirley MacLaine, Paris, France. Following spread: Shirley MacLaine and daughter Sachi while visiting Paris, France, 1962.

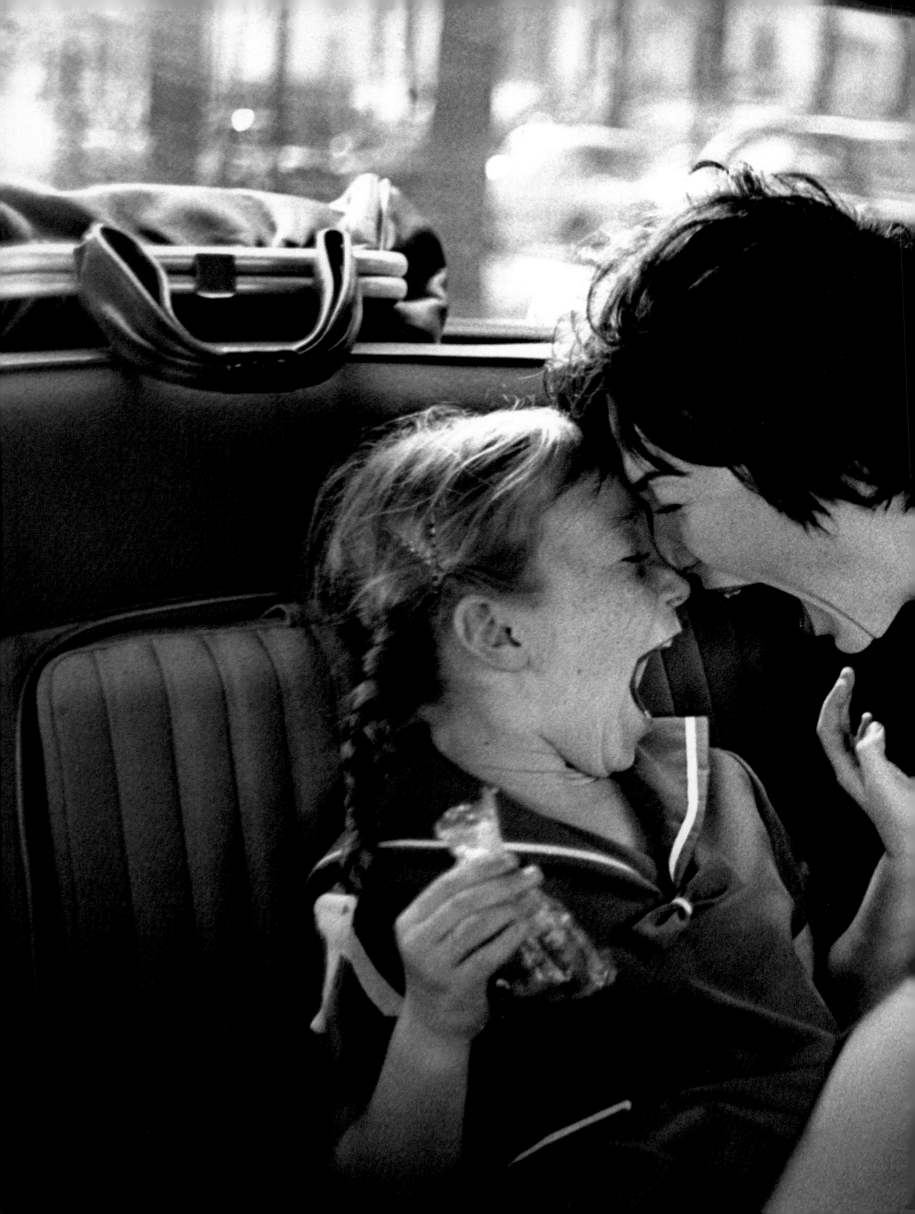

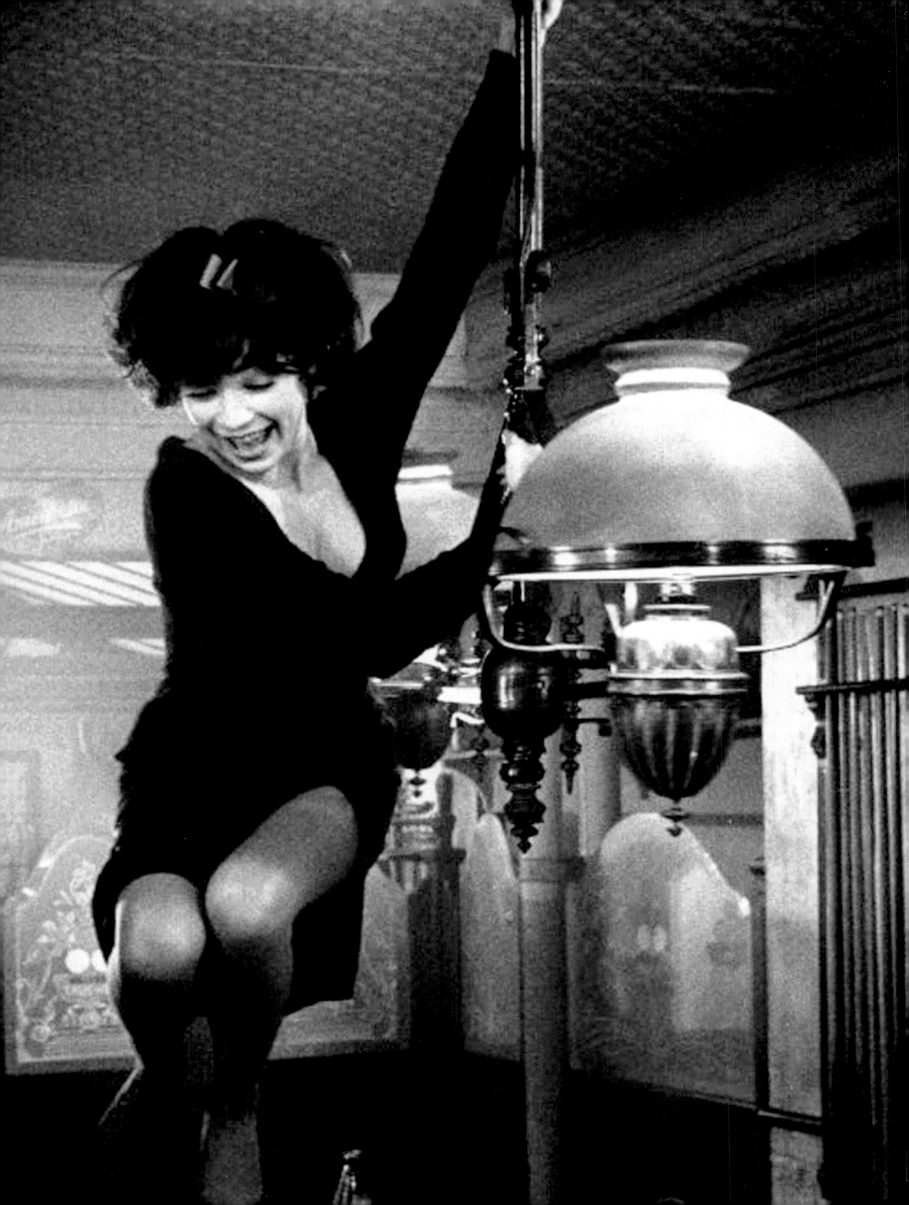

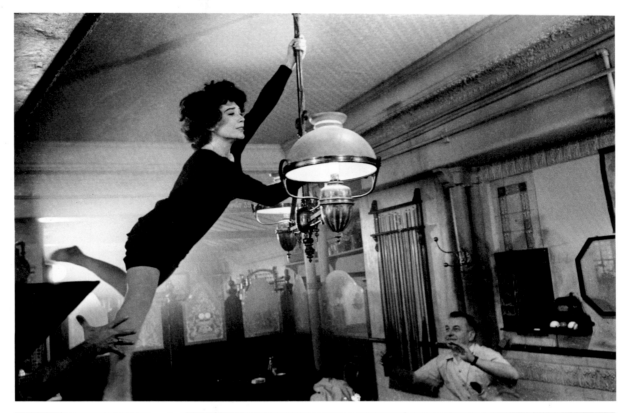

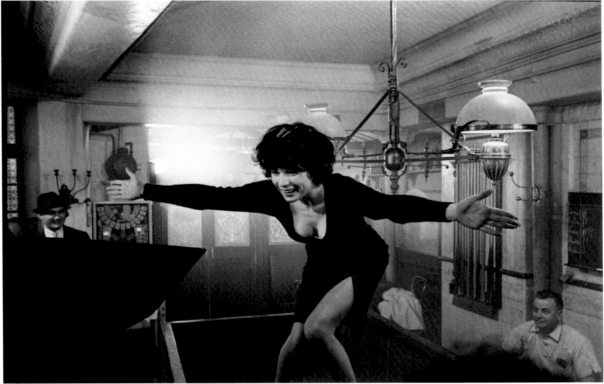

Opposite, above, and following spread: Shirley MacLaine during the filming of *Irma la Douce*. Second following spread: Actress Tura Satana and Billy Wilder, a perfectionist, 1962. Third following spread: Shirley MacLaine in a moment of concentration on set of *Irma la Douce* in 1962.

THE UGLY AMERICAN

DIRECTED BY GEORGE ENGLUND, STARRING MARLON BRANDO
AND SANDRA CHURCH, HOLLYWOOD, 1962.

Above and opposite: Marlon Brando, Universal Studios, California, 1962. Following spread: Marlon Brando
and Sandra Church during a rehearsal for *The Ugly American* at Universal Studios, 1962.

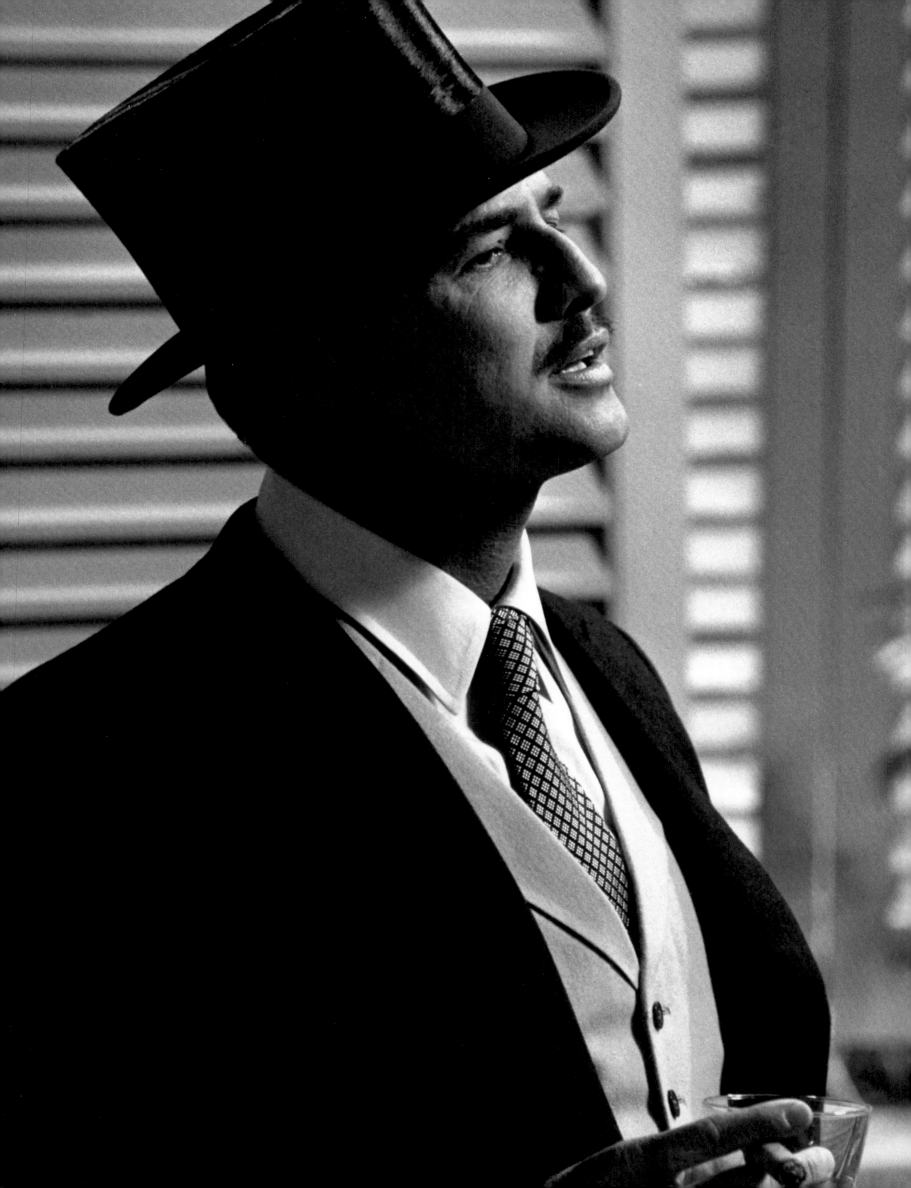

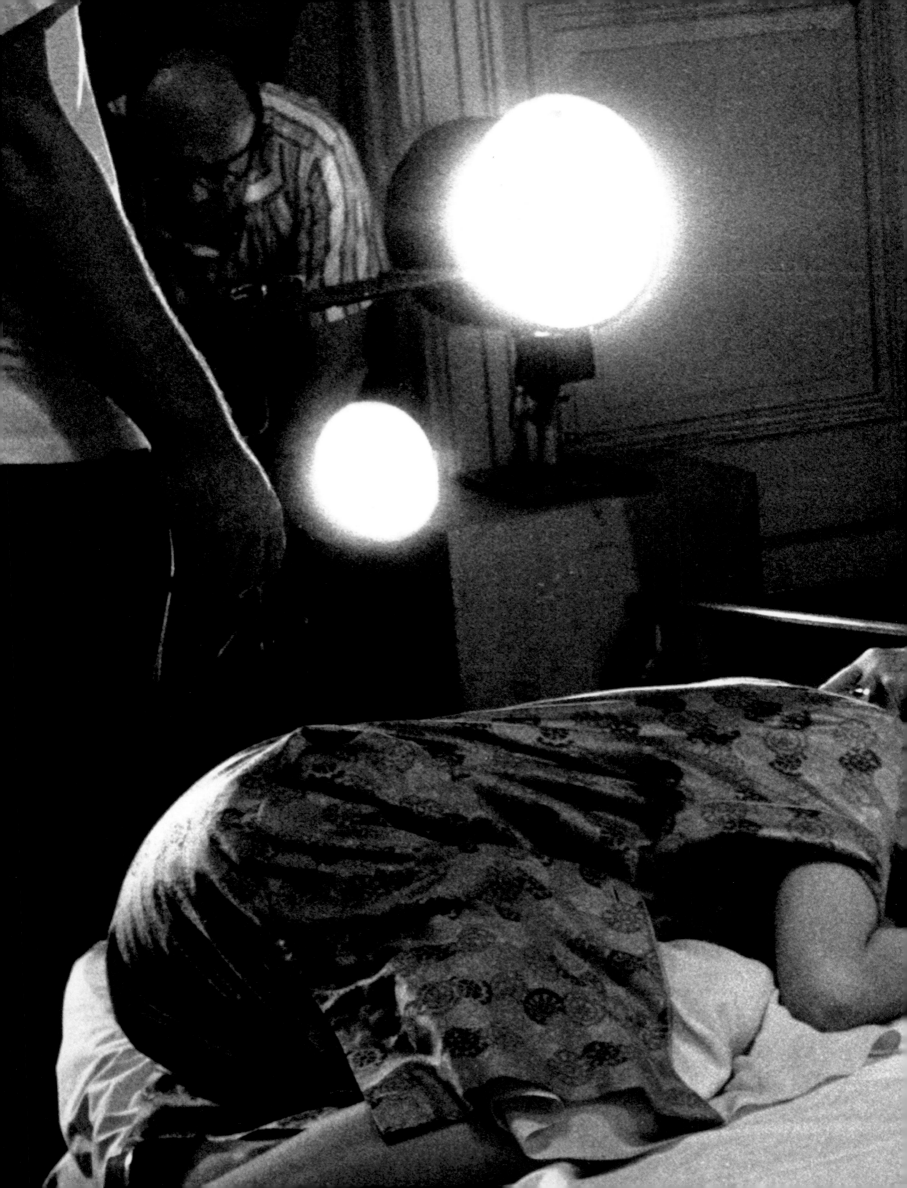

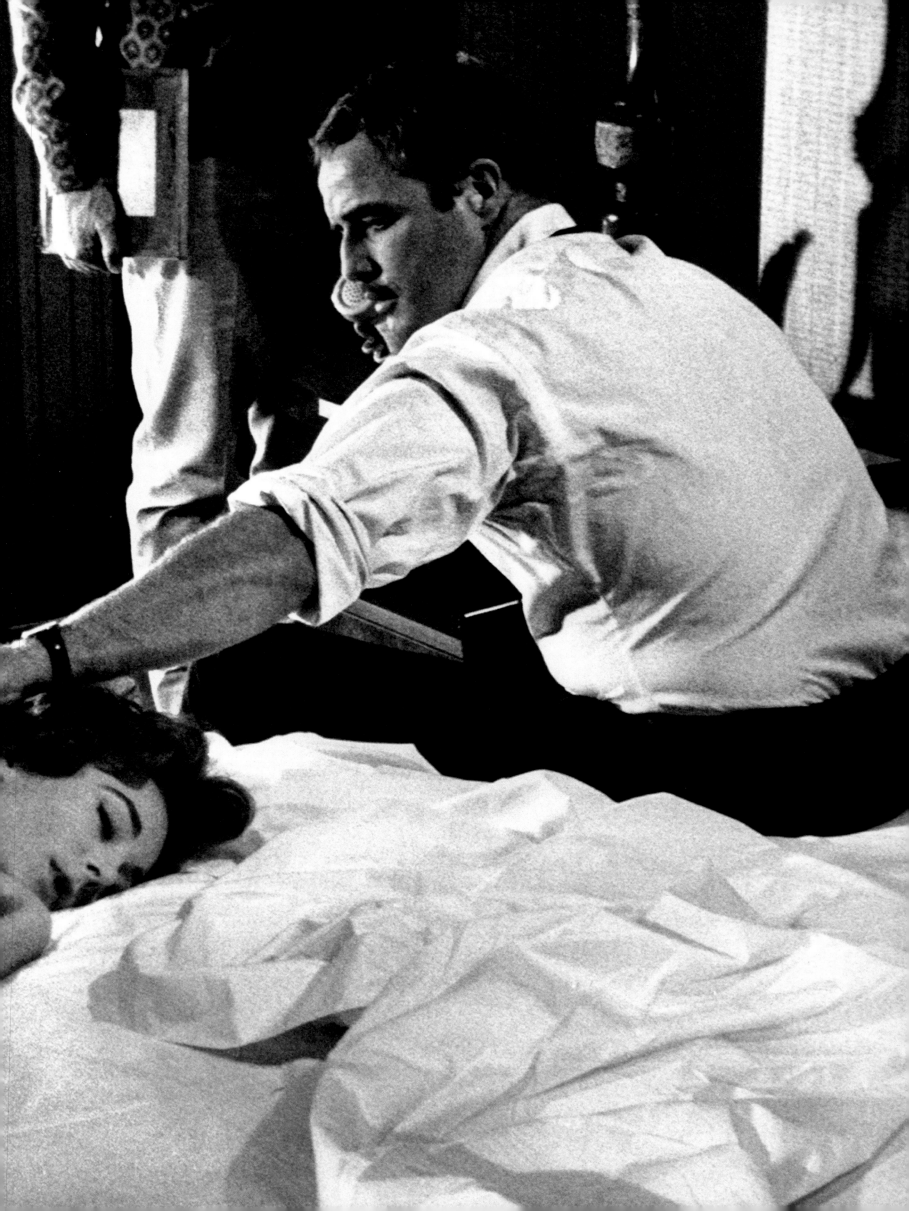

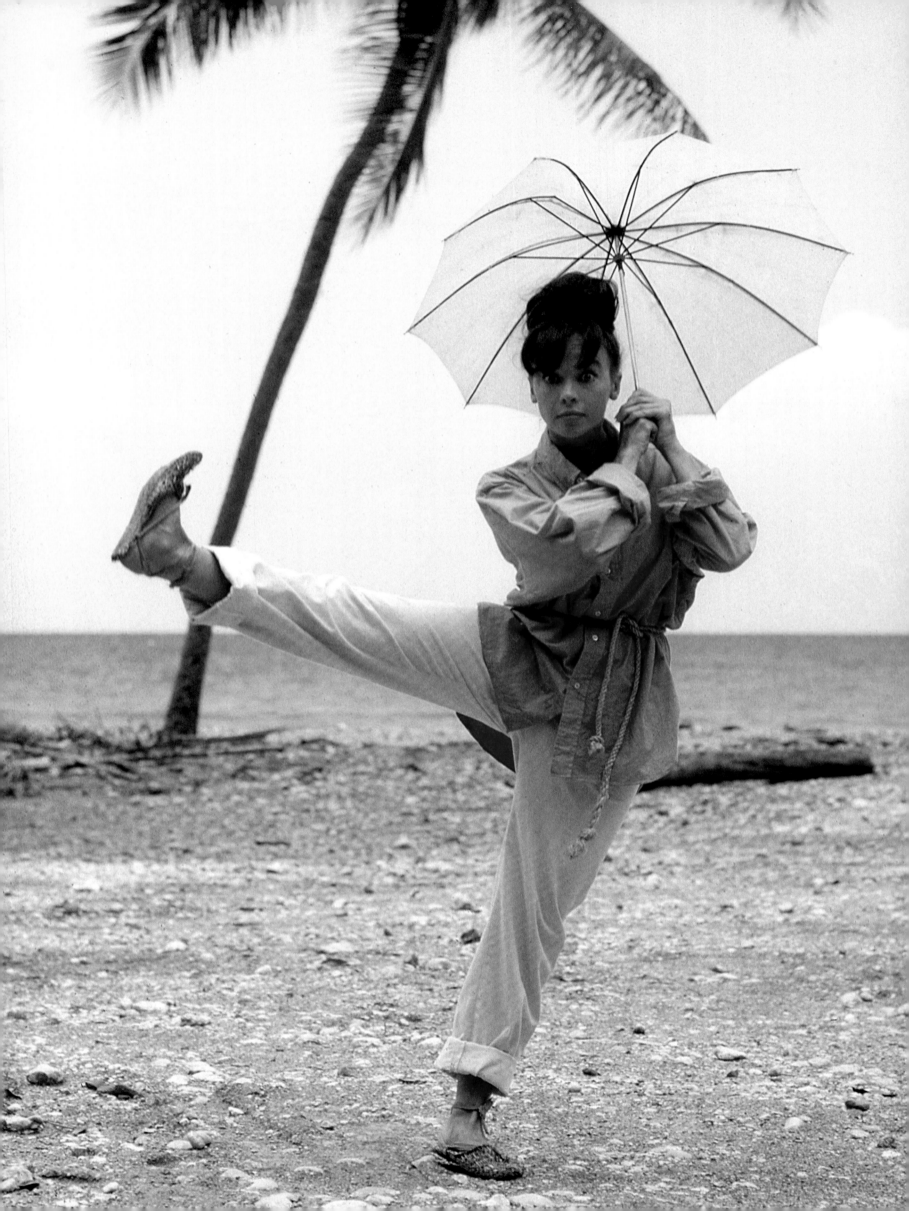

FATHER GOOSE

**DIRECTED BY RALPH NELSON, STARRING CARY GRANT
AND LESLIE CARON, JAMAICA, 1963**

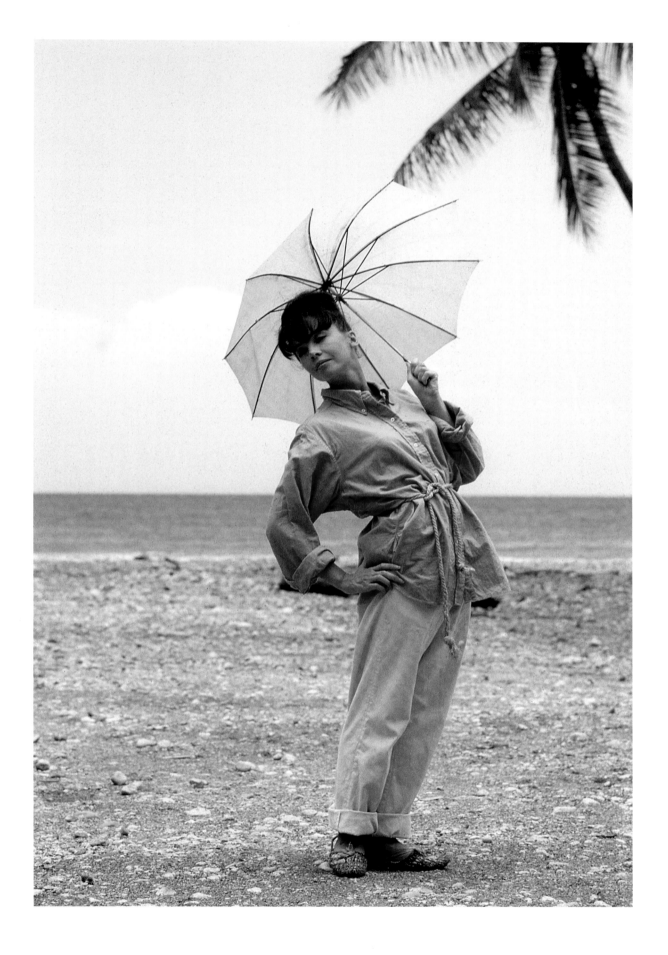

Opposite and above: Leslie Caron remembers her dancing debuts during her time off from filming *Father Goose* in Jamaica in 1963.
Following spread: Cary Grant plays a grubby, bewhiskered beachcomber in *Father Goose* shot in Ocho Ríos, St. Ann, Jamaica in 1963.

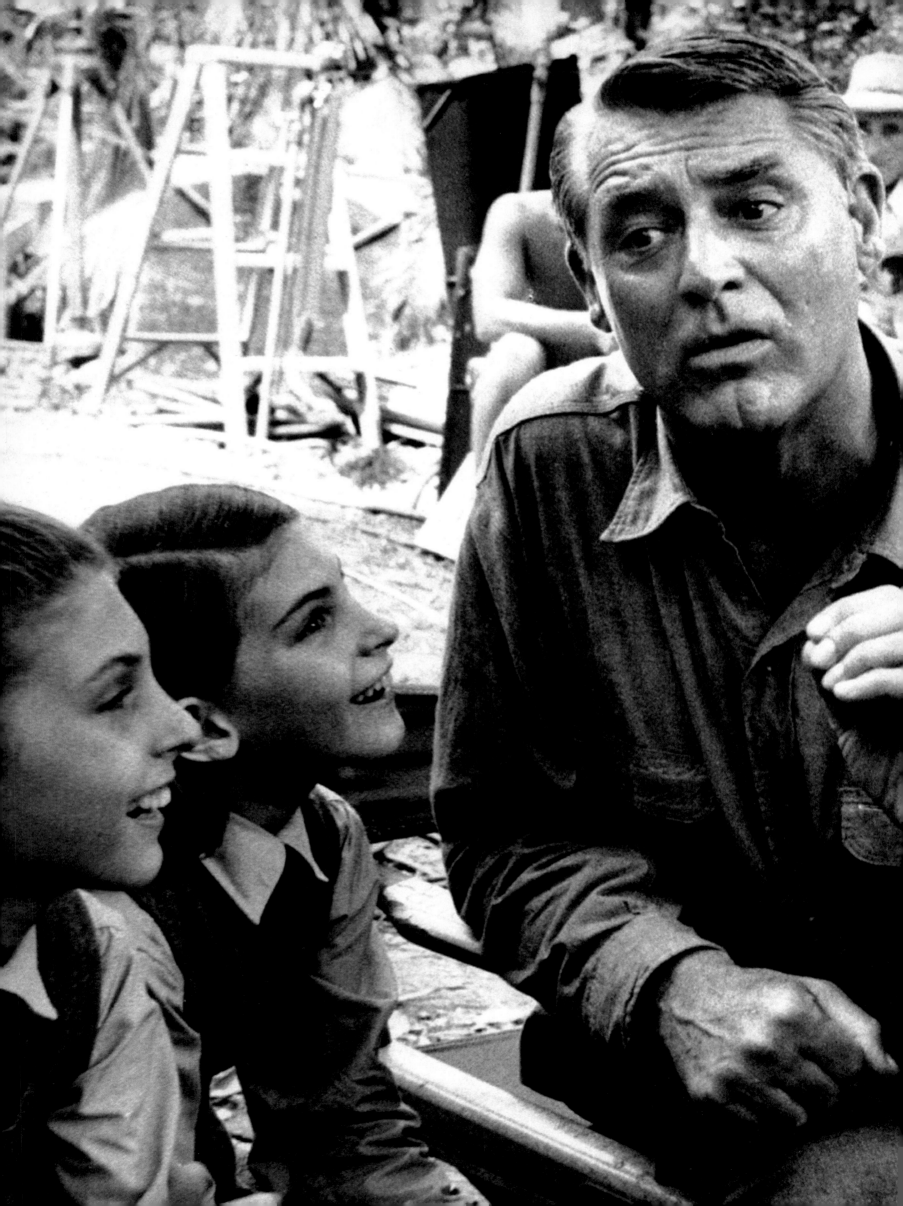

MAN'S FAVORITE SPORT?

DIRECTED BY HOWARD HAWKS, STARRING ROCK HUDSON AND MARIA PERSCHY, HOLLYWOOD, 1963

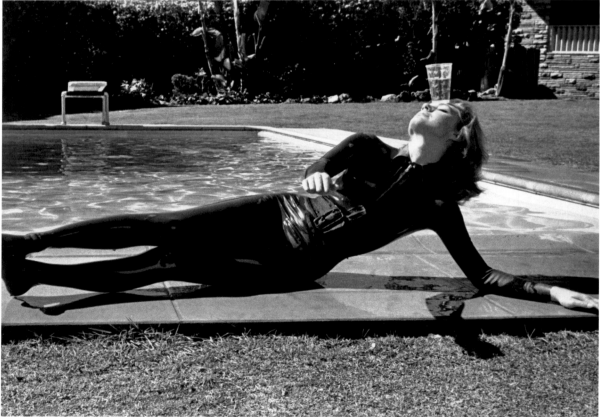

Above and opposite: Maria Perschy during the filming of *Man's Favorite Sport* in 1963. Following spread: Rock Hudson, 1963.

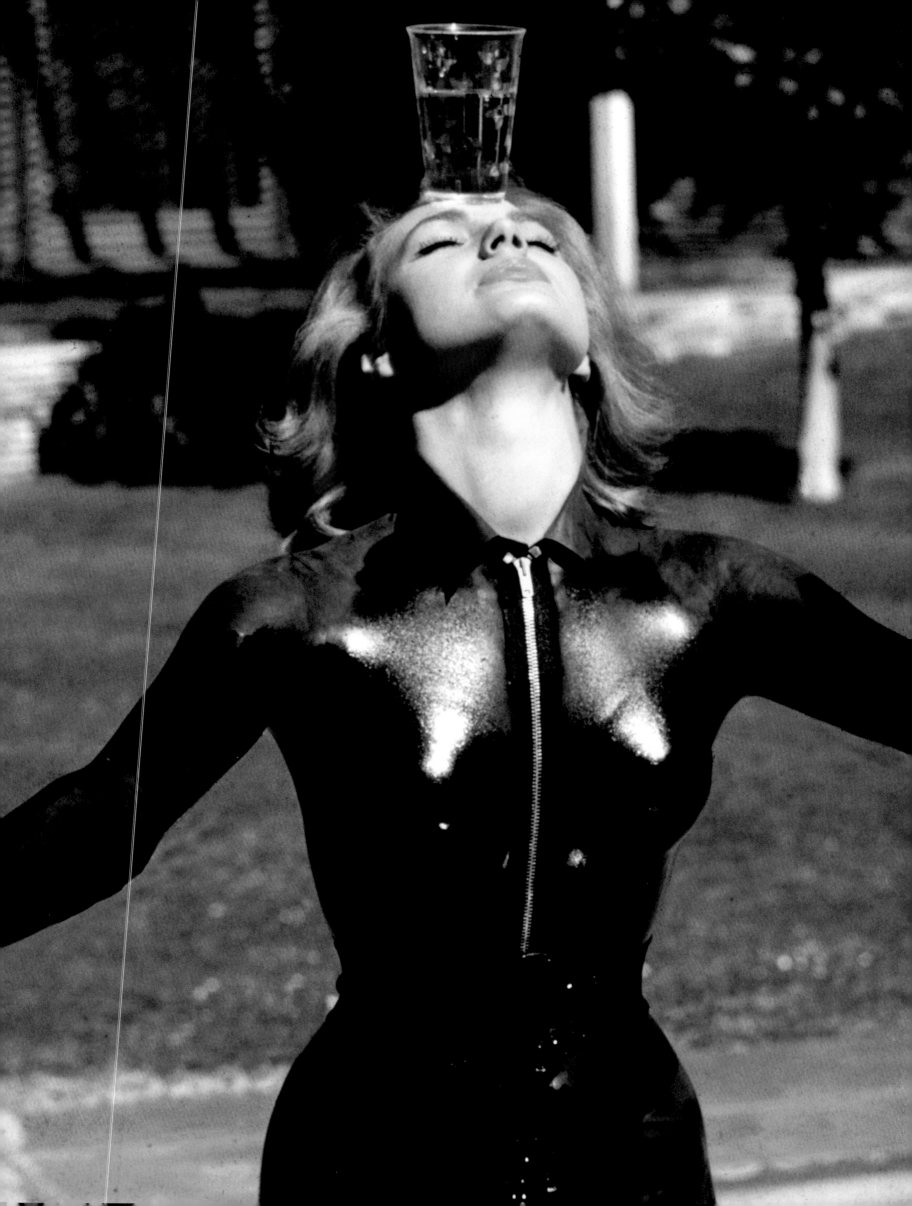

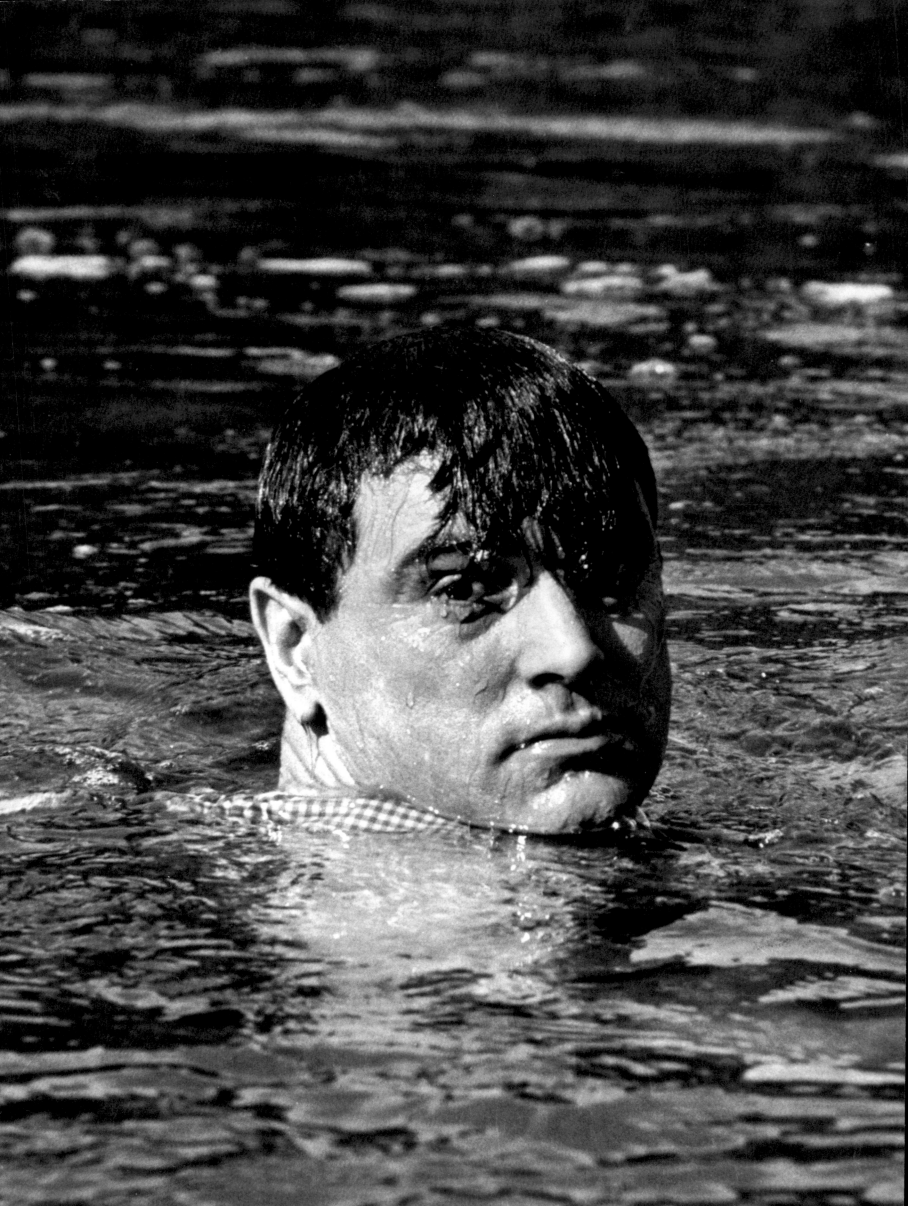

MARNIE

DIRECTED BY ALFRED HITCHCOCK, STARRING SEAN CONNERY AND TIPPI HEDREN, PENNSYLVANIA, NEW JERSEY, AND VIRGINIA, 1963

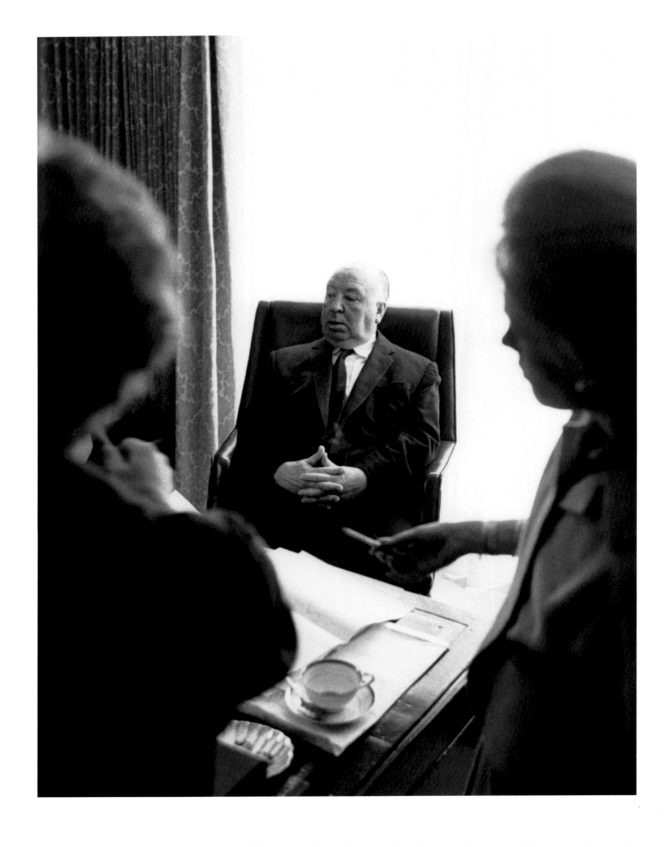

Above, opposite, and following spread: Alfred Hitchcock at his production office at Universal Studios in 1963 preparing for *Marnie*.

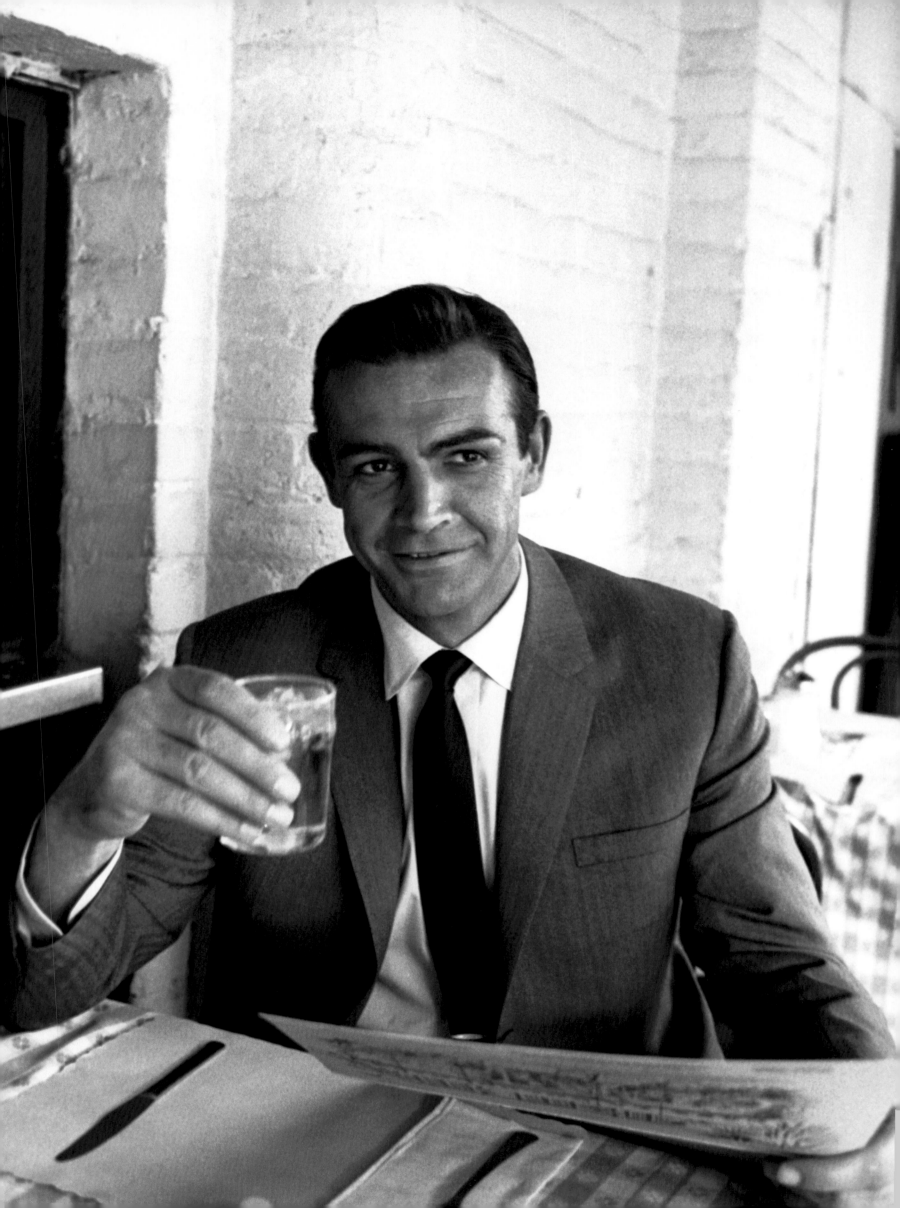

Opposite: Sean Connery takes in Olvera Street, one of the oldest streets in Los Angeles. Above: Tippi Hedren preparing for *Marnie*.

WOMAN OF STRAW

**DIRECTED BY BASIL DEARDEN, STARRING SEAN CONNERY,
SPAIN AND THE UNITED KINGDOM, 1963**

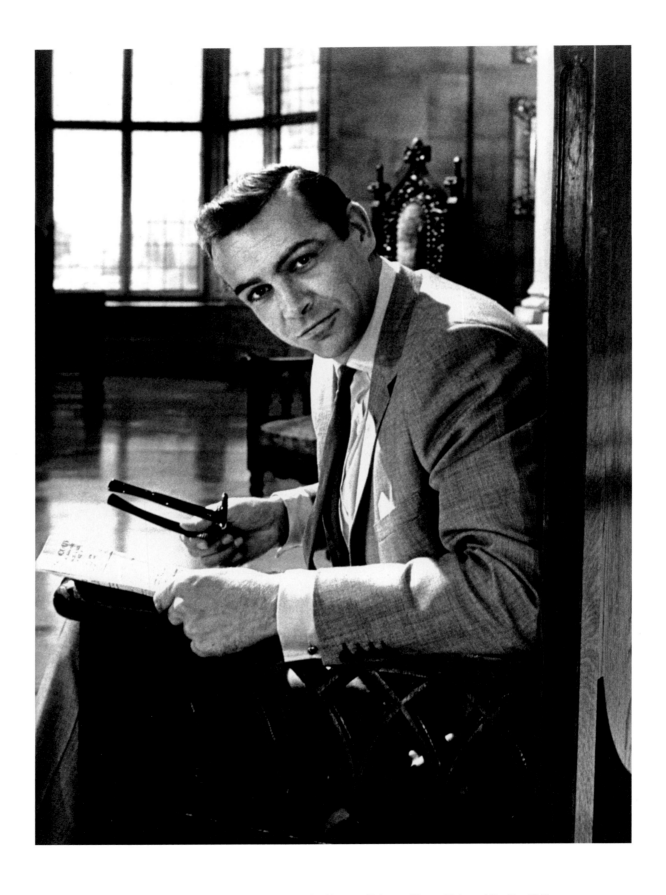

Above and opposite: Sean Connery during the filming of *Woman of Straw*, Universal Studios, 1963.

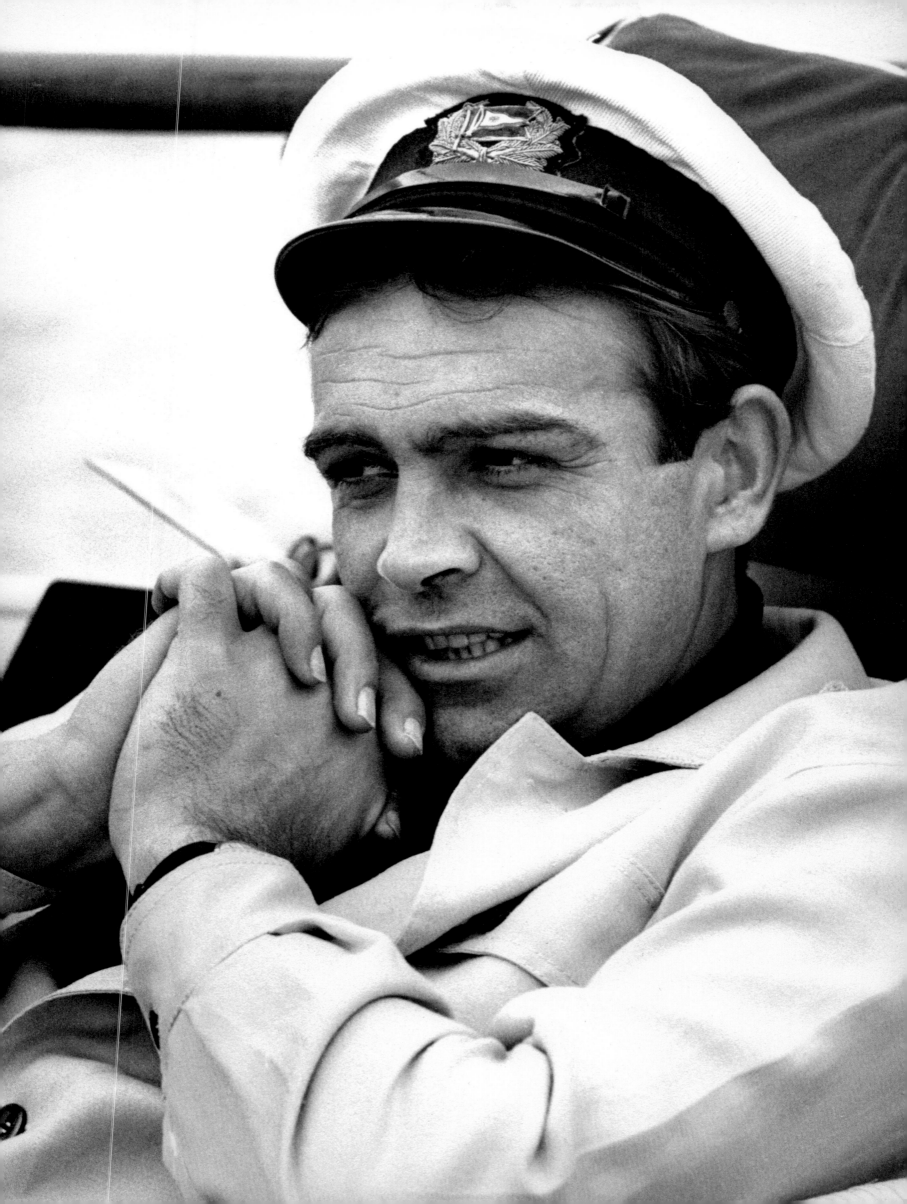

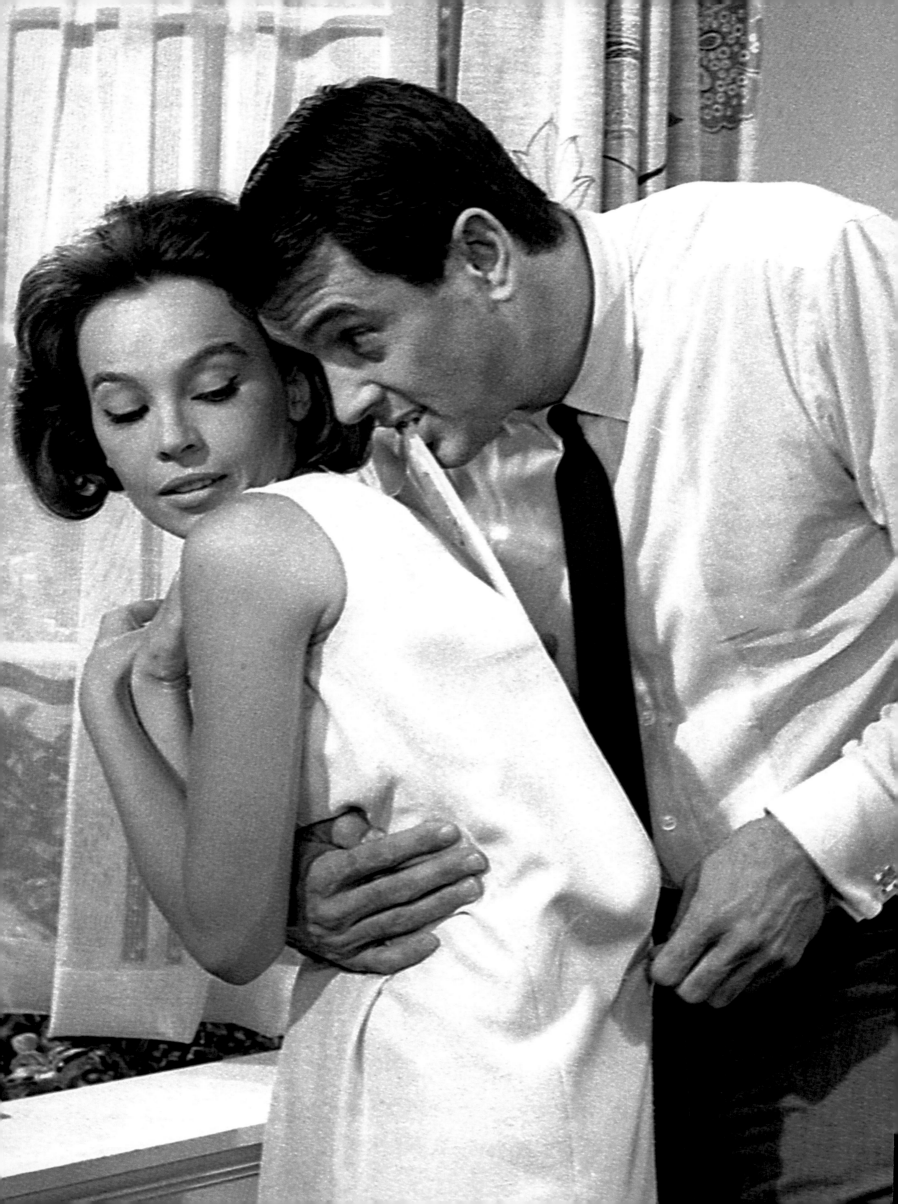

A VERY SPECIAL FAVOR

DIRECTED BY MICHAEL GORDON, STARRING ROCK HUDSON
AND LESLIE CARON, HOLLYWOOD, 1964

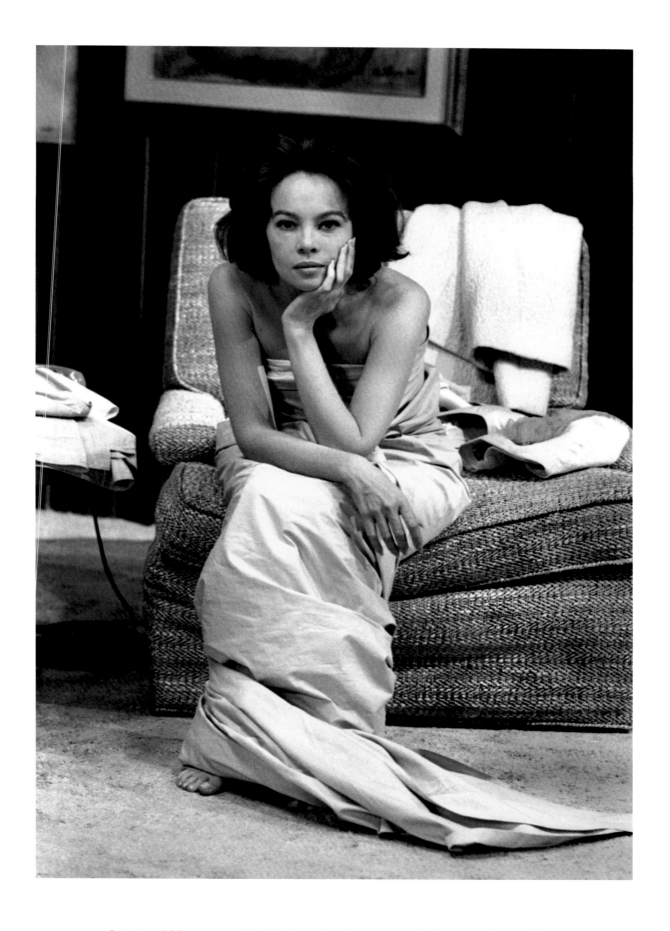

Opposite and following spread: Rock Hudson and Leslie Caron during the filming of *A Very Special Favor*
at Universal Studios, 1964. Above: Leslie Caron poses on the set, 1964.

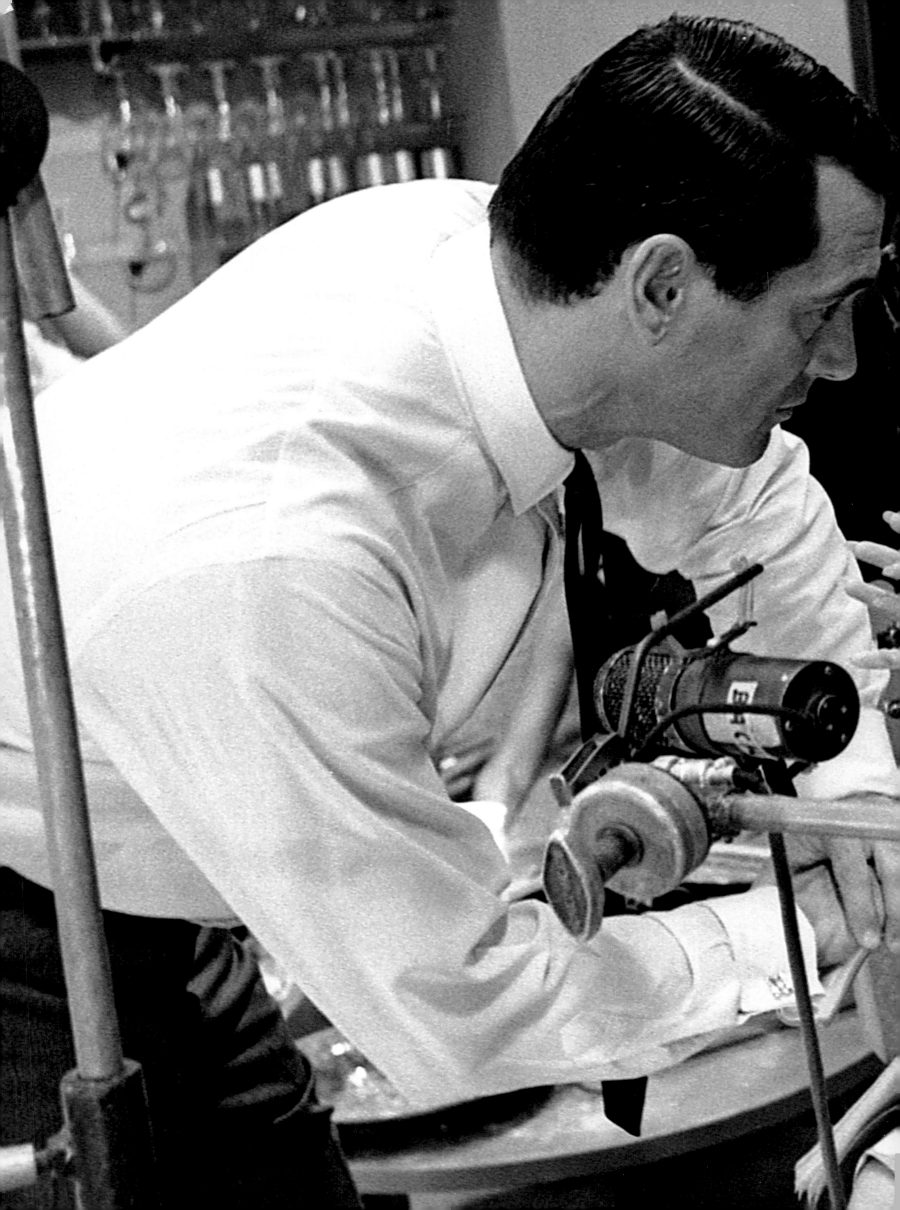

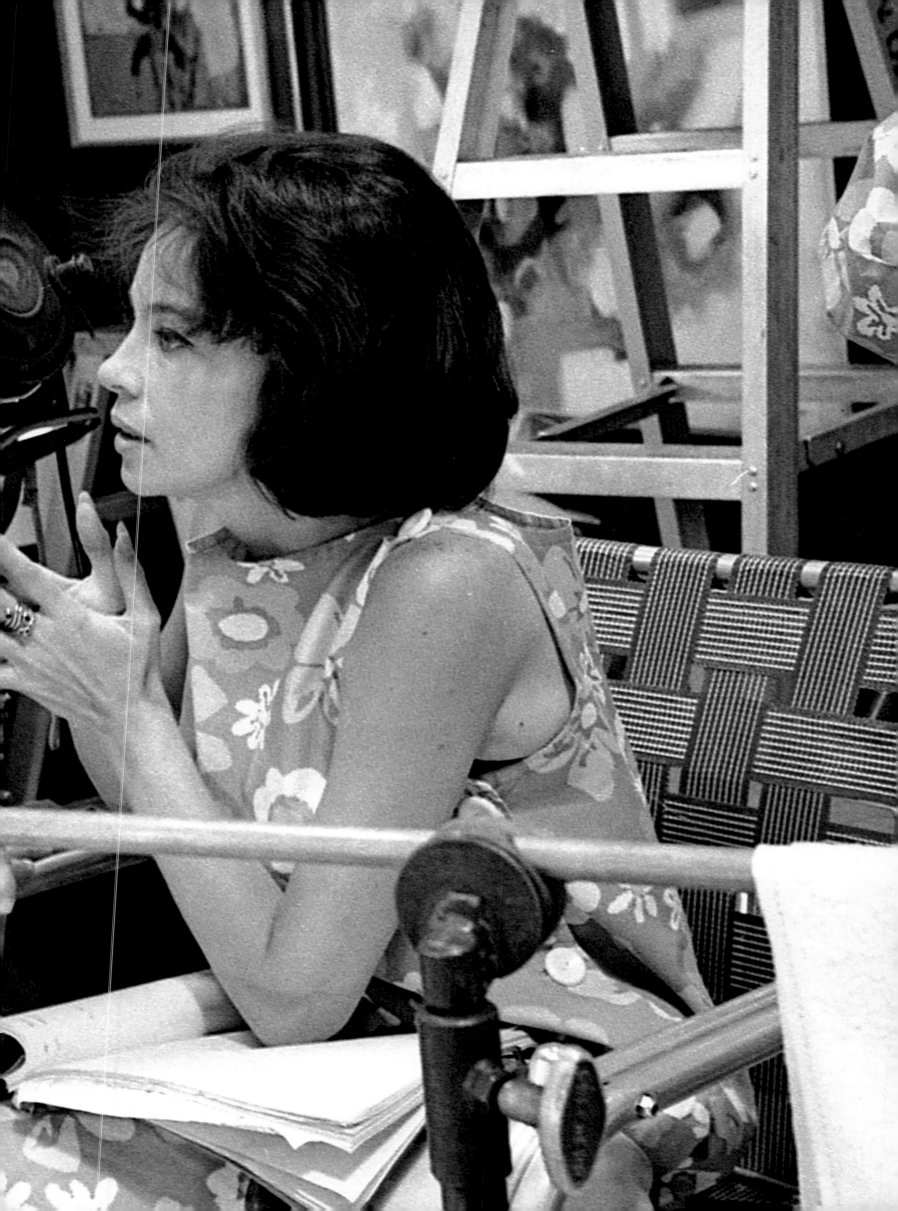

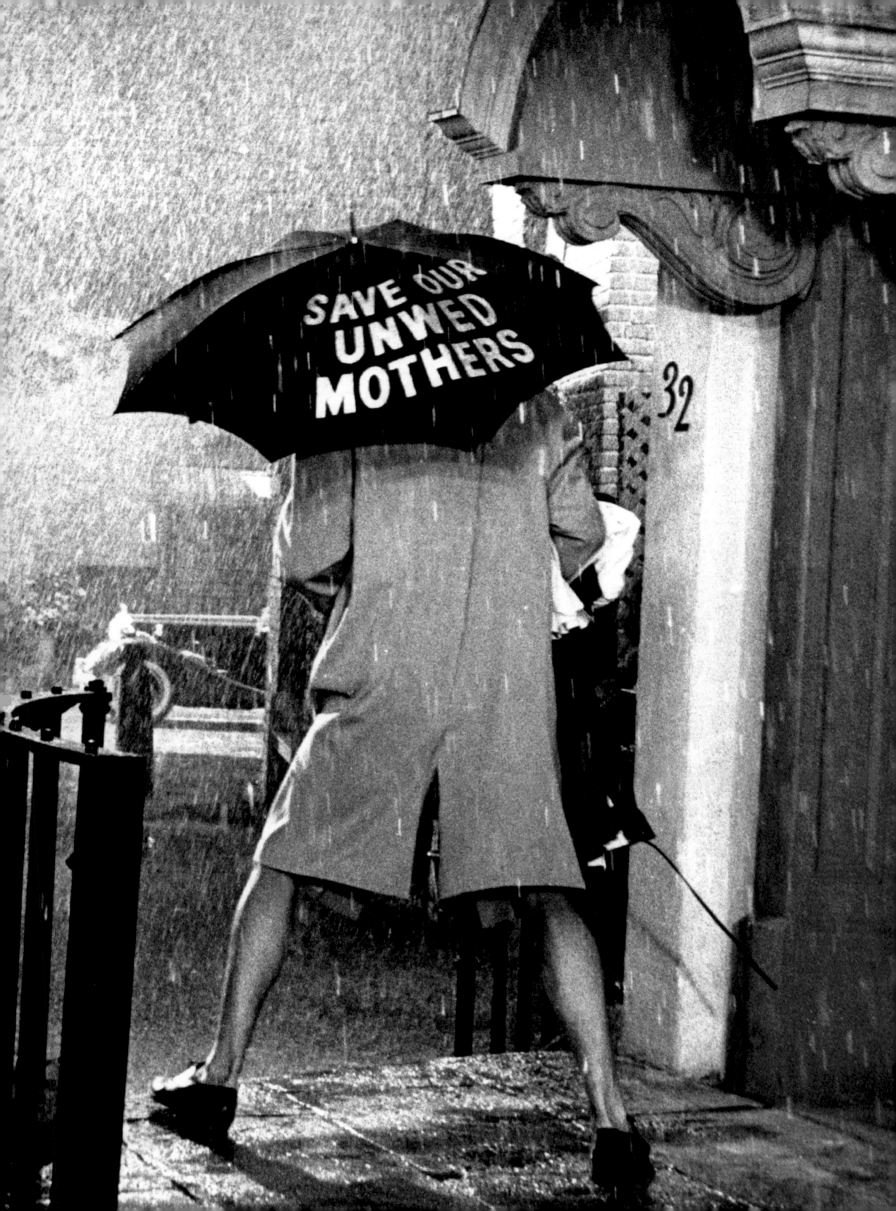

STRANGE BEDFELLOWS
DIRECTED BY MELVIN FRANK, STARRING ROCK HUDSON
AND GINA LOLLOBRIGIDA, HOLLYWOOD, 1964

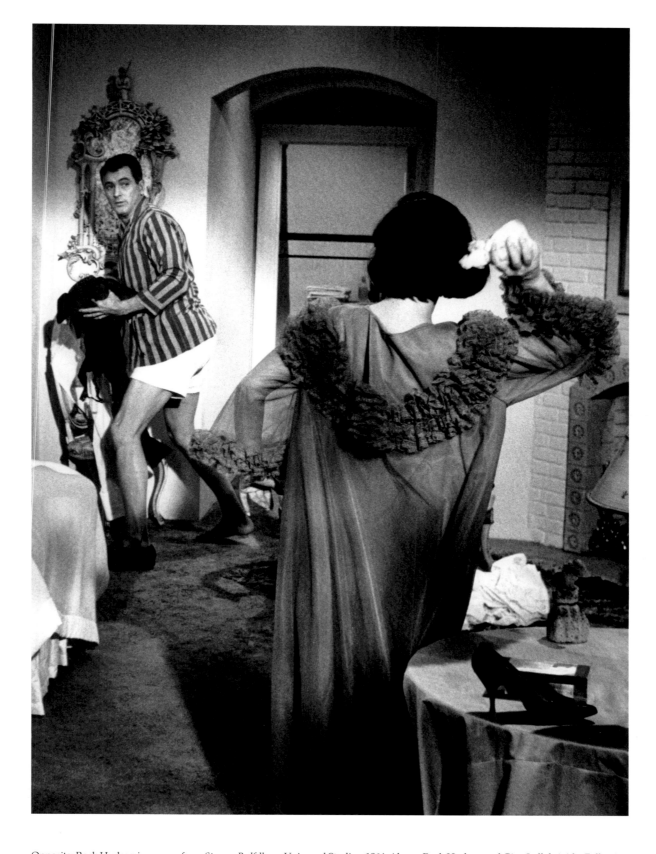

Opposite: Rock Hudson in a scene from *Strange Bedfellows*, Universal Studios, 1964. Above: Rock Hudson and Gina Lollobrigida. Following spread: Rock Hudson, Gina Lollobrigida, and director Mel Frank, 1964. Final spread: Leo taking a picture of Leslie Caron on set, 1964.

ACKNOWLEDGEMENTS

To Rebeca my love and my new family for their support, spirit, and sense of humor. Special thanks to creative director Sam Shahid and art director Matthew Kraus whose eyes and taste made the book what it is. To Bruce Weber and Eva Lindemann whose generous support and advice made this book possible. To Craig Cohen and the nice folks at powerHouse Books. To Verena Bayer, Dorothea Resch, Emma Geraud, Maho Harada, and Lisa Vanco for their hard work in the archives over the years. To the many with whom I discussed the book and who offered valuable insights including David Toscan, Maya Roberts, John Burton, Dany Levy, Natalie Massenet, Katrina Pavlos, Bruno Dell'Isola, Tarek, Javed, Veronique, Gina, Benvinda, Jackie, Jakki, Avi, as well as Jan Korbelin, Marina Grasic, Leopoldo Gout, Mary Knox, and the rest of the folks at Curious. To Jon Glovin at The Helios Gallery, Gemma Barnett at the Photographer's Gallery, and Etheleen Staley and Taki Wise at Staley Wise for representing my father's work with passion. And to Sylviane, Manny, Killy, Greg, and others remembered here.

LEO FUCHS
Special Photographer
from the Golden Age of Hollywood

Compilation © 2010 powerHouse Cultural Entertainment, Inc.
Photography & text © 2010 Leo Fuchs
Introduction © 2010 Alexandre Fuchs
Essay © 2010 Bruce Weber

Published in the United States by powerHouse Books,
a division of powerHouse Cultural Entertainment, Inc.
37 Main Street, Brooklyn, NY 11201-1021
telephone: 212.604.9074, fax: 212.366.5247
email: specialphotographer@powerhousebooks.com
website: www.powerhousebooks.com

www.leofuchs.com
www.leofuchsarchives.com
www.theheliosgallery.com

First edition, 2010

Library of Congress Control Number: 2010933880

Hardcover ISBN 978-1-57687-558-2

Printing and binding by EBS, Verona

Design by Sam Shahid

A complete catalog of powerHouse Books and Limited Editions is available upon request; please call, write, or visit our website.

10 9 8 7 6 5 4 3 2 1

Printed and bound in Italy

Fuchs

SOLOMON AND SHEBA

ESTUDIOS SEVILLA FILMS, S. A.

AVENIDA PIO XII, 2
MADRID

*PHOTOS
DE
PRESSE*